WITHDRAWN BY THE
UNIVERSITY OF MICHIGAN

Goddess and Polis

Goddess and Polis

THE PANATHENAIC FESTIVAL IN ANCIENT ATHENS

JENIFER NEILS

with contributions by

E.J.W. BARBER

DONALD G. KYLE

BRUNILDE SISMONDO RIDGWAY

H.A. SHAPIRO

1992

Hood Museum of Art, Dartmouth College, Hanover, New Hampshire

Princeton University Press, Princeton, New Jersey

Copyright © 1992 by The Trustees of Dartmouth College,
Hanover, New Hampshire
All rights reserved
Hood Museum of Art, Dartmouth College, Hanover, NH 03755

Co-published and distributed by the Princeton University Press,
41 William Street, Princeton, New Jersey 08540–5237

CATALOGING IN PUBLICATION DATA

Neils, Jenifer, 1950–
Goddess and polis: the Panathenaic Festival in ancient Athens:
[exhibition] / Jenifer Neils; with contributions by E.J.W. Barber . . .
[et al.]
Includes bibliographical references and index.
ISBN 0-691-03612-8. — ISBN 0-691-00223-1 (pbk.)
1. Panathenaia—Exhibitions. 2. Greece—Antiques—Exhibitions.
3. Arts, Greek—Exhibitions. I. Hood Museum of Art. II. Title
DF123.N45 1992
938".5'007473—dc20 92-17660
 CIP

Editor: Elizabeth Bobrick
Design: Malcolm Grear Designers
Typesetting and Printing: The Stinehour Press

This exhibition has been funded in part by grants from
the National Endowment for the Humanities and the
National Endowment for the Arts, federal agencies.

Cover illustration:
cat. 18
Detail of Athena from black-figure amphora (Panathenaic shape)
Attributed to the Princeton Painter [Bothmer], ca. 540 B.C.
The Metropolitan Museum of Art, New York
Gift of Nobert Schimmel, 1989
1989.281.89
For full view of this amphora see p. 43 of this catalogue.

This book has been published in conjunction with an exhibition
entitled *Goddess and Polis: The Panathenaic Festival in Ancient Athens*
organized by the Hood Museum of Art.

Exhibition schedule

HOOD MUSEUM OF ART
Dartmouth College
Hanover, New Hampshire
September 12–December 6, 1992

TAMPA MUSEUM OF ART
Tampa, Florida
January 9–April 16, 1993

VIRGINIA MUSEUM OF FINE ARTS
Richmond, Virginia
May 11–August 1, 1993

THE ART MUSEUM, PRINCETON UNIVERSITY
Princeton, New Jersey
August 31–November 28, 1993

Frontispiece:
cat. 39
Black-figure Panathenaic prize amphora with wrestlers
Attributed to the Berlin Painter, ca. 480–470 B.C.
Hood Museum of Art, Dartmouth College, Hanover, New Hampshire
Gift of Mr. and Mrs. Ray Winfield Smith, Class of 1918
c.959.53

Table of Contents

6 Lenders to the Exhibition

7 Foreword

10 Preface

13 *The Panathenaia: An Introduction*
 JENIFER NEILS

29 *Panathenaic Amphoras: Their Meaning, Makers, and Markets*
 JENIFER NEILS

53 *Mousikoi Agones: Music and Poetry at the Panathenaia*
 H. A. SHAPIRO

77 *The Panathenaic Games: Sacred and Civic Athletics*
 DONALD G. KYLE

103 *The Peplos of Athena*
 E. J. W. BARBER

119 *Images of Athena on the Akropolis*
 BRUNILDE SISMONDO RIDGWAY

143 Catalogue of the Exhibition
 JENIFER NEILS

192 Abbreviations

194 Notes to the Essays

216 Suggestions for Further Reading

218 Glossary

222 Index

Lenders to the Exhibition

Albright-Knox Art Gallery, Buffalo, New York

Allen Memorial Art Museum, Oberlin College, Oberlin, Ohio

The American Numismatic Society, New York

Archer M. Huntington Art Gallery, University of Texas at Austin, Texas

The Art Museum, Princeton University, Princeton, New Jersey

The Cleveland Museum of Art, Cleveland, Ohio

The Detroit Institute of Arts, Detroit, Michigan

Duke University Museum of Art, Durham, North Carolina

Ella Riegel Memorial Museum, Bryn Mawr College, Bryn Mawr, Pennsylvania

Mr. and Mrs. Lawrence Fleischman

The J. Paul Getty Museum, Malibu, California

Harvard University Art Museums, Cambridge, Massachusetts

Hearst Castle, California Department of Parks and Recreation, San Simeon, California

Hood Museum of Art, Dartmouth College, Hanover, New Hampshire

Indiana University Art Museum, Bloomington, Indiana

The Johns Hopkins University Archaeology Collection, Baltimore, Maryland

Mead Art Museum, Amherst College, Amherst, Massachusetts

The Metropolitan Museum of Art, New York

The Museum of Fine Arts, Houston, Texas

National Museum of American History, Smithsonian Institution, Washington, D.C.

The Nelson-Atkins Museum of Art, Kansas City, Missouri

George Ortiz Collection, Switzerland

Private collection, Cincinnati, Ohio

Private collection, New York

Royal Ontario Museum, Toronto, Canada

The Saint Louis Art Museum, St. Louis, Missouri

San Antonio Museum of Art, San Antonio, Texas

Santa Barbara Museum of Art, Santa Barbara, California

Tampa Museum of Art, Tampa, Florida

The Toledo Museum of Art, Toledo, Ohio

University Museums, The University of Mississippi, University, Mississippi

Virginia Museum of Fine Arts, Richmond, Virginia

The Walters Art Gallery, Baltimore, Maryland

Shelby White and Leon Levy

World Heritage Museum, University of Illinois, Urbana-Champaign, Urbana, Illinois

Yale University Art Gallery, New Haven, Connecticut

Nicholas S. Zoullas

Foreword

In an Olympic year, such as the present one, we are invariably reminded of the origin of the modern games in the festivals of ancient Greece. It is important to recognize the similarities between the two, most notably the participation of the finest athletes from throughout the world and an emphasis on competitive excellence; but such similarities extend only so far. The differences are far more interesting, and have much to tell us about the religion and culture of the ancient Greeks.

Their festivals were complex phenomena, comprising not only competitions of various types, but many other activities as well: processions, sacrifices, feasting, and musical and theatrical performances. They were, above all, religious gatherings, intended to honor the gods and, according to Plato, give members of the community "periods of rest" from their labors. This catalogue and the exhibition it accompanies examine in detail one such event, the Panathenaia, the great state festival of Athens devoted to the patron goddess of the city. As a subject it is particularly well suited to this format because the Panathenaia was unique among Greek festivals in commissioning works of art as prizes for many of the competitions. With this exhibition we have taken a contextual approach, bringing together works of art that are diverse in medium and function but linked thematically by their relation to the Panathenaia. It is our hope that in doing so we will have fostered a greater understanding of a world that is distant from our own both in time and in habit of thought.

As with any such undertaking, the successful realization of exhibition, catalogue, and accompanying educational programs required the cooperation of many friends and colleagues. First, I would like to express my gratitude to two former members of the museum's staff: Hilliard Goldfarb, who as our Curator of European Art held initial discussions with guest curator Jenifer Neils and enthusiastically proposed the project to our Exhibitions Committee; and our former Director, James Cuno, whose sound advice and firm support for the exhibition during the early stages of its planning were extremely helpful.

I would like to take this opportunity to recognize the important contributions of several members of the museum's staff. Our Curator of Academic Programming, Katherine Hart, was responsible for coordinating every aspect of our work on the exhibition. In addition, she played a major role in the production of the catalogue. Her selfless devotion and extraordinary attention to every detail are greatly appreciated. Our Exhibitions Assistants, Elisabeth Gordon and Sarah Lord, and Public Relations Assistant, Adrienne Hand, helped us in countless ways, most notably with the production of several lengthy grant applications and the complex requirements of arranging the two-day symposium entitled *Athens and Beyond* held in conjunction with the exhibition during its presentation at Dartmouth. Jennifer Miglionico, Dartmouth Class of 1995, has provided invaluable help in the exhibitions office, in particular with the compilation of material for the glossary.

I am especially grateful for the patience and good will of the staff of our Registrar's department—Kellen Haak, Kathleen O'Malley, Cynthia Gilliland, and Karin Rothwell—whose handling of the myriad details involved in the organization of this project was exemplary. Special thanks are due as well to Evelyn Marcus, the museum's Curator of Exhibitions, for managing the development of the installation design and overseeing the production of exhibition furniture with great skill and diplomacy. Her collaboration with Josh Metcalf, who designed and constructed the pedestals and exhibition

entrance, resulted in an installation whose classical spirit is in keeping with the Panathenaia. Lesley Wellman, Curator of Education, worked not only on the educational materials for the exhibition, but also, with the assistance of Katherine Tako, developed two exceptional teacher workshops for area educators. Finally, I would like to acknowledge the important contribution of our Financial Manager, Nancy McLain, who has, as always, managed our exhibition budget with efficiency and good cheer.

We have also been encouraged by the support for this project shown by members of the faculty and staff of Dartmouth College. In particular, I would like to thank Provost John Strohbehn and the members of the committee of the William and Flora Hewlett Foundation Presidential Venture Fund for their assistance with the development of the computerized educational program that was presented with the exhibition at the Hood Museum of Art. Credit for the design and development of this program belongs to three recent graduates of the College—Heidi Steinmetz, Justin Firestone, both of whom majored in Classics, and Tilmann Steinberg, a Computer Science major—and to Otmar Foelsche, Director of the College's Language Resource Center, who acted as an informal advisor throughout the process. We are grateful as well for the enthusiasm of several members of the Classics and Art History departments at Dartmouth for this project: Edward Bradley, Matthew Weincke, Ada Cohen and, most notably, Jeremy Rutter, who served as the faculty representative on our committee of consultants and as an advisor to the students working on the computerized education program and to the teacher workshops.

In her work on the exhibition and catalogue, Dr. Neils was generously assisted by a number of colleagues in the field who facilitated her personal study of objects in their care: Carmen Arnold-Biucchi, Curator of Greek Coins at The American Numismatic Society; Sandra Barghini, Curator of the Hearst Collection, San Simeon; David Gordon Mitten, James C. Loeb Professor of Classical Art and Archaeology and Curator of Ancient Art and Amy Brauer, Assistant Curator of Ancient Art, at the Harvard University Art Museums; Carol W. Campbell, Curator of Collections at Bryn Mawr College; Arielle Kozloff, Curator of Ancient Art at The Cleveland Museum of Art; Kurt Luckner, Curator of Ancient Art at the Toledo Museum of Art; Susan B. Matheson, Curator of Ancient Art at the Yale University Art Gallery; Margaret Mayo, Curator of Ancient Art at the Virginia Museum of Fine Arts; Joan Mertens, Curator of Greek and Roman Art at The Metropolitan Museum of Art; Anne Moore, Director of the Allen Memorial Art Museum, Oberlin College; Michael Padgett, Associate Curator of Ancient Art at The Art Museum, Princeton University; Ellen Reeder, Curator of Ancient Art at The Walters Art Gallery; Wolf Rudolph, Associate Professor of Classical Art and Archaeology at Indiana University, Bloomington; Gerry D. Scott, Curator of Ancient Art at the San Antonio Museum of Art; Marion True, Curator of Antiquities at The J. Paul Getty Museum; and Dyfri Williams, Curator of Greek and Roman Antiquities at the British Museum.

The following persons deserve special mention for advising Dr. Neils on various matters during the course of this project: Homer Thompson, of the Institute for Advanced Study in Princeton, New Jersey; Patricia N. Boulter; Kenneth Hamma, of The J. Paul Getty Museum; and Richard Hamilton, of Bryn Mawr College. The gracious hospitality shown by George Ortiz and Barbara and Larry Fleischman to Dr. Neils was also greatly ap-

preciated. We are also grateful to Suzanne Ferguson, Dean of the Humanities, Arts, and Social Sciences at Case Western Reserve University for generously granting Dr. Neils a special research leave to work on this project, and to several other staff members and students at the University who assisted her in various ways: Deborah Tenenbaum, Tamara Durn, and Panagiota Alexi-Mandralis.

Were it not for the generous financial assistance of the National Endowment for the Arts and the National Endowment for the Humanities, which provided funding for both the planning and implementation of the exhibition, we simply would not have been able to go forward with this project. We are grateful for the support of these two organizations which has made it possible to share our work with a large and diverse audience.

It has been a special pleasure to work with several talented professionals on the design and production of this catalogue. Our editor, Elizabeth Bobrick, strengthened the manuscript in a number of important ways and was primarily responsible for knitting the various essays together into a seamless whole. Mary Sherrell did an admirable job proofreading the galleys. We have also benefited from the expertise of Pat Appleton and Malcolm Grear, who provided the insightful and elegant design of this volume.

We are grateful as well to the many individuals and institutions who agreed to lend important objects from their collections for this exhibition. Their willingness to share these works with a broader public during a tour that will last some fourteen months represents a deep commitment to education and scholarship. I would also like to thank R. Andrew Maass of the Tampa Museum of Art, Katherine Lee of the Virginia Museum of Fine Arts, and Allen Rosenbaum of The Art Museum, Princeton University, for their interest in presenting this exhibition at their respective institutions.

It has been our pleasure to work with the splendid group of scholars who agreed to serve as consultants for this project. Without their wise counsel and appreciation of what we hoped to achieve in both the exhibition and catalogue, very little would have been accomplished. I would therefore like to express a special debt of gratitude to A. E. Raubitschek, Professor Emeritus of Humanities at Stanford University, E.J.W. Barber, Professor of Linguistics and Archaeology at Occidental College, Brunilde Sismondo Ridgway, Rhys Carpenter Professor of Classical and Near Eastern Archaeology at Bryn Mawr College, Donald G. Kyle, Associate Professor in History at the University of Texas at Arlington, and H. A. Shapiro, Associate Professor of Humanities at Stevens Institute of Technology, for the many ways in which they have helped us.

Lastly, we are deeply grateful to Jenifer Neils, Associate Professor of Art History at Case Western Reserve University, who initially proposed the exhibition to us and agreed to serve as guest curator. Having worked closely with Dr. Neils over the past four years, I have some small knowledge of the time she has spent on this project and the attention she has given to its every aspect. The success of the exhibition and this catalogue is due to her energy, dedication, and commitment to the project, and to her we owe our greatest thanks.

TIMOTHY RUB
Director
Hood Museum of Art, Dartmouth College

Preface

One of the finest objects in the collection of ancient art at Dartmouth College is a Panathenaic prize amphora decorated early in the fifth century in the workshop of the Athenian artist known as the Berlin Painter. One of eight surviving prize Panathenaics by this artist, it is the only example in an American museum. Donated to Dartmouth in 1959 by Mr. and Mrs. Ray Winfield Smith (Mr. Smith was a member of the Class of 1918), this gift encouraged the College to establish an annual prize in which this trophy from classical antiquity is symbolically "awarded" to that undergraduate who best exemplifies the four Greek criteria of excellence: intellectual achievement, character, leadership, and athletic prowess.

It was through a consideration of this object that we decided to organize a loan exhibition on the Panathenaia—or, more properly, on the Greater Panathenaia, the quadrennial festival for which prize amphoras such as this were produced in great number. In addition to their artistic merits, these vases convey a great deal of information about Athenian civilization in its prime, such as its devotion to the goddess Athena, its religious conservatism, and the competitive spirit of its citizens. We have also focused more broadly on the context of the festival, for the Panathenaia was, first and foremost, a civic event and can be properly understood only in relation to the development of the city and its political and religious institutions.

Fortunately, North American museums are particularly rich in objects relating to Athenian athletics, music, and religious rites, as well as in images of Athena. The seventy-one objects in this exhibition demonstrate the range of media in which Greek artists worked, from coins to monumental marble sculpture. The majority of works are Attic vases, which provide valuable contemporary pictorial evidence on a range of topics related to the Panathenaia. Since this festival was devoted to Athena, the exhibition also includes representations of the goddess from the sixth and fifth centuries, a period during which her image changed dramatically. Finally, we hope that the objects assembled here will not only demonstrate the consummate skill of Greek artisans, but also clarify the important relationship between art and cult in classical antiquity.

Another compelling reason to present an exhibition at this time is our current state of knowledge regarding Athenian religion, art, and history. The foundation for all subsequent studies of the Panathenaia resides in nineteenth-century German scholarship, in particular the pioneering work of August Mommsen, *Feste der Stadt Athen im Altertum* (1898). During the last sixty years, work in this area can be characterized by four basic approaches: the philological, the anthropological, the art historical, and the archaeological. Classicists such as Deubner (1932), Davison (1958) and Parke (1977), have continued Mommsen's work by collecting all surviving texts that deal with the festival, relating them to the extant visual material, and ultimately synthesizing this body of information into a plausible account of what constituted the Panathenaia, when and where it took place, and who participated. Given the incomplete and often late nature of the epigraphical evidence, this approach leaves some gaps in our understanding of the festival, in particular its origins. Adapting the methods of comparative anthropology, Walter Burkert and others (e.g. N. Robertson, 1985) have investigated the mythical past of the Panathenaia, and in so doing have helped explain the origins of many of its rituals. Works of art, either commissioned for the festival such as the prize vases, or representing some aspect of it, such as the Parthenon frieze, have been, and continue to be, analyzed

in order to shed light on various aspects of the Panathenaia. Since the earliest Panathenaic vase was discovered on May 16, 1813, these amphoras have been extensively catalogued (von Brauchitsch, 1910), dated (Smets, 1936; Edwards, 1957; Eschbach, 1987), attributed (Peters, 1942; Beazley, 1943; Brandt, 1978), measured (Vos, 1981), counted (Johnston, 1987), and analyzed (Tiverios, 1974, 1990; Hamilton, 1992). The Parthenon frieze, which is not a literal representation of the Panathenaic procession, has been subject to various interpretations, most recently that of John Boardman (1977) who suggests that it honors the 192 heroes of Marathon. The latest round of research on the Panathenaia has been more interdisciplinary, utilizing the methodologies mentioned above, but also bringing cultural and historical considerations to bear on the subject (e.g. Simon, 1983; Shapiro, 1989). More focused (and controversial) are the contributions of Pinney (1988), who interprets the Panathenaic Athena as dancing the pyrrhic in celebration of the gods' victory over the giants; Mansfield (1985), who uses literary evidence to argue that there were two different types of peploi presented to Athena on different occasions; and Osborne (1987), who believes that the frieze "presents the very aristocratic image of Athenian democracy at its most elitist." Given these new avenues of research and the extensive background and excellent scholarship, it seemed timely to devote an exhibition and catalogue to this topic.

This catalogue represents the collaborative efforts of scholars in different fields, but we have all tried to look at the evidence on our particular subject with fresh eyes. As organizer of the exhibition, I have written an introduction to the festival in which I attempt to sort out what we currently know about the Panathenaia, how it developed over time, and what specific effects it had on Athenians and the development of their art. My essay on the Panathenaic prize amphoras discusses the meaning of their imagery, how their shape, decoration, and inscriptions changed in spite of their conservative format, and the roles they played in Athenian craftsmanship, in the city's economy, and beyond as victory tokens. Alan Shapiro has compiled all the relevant vase-painting evidence to document the musical and rhapsodic contests held at the Greater Panathenaia. Donald Kyle, a historian of Greek sport, discusses the athletic and equestrian competitions of the Panathenaia in relation to the political development of Athens which evolved from tyranny to democracy in the period covered by the exhibition. Moving ahead from her recent book on Bronze Age textiles, Elizabeth Barber has dealt for the first time with the peplos from a technological point of view. In the final essay Brunilde Ridgway examines the various sculpted images of Athena in relation to cult and the topography of the Akropolis, incorporating many important new archaeological discoveries.

As the first book devoted exclusively to the Panathenaia, it is our hope that it will prove useful to scholars as well as students of ancient Greece, and thereby do some small honor to the goddess of wisdom herself.

JENIFER NEILS
Case Western Reserve University

JENIFER NEILS

The Panathenaia: An Introduction

As I said before, the Athenians are more devout about religion than anyone else.

Pausanias (I.24.3)

In defining their common brotherhood with other Greeks, the citizens of the ancient polis or city-state of Athens, according to the historian Herodotus (8.144.2), cited their shared language and "the altars and sacrifices of which we all partake"—in short, their common religion. To the ancient Greeks, organized religion focused neither on a sacred text like the Bible or Qur'an, nor on abstract dogmas and creeds, but rather was comprised principally of actions: rituals, festivals, processions, athletic contests, oracles, gift-giving, and animal sacrifices. It is not an exaggeration to say that festivals were the single most important feature of classical Greek religion in its public aspect, and nowhere more so than in classical Athens where 120 days—one-third of the calendar year—were devoted to festivals. These communal assemblies not only provided occasions for honoring the gods with gifts and sacrifices, but were equally regarded, in Aristotle's words (Nicomachean Ethics 8.9; 1060a), as "times of pleasant relaxation" in which men enjoyed feasting and entertainment, such as music, theater and games, and thereby a reprieve from the monotony of daily life.

The single most important festival celebrated in ancient Athens was the Panathenaia, the state festival honoring the city's patron deity, Athena Polias ("of the city"). In the earliest surviving reference to the city of Athens, the worship of the goddess Athena is already an established rite. Homer states in the Iliad (2.549–551) that there existed not only a rich temple of the goddess, but also an annual sacrifice of rams and bulls to her earth-born son Erechtheus. In historic times there were many festivals devoted to Athena throughout the year, but by far the most elaborate was the Panathenaia, celebrated annually but on a much greater scale every four years. These "Greater" Panathenaias included musical competitions, recitations of Homer's epic poetry, gymnastic and equestrian contests, events such as dancing in armor (*pyrrhike*), torch racing and a regatta in the harbor, as well as a long, colorful procession through the city to the goddess Athena's shrine on the Akropolis. The culmination of this spectacle was the presentation of a peplos, a richly woven robe, to the venerable cult statue of Athena, and the sacrifice of one hundred cows on her altar set aflame by the winning torch-bearer.

The origins and many of the events of this multi-faceted festival are still obscure despite nearly a century of scholarship dealing with the subject.[1] Here the Panathenaia will be considered from four different points of view in an attempt to achieve a comprehensive understanding of the festival and its impact on classical Athens. First we will consider the "facts" as established by ancient texts and artifacts. Then an attempt will be made to trace the historical development of the festival from its foundation in 566 to the end of the fifth century. How the festival affected the inhabitants of Athens and the surrounding territory of Attika will be considered next, and finally an assessment of the impact of this festival, which lasted until A.D. 410, on the cultural, and in particular the artistic, life of the city will be essayed.

8 Bronze statuette of Athena with an owl, mid-5th century

71 Marble relief with athletic trophies, 2nd century A.C.

"The Facts"

The so-called "facts" concerning the Panathenaia come from ancient literary sources, many of which are Hellenistic, Roman, or even Byzantine commentaries on classical texts and so considerably later than the period under consideration. The epigraphical evidence, consisting of inscriptions carved in stone, is closer in time but often fragmentary. Archaeological evidence is less factual but nonetheless important: topographical features like the Panathenaic Way, sculptural and vase-painting representations of the competitions and procession, and sculpted images of the goddess, often on a reduced scale, contribute to our fuller understanding of the festival. With the exception of the Panathenaic prize amphoras awarded to victorious athletes, none of the above is specifically labeled as pertaining to the festival. And many key elements of the cult, such as the perishable olive-wood statue or the elaborate robe woven for it, are forever lost. Nonetheless there are enough ancient references to the Panathenaia to give us a picture of its main components.

Festival Calendar

We know when the Panathenaia was celebrated. Although held annually, it was celebrated with special pomp every four years. Both inscriptions and texts distinguish between the "yearly" and the "great" festival. The earliest extant reference to the "great" Panathenaia appears on a fifth-century victor's monument found on the Akropolis. The wealthy Athenian Kallias lists his victories: one at Olympia, two at Delphi, five at Isthmia, four at Nemea, and one at Athens.[2] The first four constitute the *periodos* or "circuit games," all of which were held on a two- or four-year cycle, rather than annually. They are also known as *stephaniteis* or "crown" events, since the athletic victors received a wreath of olive, laurel, pine, and wild celery respectively. A relief of the Roman Imperial period (cat. 71) illustrates two of these wreaths along with a prize shield from the games at Argos, and a Panathenaic amphora. The victor, whose name is lost, was a son of Alexander and belonged to the Attic deme of Rhamnous. That these "crown" athletes enjoyed tremendous prestige in Athens is indicated by a law passed around 430 that entitled an Athenian victor at any one of these games to free meals at state expense for the rest of his life.[3] Since the quadrennial Olympic games were reputedly founded by 776, and were certainly the most prestigious in all of Greece, it seems likely that the four-year cycle of the Greater Panathenaia was modeled on this Panhellenic festival. The Athenian festival fell in the third year of each Olympiad, so, for instance, the Olympics of 500 were preceded by the Panathenaia of 502 and followed by that of 498.

The exact days on which the festival was celebrated are not altogether clear. We know that it took place in Hekatombaion, the first month of the Athenian calendar year, roughly approximating our month of July. According to two ancient sources, the main day of the festival was the "third from the end" of the month, or the 28th of Hekatombaion.[4] This day was traditionally thought to be Athena's birthday, although it could be that the third day of the month was also considered the

date of her birth, since all the other Olympian deities had their birthdays in the first ten days of the month (cat. 1).[5] One of her epithets is "Tritogeneia" which can mean either thrice-born or born on the third day of the month, counting from either end.[6]

The duration of the festival is not known precisely, although some ancient authors suggest three or four days.[7] A recent study of meeting dates in the Athenian calendar indicates that there were no sessions of the Ekklesia (Assembly) or Boulé (Council) on the last eight days of Hekatombaion. This evidence suggests that the Panathenaia regularly went from the 23rd to the 30th of Hekatombaion.[8] Although an eight-day festival may seem excessively long to us, it was not particularly lengthy for the Athenians, who celebrated two festivals of Dionysos (the Lenaia and the City Dionysia) for over a week each.

1 Detail of amphora with the birth of Athena, attributed to Group E, ca. 540

The Program

Given the number of musical, athletic, and equestrian contests which constituted the Panathenaic program, a week is not overly long. The individual events and their prizes are conveniently listed for us on an important early fourth-century inscription *IG* II² 2311 (fig. 1) which is broken in two and parts of which are missing.

The inscription makes it clear that there were two categories by age for musicians and three for athletes and pyrrhic dancers (men, beardless youths, and boys) as opposed to the two at Olympia. According to one scholar these age groups are: boys, 12–16; beardless youths or *ephebes*, 16–20; men, over 20.[9] Also, in contrast to Olympia, prizes were awarded to the runners-up. The missing portions of the stone probably included a listing of prizes for the rhapsodes who recited the *Iliad* and *Odyssey*, the men's events including long-distance races, the four-horse chariot-racers, and the contestants in the *apobates* event who leapt on and off a moving chariot, all of which are documented in other sources. A newly published inscription which preserves a remarkably complete record of the victors in the equestrian contests of three Greater Panathenaias (probably those of 170, 166 and 162) demonstrates that the equestrian program had considerably expanded in Hellenistic times.[10] It also gives a tantalizing suggestion regarding theatrical performances as a hitherto unknown part of the Panathenaia; if the text is restored correctly, these dramatic performances were staged for the first time in 162.[11] Using these inscriptions one can reasonably reconstruct a program as follows:

Day 1 Musical and Rhapsodic Contests
Day 2 Athletic Contests for Boys and Youths
Day 3 Athletic Contests for Men
Day 4 Equestrian Contests
Day 5 Tribal Contests
Day 6 Torch Race and *Pannychis*
 Procession and Sacrifice
Day 7 Apobates
 Boat Race
Day 8 Awarding of Prizes
 Feasting and Celebrations

This hypothetical reconstruction is based on the order of prizes as listed on the inscription *IG* II² 2311, and on the fact that the torch race and all-night revel (*pannychis*) should occur on the night before the procession to the Akropolis which began at sunrise on the 28th of Hekatombaion. We have no evidence for the timing of the awarding of prizes, although a number of vases show what looks to be a special ceremony for the proclamation

FIG. 1 Marble block with inscription *IG* II² 2311, ca. 370. Epigraphical Museum, Athens. Missing text is indicated by brackets in the translation below.

[Boy Kithara-players]
 [1st prize: crown]
 [2nd prize:]
 [3rd prize:]
Men Kithara-singers
 5 1st prize: gold crown worth
 1,000 drachmas and 500
 silver drachmas
 2nd prize: 1,200 drachmas
 3rd prize: 600 drachmas
 10 4th prize: 400 drachmas
 5th prize: 300 drachmas
Men Flute-singers
 1st prize: crown worth 300 drachmas
 2nd prize: 100 drachmas
 15 **Men Kithara-players**
 1st prize: crown worth 500 drachmas
 and 300 drachmas
 2nd prize: [200 drachmas]
 3rd prize: [100 drachmas]
 20 **Flute-players**
 1st prize: crown
 2nd prize:
 (lines missing on the stone)
Boys' Stadion
 1st prize: 50 amphoras of olive oil
 25 2nd prize: 10 amphoras of olive oil
Boys' Pentathlon
 1st prize: 30 amphoras of olive oil
 2nd prize: 6 amphoras of olive oil
Boys' Wrestling
 30 1st prize: 30 amphoras of olive oil
 2nd prize: 6 amphoras of olive oil
Boys' Boxing
 1st prize: 30 amphoras of olive oil
 2nd prize: 6 amphoras of olive oil

 35 **Boys' Pankration**
 1st prize: 40 amphoras of olive oil
 2nd prize: 8 amphoras of olive oil
Youths' Stadion
 1st prize: 60 amphoras of olive oil
 40 2nd prize: 12 amphoras of olive oil
Youths' Pentathlon
 1st prize: 40 amphoras of olive oil
 2nd prize: 8 amphoras of olive oil
Youths' Wrestling
 45 1st prize: 40 amphoras of olive oil
 2nd prize: 8 amphoras of olive oil
Youths' Boxing
 1st prize: [40 amphoras of olive oil]
 [2nd prize: 8 amphoras of olive oil]
[Youths' Pankration]
 1st prize: [50 amphoras of olive oil]
 [2nd prize: 10 amphoras of olive oil]
[Men's Stadion]
 [1st prize:]
 [2nd prize:]
[Men's Pentathlon]
 [1st prize:]
 [2nd prize:]
[Men's Wrestling]
 [1st prize:]
 [2nd prize:]
[Men's Boxing]
 [1st prize:]
 [2nd prize:]
[Men's Pankration]
 50 [1st prize:]
 [2nd prize:]
Two-horse Chariot Race (foals)
 1st prize: 40 amphoras of olive oil
 2nd prize: 8 amphoras of olive oil

 55 **Two-horse Chariot Race (full-grown)**
 1st prize: 140 amphoras of olive oil
 2nd prize: 40 amphoras of olive oil

Prizes for the Warriors

Horse Race
 60 1st prize: 16 amphoras of olive oil
 2nd prize: 4 amphoras of olive oil
Two-horse Chariot Race
 1st prize: 30 amphoras of olive oil
 2nd prize: 6 amphoras of olive oil
 65 **Two-horse Chariot Procession**
 1st prize: 4 amphoras of olive oil
 2nd prize: 1 amphora of olive oil
Javelin Throw on Horseback
 1st prize: 5 amphoras of olive oil
 70 2nd prize: 1 amphora of olive oil
Boys' Pyrrhic Dance
 100 drachmas and a bull
Youths' Pyrrhic Dance
 100 drachmas and a bull
Men's Pyrrhic Dance
 100 drachmas and a bull
Tribal Contest in Manly Excellence
 75 100 drachmas and a bull
Torch Race
 Winning Tribe: 100 drachmas and a bull
 Individual Victor: 30 drachmas and a hydria
Boat Race
 1st prize: 300 drachmas, 3 bulls, and
 200 free meals
 2nd prize: 200 drachmas and 2 bulls

 (rest of stone missing)

FIG. 2 Amphora showing the crowning of the victor, attributed to the Painter of Berlin 1686, ca. 540. Department of Anthropology, Smithsonian Institution, Washington, D.C., 136415

and crowning of the victor (fig. 2).[12] The feasting would naturally take place after the distribution of meat from the large sacrifice to Athena Polias following the presentation of the peplos.

Administration

Such a complex festival obviously required considerable preparation and adroit management. The best source for the administration of the festival is the fourth-century *Constitution of Athens* (60.1–3) where we learn that a group called the *athlothetai*, chosen by lot by the Boulé, one each from the ten tribes, "manage the procession of the Panathenaia, the musical and gymnastic contests, and the horse race; they arrange for the making of the peplos, and, in association with the Boulé, for the making of the vases; and they present the olive oil to the winning athletes." Their term of office was four years, but when it commenced is not known, although presumably directly after one Greater Panathenaia was completed.[13] We are informed later (*Constitution of Athens* 62.2) that the athlothetai were eligible to dine in the *prytaneion* (i.e. at public expense) during Hekatombaion, from the fourth of the month on. This perquisite indicates the weightiness of their responsibilities during the month of the festival.

Another group of officials concerned with the Panathenaia was the *hieropoioi* ("doers of sacred things"), two of whom are represented on a vase in Buffalo (cat. 55). In contrast to the more secular duties of the athlothetai, this group of ten appointed by the Boulé (*Constitution of Athens* 30.2) was in charge of the sacrifices offered at Athenian festivals. The *Constitution of Athens* 54.7 specifically excludes the Panathenaia from the list of quadrennial festivals administered by the hieropoioi, but earlier inscriptions cite them as ministrants of the Greater Panathenaia.[14] They, as a board of eight, are also mentioned on early sixth-century inscriptions found on the Akropolis. Here they are responsibile for the *agon* and the *dromos*, which have been interpreted as the sacred ceremonies and games respectively.[15] Sometime late in the fifth century, perhaps as a result of the expansion of the festival, their duties in regard to the Panathenaia were transferred to the athlothetai.[16]

That the organizers of the festival were not immune to graft and corruption is indicated in another passage of the *Constitution of Athens* (49.3). Here we learn that the Boulé, which used to judge the designs for the peplos but was found to show favor, had to be replaced in this function by a more impartial jury-court chosen by lot. The actual weaving of the peplos was entrusted to two groups of women, the *arrephoroi* and the *ergastinai*. Nine months before the Panathenaia, at the festival known as the Chalkeia which honored Athena as goddess of handicraft, the arrephoroi together with the priestesses of Athena set up the loom on which the peplos was to be woven. Ancient sources tell us that these four arrephoroi were girls between the ages of seven and ten selected on the basis of good birth. The ergastinai ("workers") were the matrons who actually did the weaving. It is surely this event which is depicted on the famous lekythos by the Amasis Painter (see p. 108, fig. 66), given the small size of the weavers and the religious procession to a seated goddess on the shoulder of the vase.[17] Once the peplos was completed, it was borne to the Akropolis and presented to the goddess by the Praxiergidai, a clan whose ancestral privileges included the washing of the cult statue and its garments.[18]

55 Lekythos with hieropoioi, attributed to the Athena Painter, ca. 500–480

Topography

The procession of the peplos took place on the Street of the Panathenaia, which served as the sacred way of ancient Athens.[19] Large sections of this roadway, parts of it paved in stone in Roman times, are still visible. It begins at the Dipylon Gate in the northwest part of the city at a building called the Pompeion, which served as a place of preparation for grand religious processions (*pompai*).[20] It passes through the district known as the Kerameikos, or potters' quarter, to the Agora, entering it at the northwest corner. From here it turns to the south and bisects the Agora diagonally (fig. 3). Outside the Agora it mounts the ever-steeper north slope of the Akropolis until it meets the lower end of the ramp leading eastward up to the Propylaia, a total distance of over one kilometer. As ancient Greek roads go, it was unusually wide (10–20 meters), no doubt in order to accommodate the festival procession which included chariots and cavalry.[21] Since it connects the early Iron Age cemetery outside the Dipylon Gate to the heart of the city, it is considered one of Athens' oldest roads. In Hellenistic times it was bordered with a stone gutter on the southwest side, and the Stoa of Attalos constructed ca. 150 would have provided an excellent view of the Panathenaic procession from its upper story and broad terrace. Thus the route of the procession may have had an important impact on the planning of the city since its inception.

This street is also referred to in ancient sources as the *dromos*, perhaps indicating its use as a racecourse. This function was confirmed in 1974 when five square limestone bases with a central socket were found spaced at regular intervals across the line of the Panathenaic Way at the northwest corner of the Agora (fig. 4). This row of bases resembles the starting line of a racetrack, and since there was space for ten runners, it may well have been used for tribal events during the second half of the fifth century, its period of use.[22] It was not until the later fourth century that Athens had a walled stadium with embankments on either side for the spectators. Ideally situated in a ravine east of the Akropolis, this stadium relocated the races away from the heart of the city, but certainly provided more space for and better viewing of the athletic contests. Originally built by Lykourgos for the Panathenaic festival of 330, this monumental structure was reconstructed in white marble by Herodes Atticus for the games of A.D. 144.[23] Today at the same location one sees a modern reconstruction of this stadium, completed for the revival of the Olympic Games in 1896.

That other spectator events took place in the Agora is indicated both by references to an "orchestra" or dancing ground in its center, and by the presence of large post-holes, indicating supports for wooden grandstands.[24] Known in the ancient sources as *ikria*, these stands are occasionally shown on Athenian vases which

FIG. 3 Plan of the Agora ca. 400

FIG. 4 Starting gates for Agora race track and postholes for ikria

FIG. 5 Dinos fragment with ikria by Sophilos, ca. 570. National Museum, Athens, 15499

depict contests in action (fig. 5). Timaios, a fourth-century A.C. lexicographer, defines the orchestra as "the central part of the theater, and also a splendid place for a festal gathering, where stood the images of Harmodios and Aristogeiton."[25] The mention of these statues, whose base has been excavated, places this orchestra in the middle of the open Agora. Here, no doubt, the musical and rhapsodic contests of the Panathenaia took place, in addition to the plays produced in honor of Dionysos. Perhaps not coincidentally the Romans built an *odeion* or music hall in exactly this spot in the first century. Like the athletic events, the musical contests were also eventually moved out of the Agora. In the later fifth century, Perikles undertook the building of an odeion on the south slope of the Akropolis. Little remains today of this large (62 x 68 m.), roughly square concert hall except part of its north wall and some column bases which supported its roof, so we can say little of its actual appearance.[26] However, Classical vase-paintings often depict musicians performing in colonnaded structures which we may perhaps take to be the Odeion of Perikles.

Even more elusive is the location of the hippodrome, the site of the equestrian contests, which is first mentioned by Xenophon (*Hipparchicus*, 3.1). Since it presumably consisted of a broad open field, eight stades in length, no archaeological remains are likely. Ancient sources indicate that it was located to the southwest of the city in the area now called New Phaleron.[27] Monuments celebrating victories in equestrian contests were set up in the Agora along the Panathenaic Way, but their presence does not necessarily indicate that most contests took place here. This major artery was simply a conspicuous setting for commemorative monuments.[28] However, two inscriptions may indicate that the age-old apobates contest was performed along the dromos of the Agora, since we are told in a second-century inscription that the riders dismounted at the Eleusinion, a shrine at the southeast corner of the Agora where the ascent to the Akropolis begins.[29] It has been suggested that hippic perfomances such as these, in which a contestant jumps on and off a moving war chariot, recalled Homeric practices, and as such may be connected with hero shrines in the Agora associated with tombs dating back to the Mycenaean period.[30]

Historical Development of the Festival

Given this probable association of athletic and equestrian contests with rites for the heroized dead, it is not surprising that the apobates contest remained in the Agora when the other equestrian contests were relocated. This relationship can be traced back to Homer's account of the funeral games conducted by Achilles in honor of his slain friend Patroklos (*Iliad* 23.257–897). These *agones*, or contests, consisted of chariot racing (clearly the most important contest, since nearly 400 lines are devoted to it), boxing, wrestling, footrace, close combat, hurling iron (discus?), archery, and spear throwing. Of these contests only combat and archery, specialized events most resembling warfare, did not become part of the historic Greek games. Like the Agora with its Bronze Age tombs, three of the four Panhellenic sanctuaries contained tombs of the heroes in whose honor the games had been founded: Pelops at Olympia, Opheltes at Nemea, and Palaimon at Isthmia. But despite the presence of early tombs under the Classical levels of the Agora, there is no likely candidate for such a foundation.

We have evidence of agonistic competitions in contexts other than civic or Panhellenic games. Herodotus (6.126–130) tells a story of thirteen distinguished suitors who competed for the hand of Agariste, daughter of Kleisthenes, ruler of Sikyon in the early sixth century. In addition to the athletic events for which Kleisthenes built a racetrack and *palaestra*, the suitors competed in music and rhetoric. An Athenian, Hippokleides, was the frontrunner until he performed an obscene dance and forfeited the bride to his fellow Athenian Megakles. The mention of Hippokleides is particularly interesting because it was during his archonship (566/5) that the athletic games of the Panathenaia were established.[31] Clearly such friendly competitions were fashionable in the early sixth century, and the recently founded festivals at Delphi (582), Isthmia (581), and Nemea (573) may also have inspired the Athenians to add athletic contests to their local festival of Athena. Another ancient source credits the institution of the Greater Panathenaia to the tyrant Peisistratos, although he had not yet gained power in 566.[32] It is possible to reconcile these two accounts by postulating that

FIG. 6 Oinochoe with Athena and charioteer, ca. 510. The Department of Near Eastern and Classical Antiquities, The National Museum, Denmark, Chr. VIII.340

FIG. 7 Calyx-krater with Athena in potters' workshop, ca. 460. Museo della Ceramica, Caltagirone, Italy

while Hippokleides was archon, Peisistratos added gymnastic events to be held every four years to the more modest annual festival. This would have been a popular tactic which may have subsequently helped him usurp the tyranny of Athens in 561/60.

In any case the historic founder or reorganizer of the Panathenaia was not as important to ancient Athenians as the mythic founders. Ancient testimonia about them, while anachronistic, do reveal information about the earlier, pre–566 festival. For instance, Plutarch (*Life of Theseus* 24.3–4) credits the city's most renowned hero Theseus with the establishment of a "Pan-Athenaic" festival as a ceremony for all the people of Attika. This suggests that the original celebration may have been smaller in scale and geographically limited to the city of Athens, but was then later extended to all of Attika. Many ancient sources state that it was the earth-born king Erichthonios, son of Hephaistos and Ge (Earth), who initially founded the Panathenaia.[33] After having been reared by Athena on the Akropolis, he held games for his foster-mother and competed in the chariot race, which he reputedly invented (fig. 6).[34] Thus, the aristocratic equestrian contests probably preceded the more democratic athletic competitions, which did not involve the costs of owning and maintaining horses and elaborate equipment.

The character of Athena no doubt dictated many of the original aspects of the Panathenaia, although some scholars have assigned them to other sources: a celebration of the divine child Erechtheus, the Attic king after whom the classical temple of Athena Polias, the Erechtheion, is named; or to a harvest or New Year's festival.[35] Athena is first and foremost a martial deity, and thus armed footraces (*hoplitodromos*) and dances (*pyrrhike*) are appropriate to her worship. As a goddess of handicraft (Athena Ergane), she would oversee potters (fig. 7) and woolworkers; thus, the Panathenaic prize amphoras and the festival peplos are specifically suited to her character. Likewise the prize, olive oil, comes directly under her jurisdiction since the trees that produced it were her gift to the city in her contest with Poseidon. Athena is also associated with music, for according to Greek poets, she was the creator of the first *aulos* or double pipes. Just as Apollo, the god of the lyre, was honored with musical contests at his festival at Delphi, so Athena would have received homage with music early on, as perhaps indicated by a "proto-Panathenaic" vase in Athens of ca. 570 which depicts a flute-player on one side and a jockey on the other (see p. 64, fig. 41).[36] In terms of athletics Athena is known to intervene directly in contests on behalf of her favorite heroes, such as Diomedes in the chariot race (*Iliad* 23.388–406), and Odysseus in the

FIG. 8 Panathenaic-shaped amphora showing Athena with stylus, attributed to the Triptolemos Painter, ca. 470. Staatliche Antikensammlungen und Glyptothek, Munich, 2314

FIG. 9 Chous with Athena making clay horse, name-vase of the Group of Berlin 2415, ca. 470. Antikenmuseum, Berlin, F 2415

footrace (*Iliad* 23.770–783). In the *Odyssey* (8.193–195) Athena herself, disguised as a spectator, marks the length of Odysseus' discus throw at the Phaeacian games. On a red-figure vase of Panathenaic shape in Munich (fig. 8) she is shown, stylus and writing tablet in hand, recording the score of an athlete on the other side.[37] Given Athena's strong association with horses—she is said to have taught the Athenians horsemanship and to have helped build the Trojan horse (fig. 9)—we may safely assume that equestrian events were an integral part of the festival in its earliest form.[38]

Other elements of the Panathenaia are clearly much later additions motivated by political developments in Athens or influenced by events taking place in the greater Greek sphere. For instance, the tribal competitions certainly do not predate the democratic reforms of Kleisthenes carried out after the expulsion of the tyrants in 510, in which the citizenry of Attika was divided into ten tribes based on geography rather than wealth. The advent of a new equestrian contest, throwing javelins at a target from horseback (see p. 94, fig. 60), which first appears in Athenian art at the end of the fifth century, was perhaps motivated by the development of the Athenian cavalry at this time.[39] The institution of the ship-cart as a vehicle to both convey and display the peplos on its way from the Pompeion to the slopes of the Akropolis seems to occur in the late-fourth century possibly as a gift of a Hellenistic monarch to the city.[40] Prizes change as well. In Aristotle's time, winners of the *euandria*, the contest of "manly excellence," won shields, whereas the fourth-century inscription *IG* II² 2311 tells us that the winning team was awarded an ox and 100 drachmas.

Eminent Athenian leaders also influenced the festival from time to time. We have already noted that the sixth-century tyrant Peisistratos may have had a hand in the founding of the Greater Panathenaia.[41] The tyrant's son and successor Hipparchos is said to have established the rules for rhapsodic contests in which the *Iliad* and *Odyssey* were recited from memory.[42] We also learn in Plutarch's *Life of Perikles* (13) that this fifth-century leader introduced musical competitions, but the earlier vase-painting evidence contradicts this assertion (see p. 57). However, Perikles' interest in musical performances is indicated by his construction of the Odeion, as mentioned above. Festivals like the Panathenaia, which involved so much of the voting populace and large public expenditures, would have been of keen interest to Athenian politicians, and could be exploited for political ends, just as later Roman emperors benefited from "bread and circuses."

FIG. 10 Parthenon frieze: thallophoroi. Courtesy Alison Frantz

FIG. 11 Parthenon frieze: skaphephoroi. Courtesy Alison Frantz

Festival and Polis

The Panathenaia, by all accounts, was a remarkable public spectacle, even in ancient Greece where elaborate religious ceremonies were frequent occurrences. With its importance and grandeur, it touched the lives of every Athenian, male and female, young and old, rich and poor, citizen and metic alike. While victory records show that the competitors in the athletic and equestrian events came mostly from the old aristocratic families of Athens,[43] and team sports were limited to male citizens, the majority of the population was represented in the great procession. Old men, for instance, chosen for their good looks, were appointed *thallophoroi* (fig. 10), i.e. bearers of green branches (presumably olive). The metics, or resident non-citizens, who nonetheless could be quite wealthy and prominent, took part in the procession as *skaphephoroi* (fig. 11): dressed in special purple robes, they bore bronze or silver trays filled with offerings of cakes and honeycombs. The daughters of metics carried hydrias filled with water. One ancient reference tells us that "the freed slaves and other barbarians" (i.e. non-Greeks) carried oak branches in the procession. The allies of Athens under the Athenian empire also participated by sending offerings of cows and armor.

Perhaps the greatest impact of the Panathenaia was felt by the women of Athens since it was a festival in which they played a major role. Greek women generally led sequestered lives indoors with only occasional trips to the fountain house to fetch water or to the gravesite to mourn the dead. A conventional character of Attic comedy was the rural maiden who only got to Athens to see the peplos. In Aristophanes' *Lysistrata* (lines 641–647) the women of the chorus say:

> When I was seven, I was *arrephoros*. At ten I made cake for Athena's offering, and wore the saffron to be a bear for Artemis of Brauron. And once as a fair young girl, I was *kanephoros* . . .
>
> (trans. D. M. Lewis)

If this roster of offices is typical, then Athenian girls moved up from behind-the-scenes preparation for the festival to actual participation in the procession, as we see so vividly on the Parthenon frieze (fig. 12).

The ceremonies involved primarily aristocratic women. The most prestigious function was that of the priestess of Athena Polias, an office held for life and passed through the female line of the aristocratic clan known as the Eteoboutadai. In the distant past this of-

FIG. 12 Parthenon frieze: maidens. Courtesy Alison Frantz

fice would have been held by the king's daughter, and the Eteoboutadai claimed to be the direct descendants of the Athenian royal family. The women involved with the weaving of the peplos mentioned above, as well as the *aletrides*, the women who prepared the offering cakes for the sacrifice to Athena Polias, were all of noble birth.

The story recorded by Thukydides (6.56–57) about a would-be *kanephoros* demonstrates how the Panathenaic festival provided opportunities for the venting of personal and political hostilities. In order to insult the youth Harmodios who had rejected his sexual advances, the tyrant Hipparchos invited Harmodios' sister to be a basket-bearer in the Panathenaic procession of 514, which he and his brother Hippias were marshalling. When she arrived, they claimed she was unfit to be in the procession, i.e. they implied that she was not a virgin.[44] Harmodios and his lover Aristogeiton, taking advantage of the opportunity provided by the Panathenaia to carry weapons without exciting suspicion, avenged this outrage by murdering Hipparchos, a scene depicted on a red-figure stamnos in Würzburg (fig. 13).[45] The general confusion attendant to any major festival would have facilitated the murder in spite of the fact that Hipparchos had a personal bodyguard.

Perhaps the highlight of the festival for the general populace came immediately following the sacrifice: after giving the bones and fat to the gods, they feasted on the roasted flesh of the victims (cat. 54). Festivals were the main occasions when Athenians dined on meat. In the Lesser Panathenaia over a hundred sheep and cows were slaughtered at the main altar of Athena on the Akropolis, and the meat was subsequently distributed in the city.[46] Given this excess of meat it is not surprising that in Aristophanes' *Clouds* (lines 386–87) Sokrates associates the Panathenaia with indigestion. Some critics charged that the great state festivals were put on less for religious reasons than to satisfy the public's craving for roast meat.

Clearly the Panathenaia served many appetites, whether those for colorful spectacle, athletic prowess, music and poetry, religious fervor, or simply food. In its fullest flowering it was a festival calculated to appeal to all levels of society, and to involve as many as possible in the worship of the city's chief deity.

The Panathenaia and Athenian Art

It is not easy to assess the impact of the festival on the visual arts of Athens, although artists could not have been immune to this colorful and action-filled display. The prize vases and their imitations, discussed in the next

FIG. 13 Stamnos with scene of Tyrannicides, attributed to the Copenhagen Painter, ca. 470. Martin von Wagner Museum, University of Würzburg, L 515

54 Column-krater with a scene of sacrifice, attributed to a follower of the Pan Painter, ca. 460

essay, certainly depict Panathenaic contests, but in the case of other vase shapes it is difficult to distinguish generic scenes of sport and music from those pertaining to this, or other festivals. Tribal victories were occasionally commemorated in relief sculptures set up along the Panathenaic Way (see p. 90, fig. 57). But other than these, no Athenian monuments are specifically labeled as pertaining to Athena's festival. Of the numerous, mostly black-figure scenes of sacrifice to Athena, only one shows the peplos, the *sine qua non* of the Panathenaia, being brought to the goddess (fig. 14).[47] The Panathenaic Athena on the obverse of the prize vases might well be a statue on the Akropolis closely associated with the competitions, but not all scholars accept this interpretation. Even the sculpted frieze of the Parthenon, which is generally thought to represent the Panathenaic procession, is not without problems of interpretation.

Set up high on the temple's wall and spanning both porches, the Parthenon frieze depicts two files of figures which meet over the east entrance to the cella.[48] These include numerous knights on horseback, charioteers, older men, musicians, pitcher-bearers (fig. 15), sacrificial beasts (fig. 16), young women with libation equipment, and ten men who may represent the eponymous heroes of the ten Attic tribes, or as recently suggested, the athlothetai (fig. 17).[49] This procession moves on the east

FIG. 14 Panathenaic-shaped amphora showing a girl possibly carrying a peplos on her head, attributed to the Princeton Painter, ca. 550–540. The Metropolitan Museum of Art, New York, Rogers Fund, 1953, 53.11.1

FIG. 15 Parthenon frieze: pitcher-bearers. Courtesy Alison Frantz

FIG. 16 Parthenon frieze: sacrificial ewes. Courtesy Alison Frantz

frieze into the presence of an assembly of seated gods, the twelve Olympians, who are larger in scale. In the midst of the gods is a group of five human-sized figures engaged in the prosaic task of folding a piece of cloth (see p. 113, fig. 72). Because this scene holds the most prominent place on the frieze, the cloth is surely the peplos presented to Athena, albeit to her cult statue housed in another temple, the Erechtheion. While the priest, the Archon Basileus, folds the robe with the help of a young assistant, possibly one of the arrephoroi,[50] the priestess of Athena Polias is receiving two *diphrophoroi*, or stool-bearers. If the cloth is the peplos, then the procession must be that which brings it to the Akropolis. To us, the scene may come as an anti-climax after the drama of the cavalcade and the beauty of the draped figures, but it was the raison d'etre of the procession as well as the high point of the festival.

Even this, the most famous monument associated with the Panathenaia, presents many problems of identification and interpretation. Because of some unusual elements in the frieze, not all scholars believe that it actually depicts the historical procession. The two most problematic features are (1) the presence of human, as opposed to divine or heroic, activity in the sculptural program of a temple, and (2) the close juxtaposition of Athenian mortals with Olympian deities. Ingenious explanations have been offered to resolve these anomalies, the most convincing of which is that these male Athenians are none other than the heroes of Marathon celebrating the Greater Panathenaia of 480 just before the famous battle with the Persians in which they fell.[51] Certainly a procession into the presence of the august Olympians implies an apotheosis, as Boardman suggests, but there is no reason to view these celebrants as any other than idealized Athenians. Since the residents of this polis were entirely capable of fabricating myths to glorify themselves—such as Athena accompanying Peisistratos in his take-over of the Akropolis, a *heptathlos* for their local Theseus in order to rival Herakles, or the epiphany of long-dead heroes at the battle of Marathon—there is no reason they should not also elevate themselves to the level of heroes on the walls of their new temple. The frieze not only depicts the citizenry of Athens—and notably excludes the foreign delegations—in a mode of great piety, but also raises them above the level of ordinary humanity to the sphere of the gods.

Since the Parthenon sculptures are among the first manifestations of the high Classical style in Greek art, it is interesting to speculate to what extent the new style may have been developed specifically to reinforce this glorification of Athens.[52] In terms of style the frieze exhibits a puzzling dichotomy: a uniformity of facial

FIG. 17 Parthenon frieze: eponymous heroes or festival officials. Courtesy Alison Frantz

FIG. 18 Parthenon frieze: knights. Courtesy Alison Frantz

type combined with great diversity of pose and garb. The knights who occupy the bulk of the procession (fig. 18; cat. 51) are unexpressive, idealized types representing the Athenian polis or citizen body as a whole. Yet in their variety of poses, dress, and headgear they also appear as contemporary Athenians arrayed according to their individual tribes. This new Classical style thus ably serves to depict the body politic as at once both human and semidivine. While the pediments honor Athena, and the metopes celebrate heroic combat, the frieze tucked away behind the colonnade pays homage to the *arete* ("valor") of the citizens of Athens.

Athena's primary festival, the Panathenaia, was one of the high points of civic and religious life in classical Athens. In its inclusiveness it exemplified the city's participatory democracy; in its contests it demonstrated the competitive spirit of its people; with its prizes it displayed the skills of its artisans and the wealth of its produce; and above all, it celebrated Athena as the divine protectress of a glorious city.

51 Pelike with knight on horseback, attributed to the Westreenen Painter, ca. 430

JENIFER NEILS

Panathenaic Amphoras: Their Meaning, Makers, and Markets

Around the time of Homer in the mid-eighth century, an Athenian scratched a row of letters on the shoulder of an ordinary terracotta wine jug. One of the earliest extant inscriptions in Greek, it can be read as follows: "Whoever of all the dancers dances most spiritedly, let him receive this."[1] The prize in the dancing contest was the jug itself, perhaps filled with wine. Although simply decorated in the Geometric style, this pitcher (oinochoe) nonetheless must have been a prized possession, for it accompanied its owner to the grave. Two hundred years later, the Athenians would still be awarding vases, now considerably larger and filled with olive oil, as prizes in competitions, held every four years in honor of their patron deity, the goddess Athena. And the earliest surviving example was once again found in an Athenian grave. It was discovered in 1813 by the English merchant Thomas Burgon in a tomb near the Acharnian gate in Athens, and is now housed in the British Museum (fig. 19, for reverse see p. 93, fig. 59).[2] In ancient Greek culture there was a long-standing tradition of awarding prizes in recognition of physical prowess as demonstrated in contests with peers. Whether women or cattle, humble ceramic jars or exquisitely wrought silver and gold vessels, these prizes were cherished by their owners as lasting symbols of their excellence and glorious deeds (*arete*).

Another way to immortalize one's athletic prowess was to commission from a professional poet a commemorative ode (*epinikion*) which would be sung publicly in exaltation of the victor. The best known ancient author of such *epinikia* is the Greek poet Pindar, who was active in the early fifth century. Although Greek vases are rarely mentioned in ancient literature, in his tenth Nemean Ode Pindar praises an athlete from Argos as follows:

I sing that which is known to God and all who strive on the heights for the uttermost prizes. . . . twice before in their ceremonies the Athenian voices have risen in sweetness to acclaim him; and in earth burnt by fire and the keeping of figured vessels the olive's yield has come to Hera's land [Argos] of brave men.

(lines 31–36; trans. R. Lattimore)

These decorated earthenware containers of olive oil of which Pindar speaks are clearly the prize amphoras awarded to victors in the Panathenaic Games.

Since this ode is dated to ca. 460, and since the Argive was a wrestler, Pindar may have been thinking of a vase such as this one in the Hood Museum of Art (cat. 39), a typical Panathenaic prize amphora. On one side, denoted as the "obverse," it depicts the goddess Athena standing between two Doric columns surmounted by cocks, and on the other (the "reverse") we see the the event—wrestling in this case—for which the vase and its contents were the prize. It is officially designated as a prize vase by the inscription TON ATHENETHEN ATHLON ("from the games at Athens") which appears vertically in front of the Athena. This vase, along with approximately 300 other extant examples, represents a unique class of Greek pottery, distinguished by shape, decoration, size, and official inscription. These vases were produced in quantity every four years for the Greater Panathenaic festival by some of the finest potters and painters of the Athenian potters' quarter, the Kerameikos. Filled with oil from the olive trees sacred to Athena by officials of the festival, they returned home with the victorious athletes. In this manner many found their way to the far reaches of the Mediterranean from Marseilles to the Black Sea, where they have been uncovered in modern times.[3]

39 Panathenaic prize amphora (obverse), attributed to the Berlin Painter, ca. 480–470

39 Panathenaic prize amphora (reverse), attributed to the Berlin Painter, ca. 480–470

FIG. 19 Burgon Panathenaic prize amphora (obverse), ca. 560. British Museum, London, B 130

Obverse Decoration

At countless excavations around the Mediterranean and beyond, fragments of Panathenaic amphoras are readily identifiable, primarily on the basis of technique. Since the black-figure technique, in which the figures rendered in black slip contrast with the reddish-orange background, ceased being used for large vases by the mid-fifth century, and since smaller-scale imitations (to be discussed below) end in the early fifth century, any sherds painted in this technique from later contexts can be assumed to be Panathenaics. Also, because of religious conservatism, the imagery on the obverse remained more or less unchanged over the many centuries of its existence, and so it can be readily identified, even on the smallest sherd.

As many scholars have noted, the canonical obverse decoration appears first on a prize amphora of ca. 540 by the artist Exekias (figs. 20 and 22).[4] The warrior goddess Athena striding to the left, prize inscription, and a pair of Doric columns surmounted by cocks constitute the essential figurative elements. Subsidiary ornament consists of a double lotus-and-palmette chain at the neck, a band of alternating black and red tongues on the shoulder, and short, black rays at the base. This scheme of ornamentation had appeared earlier on a Panathenaic amphora by the vase-painter Lydos, but this vase, and all other prize vases before 540, lack cock columns.[5] The neck ornament can vary considerably before 540, ranging from the siren and owl of the Burgon amphora (fig. 19) to the palmette-lotus cross of a vase signed by Nikias (see below figs. 27a, b).[6] Once established, the ornament becomes progressively more attenuated: by the end of the fifth century the tongues have nearly doubled in height, and the palmette-lotus chain is thin and spidery (cat. 25).

The pose and proportions of Athena change as well. On Exekias' vase the goddess' rear heel is ever so slightly raised off the ground; this is a departure from her predecessors, who, like the Burgon Athena, stand flat-footed. Just as the vases themselves increase in height, so the early stocky Athenas become taller and high-waisted during the sixth century, striding ever more actively forward, until in the fifth century only the ball of her rear foot touches the ground. Late fifth-century Athenas are nearly all skirt, having become highly stylized in what is now an archaistic, or deliberately old-fashioned, mode of painting. In the archonship of Pythodelos (336/5), the

FIG. 20 Panathenaic prize amphora, attributed to Exekias (obverse), ca 540. Badisches Landesmuseum, Karlsruhe, 65.45

FIG. 21 Detail of the shield device of Athena on Panathenaic prize amphora, attributed to the Berlin Painter. Badisches Landesmuseum, Karlsruhe 69.65

statuesque pose returns briefly with a hobble-skirted Athena who stands at attention, feet together. The most noticeable change in pose occurs in the second quarter of the fourth century, when Athena turns to face the right-hand column.[7] Her shield, shown in profile and foreshortened, gives the image greater depth than it had previously, and this desire for increased three-dimensionality may have been the impetus for the change in pose. A late fifth-century prize amphora in Marseilles foreshadows this change in direction, for it depicts Athena moving to the left but with her head turned back to the right.[8] This pose is awkward to say the least, and so may have prompted artists to complete the goddess' about-face.

In the sixth and fifth centuries, the major variations on the obverses of prize amphoras occur in the garb of Athena and her shield device. The latter (fig. 21) are applied in added white over the black slip of the shield and encircled by the incised rim, which is banded with added red or a row of red dots on most Archaic vases. In the sixth century, the devices include stars, leaves, three pellets, a tripod, single leg, *triskeles*, satyr, centaur, sphinx, birds, the foreparts of animals (lion, panther, bull, horse), wolf, goat, two horses rearing, panther attacking stag, fish, and one or two dolphins.[9] Other than the horse-head, which could refer to equestrian contests, and the tripod, a traditional prize in competitions, these devices make no reference to the Panathenaia, or to Athena, and seem to be at the whim of the particular painter. It is only with the Euphiletos Painter's vases that one encounters more apt devices like the chariot wheel, cock, and gorgoneion (gorgon-mask which is the centerpiece of Athena's aegis), and later with the Painter of the Havana Owl, who, as his name implies, used the owl on a twig exclusively as Athena's shield device.[10] In the early fifth century artists are much more consistent: the Kleophrades Painter with his pegasos; the Berlin Painter, and his pupil the Achilles Painter, with the gorgoneion. So consistent, in fact, that scholars have suggested that the blazon is a trade-mark of that potter's workshop. We shall return to a consideration of the relationship of shield device and workshop when dealing with individual painters.

One of the most interesting and clearly politically motivated shield devices appears at the end of the fifth century: the statue group of the Tyrannicides which stood along the Panathenaic Way in the Agora and celebrated the murder of Hipparchos by Harmodios and

Aristogeiton in 514.[11] The three examples that are preserved have been dated to 403, because this was the year in which another tyranny, that of Sparta over Athens, was overthrown.[12] Thereafter the most common shield device is a painted or incised star, and by 360/59 the devices cease because the goddess changes position and the front of her shield is no longer visible.

Variations in the rest of Athena's armor and her dress are equally numerous, especially in the sixth century. At first Athena's helmet is a simple skullcap with tall crest. Exekias may be responsible for adding cheek-guards, and thereafter Athena is regularly given the Attic helmet. Occasionally the helmet is crowned with a wreath or red fillet.[13] In the fourth century, the crest-holder is elaborated into an *s*-shaped curlicue, and, a second-century Panathenaic amphora Athena wears what Beazley has called "a baroque Corinthian helmet."[14] Her other accoutrements include the spear which passes along the far side of her face, and jewelry in the form of button earrings and a spiral bracelet on her raised right arm.

In the sixth century, Athena wears the Doric peplos whose ornamentation, like the shield devices, is as various as the artists who paint these vases. The overfold and hem regularly receive decorative borders, and occasionally there is a central, vertical stripe, known as the *paryphe*, which is also decorated.[15] Again Exekias (see fig. 20) is innovative in giving the skirt an overall pattern, and it is such textile patterns or folds radiating from the waist which will occupy artists for the remainder of this century and the next. At the end of the sixth century, an alternate dress appears, the sleeved chiton, and from the Berlin Painter on it becomes the standard garb of the Panathenaic Athena.[16] An additional overgarment, the *ependytes*, appears in the early fifth century. This resembles a flat apron from which the folds of the longer chiton radiate, and in a few instances the ependytes itself has folds.[17] Finally, in the second quarter of the fourth century, the goddess acquires a long black shawl which she wears looped over both arms. Its archaistic swallow-tail folds echo those of her skirt.

The most distinctive attribute of Athena is her aegis, the scaly snake-fringed cloak which she received as protective armor from Zeus. At first it is indicated by three or four curled snakes emerging from behind her back,

25 Detail of column figure on Panathenaic prize amphora, attributed to the Asteios Group, 392/1

their heads shown frontally. By ca. 530 the snakes are shown in profile, tongues protruding, and bodies interwoven along the outer edge of the aegis. Initially, her bodice is squared and painted red, with a decorative border, but by ca. 540 the edge is curved and the surface decorated, appropriately with scales in the case of Exekias and the Euphiletos Painter. In one instance the scales migrate to the skirt of her peplos.[18] What one misses of course, since Athena is posed with her back to the viewer, is the gorgoneion, which is traditionally the focal point of her aegis. When Athena changes direction and it does appear, seemingly replacing the snakes, it has lost all its traditional monstrous effect, having been reduced to a mere clasp on the goddess' chest.

The other element of the obverse decoration, the cock columns, changes little during the sixth and fifth centuries. They, like the vase form itself, simply become taller and thinner with time. At the end of the fifth century, the column acquires a base which is inappropriate for the Doric order. One, and possibly two, sixth-century Panathenaics substitute Ionic columns without bases, and in the earlier fourth century we find a capital decorated with acanthus leaves, and even an acanthus column.[19] Again fourth-century Panathenaics show a momentous change: the cocks are replaced by statue groups in the first decade of the century (cat. 25, detail).[20]

25 Panathenaic prize amphora (obverse), attributed to the Asteios Group, 392/1

These include gods (Athena, Zeus, Demeter and Persephone, Aphrodite and Eros, Hades), heroes (Herakles, Triptolemos, Greek versus Amazon) and personifications (Nike/Victory, Eirene/Peace with baby Ploutos/Wealth, Tyche/Fortune). These appear to be intimately connected with the annual or eponymous archon since they change from year to year, as does the inscribed archon's name. The first to appear, a Nike, may have been inspired by the Athena Parthenos of Pheidias, which holds a winged Victory in her right hand (see p. 133, fig. 84), but the original idea of depicting statuary on Panathenaics may have been prompted by the Tyrannicides shield device of 403, if not from the Athena herself. This relationship of the Panathenaic Athena and statuary will be explored further when considering the meaning of the obverse decoration.

39 Panathenaic prize amphora (side view), attributed to the Berlin Painter, ca. 480–470

Reverse Decoration

The other side of the Panathenaic prize amphora is devoted to the athletic or equestrian contest for which the vase and its contents were the award. This side differs in some fundamental ways from the obverse. First, the reserved panel is smaller, since it does not extend all the way up to the level of the shoulder tongues; a strip of black intervenes between tongues and panel (cat. 39, side view). Second, the figural decoration keeps abreast of developments in Greek draftsmanship, unlike the Athena who retains her archaic style. For instance, in the fifth century, athletes show greater movement, realism in their musculature, and three-dimensionality through the use of foreshortening. Third, there is considerable variation among the scenes in terms of number of contestants, subsidiary figures, timing and direction of action, poses, and equipment. Since the artists were not constrained from representing the event as realistically as they desired, it is these scenes that tell us the most about the Panathenaic contests: what they were, when they were introduced into the festival, and how they were conducted.

In the sixth century, the earliest and the majority of extant prize vases (36%) depict the footrace. The runners, whose number can vary from three to five, include men and boys. Their limbs are posed differently depending on the length of the race (arms bent and held close to the body in the long race, spread out in the sprint), but all move to the right (this in contrast to another group of contestants, the *hoplitodromoi*, who run to the left in order to show off their shield devices [21]). In the fifth century, there is greater variety in the depiction of the footrace, with runners sometimes dashing to the left, and the occasional presence of a large basket of sand for the racetrack.[22] Only once is the turning post represented (see p. 84, cat. 24), appropriately, in the scene of a long race.[23]

Prize vases for equestrian events account for another third of extant sixth- and fifth-century Panathenaics. Earliest is the so-called *synoris*, the two-horse cart race, which decorated the reverse of the Burgon amphora (see p. 93, fig. 59). The scene appears twice again on two early fifth-century amphoras from the workshop of the Kleophrades Painter; here, however, one of the teams consists of mules.[24] Quadrigas or four-horse chariots are much more common and the event is fairly standardized (see cat. 45). The horses are posed rearing to the right, front legs grazing the edge of the panel and rear legs planted firmly on the ground. Two vases of the Leagros Group, however, show the chariot wheeling around, a favored composition on other vases from this work-

shop.[25] The charioteer, usually dressed in a long white chiton, holds a goad or *kentron* as well as the reins. On the Burgon amphora, in addition to a goad, the driver holds a long stick with a rattle-like device at the end to encourage the horses.

The horse race, while not as common as the chariot-race, is nonetheless frequently shown on extant prize vases. On the earliest, an amphora from Nauplion, the race itself is not shown, but rather the crowning of the winning horse.[26] Similarly, on a prize vase in Leningrad the race appears to be over as two jockeys walk their horses to the left.[27] The scheme of two jockeys racing to the right, which appears on two sixth-century vases,[28] becomes the norm in the early fifth century in the work of the Eucharides Painter and his followers.[29] Only once is a turning post shown, and in one instance a trainer with a long stick.[30] The last representation of the horse race in the fifth century is that of the Berlin Painter, who masses four horses into the panel; thereafter there are no extant depictions of this event for approximately a century.[31] However, at the very end of the fifth century a new equestrian event, possibly prompted by the development of the Athenian cavalry, is introduced: throwing javelins at a target from horseback (see p. 94, fig. 60).[32] The most distinctive of Athenian equestrian events, the *apobates*, is not shown on a prize amphora before the mid-fourth century (see p. 90, fig. 58).[33]

Prize vases for the combat sports (boxing, wrestling, and pankration) and the pentathlon appear to be the least numerous given our present evidence. Although we are certain that the final trial of the pentathlon was wrestling, depictions of this event include only javelin-throwers (acontists), discus-throwers (*diskoboloi*), and long-jumpers. Before the last decade of the century, the standard composition consists of four athletes: two acontists, a diskobolos and a jumper. The Antimenes Painter substituted a referee in his depictions of this event, and the Kleophrades Painter, a musician.[34] As one might expect in wrestling (which appears first on the prize vase of Exekias; fig. 22) and in boxing, the contestants are regularly accompanied by a referee, and often a third nude athlete, either acting as a spectator or waiting for his bout with the winner. Scenes of combat sports are more numerous in the fifth century and often show the boys'

FIG. 22 Panathenaic prize amphora with wrestlers, attributed to Exekias (reverse), ca. 540. Badisches Landesmuseum, Karlsruhe, 65.45

event, but it is sometimes difficult to distinguish between boxing, wrestling, and the pankration. As one would expect, the boxers wear or carry leather thongs for their hands, but pancratists are difficult to identify unless they have grabbed their opponent's leg, as in the case of vase-paintings by the Kleophrades Painter (see p. 88, fig. 53).[35] A possible clue may lie in the position of the referee, the draped man with the forked cane: in most wrestling bouts he stands at the left, but in verifiable scenes of the pankration he is always on the right.[36] If this scheme is correct, then it would help us identify scenes like that on a Panathenaic in Copenhagen where two hefty nude athletes are just about to engage, the referee standing calmly at the right; without such a scheme there is no way to tell whether we are dealing with wrestlers or pancratists.[37]

Among the 150 prize Panathenaics from the sixth and fifth centuries that are well enough preserved to decipher their obverses, only two are problematic. One from the end of the sixth century in Leningrad shows a kitharist on a bema or platform flanked by two figures; this amphora is undersized (54 cm.), but inscribed as a prize vase.[38] If the inscription is authentic, it suggests that olive oil, instead of a gold crown, was awarded at least for one festival. The second vase (cat. 46), formerly in the Hunt collection, shows two contestants with

46 Panathenaic prize amphora with hoplitodromos (reverse), attributed to the Kleophrades Painter, ca. 490

shields before a judge or referee. The scene has been identified as both the pyrrhic dance and the *euandria*.[39] However, both of these events were tribal, and their prizes consisted of a hundred drachmas and an ox. It is much more likely that this scene is an unusual representation of the *hoplitodromos* (an event for which we have other illustrated prize amphoras), rather than a unique instance of a team sport. This interpretation is verified by the prominent shield device, a running hoplite; such devices are common in scenes of the armed race.[40] Rather than showing the race itself, as other representations do, it depicts either preparations beforehand, or the shedding of armament at the termination of the race.[41] Painters of the Kleophrades Painter's workshop often prefer a moment preparatory to the action of the contest.

Meaning of the Panathenaic Imagery

While the pertinence of the contest scenes on the reverse of prize amphoras is obvious, the origins and precise meaning of the martial Athena posed between cock columns have puzzled generations of classical scholars. Is she a statue, as many have suggested, and if so, which one? And what is the significance, if any, of the cock columns? Since both the Panathenaic Athena type and the cock columns appear on other kinds of Attic vases (see p. 47, cat. 13), must they always signify the Panathenaic festival? Given the manifold aspects of Athena in ancient Athens (see pp. 21–22), what specific characteristics are conveyed by this imagery?

There are no hard and fast answers to these questions, but one way to approach the problem is to look back at the earliest images of the goddess in Attic art in an attempt to understand her special significance for the Athenians. In Proto-attic vase-painting of the seventh century, she stars in the role of protectress of heroes. In her earliest appearances she lacks armor, and would be unidentifiable if it were not for all the later representations that show her aiding Herakles, Perseus, Theseus, and other heroes. In the early sixth century, she is represented in a more militant posture, fighting the giants or as an armed statue at which the helpless figure of Kassandra takes refuge (cat. 3). In this sense she is Pallas Athena, or the Palladion, a goddess of the citadel without whose protection Troy will fall. The name Pallas probably derives from the Greek verb *pallein*, "to brandish" or "shake," and indeed the goddess is shown brandishing her spear. The early sixth-century Athenian statesman Solon reputedly believed that as long as the protecting

3 Plate with statue of Athena, attributed to Paseas, ca. 520–510

hands of Athena were stretched above her city, Athens could not perish except by the fault or folly of her citizens.[42] Thus, in the early Archaic period Athena is preeminently a divinity, not of bloody battle like Ares, but of military might that serves to guard or protect. As such she is an ideal civic emblem.[43]

The inspiration for the military Athena of the Panathenaic vases, referred to hereafter as the "Panathenaic Athena," may well have been an outdoor statue actually set between columns, which served the cult in addition to the sacrosanct cult statue of Athena Polias, housed in the temple on the north side of the Akropolis (see pp. 120–127). Scholars have argued that the changing garments and shield devices of the vases work against this interpretation, but the Akropolis sculptures of maidens known as *korai*, with their well-preserved painted decoration, should serve to warn us that such embellishments could very well have been renewed and changed periodically with paint. There is concrete evidence in the form of vase-paintings to indicate that the Panathenaic Athena was indeed a statue. On some vases, including an early prize amphora, she is approached by worshipers or victors, often smaller in scale (fig. 23).[44] In other black-figure vase-paintings this Athena type is posed behind an outdoor altar approached by worshipers; altar cum statue is standard shorthand for a Greek sanctuary.[45] That the Panathenaic Athena was an outdoor statue is perhaps corroborated by Panathenaic-shaped vases where an owl has alighted on the upper edge of her shield (see p. 43, cat. 18). While some might view the bird as an attribute, it might also be a naturalistic detail, since the rocky Akropolis was home to the small owl.[46] Other vases (such as cat. 7) show many owls perched around the sanctuary of Athena, as if this was their natural habitat. The most compelling evidence for a statue occurs on a black-figure hydria in Munich where a Panathenaic Athena is posed on a low base, a form that invariably signals a statue.[47] Since this vase was painted by an artist who produced prize amphoras as well as painted scenes with obvious topographical references (i.e. fountain houses), perhaps we should accept this Athena as a specific and accurate representation of a well-known Athenian monument. Finally, as noted above, on some sixth-century imitation Panathenaics Athena is shown facing right,[48] and in the fourth century her pose is reversed, so that we see her frontally. This dual vantage point often indicates that an artist had access to a three-dimensional model. In later Attic vase-painting, when figures are shown in the same pose from both front and back, they can often be associated with known statue types.[49] Thus the preponderance of vase-painting evidence points to a statue as the source of the Panathenaic Athena.

FIG. 23 Panathenaic-shaped amphora with statue of Athena and two worshipers, ca. 530. Bibliothèque Nationale, Cabinet des Médailles, Paris, 243

The enigmatic cock columns, which have traditionally been explained as emblems of the competitive spirit,[50] also suggest architectural elements of an outdoor sanctuary. However, there is no corroborative evidence from other sources since these columns are unique.[51] There were many columnar monuments on the Athenian Akropolis in the Archaic period, and these held statues of both humans and animals, as well as bowls and tripods. There well might have been a pair of such columns surmounted by cocks in the vicinity of a statue of Athena, and both might have had some role in the festival.[52]

Although birds are often closely associated with Greek divinities (the owl with Athena, the eagle with Zeus, and the dove or goose with Aphrodite), the cock is mostly seen in art as a love-gift of older men to boys. Zeus frequently presents such a gift to Ganymede, and in one instance it is shown in association with Zeus and an altar.[53] Erika Simon has made the ingenious suggestion that these columns refer to Athena's father Zeus, who

was worshiped on the Akropolis as Zeus Polieus together with Athena Polias, i.e. they were both city divinities.[54] Athena derived her aegis and, symbolically, her protective power from her father, and the two are closely united in representations of groups of gods, as for instance in the gigantomachy. Aischylos demonstrates their intimate relationship when the chorus states at the end of the *Eumenides* (lines 997–1002):

> Farewell citizens, seated near the throne of Zeus, beloved by the maiden he loves, civilized as years go by, sheltered under Athena's wings, grand even in her father's sight.

Here Aischylos emphasizes the maiden Athena's ability to protect, a power derived from Zeus.

An important vase-painting in this context is an extremely fine but fragmentary amphora of Panathenaic shape found, and presumably dedicated, on the Akropolis.[55] On the obverse is the standard Panathenaic Athena posed between cock columns; on the reverse, in place of the expected athletic event, is an assembly of gods. In the center of the group, Athena faces her father, identified by the thunderbolt in his left hand. This association of Athena and Zeus on a vase of obvious Panathenaic shape and decoration emphasizes the close connection of Zeus to his daughter's festival.

They are further associated by their shared function as protectors of the olive tree. As such it is not surprising that they appear together on a jar made specifically for the holy oil.[56] Sophokles has the chorus of *Oedipus at Colonus* sing praises to the olive tree:

> For Zeus the father smiles on it with sage
> Eyes that forever are awake,
> And Pallas watches with her sea-pale eyes.
>
> (lines 704–706, trans. R. Fitzgerald)

As protectors of city and olive alike, these intimately related deities are appropriately honored on the Panathenaic prize vases, Athena with her statue type, Zeus with the cock columns. Together they refer to the sanctuary of Athena on the Akropolis, the ultimate destination of the Panathenaic festival procession.

63 Panathenaic-shaped amphora, ca. 525–500

Shape

The Panathenaic amphora's distinctive shape (cat. 63), like much of Greek pottery, can be accounted for by its function as a container and vehicle of transport for olive oil. It is a variant of the neck-amphora, a two-handled vase whose neck meets the body at a distinct angle. The neck of the Panathenaic, however, is more constricted and shorter than that of a standard neck-amphora, and joins the shoulder at a less acute angle. Its bulging ovoid body tapers more dramatically toward the base, resembling a balloon. Both of these features, narrow neck and base, derive from the undecorated coarse-ware commercial jars used to transport wine and oil overseas. A narrow mouth could be easily plugged, and the tapering body makes them convenient to stow as cargo. Likewise the sturdy cylindrical handles and small foot provide for ease in carrying as well as pouring out the liquid contents. Many Panathenaic amphoras preserve lids with knob handles; these would have served to protect the contents from dirt and dust.

It should be stressed that the Panathenaic amphora was from its inception a special shape, and in a sense a hybrid. For while it has the distinct neck, often defined by a collar-ridge, of the neck-amphora, it bears the handles and panel decoration of a belly-amphora (fig. 24). Scholars have traced its ultimate origins to the Attic

FIG. 24 Amphora types

neck-amphora belly-amphora Panathenaic amphora

"SOS" (so-called after the decoration on the neck) transport amphora (fig. 25), a logical source given their common function and size.[57] They share not only overall shape, but a ridge at the juncture of neck and body, and a dark body with reserved neck. Their immediate predecessors, however, are the panel neck-amphoras emanating from the workshops of early black-figure artists such as the Painter of Acropolis 606 and London B76.[58] This distinct shape rapidly asserted itself as the official prize vase shape, as evidenced by the fact that early small-scale imitations bear the standard imagery of Athena between cock columns, and often an athletic, equestrian, or musical contest on the reverse.[59] These imitations of the prize vases will be discussed later.

As a shape, the Panathenaic amphora has a long history, much longer in fact than most vase shapes, since it continued in use for the festival until at least the second century. The stout (H. 61.3 cm.), thick-walled (7–8 mm.) bulging Burgon amphora has an echinus mouth and foot, like contemporary neck-amphoras. During the later sixth and fifth centuries the jars become taller (62.6 cm. is the average size of the Berlin Painter's prize vases), their walls thinner (4–6 mm.), and the center of gravity moves up. The foot and mouth grow steeper and taller, becoming almost disc-shaped. Equally noticeable is the change in the point of attachment of the handles, which moves from the middle of the neck to its base, thus causing them to be more vertical and less jug-eared. To put it another way, the void described by the handles develops from a semi-circle to an oval. In effect the changes parallel those of the standard neck-amphora during the sixth century. During the late fifth and fourth centuries the amphoras grow considerably taller, but much of the growth can be accounted for by the taller foot and lip (see p. 32, cat. 25).

FIG. 25 SOS transport amphora, ca. 600. British Museum, London, 1848.6–19.9

Size

While the outer dimensions of Panathenaic prize amphoras vary over time, it can be assumed that their capacity remained essentially the same. It is recorded in the Aristotelian *Constitution of Athens* (60.3) that at the time of the Panathenaia the Treasurers on the Akropolis measured out the sacred olive oil to the commissioners of the games (*athlothetai*) to be awarded to the victors in the contests. Thus, we can assume that the quantities were strictly controlled. In an earlier passage (60.1) these same athlothetai, together with the Athenian Boulé (Council), are said to provide the amphoras. One could conclude from this that elected officials commissioned the amphoras from local ceramicists and made certain that their capacity as well as decoration accorded with the regulations.

Problems arise in attempting to determine the amount of olive oil prescribed. Given the variety of heights and diameters, volume is the only reliable criterion of measure. But since the condition of many prize amphoras precludes the use of liquid, very few vases have been tested for capacity. Of those that have, the capacities range from 35 to nearly 40 liters, but the average is approximately 38–39 liters when filled to the brim, and hence very close to the standard Athenian liquid unit of measure known as the *metretes* (38.88 liters).[60] Consid-

ering the fact that these vessels were handmade, their capacities are remarkably consistent. Given that this amount of olive oil would weigh approximately 80 pounds (not including the amphora), it is not surprising to see that two men were needed to carry a full amphora, as pictured on this vase by the Theseus Painter (cat. 53).

That the metretes was an an official unit of measure in ancient Athens is indicated by amphora fragments found in the Agora which bear the inscription *demosion* ("of the state") and are decorated in black-figure with the helmeted head of Athena and an owl, in obvious reference to the city's coinage (see cat. 10). Most of these fragments, along with other official weights and measures, were found in the vicinity of the Tholos; hence this building or another near it must have housed the official standards, of which labeled replicas in clay were made available. Both the athlothetai and the potters commissioned to produce that festival's batch of Panathenaics would have had need of such standardized measures. Evidence from the inside of some "demosion" amphoras and Panathenaics indicates that they were either pared down or padded with clay in order to adjust their internal dimensions. Thus it seems clear that Panathenaic prize vases were as standardized as any other unit of measure in ancient Athens, and that these standards were adhered to by potter and commissioner alike.

53 Skyphos with religious procession (obverse), attributed to the Theseus Painter, ca. 490

Inscriptions

In the same way that official units of measure were labeled, most Panathenaic prize vases bore the official inscription TON ATHENETHEN ATHLON. The Burgon amphora (see p. 30, fig. 19) is the earliest extant vase to be so inscribed, and it and others close in date conclude the inscription with *emi* ("I am"), so that the vase declares its own authenticity.[61] This archaic formula, in which the artifact speaks for itself, is common in early Greek art and appears on sculpture, grave *stelai*, and boundary stones, as well as vases. Although the location of the inscription on the Burgon amphora, running vertically in front of the Athena, becomes canonical, at least four sixth-century vases place it elsewhere: in two instances outside the left column, once behind Athena (see p. 31, fig. 20), and once on the reverse, inscribed horizontally above a charioteer (fig. 26).[62] On a late sixth-century amphora of Panathenaic shape in Madrid, the prize inscription is painted directly on the column in added red; but the small size of this vase (H. 48 cm.) and the hoplite duel decorating the reverse indicate that this is almost certainly not a prize vase.[63] However, the letters on the column suggest that the inspiration for the vertical inscription may indeed be a columnar monument. From the early sixth century such vertically inscribed columns were a common sight on the Athenian Akropolis.[64] Since the painter of the Burgon amphora could have placed the text anywhere in the field, as Sophilos did on his dinos depicting the "games for Patroklos" (see p. 19, fig. 5),[65] its deliberate and careful placement, including punctuation, suggests familiarity with stone inscriptions.

On early Panathenaics the inscriptions are usually retrograde (i.e. read from right to left),[66] but by ca. 530 the majority become orthograde (left to right; cat. 39, detail). As one might expect, they are written in the Attic script, but in 403, when the Ionian alphabet was officially adopted after the tyranny imposed by Sparta was deposed, a few vases use the new script. It was, however, not used universally until 336. The most significant change in the prize inscription occurs in the second quarter of the fourth century, when the letters rotate ninety degrees, becoming horizontal. It is at this time that another official inscription is added, the name of the

FIG. 26 Panathenaic prize amphora with inscription placed horizontally over chariot (reverse), attributed to Lydos, ca. 550. Museo Archeologico, Florence, 97779

39 Detail of inscription on Panathenaic prize amphora (obverse), attributed to the Berlin Painter, ca. 480–470

eponymous archon. It is usually placed along the right-hand column, balancing the prize inscription on the other side, although locations seem to be interchangeable. The earliest vase with an archon's name preserves only the final letter sigma; most scholars take it to be that of Philokles who held office in 392/1.[67] The latest is that of the archon Polemon who gave his name to the year 312/11. Surprisingly, the years of office of these archons do not coincide with the years in which the Panathenaia was held, so they must refer to the off years in which the olive oil was collected from the groves and stored for future use. When the archon's name falls out of use, it is replaced by that of the Treasurers, who, according to the *Constitution of Athens* (60.3), kept the oil on the Akropolis until it was measured out for the games. And finally in the mid-second century the *agonothetes* ("commissioner of the games") is named. He was usually a wealthy Athenian who assumed the costs connected with the festival. Famous agonothetes during the Roman period include Herodes Atticus, the great second-century benefactor of Athens, and P. Herennius Dexippos, who defended Athens against the Herulian invasion of A.D. 267.

In addition to these official inscriptions which provide legitimacy and often a date for the contents of the Panathenaic prize amphoras, there is an array of "unofficial" writing inscribed on the early examples. These include most commonly the potter's or painter's signature on the obverse, and the name of the particular contest pictured on the reverse, and, in one instance, a *kalos*-name. The most loquacious vase is that signed by the potter Nikias (figs. 27a, b) which bears not only the prize inscription, but also the potter's signature balancing it along the left side of the obverse. On the reverse is the designation of the contest, the "*stadion* [sprint] of the men." A fragmentary Panathenaic from the Akropolis may once also have had three separate inscriptions: behind Athena, the potter's signature Mnes[iades]; the prize inscription (now missing) in front of her; and on the reverse, the name of the contest.[68] With the exception of a vase in Naples that names the pankration (see p. 88, fig. 54),[69] all other contest titles refer to races. Because it is not always easy to distinguish visually between the stadion (sprint), *diaulos* (double stadion), and *dolichos* (long race), these captions may have been considered

FIG. 27a, b Panathenaic prize amphora by Nikias (obverse and reverse), ca. 560. The Metropolitan Museum of Art, New York, Classical Purchase Fund, 1978, 1978.11.13

necessary in the beginning. The inscription *andron* ("of the men"), which can occur by itself in depictions of footraces, differentiates the contest from that held for youths, although on the earliest example in Halle one of the runners is as yet unbearded.[70] On the fragment from the Akropolis mentioned previously, the race labeled the diaulos is in fact a hoplitodromos, as the men are helmeted and carry shields.[71] Finally, a prize vase in Munich declares that it is for the victor in the men's stadion, possibly to differentiate it from the prize for the runner-up.[72]

Artists' signatures are less common. In addition to Nikias mentioned above, the potter Hypereides (ca. 560) proudly signs two of his Panathenaics as "Hypereides, son of Androgenes."[73] His signature, unlike Nikias' and the putative Mnesiades,[74] lies alongside the prize inscription at the left of the panel. To date, only one painter's signature is preserved, that of Sikelos, whose name is discreetly incised into the right-hand column on a Panathenaic in Naples.[75] It is perhaps surprising that a relative unknown like Sikelos signs his name, while more accomplished artists like Exekias do not, but as scholars of vase-painting have noted time and again, there appears to be no rational basis for ceramicists' signatures. In the fourth century we again have potters' signatures from two generations of an Athenian family. In the first generation are the potter Bakchios, dated by an archon inscription to 375/4, and his younger brother Kittos; their descendants of the same names are mentioned as potters from Athens in a decree of Ephesos in Asia Minor, indicating that they emigrated to more lucrative markets in the latter half of the fourth century when Attic pottery was in a decline.[76]

Finally, there are preserved two *kalos*-names on prize Panathenaics. From about the mid-sixth to the mid-fifth century, vase-painters occasionally inscribed the name of a young Athenian aristocrat followed by the adjective kalos (handsome) in the background of their figured scenes (see cat. 28), perhaps as a compliment to a local youth. "Euphiletos kalos" is inscribed in added white around the chariot wheel decorating Athena's shield on a Panathenaic in London.[77] The other name, "Echekles" (which may be a kalos-name) appears in front of Athena on a fragment from the Akropolis.[78] Obviously such personal references, even if concealed as part of a shield's decoration, were out of place on official prizes and so did not become commonplace.

"Pseudo-Panathenaics" or Reduced-Scale Reproductions

A class of amphoras that scholars have dubbed "pseudo-Panathenaics" lack inscriptions altogether.[79] These are amphoras of Panathenaic shape which are undersized reproductions. Their height generally varies from 38 to 44 centimeters, but their decoration is fairly canonical: Panathenaic Athena between columns on one side, contest on the other, palmette-lotus chain on neck. But the prize inscription, the *sine qua non* of a prize vase, is miss-

18 Panathenaic-shaped amphora (obverse), attributed to the Princeton Painter, ca. 540

64 Miniature Panathenaic-shaped amphora (obverse and reverse), attributed to Bulas Group, ca. 400

ing. Also, the painters often take small liberties with the standard decoration, such as reversing the pose of Athena, or substituting owls (see cat. 17), vases (see p. 37, fig. 23) or panthers for the cocks on the columns.[80] Sometimes the columns are done away with altogether in order to substitute one or more additional figures on the obverse.[81] The scenes on the reverse, while often of athletic and equestrian contests, can also be musical, rhapsodic or acrobatic performances which did take place at the Panathenaia, but for which olive oil was not the prize.[82]

Clearly, then, these vases are not "pseudo" in the sense that they were meant to deceive, but are rather smaller-scale imitations produced in many of the same workshops as the prize vases. They begin around 550 and end at the beginning of the fifth century, when black-figure is on the wane for all large vases with the exception of the prize amphoras. Their capacity is approximately half that of full-sized prize vases. It has been suggested that these are either wine jars for a victory celebration or commemorative vases which functioned as souvenirs for competitors at the Panathenaia.[83] By far the vast majority of these reproductions comes from Italy, specifically Etruria. Etruscans could not have competed at the games, but their tomb-paintings attest that they enjoyed athletic competitions. These vases may well have been made for the export market. Boxing scenes, for instance, are found on 30% of these small Panathenaics versus 8% of the prize vases for the same period; the difference may indicate a market preference.

An alternative explanation is that these jars were made as export containers for the excess olive oil from the sacred trees of Athena, known as the Moriai. These trees were so cherished that anyone caught damaging them could be sentenced to death.[84] With the exception of the winners at the games, individuals were not allowed to sell this sacred oil; the excess was sold by the state.[85] What better way to label this special Athenian product than with the image of the Panathenaic Athena? The disappearance of these vases at the beginning of the fifth century may be due to historical events that affected the production of olive oil. First, the Persians ravaged the Attic countryside in 480, burning the older trees which produced the greatest quantity of oil. It is therefore likely that no surplus would have been available for export in the years that followed. At some later date, according to the *Constitution of Athens* (60.2), the collection of oil constituted a tax per olive orchard rather than collection from specific sacred trees, and so such labeling would no longer be necessary.

That the Panathenaic Athena could have served as an advertisement for an Athenian product is indicated by another group of Panathenaic-shaped amphoras, so small (H. 8–9 cm.) that they can be called miniatures (cats. 64 and 65).[86] Scholars have recognized for some time that these vases must have contained small quan-

65 Miniature Panathenaic-shaped amphora (obverse and reverse), attributed to Bulas Group, ca. 400

tities of scented oil, the perfume called *panathenaikon* mentioned by Pliny (*Natural History* 13.6). Both the shape and the decoration of these small black-figure vases would have immediately suggested Athens because of their similarity to the larger prize vases. This series of miniatures begins ca. 400, with Athena facing left *sans* columns, and continues into the second quarter of the fourth century, as evidenced by one vase where she has changed direction.[87] Instead of athletic or equestrian contests, these vases usually depict either a torch-bearer or a seated athlete. Only two of the thirty or so preserved are decorated with athletic contests, and these also have cock columns on the obverse.[88] The most unusual miniature Panathenaic is red-figure and shows Athena with Poseidon on one side and Hermes flanked by olive trees on the other (cat. 66). The combination of Athena, Poseidon, and the olive tree recalls their contest for the hegemony of Athens, the theme of the west pediment of the Parthenon.[89]

All of the above are clearly reproductions of the larger prize vases. But what of the few regulation-size amphoras which resemble prize Panathenaics in every detail, but lack the prize inscription (cat. 44)?[90] Are they festival souvenirs, workshop models or actual prize vases which the painter has neglected to inscribe? Some scholars, like Gardiner, saw no reason not to regard such vases as genuine Panathenaics.[91] Because there are so few, Tiverios suggested that they might be competition sam-

66 Minature Panathenaic-shaped amphora (obverse), ca. 400

45

44 Panathenaic amphora (obverse), possibly by the Painter of Würzburg 173, ca. 500

ples, the *paradeigmata* mentioned in the *Constitution of Athens* (49.3), although this passage most likely refers only to the peplos.[92] Workshop overruns have been offered as another explanation, although it is not clear why vases produced for the festival would be uninscribed.[93] Some of these amphoras have slight aberrations: for instance, the Ionic columns on London B135, or the lack of black band below the tongues on the reverse of Louvre F280. If the vases were inspected by the athlothetai before firing, as the *Constitution of Athens* suggests (60.1), these irregularities could account for the deletion of the prize inscription.

Finally, there are some undersized Panathenaic-shaped amphoras that, surprisingly, do bear the prize inscription.[94] One of these has a unique depiction of the chariot race: the horses are wheeling around to the left, rather than racing straight ahead as was traditional.[95] Two depict scenes for which wreaths, not olive oil, were the traditional prize: kithara playing, and javelin throwing on horseback.[96] Most of the later small-scale inscribed vases were awarded in contests for boys. In particular one might cite the Panathenaic in Athens which preserves the only known youthful (i.e. unbearded) charioteer.[97] We know that there were lesser prizes awarded for second place as well as for the boys' events. Might these undersized but inscribed vases have held the official oil for either the boy victors or the second-place winners?

Workshops and Artists

It has been estimated that a minimum of 1,400 prize amphoras were thrown, painted, and fired for the Greater Panathenaia every four years.[98] If produced over the entire interval between festivals, this would amount to approximately one per day. It is more likely that they were produced in batches for the particular events, but in any case the commission would be a major one if it went to a single workshop. Nowhere are we told the cost of a new prize amphora, but it is recorded that *used* Panathenaic amphoras were auctioned off in the late fifth century for 2.4–3.7 obols each.[99] If we can assume that a new Panathenaic vase cost about 6 obols,[100] the total commission per festival would amount to a minimum of 1,400 drachmas, or in 1992 U.S. dollars, $112,000. (Using the same equivalents, the winner of the kithara contest earned $84,750, and the first-place charioteer, $94,920.[101])

To approach it another way, in the first one hundred years of the festival there were 26 Greater Panathenaias, or about eight per generation. In the first generation (ca. 566–534), we can account for a minimum of seven workshops, in the second generation (ca. 530–502) eight, and in the third (ca. 498–466) six. But whereas in the first generation the workshops are represented by singletons or at most two vases, up to 25 prize amphoras by a single painter are preserved from the third generation. This increased rate of preservation can in part be accounted for by wider exportation, but it may also reflect some expansion of the festival itself, and in any case implies the dominance of certain workshops that are likely to have won the contracts for successive festivals.

With only about 0.4% of the prize vases extant, it is perhaps rash to speculate about trends within workshops, but nonetheless some artistic patterns are evident by the end of the sixth century. These in turn may give us some idea of how the commissions were organized. The Euphiletos Painter is the first artist for whom a significant number of Panathenaics is preserved.[102] While chariot scenes figure prominently on his other vases, only two of his Panathenaics depict chariot racing. Rather, his specialty seems to have been the footrace, of which five examples are preserved. Although the goddess' shield

13 Panathenaic-shaped amphora with Athena at altar, Name-vase of the Nikoxenos Painter, ca. 500

devices differ, on at least three vases the details of Athena's drapery, aegis, and helmet are nearly identical, suggesting that the artist not only painted them at the same time, but that they were produced for a single event, the sprint.[103] When he paints a vase with the long race, Athena's dress is completely different.[104] Likewise, on his two vases with the pentathlon, Athena is dressed identically, now with a tiered skirt.[105] Might this linkage of costume with a specific contest have preceded the shield device as a means of monitoring the production of vases for the festival?

A late sixth-century workshop, that of the Michigan Painter, is the first to use a consistent shield device, an owl perched on a twig.[106] However, as Beazley has noted, it was not the Michigan Painter himself but another dubbed "The Painter of the Havana Owl" who executed most of the obverses.[107] So here, as later, we have instances of teamwork within a workshop, and the shield device would appear to be either that of a single festival or the signature of a specific painter. On the one vase with a different shield device, Louvre F278, the artist is yet a third member of the workshop. It is clear both from the Panathenaics and from other vases by the Michigan Painter (see cat. 26) that he specialized in athletic scenes and chariot racing, and so was an appropriate choice for decorating reverses of the prize vases. Likewise, chariots wheeling around were a specialty of the Leagros Painter's workshop, and so it is not surprising to see this event predominating on its prize vases.[108] Perhaps the motif was invented in order to vary temporarily the somewhat monotonous position of the racing chariot in profile to the right.

Coming into the era of red-figure, the technique which was invented ca. 530, it is surprising to note that possibly only one of the Pioneers, artists presumably adept at both techniques, produced prize amphoras.[109] One might also have expected to find prize Panathenaics by the Nikoxenos Painter, an artist working in both techniques but who seems to have preferred decorating his Panathenaic-shaped amphoras with red-figure Athenas between Ionic columns, and/or at an altar (cat. 13).[110] His pupil, the Eucharides Painter, however, did produce a series of both prize amphoras and reproductions, many fragments of which were found on the Akropolis.[111]

The snake is his usual shield device, and the horse race his only assured contest. At least two of these, Toronto 350 and New York 56.171.3, are compositionally so close with the rear jockey looking back, whip overhead, that they were surely produced in the same batch.

The two major vase-painters of the late Archaic period, the Kleophrades Painter and the Berlin Painter, both produced prize Panathenaics in such quantities that each must have worked for more than one festival. The earlier, i.e. those by the Kleophrades Painter, show the artist's great variety of drapery patterns, decorative details, and composition in spite of his constant shield device, the pegasos.[112] The racing chariot, the most numerous of his reverse scenes, develops in three distinct phases, moving from a fairly static pose to one which displays great movement. This variety could indicate either three successive festivals, or different workshop hands copying the master's model. The latter is a definite possibility when one considers that 140 amphoras were awarded to the victor in the chariot race. It is highly unlikely that the master painter executed all of them.

We see from the work of the Berlin and Achilles Painters that a teacher could pass on the practice of producing prize vases to his pupil. The Achilles Painter, like his master, uses the gorgoneion as shield device, even though his vases are clearly later, and so we must assume that the device belonged to the workshop rather than to an individual, whether artist or commissioner, as some have suggested.[113] The Achilles Painter is the last identifiable artistic personality to have painted Panathenaics; thereafter, the vases which have survived are assigned to stylistic groups, not to specific hands.

Markets

Panathenaic amphoras or fragments thereof have been unearthed in sanctuaries, habitations, and graves. Many have been found in mainland Greece, but they turn up from as far east as South Russia and as far west as Spain. The question of whether they were exported for their own sake, either as mementoes of victory or as seconds for the export pottery trade, or whether they served as vehicles of transport for Attic olive oil has not been satis-

factorily answered.[114] We know that the victors were allowed to sell their winnings, and the oil may have had an added cachet if it arrived in an Athenian prize vase. The prevalence of these vases as well as of reproductions in central Italian tombs would indicate an abiding interest on the part of the Etruscans even when black-figure was *retardataire*. The fact that many show ancient repairs also attests to their value in antiquity.[115] A prize amphora from Cerveteri, now in the British Museum, shows evidence of 155 ancient repairs.[116] That the vase was considered worth repairing after such extensive damage indicates its value to its former owner.

Tombs in North Africa and South Italy have also produced fine fifth-century prize vases in contexts which suggest that they were something other than standard import pottery. A tomb in Cyrenaica excavated in 1969 yielded the earliest Panathenaic found thus far in North Africa. In addition to the prize vase attributed to the Kleophrades Painter, two Chian wine jars, an exceptionally large (H. 40 cm.) stone alabastron, an Achaemenid glass bowl, a silver gilt wreath of olive leaves and fruit, a bronze strigil, and two bone chiton buttons accompanied the skeleton of an older male in a wooden coffin.[117] The tomb is dated by its Attic black-glaze pottery to ca. 425, although the Panathenaic amphora is 50 to 60 years earlier. Is this the final resting place of a victorious athlete who won the pentathlon in his youth, or is it the tomb of a cosmopolitan Hellenized Libyan?

Tombs in Taranto might provide the answer.[118] These sixth- and fifth-century chamber tombs housed from one to seven tufa sarcophagi which contained objects like strigils, stone alabastra, Attic lekythoi, skyphoi, and kylixes. Outside one of the seven sarcophagi in Tomb B was a prize Panathenaic of ca. 520 showing the chariot race on the reverse. Lo Porto concludes that this tomb must have belonged to a clan of aristocrats who could afford to enter a team of horses in the Greater Panathenaia. A similar tomb (Tomb A) discovered by tomb robbers in 1880 produced fragments of a minimum of five Panathenaics of the late sixth century, and possibly also the prize vase in Naples signed by Sikelos.[119] This last vase and the only fragment preserving a reverse depict wrestlers. This evidence suggests that one of the occupants of this tomb was a champion

FIG. 28 Athlete's tomb at Taranto with Panathenaic prize amphoras at four corners

wrestler. A third tomb (Tomb D) with three sarcophagus burials contained a prize vase of the later fifth century depicting two young boxers. The most spectacular find, Tomb C, had four prize Panathenaics carefully poised at the corners of a richly painted sarcophagus (fig. 28). The three preserved contest scenes are all different (pentathlon, chariot race and wrestling), but all seem to have been produced in the same workshop, that of the Kleophrades Painter, if the common shield device, the pegasos, is a reliable indicator.[120] Was this man a wealthy "super-jock" as Lo Porto suggests—a pentathlete in his youth, an aristocratic racehorse owner, and an adult wrestler—or a poseur who bought his attributes of victory?[121] The man appears to have died around the age of 35, and his remains were treated with the utmost respect and dignity, almost as if he had been heroized. These Tarentine tombs demonstrate a special regard for the prize vases of Athens, and if one takes into account the long tradition of Olympic victors from South Italy, it seems more than likely that Lo Porto is correct in interpreting these as tombs of victorious athletes. The prevalence of alabastra and strigils confirms this conclusion, and perhaps a similar conclusion should be reached regarding the Libyan tomb.

The high regard in which the prize vases of Athens were held is also demonstrated by the fact that they were commonly dedicated in sanctuaries. Naturally, they are most prevalent on the Akropolis, presumably dedicated by victorious athletes to the goddess presiding over the games. But non-Athenian competitors seem also to have

FIG. 29 Detail of boy carrying Panathenaic on Panathenaic-shaped amphora, attributed to the Painter of Palermo 1108, ca. 480. Staatliche Antikensammlungen und Glyptothek, Munich, 2315

taken them home to dedicate in their own local sanctuaries, as for example that of Poseidon at Isthmia or Demeter and Persephone at Cyrene.[122]

Perhaps the most concrete proof of the value of Panathenaic prize amphoras can be found in the inscription of the Attic stelai which refers to the sale of a minimum of 102 by a single owner.[123] It has been suggested that this part of the stele refers to the property of the famous Athenian statesman Alkibiades, who entered seven teams in the chariot race at the Olympic games of 416, and won first, second and fourth places.[124] Thus, it is not unlikely that he could also have won the chariot race held at the Panathenaia of 418, and so have acquired over 100 prize vases. After his property was confiscated during the disastrous Sicilian expedition of 415, it may well have been auctioned off by the state, and the empty Panathenaics fetched between 2.4 and 3.7 obols, or about $40 apiece.

Returning to the beginning with our earliest preserved amphora, it should be recalled that it was one of possibly five uncovered by Burgon in this early sixth-century Athenian grave. Might the other four, which were not recognized at the time, have also depicted the horse-cart race? We will probably never know the answer to that question, but from their inception these vases seem to have been prized by their owners, whether Athenians or foreigners, who took them along to their graves.

Because of their wide distribution, we can expect that these vases will continue to appear in future excavations, thus enabling us to understand more about this unique class of ancient pottery.[125]

The Panathenaic Amphora as Symbol

Just as the owl and olive tree were symbols of Athens, so the Panathenaic amphora came to symbolize the festival of Athena. When it is depicted in scenes of procession to sacrifice, as on the skyphos by the Theseus Painter (see p. 40, cat. 53) we can assume that the artist is referring to the Panathenaia. Here two men are needed to carry what must be a full amphora, whereas on other vases, (interestingly enough, amphoras of Panathenaic shape), a single man bears an empty (?) amphora on his shoulder (fig. 29).[126] Perhaps he is bringing it to the Akropolis to be filled, but in any case, the allusion to the Panathenaia is obvious.

On many Archaic vases that depict athletic or equestrian contests, the prizes are often conspicuously displayed. These usually consist of bronze tripods or dinoi (see cat. 36), but on at least two vases the prize is a neck-amphora. A band-cup in Munich (fig. 30) and a

FIG. 31 Amphora with Nike carrying prize amphora, attributed to the Peleus Painter, ca. 440. Agora Museum, Athens, P 9486

FIG. 30 Band-cup with boxers and prize amphora, ca. 550–530. Staatliche Antikensammlungen und Glyptothek, Munich, 2220

black-figure amphora of Panathenaic shape by the Swing Painter show two boxers confronting each other over what must be, on the basis of its size in relation to the figures, a prize oil vessel.[127] Again the artists are clearly referring to Panathenaic contests. On later red-figure vases Nike can be seen bearing the prize, a Panathenaic amphora, to the victor (fig. 31).[128]

The Panathenaic amphora shape is used as well in more official contexts. Amphoras, half-amphoras, and quarter-amphoras appear in relief on official bronze and lead weights found in the Athenian Agora (cat. 70).[129] The Panathenaic amphora also appears on the earliest and latest coinage of Athens: the so-called *Wappenmünzen* (cat. 67) display the bulbous Archaic vase shape, while the "New Style" coins of the second and first centuries (cat. 69; see also cat. 68) show an owl perched on the elongated Hellenistic variety of Panathenaic.[130]

Even in Roman times the Panathenaic amphora lived on as a symbol of the games at Athens. The dedicatory relief commemorating the multiple victories of a man from Rhamnous (see cat. 71), mentioned in the Introduction, is one of many late classical reliefs that feature the distinctive amphora of Athens.[131] Thus, long after the glory of Classical Athens had declined, its festival and games continued to have prestige in the ancient Mediterranean with the Panathenaic amphora serving as its symbol.

70 Weight, 4th century

67 Wappenmünze with amphora (obverse), ca. 560–545

69 New Style tetradrachm with owl perched on an amphora (reverse), 187/6

H. A. SHAPIRO

Mousikoi Agones: Music and Poetry at the Panathenaia

Important religious rituals in virtually all cultures, from African tribal ceremonies to the Roman Catholic mass, include music as a central element. The Greeks were no different in this, and the visitor to the Panathenaic festival would have heard the music of wind and stringed instruments in a variety of contexts: as accompaniment to processions, revelry, and sacrifices; as an adjunct to athletic events; and as music for its own sake in the competitions for professional players and singers. The music of the ancient Greeks is almost entirely lost to us and can never be recovered acoustically, leaving perhaps the greatest gap in our efforts to reconstruct the life and culture of the Greeks. Countless texts attest to the collective Greek passion for music, from earliest times and in the unlikeliest places. We may recall the striking image of Achilles, greatest and most savage of the Greek heroes at Troy, soothing his anger and "delighting his spirit" with the music of the lyre as he brooded in his tent (*Iliad* 9.185–89).

Even our appreciation of some of the finest Greek literature is greatly diminished by the loss of the music that accompanied it in performance. Attic tragedies and comedies sit silent on the printed page, as we often forget that their choral odes were performed to the music of the seven-stringed *kithara*.[1] Philologists have spent centuries deciphering the dazzling imagery of Pindar's victory odes, but still have little idea how they were performed and to what kind of music.[2]

At Athens in particular, musical training was an integral part of the education of a citizen youth.[3] Musical skill was widely acknowledged as a mark of the well-bred aristocrat, as numerous anecdotes attest. Themistokles, hero of the Athenian defense against the Persians in 480, never quite overcame the social stigma of his lowly birth and poor education. But he answered his critics with contempt, "saying that he might not know how to tune a lyre or handle a harp, but he could take a small and unknown city and make it great and glorious" (Plutarch, *Life of Themistokles* 2.3). Training on the lyre began early in life, and many vase-paintings show small boys practising under the watchful eye of the music master.[4] Among these school scenes, one on a pyxis of Nikosthenic type[5] is unique in showing the boys simulating musical contests like those at the Panathenaia. On a two-stepped platform, a boy plays the lyre while a second, slightly older boy sings and a bearded man nearby listens (fig. 32a).[6] Neither the instrument itself, a curved lyre rather than the kithara, nor the combination of stringed instrument and singer accords with any of the known Panathenaic contests. Elsewhere on the vase (fig. 32b) an aulode and flutist share a long, low platform with an inscription praising Nikosthenes. These are flanked on either side by seated youths playing the lyre. Yet another group (fig. 32c) shows a bearded man punishing a nude youth with a sandal while a flute-player stands nearby.[7]

The Athenian respect for musical skill is perhaps best mirrored in the figure of Theseus, national hero *par excellence* and exemplar of the qualities Athens most admired. When we first meet Theseus in Athenian art, on the François Vase,[8] he holds a large lyre at the head of the procession of Athenian youths and maidens sent to Crete. At other moments too, whether with Ariadne or even in the labyrinth to fight the Minotaur, Theseus' regular attribute is the lyre, as if this marked him as the perfect gentleman prince.[9]

Despite the loss of the aural dimension, we are fortunate to possess a large corpus of images in Athenian art of musical instruments and performers,[10] many of them at the Panathenaia. The purpose of this essay is to gather

19 Neck-pelike with aulodic contest, ca. 500

FIG. 32a,b,c Nikosthenic pyxis (three views), ca. 520, Antikensammlung, Kunsthistorisches Museum, Vienna, IV 1870

Music and Sacrifice

The central act of most Greek religious rituals was the sacrifice to goddess, god, or hero. As early as the Bronze Age, there is evidence that both the sacrifice itself and the procession leading to the sacrifice were accompanied by music. The most detailed portrayal of a sacrificial ritual in Minoan or Mycenaean art, found on the long sides of the famous painted limestone sarcophagus from Hagia Triada in Crete, includes two musicians.[11] On one side, a man in a long robe plays a heavy stringed instrument as two women before him gather water for the sacrifice. On the other side, women prepare to slaughter a trussed bull as a man playing the double flutes stands alongside the sacrificial victim. This combination of flutes and lyre or kithara was to recur across the Aegean and a millennium later at the great Athenian festival.

The earliest certain representation of the Panathenaic procession appears on the Parthenon frieze (ca. 438–432), but this depicts the preparations for sacrifice and not the moment itself.[12] No altar is shown. Yet already on black-figure vases we have scenes of the cult of Athena that can with some likelihood be associated with the Panathenaia. These highlight the integral role of music in the cult, and it is no coincidence that the earliest of these scenes falls in the mid-sixth century, soon after the reorganization of the Panathenaia into the principal civic festival of the Athenians, in 566.

A band cup of about 560 (fig. 33), although not certainly showing the Panathenaia, gives our fullest picture of a sacrificial procession in honor of Athena in the early years of the reorganized festival.[13] The object of the procession is a statue of the goddess, and just before it her priestess greets the leader over a flaming altar. The sacrificial animals, ox, boar, and ram, are followed by a trio of musicians, two flute-players and a lyre-player. These musicians reappear, in much greater splendor, on an amphora in Berlin one to two decades later.[14] As the sacrificial ox is brought before Athena on one side of the vase (fig. 34a), four musicians approach from the other side, two each with kithara and flute (fig. 34b). It may

FIG. 33 Detail of band cup with religious procession, ca. 560. Private collection

FIG. 34 a,b Amphora with religious procession (obverse and reverse), name-vase of the Painter of Berlin 1686, ca. 540. Staatliche Museen, Berlin, F 1686

be significant that an equal number of each instrument is shown, since this is true of the Parthenon frieze a century later. The Berlin amphora also gives us our first glimpse of the colorful and elaborate costumes characteristic of professional musicians at Athens.

Contemporary with the Berlin amphora is a very fragmentary vase of the same shape that is of particular interest because it was dedicated on the Akropolis and names most of the principal figures.[15] A sacrificial ox, his head festooned with a red and white garland and his legs bound with ropes, is led to sacrifice by two youths. Parts of three musicians are preserved following the victim: a tall bearded flute-player; a boy playing the kithara; and an adult kitharist whose head is lost. The flutist is named Exekestos, a very unusual name, suggesting a possible family tie to the great vase-painter Exekias who was active at this time.[16]

These early Archaic vases provide the best evidence for music in sacrificial processions for Athena before the time of the Parthenon. Comparable scenes in red-figure are rare and harder to connect with the Panathenaic festival. An early red-figure loutrophoros of ca. 520, found on the Akropolis, includes a lone flute-player named Lykos.[17] But the only animal shown is a pig, and we may be dealing with a more modest rite for Athena (or even a hero or another divinity, since she was not the only one worshiped on the Akropolis), rather than the Panathenaia.

The musicians on the Parthenon frieze occupy two slabs of the North side, just behind the carriers of water-jars.[18] The first four are playing the flutes, followed by four kitharists, one of whom has turned and stopped to face his companion (fig. 35). All appear to be playing at once, except the one who may have stopped to adjust his instrument. All eight appear to be male, as are all the musicians in vase-paintings of religious processions (though we know women often played the flutes and occasionally the lyre in secular contexts such as the symposium or at home),[19] but they are not sufficiently well preserved to allow us to determine their age.

Several vase-painters of the Parthenon generation and later were strongly influenced by its sculptures, and there are many echoes of the procession of the frieze, especially in the Polygnotan workshop. A bell-krater in Boston, for example, shows men and youths preparing to sacrifice a sheep at an altar, accompanied by a youth on the double aulos.[20] A contemporary amphora, also

FIG. 35 Parthenon frieze: kitharists. Courtesy Alison Frantz

with a sacrificial scene, gives the name of the man conducting the sacrifice, Archenautes.[21] Yet alongside this realistic touch the painter has added a hovering Nike, deliberately mixing the worlds of the everyday and the divine. This is a peculiar characteristic of the art of High Classical Athens that we shall meet again in the proliferation of Nikai crowning musical and athletic victors.

The night before the Panathenaia proper was marked with an all-night celebration (*pannychis*) whose highpoint was a torch race. Music, singing, and dance were surely all part of the festivities, though our sources are sparse and no representations can be connected with these events, apart from a few showing the torch race (see cats. 49, 50).[22]

Music and Athletics

The association between music and athletics was always very close in Athens. Many vase-paintings show that young athletes in the palaestra regularly trained to the accompaniment of flute music. The music may have provided a steady rhythm to which wrestlers, boxers and jumpers practised their dance-like movements.[23] But it is less clear how often actual athletic competitions, as they were played out at the festival, had musical accompaniment. Only two Panathenaic prize amphoras offer evidence for flute-players at the athletic events they depict.[24] Yet certain other contests, as shown on non-prize vases, do include a flute-player. The unique representation on a black-figure amphora of Panathenaic shape in Paris (fig. 36) depicts a youth carrying two shields jumping on or off a horse before an audience and a man playing the flutes at the left.[25] The audience of spectators, the shape of the vase, and the figure of Athena between columns on the obverse all suggest that this is indeed a Panathenaic *agon*, but just what to call it is uncertain.[26]

One contest in which music was surely an integral part was the armed dance, or *pyrrhike*.[27] Vase-paintings generally show athletes practising for this event to the accompaniment of the flute (cat. 48), not the competition itself (hence the absence of judge or audience). Pyrrhics are not shown on prize Panathenaics, since the prize for which they competed was something other than olive

FIG. 36 Panathenaic-shaped amphora with acrobatic performance (reverse), ca. 530. Bibliothèque Nationale, Cabinet des Médailles, Paris, 243

48 Pelike with pyrrhic dancer and aulete (reverse), attributed to the Theseus painter, ca. 500

oil.[28] But the element of dance makes it clear that the music of the flute was indispensable.

A musical fanfare probably accompanied the presentation of the victors in athletic contests. This is especially clear on vases of the Late Classical period, where the instrument used is a long trumpet, or *salpinx*.[29]

Musical Contests

In addition to these various adjunct roles played by music at the Panathenaia, musicians and singers had the opportunity to take center stage. Complementing the athletic and equestrian competitions were at least a half-dozen musical contests for which valuable prizes were awarded. This custom was by no means unique to Athens or to the Panathenaia. Of the four great Panhellenic festivals, all but the Olympic Games had some form of musical contest, and the Pythian Games at Delphi, in honor of Apollo, patron god of music, probably gave special prominence to such competitions.[30] A unique red-figure pelike found in modern-day Bulgaria shows a victorious kithara-player surrounded by four Nikai symbolizing (as the inscriptions inform us) the four festivals at which the musician has won the prize.[31] Beside the Panathenaia and a local Attic festival, at Marathon,[32] two of the Panhellenic games are included, the Nemean and Isthmian.

Mousikoi agones, musical competitions, are attested at the Panathenaia over several centuries, from the sixth down into the Hellenistic period. Undoubtedly their number, form, prizes, and regulations changed over the years, though it is probably fair to say that more elements remained consistent than not.

For the Archaic period we have virtually no literary or epigraphic texts that refer to the mousikoi agones, but we are compensated for this dearth of evidence by a large number of Attic vase representations of the contests, to be considered below. For the Classical period we are somewhat better informed, but also faced with contradictory evidence, especially on the role of Perikles in relation to the musical contests. Plutarch credits him not only with the introduction of musical contests at the Panathenaia, but with the building of the Odeion, an indoor concert hall[33] where, he says, these performances took place (*Life of Perikles* 13.5–6). The former assertion is clearly disproved by dozens of sixth-century black- and early red-figure vases showing musical performances in a Panathenaic setting. J. A. Davison's hypothesis of a hiatus in the mousikoi agones in the Early Classical period allows Plutarch to mean that Perikles reintroduced these contests.[34] However, I prefer to think that Perikles did not introduce or reintroduce but rather *reorganized* the musical games, perhaps adding certain events and dropping others, and, above all, officially enacting the new program as law (*Life of Perikles* 13.6: *epsephisato*). Plutarch is in general not well-informed about the sixth century, but he may have had access to the inscribed *psephisma*, the official decree, which he understandably (but incorrectly) took to be the founding of the mousikoi agones rather than their reorganization.[35]

There is a clear precedent for Perikles' reorganization in what we hear about the contest for rhapsodes, reciters of epic verse without musical accompaniment, and the role of the tyrant Hipparchos. He laid down new rules for an already existing competition, but has sometimes wrongly been treated as its founder.[36] More broadly speaking, there is also a parallel with the events of 566, when someone in Athens—possibly Peisistratos or the Archon Hippokleides (see p. 20)—reorganized and set down regulations for an older, local festival of Athena and thereby created what we know as the Greater Panathenaia.[37] What set the Panathenaia apart from other regional and Panhellenic festivals was not so much its musical contests but contests for rhapsodes, to which we shall return at the end of this essay.

An inscription that may be correlated with the decree on musical contests to which Plutarch refers, listing contests and their prizes at the Panathenaic Games, is preserved in several large fragments (see fig. 1), *IG* II² 2311.[38] The column dealing with the musical contests preserves about twenty lines, with entries for most, but not all, of the events. Dating to the first half of the fourth century,[39] it is our fullest document on these games and must certainly reflect the program as it was laid down by Perikles. It is not, however, a reliable guide to the program before Perikles' time, and here only a close comparison with the imagery of Archaic vases will allow

FIG. 37 Panathenaic-shaped amphora with kitharode, attributed to the Berlin Painter (obverse), ca. 490–480. (Formerly in the Hunt Collection)

was either considered not worthwhile to have two such events, or else both men and boys competed in the same category.

Musicians in Classical Red-Figure

Kitharodes and Kitharists

When we compare *IG* II² 2311 to representations on red-figure vases of the second half of the fifth century, the correspondence is very close. We should first note that there is a sudden surge in depictions of musical contests and victors about 440, suggesting that whatever Perikles did made these contests more visible and more popular with the Athenian audience than they had been at any time since before the Persian wars.

Kithara players are the most often depicted, but it is not easy to say which are kitharodes and which are kitharists. In Archaic art, the distinction was often obvious, because the portrait of the kitharode in performance, his head thrown back and mouth open, was a favorite image (fig. 37). But in Classical red-figure, the moment shown is usually the presentation of prizes, whether by Nikai (cat. 22) or mortals, after the performance is over,[42] or, less often, a contestant mounting the platform to begin.[43]

The musician is usually a beardless youth, in keeping with the idealizing style of High Classical art, though the judge may be (and in real life surely was) a bearded man.[44] Owing to the youthful appearance of virtually all the contestants, it is hard to say which, if any, may be intended as entrants in the contest for boy kitharists. On an oinochoe in Rome, the kitharist mounting the bema does, however, look like a boy, his hair long and flowing as boys wore it before they became ephebes and entered military service at age eighteen.[45] His audience is, exceptionally, two women, one of whom brings metal *phialai*, the victor's cash prize (he is already wearing a wreath). Because the one extant Panathenaic prize amphora showing a musical victor also belongs to this period (see p. 35),[46] there had been some confusion about what prizes the winners in these contests actually received: olive oil, as the Leningrad Panathenaic would suggest, or gold and silver, as the inscription prescribes

us to make some inferences about the changes made by the great statesman.

The inscription lists four musical events,[40] in this order: *kitharodes* (singing and accompanying oneself on the kithara); adult *aulodes* (man singing to the flute); adult kitharist (man playing the kithara); and *auletes* (playing solo flutes). The wording implies that at least two events, those for boy aulodes and kitharists, are lost from the inscription.[41] Why two events had separate divisions for men and boys while two were open only to men can only be guessed at on the basis of what we know about the instruments and voices and their place in Athenian education and society.

The contest for kitharodes was clearly the most prestigious, judging from the number (five) and size of the prizes (a maximum of 1500 drs.). These men were evidently highly sought-after and well-paid professionals who performed at various festivals around the Greek world. While Athenian boys did learn to play the kithara, and could compete in this, they probably did not attempt the complex feat of simultaneous playing and singing until grown. Singing to flute accompaniment, on the other hand, was a natural activity for young boys, and their clear soprano voices were probably much admired, like those of choir boys today. Grown men and youths whose voices had changed would logically have had a category of their own. Lastly, the contest for solo flute was the least prestigious, with the smallest prizes, and it

22 Lekythos with Nike carrying kithara, attributed to the Oionokles Painter, ca. 470

FIG. 38a,b Amphora with kitharist (obverse) and aulete (reverse), attributed to the Peleus Painter, ca. 440. Agora Museum, Athens, P 27349

and several scenes like the one on this oinochoe show.[47] The solution, as seen by Davison, is probably to consider the prize vase an aberration of the Peloponnesian War years, when precious metals were needed for more urgent purposes.[48] Yet another form of prize indicated by some vases (but not mentioned in the inscription) is a bronze hydria, which Nike may bring, or even use in lieu of a chair.[49]

These scenes of the last four decades of the fifth century now decorate a wide variety of shapes, especially stamnoi and pelikai, rarely the amphora of Panathenaic shape that had been so prevalent earlier (see figs. 43, 46). One exception is a vase in Boston, the association with the Panathenaia emphasized even further by the presence of Athena herself as the listener.[50] No two of the kithara-players on these vases wear the identical outfit, but virtually all wear two or more long garments with contrasting textures and patterns to create a festive and elegant costume.[51]

Aulodes and Auletes

Representations of aulodes and auletes in Classical red-figure are somewhat less numerous than those of kithara-players, a further indication that these contests had a lower status in the popular perception. Despite the epigraphic evidence that there were two separate contests for aulodes, for men and for boys, all the extant representations from the time of Perikles and later show a boy aulode.[52] The difference in size between him and the adult accompanist is marked, further underlined in one instance by a bearded flutist.[53] The usual arrangement is for both performers to face the same direction, the singer in front, although they occasionally face one another.[54] There are precedents for both arrangements in Archaic vase-painting. An unusual variation is a scene of two flute-players, either standing side by side or one behind the other.[55] The fourth-century inscription does not make reference to such a flute duet, yet both vases have clear indications of an agon: on one, two Nikai, one of them carrying prize phialai; on the other, a bearded listener with a knotty stick, who should be a judge. The duet could correspond to the *synaulia*, or flute duet, attested elsewhere for the Panathenaic festival.[56]

Lastly, two large vases with much in common have considerably enriched our picture of the mousikoi agones as they took place in Periclean Athens. Both were found relatively recently and are incompletely preserved, both date to the years just after Perikles' reforms, and both have unexpected provenances in mainland Greece, unlike the great majority of Attic red-figure vases that were exported to Italy.

A fragmentary belly amphora found in 1965 in the American excavations of the Athenian Agora was dated about 440 by the excavator and attributed to the Peleus Painter (figs. 38a,b).[57] It is quite unusual in that it depicts two different contests: on the front, a kitharist, on the back, an aulete. Several Archaic vases juxtapose two contests in this manner (see fig. 49 and cat. 19), but the combination of scenes is rare in Classical red-figure. Indeed, the very shape of the vase is an Archaic one that was almost extinct when the Agora amphora was made.[58] One other detail is also more reminiscent of Archaic scenes than of contemporary vases: the aulete

FIG. 39a, b Calyx-krater with musical and athletic contests (obverse and reverse), attributed to the Painter of Munich 2335, ca. 440–430. Larisa, Greece, 86/101

does not stand on a bema, even though the presence of Nike behind him assures us that he is a victor in the Games. Even the representation of the lone aulete is an oddity since, as we have seen, the contest for aulodes was of much greater interest to the Athenian audience.

Many of the same unusual features recur on a calyx-krater found in 1970 at Larisa, in Northern Greece (figs. 39a,b), which is if anything even more extraordinary.[59] Again two musical contests are shown, for aulete and aulode, along with two athletic contests, one for armed runners (*hoplitodromoi*), the other uncertain. The aulete's prize, a wreath, is handed to him (the figure bestowing it is lost), while a Nike approaches carrying another prize, a bronze hydria. The aulode is too poorly preserved to tell if he is a man or boy, but most of a Nike and a column of the Odeion are preserved. The krater is utterly unique in presenting a compendium of four Panathenaic events, and this, along with the many inscriptions, some of them naming historical persons known from other contexts, strongly suggests that it was a special commission, probably for a man from Larisa.[60]

As we have seen, vase-paintings of the second half of the fifth century do, for the most part, corroborate the epigraphic evidence for the musical competitions in the time of Perikles and after. They confirm that kitharists could be either men or boys, but are more ambiguous on the question of kitharodes, since none is shown in the act of singing that would clearly identify him as such. They seem to confirm that auletes were always men (or at least grown-up youths), but, in their enthusiasm for boy aulodes, the painters fail to provide evidence that adult men also competed in this event.

Archaic Vase-Painting and the Origins of the *Mousikoi Agones*

Aulodes and Auletes

For the Panathenaic Games of the Archaic and Early Classical periods we have no inscription like *IG* II² 2311 to guide us, and few references in ancient literature. Therefore we must evaluate the growing corpus of visual evidence all the more carefully in order to address such questions as: When were the various musical contests first put on the program at the Panathenaia? Once introduced, did they stay on? Were certain events restricted to men or boys even before Perikles' legislation? Were the relative prestige and popularity of the various events reflected in the hierarchy of the prize lists of *IG* II² 2311, and what form did the prizes take in the time before Perikles? Finally, and perhaps most difficult, what material did these musicians perform? By this I mean, primarily, from which poets did the kitharodes and aulodes draw the texts that they sang?

While the evidence for both flute and kithara contests is plentiful in the sixth century, the flute has priority by nearly a full generation. Even if we were to discount a few very early scenes of flute performances on the grounds that they are not necessarily contests, we are still left with a sizeable corpus of both aulodes and auletes in a Panathenaic setting in the period ca. 550–530, before our earliest certain picture of a Panathenaic kitharode or kitharist. The historical implications of this chronological sequence are evident. Whereas the presumption that musical contests were introduced as part of the major reorganization of the Panathenaia in 566 has great credi-

FIG. 40 Panathenaic-shaped amphora with aulode (reverse), ca. 550–540. British Museum, London, B 141

bility where flute contests are concerned, it is less convincing in the case of the kithara, and the hypothesis of a later introduction of these contests, during the Peisistratid tyranny, should also be weighed. But we may first take a closer look at the images themselves.

The earliest representation of an aulode is a small amphora of about 550–540 in London (fig. 40). It has all the Panathenaic hallmarks we have learned to look for: the shape is that of a prize vase but greatly reduced, and a striding Athena decorates the obverse. On the reverse, aulode and aulete stand on a table facing each other, flanked by a seated judge and a standing listener.[61] The vase is not only quite small, but crudely painted, giving little hint of the splendor the festival had recently acquired. But within a decade or so, the same scene will reappear on generously proportioned amphoras by some of the finest black-figure artists.

One whose interest in the Panathenaia and the cult of Athena is unmistakable is the Princeton Painter, active in the years around 540. No prize Panathenaics have been attributed to his hand, but he decorated several amphoras of the same shape, one with an aulodic contest (cat. 18).[62] The two performers stand on a high table, not the stepped bema that will later become canonical. A small footstool under the table seems to serve as a kind of step for mounting the platform. The singer holds a branch, perhaps alluding to the prize wreath he hopes to win,

and each bearded listener holds up an object, most likely flowers or buds. This is one of the earliest instances of a curious detail that will become more popular in early red-figure, the audience member at a musical performance who sniffs a flower. The two musicians are much smaller in scale than the listeners, but it is not obvious whether this is because they are boys or simply because the high table left the painter so little room. They are beardless and so certainly younger than the audience, but since we do not otherwise see or hear of boy flutists accompanying boy aulodes, these two are probably meant as youths of ephebic age.

The same is true of a contemporary amphora in Bonn,[63] not as finely detailed but following a similar schema. The only noticeable departure is that here one listener stands, perhaps to indicate that he is, by metonymy, the audience, while the seated man is the official judge. The platform has been lowered, making the four figures more in scale, though the distinction of bearded listeners and beardless performers is retained.

To find a boy aulode in black-figure we must go down to near the end of the sixth century, to the remarkable neck-pelike in New York (see p. 52, cat. 19). Though tightly wrapped in a mantle that allows no hand gestures, the singer is giving an animated performance, with head back and mouth wide open, while his bearded accompanist is a study in quiet concentration. Instead of face to face, the singer now stands behind his partner, while yet another configuration, the two performers side by side, also occurs.[64] It seems there was no standard or required position for the aulodic contestants, nor any standard size or shape for the bema.[65]

The contest for solo flute-player, though not as popular as that for aulode, is fairly well represented throughout black-figure and begins almost as early. Perhaps the earliest is shown on the small amphora of Panathenaic shape in Austin (cat. 17). Here we may be certain that the diminutive size of the aulete atop his high podium is due to nothing more than the painter's inexperience, since there is no evidence that boys ever competed in this event. Late black-figure auletes include both bearded men and beardless youths,[66] but surely the most evocative picture of an auletic contest is on the reverse of Euphronios' great Antaios krater in the Louvre.[67]

18 Panathenaic-shaped amphora with aulodic contest, attributed to the Princeton Painter, ca. 540

17 Panathenaic-shaped amphora with recital of double pipes, ca. 540

FIG. 41 Amphora with aulete (obverse), ca. 560. National Museum, Athens, 559

The music of the flute was ubiquitous in Greek life long before it became the focus of contests at the Panathenaia. Aside from its role in sacrificial processions and athletic training already noticed, flute music accompanied soldiers into battle[68] and was the preferred form of entertainment at social gatherings, from the boisterous *komos*, or revel, of Archaic art to the more sedate symposia of red-figure. Perhaps the earliest Athenian flute-player whom we know by name is one Empedokrates, depicted on a cup of ca. 560 playing between two dancing men.[69] All three are male, but the flutist is set apart as a youth with long hair, while the revelers are bearded men. A fragmentary amphora contemporary in date shows the first flute-player we may confidently call a professional, based on his outfit of sleeveless *ependytes* over a long chiton.[70] He stands on the ground, and his listeners hold drinking horns, so there is no reason to think the context here is the Panathenaia, much less an agon.

A much-discussed vase of the same period has an amusing combination of flute-player, listener, and a very attentive goose (fig. 41).[71] Semni Karouzou's ingenious attempt to connect the flute-player with Olympos, the mythical inventor of the art, is still quite attractive.[72] But her further hypothesis, that the vase's shape is "proto-Panathenaic" and anticipates the earliest prize vases and the events of 566, is less convincing today. The shape is a standard ovoid neck-amphora of a type especially popular in the second quarter of the sixth century, and the date, judging from both shape and drawing, is rather about 560 than 570.[73]

If the contests for aulodes and auletes were indeed instituted at the reorganized Panathenaia of 566, as seems probable from the visual evidence, a likely source of inspiration was the Pythian Games at Delphi. Here, according to Pausanias (10.7.3–5), both flute contests were introduced in 586,[74] though the one for aulodes was quickly dropped at the next festival four years later, because it was thought too "elegiac." That is, it was too reminiscent of the singing of dirges at funerals. This evidently did not bother the Athenians, perhaps because the custom of singing laments to the accompaniment of the flute was not widespread in Athens.[75] Pausanias' reference to elegy nevertheless gives a clue to what the

aulodes performed, that is, verse in elegiac meter (alternating hexameter and pentameter lines). This is confirmed by Plutarch (*On Music* 1134A), who cites an official regulation at the Panathenaia (*graphe Panathenaion*) requiring aulodes to sing elegy. These elegies had nothing to do with laments, however (except for sharing the same meter), but were long narrative poems that could have dealt with various mythological and non-mythological subjects, such as local historical traditions, colonization, or heroic deeds.[76]

Kitharodes and Kitharists in Archaic Vase-Painting

When we turn to the imagery of kithara-players in Archaic art, it is both richer and more difficult to interpret as evidence for the Panathenaic contests than that of aulodes and auletes. One complication, already met in red-figure, is the problem of distinguishing kitharodes, who both play and sing, from kitharists, who only sing. Another is to distinguish mortal, Athenian kithara-players, participants in the Panathenaic Games, from their divine role-model Apollo, who is frequently depicted as *kitharoidos* in Attic black-figure. Indeed, from his earliest appearance in Athenian art, on Sophilos' great dinos in London of ca. 580,[77] Apollo's principal attribute is the kithara. The potential for ambiguity is well illustrated by the fine amphora of Group E in San Antonio (cat. 20). Its shape is not Panathenaic; rather, it is the standard one-piece amphora so characteristic of the third quarter of the sixth century. Yet there is an unmistakable allusion to the Panathenaia in the columns that flank the scene on both sides.[78] Is the young performer, then, a victorious kitharode at the Panathenaia, the struggle of Herakles and the Lion on the other side perhaps alluding to the subject of his song? I would be inclined to this view, though neither the bema nor the audience that would assure the interpretation is shown.[79]

The question, Apollo or mortal, is of some import, for this amphora, at ca. 550–540, is some two decades earlier than the first kitharodes in vase-painting who can unambiguously be called Panathenaic competitors. Nor is this amphora unique. We may associate it with several more vases of the same date that present similar problems of interpretation. A neck-amphora by the Princeton

20 Amphora with lyre-player, attributed to Group E, ca. 550–540

Painter, recently acquired by the Musée d'Art et d'Histoire in Geneva,[80] pairs Athena in a quiet encounter with an elaborately garbed kitharist. Is he Apollo, joining his Olympian half-sister in one of the intimate divine gatherings that are ubiquitous in black-figure, or a Panathenaic victor enjoying the favor of the goddess herself?[81] The large tripod posed between the two figures perfectly captures the dilemma, for in one interpretation it would be Apollo's oracular tripod at Delphi, in the other, a prize for the victorious musician.[82] The scene on the obverse of the rape of Kassandra seems at first glance wholly unrelated, though partisans of a Panathenaic interpretation of the reverse would be quick to point out that the statue of the martial Athena to which Kassandra flees is strikingly reminiscent of the striding Athena on Panathenaic prize amphoras.

Another neck-amphora of similar shape and style appears to draw most explicitly the parallel between the mortal kitharode and his divine prototype (figs. 42a,b).[83] On one side Apollo stands next to his sister Artemis and strums his instrument. On the reverse, a kithara-player assumes the very same pose as the god, but he is alone and framed by sphinx-topped Doric columns. The praise for the mortal musician that is implied in the juxtaposition of god and man is clear; and lest we confuse the two musicians, the painter has made the Athenian a mature, bearded figure of ample propor-

FIG. 42 a, b Neck-amphora with kitharists (obverse and reverse), ca. 550–540. British Museum, London, B 260

FIG. 43 Panathenaic-shaped amphora with kitharist (reverse), ca. 550–540. British Museum, London, B 139

tions, while Apollo is youthful and beardless, the eternal ephebe.

Lastly, a modest vase again datable to shortly after the middle of the sixth century goes one step further in establishing a Panathenaic context for the kitharode (fig. 43).[84] Now both sides include framing columns, and all are topped by cocks borrowed from prize Panathenaics. The shape is Panathenaic as well, but the painter has distanced his Athena from the familiar Promachos type by turning her around and immobilizing her with both feet planted firmly on the ground. This has the additional effect of making her face the kithara-player, who is similarly still.

The vases just considered may well have been inspired by performances of kitharodes at the Panathenaia, but it is still surprising that to find a scene that unquestionably depicts such a performance we must come down to the decade 530–520 and look to red-figure. The Andokides Painter's splendid amphora in the Louvre (fig. 44) has the two decisive elements: a two-stepped platform on which the youthful musician stands, and a pair of elegant young listeners.[85] The scene is in every way a fitting counterpart to the same artist's Basel amphora with an aulodic competition (fig. 45), right down to his signature flower-sniffer.[86] Though technically brilliant, the scene captures little of the excitement of a live performance, the singer rather stiff and uninspired and

FIG. 44 Amphora with kitharist (reverse), attributed to the Andokides Painter, ca. 530–520. Musée du Louvre, Paris, G 1

FIG. 45 Amphora with aulete (reverse), attributed to the Andokides Painter, ca. 525–520. Antikenmuseum Basel und Sammlung Ludwig, Basel, BS 491

FIG. 46 Panathenaic-shaped amphora with kitharist (reverse), ca. 500–485. The Walters Art Gallery, Baltimore, 48.2107

the listeners more self-absorbed than rapt. What a contrast with the powerful versions of the same subject by another great artist two generations later, the Berlin Painter (see fig. 37).

The rigid posture is not just a trait of the Andokides Painter, however, but rather a feature common to all the earliest depictions of Panathenaic kithara-players, including several in black-figure. An amphora in Baltimore (fig. 46) follows an almost identical scheme, but adds two more Panathenaic elements, the shape of the vase and the striding Athena on the front. Only the size and the lack of an inscription prevent this vase from being mistaken for a prize amphora.

In both instances, the player's immobility leaves us wondering whether he is a kitharode or kitharist. But by the last decade of the sixth century, kithara-players assume a variety of poses, and in general, the more animated they are, the more they convey the impression of vocal performance. They may take a striding step, as on a pelike in Bologna,[87] or lean forward on one foot, as on an unusual black-figure amphora with a lone kithara-player between columns on either side of the vase.[88] The earliest to combine the striding pose with the distinctive tossing back of the head is on a black-figure pelike in Kassel (fig. 47).[89] The bema is curiously absent, but one look at this impressive musician, with his hefty instrument already poking up into the palmette ornament,

67

FIG. 47 Pelike with kitharode (obverse), attributed to the Leagros Group, ca. 500. Staatliche Kunstsammlungen Kassel, Antikensammlung, T. 675

shows why the painter wisely chose to omit the platform.

Other motifs that we have already seen in red-figure are anticipated by more than half a century, such as the kitharode mounting the bema.[90] But the greatest innovations in the iconography, and the most evocative images of the kitharode, are owed to the Berlin Painter, in the first two decades of the fifth century. He was so fond of this subject that he repeated it many times, but always with variations and subtle exploration of the psychology of performer and listener.[91] His fascination with the instrument led to the creation of another image that resonates through Early Classical vase-painting: a flying Nike holding a large, ornate kithara (cat. 21). It has recently been argued that these scenes allude directly to victories in the Panathenaic contests for kitharodes during the years ca. 480–450, when the event itself is not represented.[92]

Kitharodes, Historical and Legendary

The enormous esteem and popularity of the kitharode in Archaic Greek society is suggested not only by the divine exemplar, Apollo, but by the mythical singer Orpheus. When first seen in Greek art, on a metope of the Sikyonian Treasury at Delphi,[93] he stands in the prow of the Argo, holding a lyre, next to a similar figure who holds the same instrument. Some thirty to forty years later, the earliest representation of Orpheus in Athenian art is strikingly similar to contemporary images of kitharodes at the Panathenaia.[94] His instrument is now the seven-stringed kithara, and he mounts a bema, not unlike several performers on vases just a few years later.[95] An inscription ("Greetings, Orpheus!") identifies him beyond question, but by the fifth century, when Orpheus becomes popular in vase-painting as the victim of the Thracian women's wrath, he has returned to the more primitive looking lyre.[96]

We are very poorly informed about the historical kitharodes who performed at the Archaic Panathenaia,[97] though a famous legend recounted by Herodotus (1.23–24) gives a vivid portrait of a successful professional. Arion, a native of Methymna on the island of Lesbos, was reputed to be the greatest kitharode of his time. He spent most of his career at the court of the enlightened tyrant Periander of Corinth in the late seventh and early sixth century, an association that the Athenian tyrants Hippias and Hipparchos would emulate years later in sponsoring some of the most famous poets of their day. Arion went to perform in some of the Greek cities of South Italy and Sicily—an indication of the itinerant careers of the more successful musicians[98]—and it was on the return journey to Corinth that the extraordinary events took place that so fascinated Herodotus and his audience. Betrayed by the Corinthian sailors he had engaged to take him home, Arion was forced to jump overboard. But he was miraculously rescued by a dolphin and conveyed to the Peloponnesian shore.

The Herodotean version contains many incidental details that help us better envision the kitharodes who performed in Athens. The large sum of money earned in the West and coveted by the sailors recalls the lavish prizes offered to the winning kitharodes at the Panathenaia.[99] Arion's costume, though never described, is referred to several times, with the implication that it was especially fine and ornate, as we see in many variations in the depictions of kitharodes.[100] And the theatrical flair of the great singer—it is he who proposes the performance with grand finale, the leap overboard—along with the evident relish of his otherwise hostile audience,

21 Nolan amphora with Nike holding kithara, attributed to the Berlin Painter, ca. 460

FIG. 48 Neck-amphora with Herakles as kitharist (reverse), attributed to the Leagros Group, ca. 515–510. Worcester Art Museum, Worcester, Massachusetts, Austin S. Garver Fund, 1966.63

suggest something of the tremendous enthusiasm that must have greeted the contest for kitharodes in Athens. Arion's rescue was no doubt believed to reinforce the sense that musicians, and especially kitharodes, enjoyed the special favor of Apollo, with whom the dolphin was closely associated.[101]

An unlikely performer who joins the ranks of kitharodes on Athenian vases is none other than the hero Herakles (fig. 48).[102] His career in vase-painting is fairly short-lived, limited to the last third of the sixth century, but the substantial number of representations makes this a significant, if puzzling variation on the Panathenaic agon. Like his Athenian counterparts, Herakles may stand on the ground,[103] mount a platform,[104] or, in one instance, stand atop a high stepped bema.[105] Athena is almost always present as a listener, linking these scenes both to the Panathenaia and to the many Archaic scenes that show her as the hero's patron and helper in his deeds.[106]

But perhaps the main reason for the extraordinary prestige of the Archaic kitharode is that the best of them composed their own songs, verses that might become known throughout the Greek world. Just as the elegiac couplet was the meter preferred by aulodes, so the kitharodes had their own meter, the dactylic hexameter. This is, of course, the meter of Homeric epic, and it is likely that at many festivals throughout Greece, kitharodes sang excerpts from Homer. But since at the Panathenaia Homer was the special province of the rhapsodes who performed unaccompanied, we must imagine another type of poetry being sung by the kitharodes, what Walter Burkert has recently called "epic narrative in lyric form."[107]

The poet most closely associated with this genre is Stesichoros of Himera, in Sicily.[108] Although not a single work of Stesichoros is preserved in more than tiny scraps, from the many fragments and references to him in later writers we gain some idea of the range of his prolific *oeuvre*. His subjects were almost always drawn from heroic legend, often the same stories that, to judge from their titles (The Sack of Troy, The Theban Cycle), were treated in epics now lost. He also dealt with some deeds of Herakles (Geryon, Pholos the Centaur) and other local heroes like the Athenian Theseus.[109] But although he shared the meter and subjects of epic, his works were counted in hundreds, not thousands, of lines and were thus suitable for a single performance. An ancient source reports that Stesichoros set his own hexameter verse to music; modern opinion is divided as to whether he performed solo or accompanied a chorus of dancers.[110] He himself died in 556 and is unlikely ever to have appeared at the Greater Panathenaia, but the well-documented impact of his poetry on Attic art of the Archaic period is best explained if we imagine the intermediate stage from poet to painting to be the public performances of kitharodes at the festival.[111]

The Setting of Musical Contests

We do not know where the musical contests at the Panathenaia took place in the Archaic period, before the building of Perikles' Odeion. Probably they were held outdoors, as dramatic performances were in all periods, perhaps in the Agora. The representations on vases do not offer any indication of setting, nor would we expect them to. But a small group of vases, all of the last two decades of the sixth century, does begin to give some of the flavor of the festival by combining two musical events in the same scene. Several of these are black-figure pelikai, like the one in New York noted above (cat. 19)

19 Neck-pelike with kithara-player (reverse), ca. 500

with the young open-mouthed aulode. The reverse of this charming vase shows a kithara-player delicately lifting his garment and right foot as he turns to look at an unseen audience. Two other pelikai combine kitharode and aulete. One, formerly on the New York art market, has on each side an audience of two men sitting on folding stools, a common arrangement.[112] But the other, in Sydney,[113] has a more unusual variation, a single listener on each side, a mature man on a block-like seat in an animated pose of evident delight.

Even more evocative of the festival atmosphere is a modest scene where the two musical events are joined in a continuous frieze, as if happening at the same time and in close proximity. A small, fragmentary alabastron at Harvard (figs. 49a,b) has a kitharode mounting a low, decorated bema while an aulode and accompanist perform on a very different bema with several steps.[114] The solitary listener, sandwiched between the two events, stands on tiptoe, as if transported by the music.

FIG. 49a, b Alabastron with two musical contests (obverse and reverse), late 6th century–early 5th century. Arthur M. Sackler Museum, Harvard University, Cambridge, Massachusetts, Transfer from the Department of Classics, Harvard University Haynes Bequest, 1977.216.2397

Rhapsodes at the Panathenaia

These and many other vases of the late sixth century give the distinct impression that this was a period of musical efflorescence in Athens, ushered in by the sons of Peisistratos, who as enlightened tyrants ruled with panache and considerable success from their father's death in 528 to the assassination of Hipparchos in 514. Hipparchos is well known for bringing to Athens two of the most distinguished poets of the day, Anakreon of Teos (in Asia Minor) and Simonides, from the nearby island of Keos. Aristotle would later call Hipparchos a "lover of the Muses" (*philomousos; Constitution of Athens* 18.1), and we may presume that the mousikoi agones were held with particular splendor in these years. While literary sources do not explicitly connect the tyrant with music or musicians, they do ascribe to him an important role in a closely related contest, for rhapsodes.

The key testimonium occurs in a dialogue named for Hipparchos and preserved in the corpus of Plato. Sokrates,[115] in a long encomium of the tyrant, says of him, "and he first brought the poems of Homer to this land and compelled the rhapsodes at the Panathenaia to go through them in order, each taking up the cue, as they still do now."[116] A century after the time of Hipparchos, in a genuine dialogue of Plato, Sokrates interviews a celebrated rhapsode, Ion, in a manner that suggests the low regard in which at least some 'intellectuals' held these professional performers by the late fifth century. In the early fourth-century inscription listing prizes at the Panathenaic Games, rhapsodes are not mentioned, but have been restored in the missing lines at the top of the column recording musical contests.[117] If this restoration is correct, then we have evidence for rhapsodic competitions over a century and a half and possibly much longer. Yet despite these sources, almost everything about the rhapsodes, even the meaning of their name, is uncertain and shrouded in a peculiar mystique.

The etymology of the word *rhapsodos* was debated even in antiquity and sometimes erroneously derived from *rhabdos*, a long walking stick or staff thought to be a hallmark of these itinerant performers. But the correct derivation of the first element is from a verb meaning 'sew' (*rhaptein*), while the second element is the Greek word for 'song'; hence a rhapsode is a man who stitches together a song.[118] The earliest performers who fit this description are several that appear in Homer, there described simply as "singers" (*aoidoi*). Employed by the nobility, they entertain at banquets, like Demodokos at the court of King Alkinoos of Phaiakia. His songs might be about the gods, like the slightly scurrilous tale of the adulterous love of Ares and Aphrodite (*Odyssey* 8.266–366), or about heroic exploits like the war at Troy (8.499–520). Homer himself was probably just such an *aoidos* and, like Demodokos, would have accompanied himself on a stringed instrument.[119] That such performers also competed for prizes at this early date is attested by Hesiod's proud boast that he had travelled to Chalkis, on Euboia, to enter the funeral games for Amphidamas and there won the prize, a bronze tripod, with his song (*Works and Days* 651–59).

But later in the Archaic period, when we first hear of rhapsodes referred to by this name, they seem to be different from the Homeric singer in several important ways. First, they perform at public festivals rather than in private homes, always in an agonistic setting. The earliest, brief mention is in Herodotus' account (5.67) of the tyrant Kleisthenes of Sikyon in the early sixth century. While at war with neighboring Argos, Kleisthenes banned the competition of rhapsodes in his city on the grounds that the Homeric poems were full of favorable references to Argos and the Argives.[120] We may infer from this that Archaic rhapsodes no longer spun their songs with free improvisation, like Homer's Demodokos or Homer himself, but performed fixed texts, such as the Homeric epics. This change was accompanied by a second, as other evidence also suggests, namely that the art of the rhapsode did not involve a musical instrument, but was "the solo presentation, in public, of a poetic text without musical accompaniment."[121]

This definition would well suit what little we know of the rhapsodic contests at the Panathenaia and Hipparchos' actions to regulate them.[122] His "bringing" of the texts of Homer to Athens (as the author of the *Hipparchos* puts it), probably from Chios, where a guild of poets called Homeridai jealously guarded what they considered the authoritative version,[123] does not imply that before this time the rhapsodes at Athens performed

something other than Homer. It suggests, rather, that they performed much the same material (i.e. the Trojan Cycle), but not according to one authoritative version, nor the two Homeric poems in their entirety. What they performed were probably individual episodes, certainly not corresponding to one of the so-called books into which the *Iliad* and *Odyssey* were first divided by Alexandrian scholars of the Hellenistic period, but self-contained, satisfying stories. Indeed, ancient commentators often refer to particular episodes within the epic by titles: "The Funeral Games of Patroklos" (*Iliad* 23); "The Embassy to Achilles" (*Iliad* 9); "The Ransom of Hektor" (*Iliad* 24).[124] One such episode, about 500 to 800 lines, would be an appropriate length for a rhapsode's performance. Even if he did not have a written text, these popular episodes were recited so often and were so well known to audiences that the rhapsode could only introduce minor variations at most. His principal creativity was expressed in the mode of performance, not in the words themselves. This is not to slight the skill or artistry of the Archaic rhapsode, as did Plato's Sokrates. After all, different Shakespearean actors, all speaking the identical lines, have produced radically different interpretations of Hamlet.

The repertoire of Attic black-figure vase-painting in the years ca. 560–520 tends to support and clarify this view of the pre-Hipparchan rhapsode. For if we suppose that rhapsodic performances were a key means of transmitting the Homeric stories to the vase-painters who, along with their fellow Athenians, were in the audience at the Panathenaic Games, then the subjects they favor should provide a rough guide to the episodes most often performed.[125] The repertoire includes many scenes from the Trojan War story that had not been seen in Attic art prior to about 560. But the most striking feature, as has often been observed, is the underrepresentation of subjects from the *Iliad* and *Odyssey* and the prominence of other parts of the Trojan Cycle.[126] A glance at the finest black-figure vase-painting quickly reveals the favorite subjects (after Herakles' deeds and the Dionysiac entourage, which together far outnumber all others): The Judgment of Paris, The Sack of Troy, Achilles' combats with Memnon and Penthesilea, his ambush of Troilos, to name just a few.[127] None of these occur in Homeric epic, yet all relate to the Trojan War and all would have been well suited, in length, narrative excitement, and vivid characterization, to a rhapsodic performance.

All this suggests a possible key to understanding the importance of Hipparchos' action in "bringing the Homeric epics" to Athens. Part of Homer's genius was to select two coherent complexes from the mass of stories about the Trojan War which circulated orally for centuries—one revolving around the theme of Achilles' anger with Agamemnon, the other around Odysseus' adventures in the aftermath of the war—and to shape each into a lengthy, artistically unified narrative. Many other poets attempted to do the same for other parts of the Cycle, and some of their names and the names of their works are known to us.[128] Yet none of them survives, except in the tiniest of fragments, because in the collective judgment of antiquity they were inferior to the works of the blind poet from Chios.

I would like to suggest that Hipparchos was one of the first to be instrumental in this process of weeding out. In the early sixth century there must still have been great confusion about which poet composed which part of the Cycle and much disagreement about what were genuine works of Homer.[129] Hipparchos, advised perhaps by the Homeridai, the 'keepers of the flame,' determined that only two poems were genuinely Homer's. By ensuring their regular performance in Athens while barring others, he began the process of fixing authorship.[130] Of course, other parts of the Cycle retained their appeal as good stories and as choice material for visual artists. Still, Hipparchos' literary judgment (and his ability to act on it) helped set in motion the long tradition of the Homeric poems as the foundation of Greek education.

Athenian vase-painters have, unfortunately, left us a much less complete record of the agon for rhapsodes than for any of the musicians. The reason may be that, with no fancy costume or distinctive instrument, the rhapsodes tended not to catch the artist's eye. There are, nevertheless, a few performers who, precisely because of this lack of both costume and instrument, can be recognized with some certainty as rhapsodes.[131] A pair of vases both dated to about the last decade of the sixth century have many features in common, especially the

FIG. 50 Panathenaic-shaped amphora with rhapsode (obverse), ca. 520. Stadtmuseum, Oldenburg

lone performer on a low podium between listeners. One, an amphora in Oldenburg (fig. 50),[132] is even of Panathenaic shape. The rhapsode carries a crooked staff that must be the rhabdos, while one of the listeners holds the forked stick that may mark him as the judge. The other vase, a pelike in Dunedin,[133] distinguishes the judge from audience by having the former seated. A homey touch is the listener's dog, who is more interested in chewing a bone than in the words of the rhapsode. The performer lacks his staff, but with head thrown back he is clearly in the midst of a recitation.

Both vases are some one to two decades after Hipparchos' reforms and thus give no evidence for how early the contest existed. A fine amphora of about 540, however, also seems to depict a rhapsode (figs. 51a,b), offering firm evidence that the contest certainly predates Hipparchos and may well have been introduced along with the other mousikoi agones in 566. The vase is again Panathenaic in shape and has the striding Athena on the obverse, so it surely must show a contest.[134] The only element missing is the bema, but we have seen that this was not an absolute requisite for musicians and surely was not for rhapsodes either.[135] One listener sniffs a flower, a gesture we have established as typical of audience members at musical contests.[136] Like the two later rhapsodes, the performer is a bearded man dressed in civilian clothes, indistinguishable from his audience except for the characteristic staff. His head is lowered in contemplation as he prepares to begin or resume the recitation.

The most complete surviving literary portrait of a rhapsode is Plato's dialogue *Ion*. Here, the celebrated professional, Ion of Ephesos, has just won the prize in a contest at Epidauros (presumably at a festival in the sanctuary of Asklepios) and now hopes to win again at the Panathenaia. The portrait is not entirely flattering, for Sokrates suggests that the rhapsode's power over his audience does not come from a special artistic or intellectual skill, but rather from his function as a kind of divinely possessed medium. In other words, Sokrates tries to show that Ion is merely the mouthpiece of Homer.[137] In modern terms, the successful rhapsode is like a good actor, memorizing his lines and reciting them with the proper delivery, but not engaged in the actual process of composition. Indeed, Ion boasts that, like a modern actor, he is most effective when he really "works his way into the role," experiencing the powerful emotions of the heroes of whom he sings (535C–E). Since stage actors were never held in high repute in antiquity, it is little wonder that intellectuals like Sokrates and Plato had low regard for the histrionics of the rhapsode. But the typical Athenian audience at the Panathenaia was surely not so elitist, and for them the rhapsodes provided great popular entertainment. It is a tribute to the skills of the Classical rhapsode that, in performing poems already hundreds of years old, in an epic diction as archaic as Chaucer's is for us, he was still able, as Plato's Ion claims he was, to hold the audience in the palm of his hand.

The contest for rhapsodes thus served many purposes in the overall *Kulturpolitik* of the tyrants. In addition to providing first-class free entertainment and proclaiming Athens as the home of the Muses, where the greatest performers of the day could be heard, the rhapsodes now insured that all Athenians would be continually exposed to the great artistry and ethical teachings of the immortal bard. The institution of musical and poetic

FIG. 51a, b Panathenaic-shaped amphora with rhapsode (obverse and reverse), ca. 540. The Board of Trustees of the National Museums and Galleries on Merseyside, Liverpool, 56.19.18

contests for the edification and enjoyment of the citizenry anticipates by over a century Perikles' boast, in his great funeral oration, that Athens, more than any other city, provides her citizens spiritual nourishment and respite from daily chores in the form of sacrifices and games at the major festivals (Thukydides 2.38).

A century earlier, Hipparchos had regulated the contest for rhapsodes because he thought it would be beneficial for the Athenians to hear the great works of Homer properly recited. The tyrants' sponsorship of the rhapsodes is typical of their almost paternalistic attitude toward their Athenian subjects. This attitude is manifested above all in the founding of cults and sanctuaries which, like the Panathenaic festival, often combined religious piety with civic benefaction. For example, the many statues of Hermes set up by Hipparchos in the Attic countryside to mark the distance from the center of Athens also carried inscribed verses by the tyrant himself admonishing his people to virtue and good deeds.[138] By elevating Homeric recitations to a popular and prestigious agon, the tyrants transformed the performance of epic poetry itself into a heroic act.

DONALD G. KYLE

The Panathenaic Games: Sacred and Civic Athletics

Most people associate Greek athletics with Olympia and the games of Zeus, and they associate Athens and Athena with democracy and cultural achievements, but athletics, Athens, and Athena overlap spectacularly in the Greater Panathenaic festival. Olympia and the Panhellenic Games have been studied extensively, but athletics at Athens deserve more recognition as a vital and popular element in the religious, social and civic life of the Athenians. In his famous funeral oration (Thukydides 2.38), Perikles applauded Athens for the "contests and sacrifices all year round" which refresh the spirits of the Athenians. When Isokrates (50.45–46) looked back from the fourth century on the great legacies of Athens, among them he praised the varied games ("contests not just of speed and strength but of eloquence, wisdom, and all the other arts") and the "greatest prizes" at Athens. In Greek legend Athena herself was competitive and attentive to games. Especially as Odysseus' patron, she was the most involved of the Olympians in the athletic contests in Homer (*Iliad* 23, *Odyssey* 8), and athletes, quite appropriately, performed in her honor at the Greater Panathenaia.

While many books on Greek sport use Attic vase-paintings to illustrate athletics at Olympia, the exhibition, "Goddess and Polis: The Panathenaic Festival in Ancient Athens," includes *Athenian* artifacts illustrating *Athenian* athletics. In this essay I use these and other archaeological and literary sources to discuss the Panathenaic Games as the showplace of Athenian athletics and as a major ceremonial and celebratory component of the Greater Panathenaia.[1] After noting recent, relevant developments in the study of sports and communities, I shall survey the origin and development of the Panathenaia's sacred and civic athletics, and discuss the relationship of athletic training to Athenian city life. I shall examine the Panathenaia's array of challenging and thrilling events, most of which were open to all Greeks but some of which were restricted to Athenian citizens. Finally, I shall look at Panathenaic athletes themselves, both Athenians and non-Athenians, and evaluate expressions of intellectual and popular attitudes to the games. We will see throughout the interconnections between the diversity and vitality of both athletics and civic life at Athens.

Approaches to Greek and Athenian Sport

Such an investigation of Panathenaic athletics complements recent trends in the study of sport, festivals, and community. Scholars of Greek culture and society have always acknowledged that athletics were a distinctive and integral part of the Greek experience, and yet until recently the study of Greek sport was a minor area of classical studies.[2] Although E. Norman Gardiner's writings contain errors and moralizing about the decline of sport into sordid, lower-class professionalism, his outdated works long remained authoritative.[3] In the last generation, however, the study of Greek athletics has come of age.

With our current enthusiasm for sport, scholars have become more appreciative of the study and teaching of ancient sport. As Erich Segal has declared: "Sport is the most immutable and modern aspect of our heritage from the Greeks and, therefore, the stadium door is perhaps the most accessible means of entering the ancient world."[4] Sport history is especially instructive because we, as individuals and as societies, tend to reveal our true natures when we engage in or watch competitions. Moreover, at the same time that classics is increasingly

27 Kylix with boxer (interior), attributed to the Epidromos Painter, ca. 520–500

opening up to new approaches, the history of sport is becoming more sophisticated and accessible.[5]

We have improved our understanding of Greek sport by questioning traditional assumptions, assessing newly acquired archaeological evidence, reexamining existing texts and artifacts, and applying comparative and anthropological approaches. Leaders in the demythologizing trend in recent scholarship include H. W. Pleket and David C. Young.[6] Pleket explained that the study of Greek sport has suffered from a classicist bias, a tendency to impose rise and fall patterns, and a preference for amateurism. Young effectively debunked the idea of an early golden age of amateur athletics, showing that amateurism and professionalism are in fact modern concepts improperly forced onto the Greeks. Archaeology has made enormous contributions, the most obvious of which is the continuing excavation of the sanctuary and stadium of ancient Nemea, site of one of the four Panhellenic games. Catherine Morgan's sophisticated archaeological analysis of finds from Olympia and Delphi has helped place these two sites of Panhellenic games in their local contexts and in relation to the emergence of Greek city-states in the eighth century. Essays in a valuable anthology edited by Wendy J. Raschke have suggested, among other things, that the early history of cults and games at Olympia needs revision, and that Greek sport had political and erotic overtones.[7] Studies such as that by Michael B. Poliakoff on combat sports have clarified the terminology and techniques of various events; and, in a stimulating interpretive work, David Sansone has defined sport as the "ritual sacrifice of physical energy" and traced the origins of Greek and all sport back to behavior patterns of Paleolithic hunters.[8]

Recent scholarship on the importance of festivals, cults, and contests in the life of communities increasingly interprets civic cults and ceremonies as expressions of mass interests and not just as political manipulations by individual leaders.[9] Modern cultural and symbolic anthropology regards cultural performances, such as sports and drama, not as mere entertainment but as distinct systems of meaning by which cultural orders (i.e. values, norms, status relationships) are formulated and reformulated.[10] Shared experiences and communication between ritual performers and audiences are essential to community formation and civic consciousness because people best relate to historical continuity and change by visual or physical memories. Moreover, communal rituals, including games, are not simply either sacred or secular.

Influenced, then, by developments in the study of classics, cults, and sport, future studies of Greek sport are likely to be less focused on Olympia and the great games. Instead, they will pay more attention to sport at the local level and its contribution to community consciousness. Since Athens is the most well-documented city-state, a study of athletics at Athens provides our best chance to understand the interplay of cult, sport, and community—to see the significance of sport in the lives of citizens of an ancient Greek polis.

Origins and Early Development

Debate over the ultimate origins and essential nature of sport continues, but, as noted above, the study of ancient Greek sport has been significantly demythologized of late. Few of us still look to the ancient Olympics as a model for the modern games, and we now admit that sporting activities were well developed long before the Greeks. All early societies had sport in some culturally appropriate fashion.[11] Nevertheless, competitiveness (or agonism, from *agon* "contest") was especially pronounced in Greek culture, and Greeks were exceptional in the degree to which they institutionalized prizes and games,[12] as in the Panathenaia.

Greek sporting contests, often but not always in the context of funeral games, probably existed throughout the Bronze and Dark Ages (ca. 3000–800),[13] and Homer's depiction of the spontaneous funeral games of early aristocrats probably reflects Dark Age customs. However, the rise of the Greek athletic festival in the Archaic period was a crucial factor in the later development of Greek athletics. Festivals provided a regularity, a structure, and a sacred tone for an already popular activity. The history of the start or reorganization of the Olympic Games is obscured by conflicting legends, and even the traditional date of 776 is being challenged as some archaeologists now downdate the first games to around ca. 700.[14] Nonetheless, it is clear that the Olym-

FIG. 52 Late Geometric neck-amphora with chariot procession, attributed to the Workshop of Athens 894, ca. 720. The Cleveland Museum of Art, Purchase from the J. H. Wade Fund, 27.6

pic Games emerged as an increasingly prestigious model for athletic festivals in the Archaic period. Influenced by "peer-polity interaction" or "interstate competition," the sixth century saw a great increase and expansion of festivals.[15] A *periodos* or circuit of crown games developed at Olympia, Delphi, Isthmia, and Nemea. With Panhellenic participation and the awarding of wreath prizes, these were the most revered games of antiquity.

By the sixth century, then, the spread of athletic festivals had a certain momentum in Greece. This climate was conducive to athletic developments at Athens, but to understand the rise of the Panathenaic Games we must also consider internal circumstances at Athens. Proud of being different, Athens was aware of broader Greek patterns, but in sport as in politics (Thukydides 2.37.1), it did not merely copy other states.

Scholars suggest that early athletic contests in the Agora at Athens were part of a natural evolution from funeral games and cults of the heroized dead to festivals in honor of major deities.[16] Since Athens fared better than most sites in the Dark Age, athletic and aristocratic traditions at Athens were probably especially old and strong. In an aristocratic state controlled by rival baronial families, early Athenians no doubt enjoyed Homeric-style athletics and embraced the sentiment (expressed in *Odyssey* 8.147–148) that "There is no greater fame for a man than that which he wins by his footwork or the skill of his hands [in games]" (trans. S. Miller). The earliest indications of athletic games at Athens come from Geometric vases with scenes of boxers and chariots (fig. 52), which are often interpreted as elements of funeral games. Clearer evidence becomes available in the Archaic age, especially in the period from the first Olympics in 776 to the archonship of Solon in 594, by which time both Athens and athletics were gaining increased attention.

Athens' first Olympic victory, that of the runner Pantakles in 696, slightly preceded the term of the earliest known archon in 682. Victors in this period seem to have been men of wealth and standing, and competition at Olympia, like great funerals and expensive votive dedications, was an affirmation of social status. Phrynon, an Olympic victor in the pankration (see below) in 636, was probably the same Phrynon who became a general and a founder of colonies. Kylon, in his ill-fated attempt to become a tyrant after his Olympic win as a runner (probably in 640), represents the growth of both athletics and political turmoil at Athens.[17] Although Athens was the home of athletics and aristocratic athletes, athletics were still primarily a clan or regional rather than a civic matter.

Influenced by its internal maturation as well as by external Greek trends in the sixth century, Athens advanced from private or clan athletics to civically oriented and administered games. The rule of law and the promotion of civic consciousness were greatly enhanced by the brilliant legal and political reforms of Solon. Scholars generally agree that, as part of his broad program of reforms aimed at good order (*eunomia*) in the state, Solon legislated monetary rewards for Athenian Panhellenic victors—500 drachmas for an Olympic and 100 for an Isthmian victory.[18] Although Athens still had no major athletic festival, Solon's direction of civic attention to the growing activity of athletics was an important tran-

sitional stage between clan and civic competition; he helped prepare the way for the Greater Panathenaic Games.

After Solon's reforms, Athens systematically organized and institutionalized its grand athletic festival, the Greater Panathenaia. With possible precursors in earlier funeral and hero-cult games, gymnastic contests were added to (or expanded within) the reorganized Greater Panathenaia of 566. The circumstances and aims of this reorganization remain unclear,[19] but here, as elsewhere in Greece, the combination of athletic competitions with a regularly scheduled religious festival enhanced the popularity of both elements. Prior to 566 the early Panathenaic festival cannot be shown definitely to have included athletic games; processions and perhaps military displays seem more likely.[20] The earliest definite archaeological evidence of the Panathenaia as an athletic festival comes from the sixth century, when, in addition to early prize amphoras, inscriptions from the Akropolis refer to a *dromos* (whether a racecourse or a race) and an agon organized by a board of civic officials.[21]

After the introduction of Panathenaic athletics in 566, the Peisistratids reinforced their position by fostering the anti-clan, patriotic influence of civic athletics and popular cults. By the end of the tyranny in 510 the Panathenaic Games were well institutionalized.[22] With a slate of athletic competitions at least as extensive as at Olympia, the Athenian program also had its own torch and chariot-dismounting (*apobates*) races and (then or later) even team events. Both an ethnocentric and an international festival open to all Greeks, the Panathenaia combined elements from native traditions, the Panhellenic Games, and local (e.g. possibly Lemnian) festivals.

Panathenaic athletics were *civic* as well as *sacred*, and the harmony of these aspects is central to the significance of these games for the Athenians.[23] Ancient Athens did not know our modern separation of church and state: the origins, history, prizes, program, administration, and even the location of contests all reveal the sacred and civic nature of Panathenaic athletics. As an integral part of the greatest of the Athenian festivals, these athletics were always sacred; they were never divorced from the worship of Athena. However, unlike the games at Olympia, the Panathenaic Games were held in and by a dynamic city-state; they began and grew in relationship to the developing nature of Athens as a political and religious community. The Panathenaic prize amphoras themselves combine sacred, civic, and athletic elements. Filled with sacred olive oil, these commissioned vases were decorated with a defiant, warlike Athena, an official inscription, and a scene from the games.

As rituals, celebrations and spectacles, the Panathenaic Games combined sacred and civic aspects in a historical relationship that was complementary and dynamic. Although some elements of the Panathenaia as a festival of Athena have parallels elsewhere,[24] the history and resources of Athens as a city made its Panathenaia unique. Athenians were surrounded with reminders of the richness of their civic and religious life in art and architecture and in festivals and processions. Despite changes in the intellectual life of the elite, for most Athenians the sacred tone of the games did not significantly diminish over time. However, the city itself—and therefore the civic dimension of the games—expanded as the city grew from a troubled, sixth-century community into the democratic center of a powerful fifth-century empire. To some degree, the athletic program changed over time with the increasing institutionalization and expansion of the festival. The Panathenaic Games continued to be a sacred part of a hallowed festival, but increasingly the spectacle also performed the function of communicating the greatness of Athens to its citizens and to visitors. In the games, as in the sacred rituals of the Panathenaia, Athenians appreciated and celebrated being the "city of Athena."

Athletic Training and the Athenian State

Athletic training at Athens was no different from elsewhere in Greece, but we should consider the distinctive relationship of athletic training to Athenian civic life.[25] By the sixth century, with the rapid proliferation and popularity of athletic festivals, athletes already were starting to specialize in individual events and to travel from contest to contest accumulating victories and prizes. Theagenes of Thasos is said to have won over 1300 victories in a twenty-two-year career in the fifth

29 Column-krater with jumpers and trainers (obverse) and man courting youth (reverse), attributed to the Harrow Painter, early 5th century

century.[26] As more intensive training improved the level of competition at major games, aspiring athletes soon had to enlist the aid of professional trainers to supervise their exercises and diet. Along with officials, trainers appear frequently in vase-paintings, as clothed figures usually carrying forked sticks (cat. 29, obverse). In a victory ode, Pindar (*Olympian* 8.54–60,66) notes that the trainer Melesias, probably the father of the Athenian politician Thukydides, was a former victor himself and that thirty victories were won under his instruction. Pindar (*Nemean* 5.48–49) also declares it appropriate that Menander, a "fashioner of athletes," should come from Athens.[27] Increasing specialization is reflected in the artistic depictions of athletes. In late Classical vase-paintings and sculpture, boxers and runners, for example, were shown as having different builds. The overdevelopment of athletes became a motif for critics of athletics, including Plato and Aristotle, who felt that excessive training was unnatural and unhealthy.[28]

In terms of facilities for athletic training, Athens was exceptional in having three major public gymnasia, the Academy, Lyceum, and Kynosarges. These gymnasia were large suburban areas used for practice but not for competition, with facilities for track and field as well as combat sports. There were also many smaller *palaestrae* (wrestling schools),[29] and the state legally regulated both gymnasia and palaestrae to some degree. Athletic training in the nude at such public facilities undoubtedly stimulated improved artistry in drawing and sculpting bodies.[30] Numerous scholars have glorified the gymnasia for housing observant artists and loquacious philosophers; but until recently few have been willing to admit that, with the combination of young and older males, open nudity and exercise inviting homosexual encounters, athletic facilities were also "pick-up" spots (cat. 29, reverse).[31] Vases with sporting scenes often bear young men's names accompanied with the adjective *kalos* ("he is beautiful"), and some of these are of well-known Athenians (see cat. 28).[32] The comic playwright Aristophanes (*Wasps* 1023–25, *Peace* 762–63) declares that he did not take advantage of his prestige to make advances to boys in the wrestling schools; and a character in the *Birds* (lines 137–142) imagines a scene wherein a father upbraids a (male) friend for *not* making advances to his son while returning from the gymnasium. Although it was not accepted practice for a younger man to pursue an older one, Alkibiades (in Plato's *Symposium* 217c) says that he tried to seduce Sokrates by arranging that they should go to a gymnasium and wrestle together. Thus it is not by accident that the Amherst vase illustrates both ath-

letics and courting (cat. 29, reverse)—both of which were common occurrences at the gymnasium.

A traditional justification of Greek athletic training has been its purported value in preparing citizen soldiers. Certainly sport and war were analogous in Greek thinking, but early athletic contests are best understood as surrogates for (or sublimations of) military conflicts. Athletics had more to do with the Greek competitive spirit and desire for glory than with pragmatism. The actual military value of most early athletic training has been overstated, and the battle of Marathon has been misrepresented as an athletic rather than a strategic victory.[33] Some specialized events, such as the hoplite race and the javelin throw on horseback, were related to military developments; but, in fact, as Euripides charges (see below), the more specialized athletic training for traditional events became, the less suitable it was for hoplite infantrymen. When Sokrates (in Xenophon's *Memorabilia* 3.12.1–8) chastised a young man for not maintaining his physical fitness and thus not being ready in case the state needed him for military service, he was advocating physical fitness and civic responsibility, not intensive athletic training for all Athenians. The ideal of the gymnasium-frequenting, physically fit citizen-soldier persisted; centuries later Lucian (*Anacharsis* 24–28) made Solon an advocate of the ideal in an imaginary dialogue set in the Lyceum. However, the intensive athletic training soon needed for serious competition was spurned by military experts and political philosophers. Plato flatly rejected contemporary athletic training as useful for the soldiers of his ideal state: his warriors were to develop the spirited side of their nature, unlike contemporary athletes who, he said, pursued diet and exercise "for the sake of strength alone" (*Republic* 3.410b). Plato preferred something more akin to the militarily oriented, state-run system of cadet training (the *ephebeia*) institutionalized by Athens in the fourth century.

At Athens the state provided athletes with free and public gymnasia, as well as rewards and prizes for victory, but training for individual competition in the Panathenaic or Olympic Games still required leisure time, a specialized diet, and financial resources. For example, Pausanias (5.24.9) tells us that athletes at Olympia had to swear that they had been in continuous training for ten months, and they had to spend an additional month training at Olympia before the games. Predictably, well-off families had the most resources and inclination to compete at the international level. Nevertheless, Athens democratized Panathenaic sport to some degree by arranging financial support for team events (for citizens only) in torch racing and military dancing (see below). Wealthy citizens, via a system of *leitourgia* or sponsorship, were obliged to contribute money to underwrite the expenses (e.g. oil, instructors) of such teams, just as compulsory contributions underwrote the dramatic competitions at Athens. With such financial support, abundant public facilities, and other athletic festivals in addition to the Panathenaia,[34] Athens became a major center for gymnastic and equestrian sport. Although it never gained the prestige of the Panhellenic crown games, the Panathenaia was by far the greatest of the so-called "local" or "chrematitic" (offering valuable prizes) athletic festivals.

Gymnastic Events

Panathenaic athletics were distinctive not because the Athenians boxed or threw the discus in atypical ways but because Athens, knowing the value of hosting as well as winning games, staged an eclectic program of over 20 events, with three age classes, and with teams as well as individual competitors. The events, especially the more obscure, non-Panhellenic, and characteristically Athenian ones, are discussed below, following the probable sequence in which they were held in the later fifth century.[35] Panathenaic prize vases and other testimonia are used to suggest both change and consistency in the athletic program, technical or comparative points are noted at times, and the sacred and civic significance of the contests is discussed.[36]

Footraces

Running was surely one of the oldest forms of athletic contests, and Sansone suggests that victorious runners,

23 Panathenaic-shaped amphora with footrace, attributed to the Painter of Louvre F 6, ca. 540

25 Panathenaic prize amphora with footrace, attributed to the Asteios Group, 392/1

as the most conspicuous expenders of energy, were thus seen as most worthy of participating in the sacrifices.[37] In Greek tradition, the *stadion*, a sprint race of approximately 200 yards, was the oldest event in the Olympic Games, and the list of eponymous stadion victors, after whom Olympiads were named, provided a common chronology for Greeks. The first several Olympiads only had stadion races, but other footraces were added over time, the *diaulos* or "double-flute" races of two lengths in 724, and the *dolichos* or long race of perhaps 20 or 24 lengths in 720.[38] Athens had the stadion and other footraces, but, despite its modern prominence, no ancient marathon race ever existed at Athens or Olympia.

Greek athletes ran on straight, not oval tracks, and therefore had to turn around a post or posts (*kampteres*) in races longer than the sprint (cat. 24). Thus, while footraces were the simplest of athletic events, scholars still debate matters of lanes and turning posts, starting procedures and mechanisms.[39] The *dromos* or runway in the Athenian Agora (see p. 19, fig. 4) apparently could accommodate ten runners, the same number as that of the Kleisthenic tribes, but the games probably had preliminary heats, and some races may not have used all the lanes. If a runner at the starting line in the Agora gazed ahead through the town square and up to the Akropolis with its sanctuary of Athena, the association of the goddess with her polis would have been inescapable.

Several early Panathenaic prize amphoras of around ca. 560–550 depict footraces.[40] An early prize vase signed by Nikias (see p. 42, figs. 27a, b) not only depicts a race but, like some others, also bears an inscription declaring the specific event involved, the men's stadion. This and other early vases (cat. 23) typically but unrealistically depict runners with their left arms and left legs advancing at once, and with torsos but not legs presented frontally. Later depictions usually show improved realism but some do not (cat. 25). Longer and shorter races can sometimes be distinguished by the running styles involved (e.g. length of stride, position of arms); compare the runners in cat. 24 with cat. 25. Sixth-century prize vases show that the stadion, diaulos, and dolichos were early Panathenaic events, and these races continued to appear on prize vases in the fifth and fourth centuries.[41] The stadion for boys appears on prizes from the mid-fifth century on,[42] and the fourth-century prize inscription *IG* II² 2311 (line 22, see p. 16) lists this event (but not a boys' diaulos or dolichos, which Olympia also lacked). The portion of the prize list with men's events is missing, but it must have recorded these three men's events.

32 Stater of Kos with diskobolos and tripod, ca. 480–450

Pentathlon

The Greek pentathlon has inspired not only masterpieces in vase-painting, numismatics (cat. 32) and sculpture, including Myron's famous discus-thrower, but also an ongoing scholarly debate over the origin, status, operation, and scoring of the contest. Aristotle (*Rhetoric* 1361b) praises pentathletes for all-around beauty, but other sources (pseudo-Plato *Lovers* 135e, Suidas s.v. Eratosthenes) suggest that the event was for second-class athletes. Scholars agree that of the five events, running and wrestling existed independently; that the jump, discus, and javelin were found only as part of the pentathlon; and that wrestling came last. The sequence of the other four sub-events is debated. Vase-paintings (cat. 26, obverse) illustrate the use of jumping weights (*halteres*) to improve distance in the jump, which was a long or broad and probably a single rather than a combination jump. A thong (*ankyle*) also shown in vase-paintings (cat. 26, reverse) was used to improve distance and accuracy in the javelin throw. Although scholars disagree, vase-paintings suggest that the Greeks threw the discus without making 360-degree turns (cat. 30, obverse). On the scoring of the pentathlon, there is a consensus that victory in three components brought overall victory, but a controversy over scoring—now older itself than the modern Olympics—has produced theories of points systems, comparative victories or relative placements, eliminations, byes, lots, and rematches.[43] The pentathlon at Athens probably was scored in the same way as at other games, but Athens was unusual in offering three age classes and second as well as first prizes.[44]

A fragmentary non-inscribed Panathenaic of ca. 560 from the Agora with pentathletes, and an inscribed base of ca. 550 from the Akropolis, possibly recording a pentathlon victory at the Panathenaia, suggest (but do not prove) that this was an early Panathenaic event.[45] Scenes that clearly refer to the pentathlon persist on Panathenaic prizes from the last quarter of the sixth century on.[46] A

26 Lekythos with athletes practising (obverse and reverse), attributed to the Michigan Painter, late 6th century

30 Neck-amphora with two discus-throwers, trainer, and acontist (obverse), attributed to the Acheloos Painter, ca. 510

24 Panathenaic prize amphora with footrace, attributed to the Berlin Painter, ca. 480–470

36 Panathenaic-shaped amphora with wrestlers and dinos (reverse), attributed to the Swing Painter, ca. 540–530

40 Panathenaic prize amphora with boy wrestlers and judge (reverse), attributed to the Robinson Group, ca. 430

single prize vase from the Kuban group of the late fifth century shows a lone javelin-thrower, and single discus-throwers also appear on prize amphoras;[47] but, since the javelin and discus were not independent events, these vases must refer to the pentathlon.

Wrestling

The Greeks called wrestling, boxing, and the pankration "heavy events" (Pausanias 6.24.1), possibly because the training and competition involved were grievous or burdensome, or probably because there were no weight classes, and heavier athletes tended to dominate these sports. As Poliakoff has made clear, the object of wrestling was to win three falls out of a possible five, with a fall meaning a pin of the shoulders, stretching an opponent prone, or tying him up in a confining hold.[48] This is confirmed in part by Aristophanes' use of a wrestling metaphor (*Knights* 571–73): the chorus laments the decline of Athens' fighting spirit, and says that in the past, when men fell to their shoulders, they wiped off the dust (which would indicate a fall), denied that they had been thrown, and continued to wrestle.

The early popularity of wrestling scenes in Athenian black-figure vases may have been aided by the legend of Theseus (Pausanias 1.39.3; Plutarch *Life of Theseus* 11.1, 19.7), who is said to have invented wrestling or to have learned it from Athena. Like Herakles against Antaios, Theseus outwrestled an ogre, Kerkyon, on his journey to Athens. Wrestlers, often confronting each other in pairs, with a judge and an additional athlete nearby, appear on prize vases from the last third of the sixth century (see p. 35, fig. 22) and recur on official and Panathenaic-type vases (cat. 36).[49]

Pindar (*Nemean* 10.33,36; *Olympian* 9.88; see also *Nemean* 4.19) refers to an Argive wrestler victorious at Athens as a boy, and prize vases (cat. 40) show that the Panathenaia had a boys' event from at least the fifth century on.[50] Wrestling is listed on the fourth-century prize inscription for boys and youths, and another inscription probably records the boys' event for a Greater Panathenaia of the mid-fourth century.[51] Apparently there were matches for men (and possibly boys) in the sixth, for men and boys in the fifth, and for all three classes by the fourth century.

Boxing

By modern standards Greek boxing was brutal, and Etruscan and Roman boxing was even more dangerous. With unpadded leather thongs (*himantes*) (cat. 34 and see p. 76, cat. 27), without weight classes or rounds, and with most blows directed to the head rather than the body, pairs of boxers simply fought until one was knocked out or admitted defeat by raising his index finger. Bleeding and disfigured boxers (cat. 34) with scars and broken noses appear often in Greek art, and the roman satirist Lucilius in the first century A.C. wrote of a boxer becoming unrecognizable to his dog and friends. There is even a warning that one boxer should not risk the shock of seeing his own reflection in a pool.[52] Yet, as Poliakoff points out, the Greeks obviously had a high tolerance for violence, and the event remained respected and popular.[53]

34 Kylix with young boxers, attributed to the Triptolemos Painter, ca. 490

Representations of boxers are found on Geometric pottery and they increase in number, suggesting regular competitions by the sixth century. The earliest prize vases with boxers start in the last quarter of the sixth century and persist.[54] Youth or boy boxers appear on prize Panathenaics from the late sixth century, and by the fourth century three classes existed for the event.[55]

Pankration

Combining wrestling, boxing, and kicking (fig. 53), the pankration was a specialized heavy event. As Poliakoff explains, there were few rules: gouging and biting were prohibited, but choking, finger-breaking, and blows to the genitals were not. A match ended when one athlete capitulated or was incapacitated. Poliakoff has demonstrated that light boxing thongs could be used, but the event is still difficult to distinguish from boxing or wrestling.[56] For example, a prize Panathenaic of ca. 480–70 by the Berlin Painter (see cat. 39) at times has been misinterpreted as a pankration scene when it probably depicts an attempted leg-trip in wrestling.[57]

The Panathenaic pankration is represented chiefly on prize vases from the late sixth century on, and one early fifth-century prize vase is actually labeled for the event (fig. 54).[58] Although strictly a men's event at Olympia

FIG. 53 Panathenaic prize amphora with pankration (reverse), attributed to the Kleophrades Painter, ca. 500. The Metropolitan Museum of Art, New York, Rogers Fund, 1916, 16.71

FIG. 54 Panathenaic prize amphora with pankration (reverse with inscription), ca. 480. Museo Archeologico Nazionale, Naples, 81294

until 200, the pankration was a youths' event at the Panathenaia by ca. 420 when Autolykos the son of Lykon (see p. 97) was the victor. Moreover, the fourth century prize list *IG* II² 2311 (lines 35, 49) records the event for both youths and boys.

Hoplite Race

The hoplite race in armor, including helmet, shield, and sometimes greaves (fig. 55), probably reflects both developments in hoplite warfare and the old, by now largely symbolic, tie between athletics and warfare.[59] Not introduced until 520 at Olympia and 498 at Delphi, the hoplite race appears on prize Panathenaics of ca. 520–480. It also appears on an early Panathenaic-style vase of around 540 with two hoplite runners and an inscription declaring itself a diaulos prize.[60] A passage in Aristophanes (*Birds* 291–92 and Scholiast) also suggests that the Athenian race was a diaulos (i.e. two stades in length). Since definite representations of hoplite racers (with helmet and shield) appear on fourth-century prize Panathenaics, the event can be assumed to have been listed originally in the fourth-century prize inscription.[61]

By the fourth century Athens had institutionalized the ephebeia as a program of military training for its

FIG. 55 Kylix with hoplitodromoi, attributed to Onesimos, ca. 490–480. Arthur M. Sackler Museum, Harvard University Art Museums, Cambridge, Bequest of Frederick M. Watkins, 1972.39

youth, and the hoplite race remained popular as a militarily flavored spectacle.[62] However, the hoplite race is not to be confused with the *hoplomachia*, which was a military exercise and a component of Athenian ephebic training but not a Panathenaic event.[63] From the late fifth century on there are references to experts in hoplomachy or fencing with hoplite weapons, and Plato mentions a demonstration by a professional instructor at Athens.[64] While the hoplite race had military overtones, the hoplomachia was a more efficient preparation for battle.

Equestrian Events

At Athens and throughout Greece the keeping and racing of horses was always accepted as proof of wealth and status. Isokrates (16.33) declared that the breeding of horses "is possible only for those most blest by Fortune and not to be pursued by one of low esteem," and Aristotle (e.g. *Politics* 1289b, 1321a) agreed.[65] Pheidippides, a young would-be aristocrat in Aristophanes' *Clouds*, is so obsessed with horses that he even dreams of them. By purchasing racehorses, including one bought for 1200 drachmas, or roughly $26,400, he drove his father into debt.[66] The father, a narrow-minded, tight-fisted rustic, laments the expenses he took on when he raised his social status by marrying into a noble family with "Hipp-" or "horsey" names and equestrian pretensions.

Breeding and racing horses required land and wealth, but it rewarded victors with politically valuable fame and contacts in high circles.[67] The families of many famous Athenians, including the generals Kimon and Alkibiades, maintained stables. In all the equestrian events the owner of the horse(s), who was not necessarily the driver or rider, claimed the victory; the owner did not personally have to face the danger of riding bareback without stirrups or of steering a light chariot through tight, congested turns. He (or she) did not even have to be present at the games. This explains how Alkibiades was able to enter seven chariots and to come in first, second and fourth in the same race at Olympia in 416, and why the Olympic victor list includes the names of women.[68]

Apobates Race

The Panathenaic apobates[69] or chariot-dismounting race was a distinctive but not uniquely Athenian contest.[70] Combining chariots and hoplites, the event seems to have had military overtones, and possibly it preserved traditions of Homeric warfare when the chieftain was driven to the battle and dismounted to fight, remounting for pursuit or flight. However, the apobates was militarily anachronistic, even by 566.[71] Possibly associated with hero cults in the Agora, the apobates race supposedly recalled the legendary invention of the chariot by Erichthonios, who is said to have appeared at the founding of the Panathenaia in the form of a charioteer with an armed companion at his side.[72] Noel Robertson sees two elements in the legend of Erichthonios, the apobates and the fetching of fire from the Academy, as especially relevant to the origin of the Panathenaia. He therefore understands this old martial display as an essential element of the early (pre-566) Panathenaia, when the apobates was simply a procession, not a premier contest as it later became.[73]

A composition attributed to Demosthenes, the *Erotic Essay* (61.23–29), our longest source on the event, describes the apobates as a prestigious and dangerous event, one for citizens only:

> . . . you have singled out the noblest and grandest of competitive exercises and the one most in harmony with your natural gifts, one which approximates to the realities of warfare through the habituation to

FIG. 56 Parthenon frieze: apobates. Courtesy Alison Frantz

martial weapons and the laborious effort of running, in the magnificence and majesty of the equipment simulates the might of the gods, presents besides the most delectable spectacle, embraces the largest number and the greatest variety of features and has been deemed worthy of the most valuable prizes.[74]

(lines 24–25, trans. N.W. De Witt)

Despite such accolades, the technique of the apobates remains uncertain. The race is somewhat similar to an Olympic event, the *kalpe* or *anabates* (dismounting race), part of the Olympic program from 496 to 444 (Pausanias 5.9.1–2), in which a rider leaped from a mare in the last lap of the race and ran on foot to the finish.[75] According to one interpretation, the apobates dismounted from the chariot and ran to the finish on foot, but another suggestion is that the runner mounted and dismounted the chariot while it was in motion.[76] Certainly the skill of the charioteer would be an important element in any victory, but we have no proof that he shared the victory with the hoplite or that there were two prizes for the Panathenaic race.[77] Moreover, Plutarch's reference (*Life of Phokion* 20.1–2) to a victory (approximately in the 320s) by Phokos, the son of the prominent general Phokion, suggests individualized victory. Held in the Agora, this demanding and thrilling race would have presented an engrossing spectacle.[78]

Athenian artists responded to the challenge of depicting the apobates. Magnificent figures in the Parthenon frieze (fig. 56) immortalize *apobatai* (dismounters) as part of the fifth-century Panathenaia.[79] Artistic representations present apobatai in full armor, or with helmet and shield; some are clothed but most are nude.[80] Although the event is lost from the fourth-century prize list, a fourth-century base from the Agora with a relief of the race held a dedication by a Panathenaic victor (fig. 57).[81] The event is not depicted on any known early prize

FIG. 58 Panathenaic prize amphora with apobates, ca. 340/339. The J. Paul Getty Museum, Malibu, 79.AE.147

FIG. 57 Monument base commemorating a victory in an apobates chariot race, early 4th century. Agora Museum, Athens, S399

41 Panathenaic-shaped amphora with horse race, ca. 540

42 Panathenaic-shaped amphora with horse race, ca. 500

Panathenaics, but it turns up in the fourth century on a prize vase dated to 340/39 (fig. 58).[82] Since the event certainly existed earlier, either a different prize was awarded later (sacred oil), or earlier Panathenaics with the event simply have not yet been found.

Horse Race

It has been suggested that horse races evolved from the military training or recreation of knights in early times, and horses are well known in Geometric art.[83] Large numbers of equestrian vase-paintings are understandable for Archaic Athens since many aristocratic patrons kept and raced horses as a way to display their wealth. Herodotus (6.122) records that the wealthy Athenian aristocrat, Kallias son of Phainippos, from a family known for lavish expenditure and opposition to tyranny, won a horse race (and finished second in the chariot race) at Olympia in 564.

The earliest prize Panathenaics with the horse race come from the last quarter of the sixth century, and they persist.[84] The youthful jockeys are usually (cat. 42) but not always (cat. 41) depicted in the nude, and the race, as at Olympia, was probably six stades or three laps in length. Constantly associated with wealth and the cavalry, horses remained prominent in both the Panathenaic procession and the games.

Chariot Races

The *tethrippon* or four-horse chariot was the most expensive, most dangerous, and most prestigious Greek equestrian event. In the sixth century, Kimon of Athens, nicknamed *koalemos* or "stooge," won the Olympic event three times with the same outstanding team of horses, horses that later received a special burial near their owner's grave.[85] Kimon, however, when he won the race in 532, allowed Peisistratos to be declared the official victor in order that the tyrant would permit him to return to Athens from exile. Peisistratos, whose sons had "Hipp-" names (Hippias and Hipparchos), and who claimed descent from Homer's chariot-racing Neleids of Pylos (Herodotus 5.65), wanted the prestige of being proclaimed an Olympic victor.

Depictions of four-horse chariot races on early Attic vases (see fig. 52) may represent funeral games or hero cults, but it is uncertain whether some scenes derive from epic or real life.[86] The Panathenaic tethrippon is well attested by prize vases from ca. 550 on (cat. 44).[87] Charioteers (probably hired drivers rather than the owners of the team) are depicted as clothed, mature men (cat. 43), unlike jockeys. In the fifth century, Pindar (*Isthmian* 2.20, 4.25) seems to refer to a Panathenaic chariot race, and a base of ca. 450–440 from the Akropolis supported a four-horse chariot group celebrating a Panathenaic victory, presumably in the chariot race.[88]

43 Lid of a lekanis with chariot race, ca. 520–510

Another chariot event, the *synoris*, meaning simply a pair or yoke of horses, is best known from the Burgon amphora of ca. 560 (fig. 59). The history of the event is uncertain. On the Burgon vase, the clothed driver sits in a light cart, as mule drivers did, but drives a pair of horses; the wheels are cart wheels rather than chariot wheels, and the collars are similar to mules' collars. Hence, Beazley has suggested that the Burgon vase was perhaps meant to depict mules, but the animals simply look more like horses.[89] From the 560s on, Athens had two-horse chariot races, but Olympia lacked the synoris until 408. By the fourth century, both Olympia and Athens held these races for colts as well as full-grown horses.[90]

Two early fifth-century prize vases showing cart races, one apparently and the other definitely depicting mules,[91] indicate that Athens had a mule cart race at the end of the sixth century, which may have continued. Olympia also tried a mule cart race (*apene*) in 500 only to abandon it by 444.[92] Although the synoris perhaps recalled heroic chariot warfare, the mule cart race is best seen as a novelty.

Special Equestrian Events

After the chariot races, the inscription *IG* II² 2311 (lines 58–71) lists four special horse and chariot events for warriors (*polemisteriois*): a horse race, a two-horse chariot race, a two-horse chariot procession, and a javelin throw on horseback. These military events were not held at Olympia, and in the Panathenaia they were probably restricted to Athenians.[93] Panathenaic amphoras are listed as prizes but none are extant (except for the javelin on horseback; see below, fig. 60), perhaps because fewer

FIG. 59 Burgon Panathenaic prize amphora depicting synoris (reverse), ca. 560, British Museum, London, B 130.

were awarded or because of their later introduction. Photius states that the "war horses" were not really used for war, but rather gave the appearance of being equipped for war during the competitions,[94] and in Aristophanes' *Clouds* (ca. 423), a character asks about the number of courses for the "war-carts" (*polemisteria*, line 28). The distinction for "processional chariots" (*zeugei pompikoi*) may simply have been the use of a different type of chariot or cart.[95] Lysias (19.63) mentions a man who won victories with race horses at Isthmia and Nemea but also kept cavalry horses for processions, possibly for this event. Apparently these special equestrian events were seen as less prestigious and expensive. While first place in the normal chariot races brought 40 vases for colts and 140 for full-grown horses, the special events had smaller prizes (sixteen for war horses, thirty for war chariots, four for the processional chariots, and five for the javelin throw on horseback).

Plato (*Meno* 93d) says that Themistokles had his son trained as a horseman and that the youth could throw

44 Panathenaic amphora with chariot race, possibly by the Painter of Würzburg 173, ca. 500

FIG. 60 Panathenaic prize amphora with horsemen throwing javelins at a target, early 4th century. British Museum, London, 1903.2-17.1

a javelin standing upright on horseback, but javelin throwing on horseback at a target (fig. 60) does not appear on prize Panathenaics until the very end of the fifth century. On prize vases competitors wear cloaks and some wear the *petasos*, a broad-rimmed hat, and the target is a shield on a post.[96] Never an Olympic event, the contest is listed on the fourth-century prize inscription with the special equestrian events offering prize vases. Xenophon (*Duties of a Cavalry Commander* 1.21,25; 3.6; *On Horsemanship* 8.10; 12.12–13) strongly recommended proficiency in this skill for military reasons, and he mentions javelin throwing in cavalry proceedings at the Lyceum. The contest itself, the target, and Xenophon's interest all suggest that the development of the cavalry influenced the Panathenaic program in the late fifth and fourth centuries. Moreover, the *anthippasia*, a competition and display by tribal cavalry units, while not attested until the third century, may have been included in the Panathenaia earlier.[97]

Tribal Events

The team and tribal events, which were limited to Athenian citizens, formed one of the most distinctive aspects of the Panathenaic Games. While bigger prizes were offered in open events to attract competitors from outside, this does not mean that the tribal events were of little importance in the eyes of the Athenians.[98] Probably derived from ancient traditions of communal involvement, early processions developed into contests in military dancing, manly beauty, and torch racing, and these events were expanded and adapted to the Kleisthenic tribes and democracy.

Pyrrhic Dance

With probable roots in old hunting or war dances, pyrrhic dances in armor were held throughout Greece, including in both the annual Lesser and quadrennial Greater Panathenaia.[99] Legend says that Athena, having danced the pyrrhic when born from the head of Zeus, also danced the pyrrhic upon her victory over the Titans (Dionysius of Halicarnassus *Roman Antiquities* 7.72.7); and the sixth-century popularity of the gigantomachy theme in Athenian art may suggest that such a contest dates at least from 566.

Plato (*Laws* 7.815a) gives a written summary of the movements danced in the pyrrhic:

> It consists in imitating, on the one hand, movements that evade all kinds of blows and missiles — by dodging, giving way completely, jumping up, humble crouching — and then again striving to imitate the opposites to these, aggressive postures involved in striking with missiles — arrows and javelins — and with all sorts of blows.
>
> (trans. T. L. Pangle)

Pinney also offers a description derived from depictions on late Archaic and Classical vases:

> On the vases, the dancers are shown, as a rule, equipped with the weapons of Athena herself: spear and round shield. Male pyrrhic dancers can be recognized with certainty only when judges, with their forked sticks, or the aulos player who pipes the rhythm of their movements are present. The dancers otherwise look just like warriors in heroic garb.[100]

Together the descriptions allow us to identify with certainty a fine depiction of the pyrrhic dance, complete with a flutist on an Attic black-figure vase (cat. 48).

Performed in three age classes (*IG* II[2] 2311, lines 72–74; *Constitution of Athens* 60.4), the pyrrhic dance was

48 Pelike with pyrrhic dancer and aulete (reverse), attributed to the Theseus Painter, ca. 500

organized and financed liturgically, and awarded prizes of a bull and 100 drachmas for each class. In the late fifth century, a man claims to have spent 800 drachmas on the pyrrhic for the Greater Panathenaia and 700 on a boys' pyrrhic chorus for the lesser festival (Lysias 21.1,4). In Aristophanes' *Clouds* (lines 988–989) a conservative character, the Just Logos, complains that in the boys' event the effete Athenian youths now cover themselves with their shields and perform the dance poorly. However, a fourth-century base from the Akropolis (fig. 61) depicts nude pyrrhic dancers with shields; a clothed observer represents the sponsor (*choregos*), Atarbos, and an inscription records the tribal victory.[101] Perhaps an aspect of military training or possibly just in imitation of warfare, this was a Panathenaic event, but it belonged as much to the realm of dance as to that of athletics. Although its legendary significance and its military value may have waned over time, with its choruses of dancers and its musical accompaniment, the pyrrhic remained an integral and entertaining part of the Panathenaic program.

Euandria

This tribal contest in "manly beauty," closed to outsiders, remains problematic.[102] The fourth-century prize inscription records 100 drachmas and an ox for this event, but later in the fourth century the Aristotelian *Constitution of Athens* (60.3) mentions shields as prizes. Perhaps the prize changed, or probably there was a tribal prize and also individual shield prizes for winners.[103] According to N. B. Crowther:

> The *euandria* was probably a beauty contest, as defined by Athenaeus [13.565f], in which the criteria were size and strength, as suggested by Xenophon [*Memorabilia* 3.3.13]. Since the contest involved strength, more than mere posing was involved. The competitors had to perform. The euandria, therefore, as far as can be ascertained, was a team event which incorporated elements of beauty, size and strength, perhaps as a celebration of manhood.[104]

FIG. 61 Base from the votive offering of Atarbos with pyrrhic dancers, ca. 330–320. Akropolis Museum, Athens, 1338

49 Pelike with torch-race (obverse), attributed to the Painter of Louvre G 539, ca. 420–400

47 Skyphos with acrobat, ca. 470

Crowther also feels Xenophon probably means the euandria was "unmatched in quality" at Athens, rather than that it was peculiar to Athens. The name euandria suggests a contest in *kalokagathia* (moral and physical beauty), with physical beauty being seen as a reflection of moral fitness and value to the community.[105] The euandria became a competition but retained its original tone as a pageant or procession. Hence it is listed among tribal events (dance, torch, and boat events) which all have processional qualities. There is no need to see the event as a contest in armor:[106] following the three age classes in the program's pyrrhic, hoplite figures or exercises would be redundant. Rather, the euandria offers a transition to the non-military torch race. Nor need the euandria have involved acrobatics: there is no reason to drop the usual view that the depictions of acrobatics on "pseudo-Panathenaic" and other vases (cat. 47) merely indicate miscellaneous displays and diversions associated with festivals or with victory celebrations.[107]

Torch Race

Perhaps because of their antiquity or their appeal as spectacles, torch races were held in the Panathenaia and various other festivals at Athens as events combining ritual and athletics.[108] As vase-paintings indicate (cat. 49), the Panathenaic event was a relay race in which the winning team had to arrive first and also keep its torch lit. Apparently the distance of over 2500 meters was covered by 40 runners per tribe at approximately 60 meters each.[109]

Aristophanes (*Frogs* 1087–1098) depicts the fifth-century race in a comic light: Aischylos, blaming Euripides, comments that "these days no one is trained enough to run the torch race," and Dionysus recalls seeing an inglorious runner who plods along and is abused by the crowds to a point where he breaks wind, blows out his torch and departs. Humor aside, Aristophanes' words show that training and fitness were factors in the event and that there was also audience involvement.[110]

The original significance of the Panathenaic race was the ritual transfer of fire from the Academy to the Akropolis where it was used to light the fire for the sacrifice to Athena.[111] Since the Archon Basileus was in charge of all torch races (*Constitution of Athens* 57.1), implying both the antiquity and the sacral nature of the event, it is reasonable to assume that the torch race was part of the program of 566. Run from an altar of Eros at the entrance to the Academy to another at the foot of the Akropolis, the race has been associated with the tyranny,[112] but soon the race became organized by the Kleisthenic tribes.

A torch race is attested for the fourth-century Greater Panathenaia and the event was apparently held annually at the lesser festival.[113] The fourth-century prize inscription (lines 76–77) lists the torch race among the tribal rather than the normal athletic events; there were prizes for the individual torch-bearer (*lampadephoros*) (30 drachmas and a water jar) as well as the tribe (an ox and 100 drachmas). Other fourth-century inscriptions (e.g. *IG* II² 3019) record tribal victories and official sponsors (liturgical gymnasiarchs).

Boat Race

The fourth-century prize list (lines 78–81) provides the earliest proof of a Panathenaic "contest of ships," for which first prize was 300 drachmas and three oxen and 200 more drachmas for a feast (*eis estiasin*), and second prize may have been 200 drachmas and two oxen.[114] In view of the significance of the fleet in classical Athens, we might expect boat races to have been quite common, but most of the evidence is Hellenistic and details of the event remain uncertain.[115] So little is known of pre-Hellenistic boat races that they cannot be categorized as military, athletic, ritualistic or spectacular events. The contest has been seen as a rowing contest of crews of tribal youths, but this is based on later ephebic inscriptions and reliefs of Roman imperial times depicting youths with oars.[116]

It is not known when the event originated, only that it continued into Hellenistic times, and that, on a tribal basis, it postdates Kleisthenes. The race was probably held from the Peiraeus around the promontory to Mounychia harbor; the comic dramatist Plato may refer to it when he says that the tomb of Themistokles in the Peiraeus looked out on the "contest of ships."[117] This might indicate that the event arose after the Themistoclean development of the Peiraeus, possibly as a democratic supplement to allow more popular participation in the games.

Panathenaic Athletes from Athens and Beyond

The Panathenaia was a celebration of the unity of Athens by the people of Athena, but Athens also invited non-Athenians to share in the festivities. Most of the Panathenaic contests were open to non-Athenians; probably only the apobates and the tribal, team, and military events, which were non-Panhellenic in style and had lesser prizes, were closed. Since Athens offered the inducement of valuable prizes, as well as the attractions of a cosmopolitan city, non-Athenian athletes visited and competed (in Panhellenic-style events) at Athens. A fifth-century epigram records the victories of the runner, Nikoladas of Corinth, in various festivals including the Panathenaia.[118] In Aristophanes' *Acharnians*, the Old Acharnian reminisces about running against a certain Phayllos (215), probably the famous athlete from Croton, while Philokleon, an old man in *Wasps*, boasts of defeating the athlete in court (lines 1205–07).[119] Athens prided itself on being a city "open to the world" (Thukydides 2.39.1) and participation by outsiders enhanced the fame of Panathenaic competition.

Although Athens had no equivalent to the Olympic victor list, various Athenian Panathenaic victors are known, especially in equestrian and combat events.[120] Kallias son of Didymias, the Olympic pankration victor of 472 and Athens' only known pre-Hellenistic *periodonikes* (victor in each of the four great Panhellenic games), was also a Panathenaic victor. An inscription from the Akropolis records his wins at Olympia, five times at Isthmia, four times at Nemea, twice at Delphi, and once in the Panathenaia. Also, pseudo-Andokides (4.32) asserts that Kallias was ostracized, and *ostraka* (ballots) bearing his name have been found.[121] A dedication of the second half of the fifth century records Nemean, Isthmian, and Panathenaic wins (probably in chariot races) by Pronapes, who possibly was a cavalry commander and one of the prosecutors of Themistokles.[122] By far the most famous Athenian Olympic chariot victor, the flamboyant general Alkibiades, probably won a Panathenaic victory in 418.[123] His antics during the Peloponnesian War do not suggest deep civic patriotism or piety, but then again he can hardly be considered a typical Athenian. Perhaps more typical of Athenian Panathenaic athletes, Autolykos, pankration victor in 422, was praised by Xenophon (*Symposium* 1.2, 8–9) for his beauty and good character.[124]

Did the scope of Athenian participation in the Panathenaia change as Athens became more democratic? Scholars now agree that the modern categories of amateur and professional are anachronistic for ancient Greece, but the sociology of athletic competition and the issue of social mobility via athletic victory and prizes remain areas of disagreement.[125] Evidence is too limited for overly strong conclusions, but early Athenian athletes competing at major games were likely to be aristocrats,

28 Kylix with athlete (detail of interior), attributed to the the Kiss Painter, ca. 500

especially in the equestrian events, and probably in the heavy events, which quickly came to require expensive instruction and training. However, aristocrats did not restrict themselves to equestrian competition, as the Olympic pankration win by Phrynon and the diaulos win by the would-be tyrant Kylon show. Later, even under the democracy, Athenian athletics arguably remained elitist rather than egalitarian in practice (see cat. 28). Nevertheless, in the fifth century there was a significant shift from an elitism of birth to one of wealth. The predominance of the aristocracy and of equestrian events gave way as athletes from new families and groups appeared, most notably in gymnastic events. These new athletes were of respectable birth, but their families seem to have acquired the wealth and leisure for athletic competition from commerce and sources other than ancestral estates.

Estimating that a Panathenaic prize of 100 amphoras of oil for the men's stadion in the early fourth century was worth about 1200 drachmas or the equivalent of over $67,000, Young suggests that athletes from families of modest origin could work themselves up to wealth and status by climbing a ladder of local festivals with materially valuable prizes. However, this seems a possibility more than a probability.[126] Aristotle (*Rhetoric* 1365a) uses an Olympic victory won by a fish-porter as an example of something scarce and difficult to achieve — an exceptional instance of someone doing something "beyond his powers" and "beyond his equals." The influence of valuable prizes and second prizes, or probably just the improved economy of Athens, perhaps led to broader participation; but we are not certain when second prizes began, nor how many prize vases were given in the early games. As in Homer and at Olympia, there was no overt exclusion of free athletes by social class,[127] but some degree of elitism was operative in terms of resources; and, as noted above, training for individual-entry events was funded privately by families.

The best chance for lower-class participation probably was in the team contests where larger numbers were involved and where wealthy citizens liturgically financed the events.[128] In his indictment of Athenian democracy written in the second half of the fifth century, in a passage surely referring to the Panathenaia, the Old Oligarch complains that the masses support festival and liturgical programs because the rich pay while the poor get paid for their popular but less demanding participation (pseudo-Xenophon *Constitution of Athens* 1.13): "The people expect to get paid for singing, running, dancing, and sailing on the ships, in order that they may have money and the wealthy become poorer." These comments attest to non-aristocratic participation in tribal events, but the Old Oligarch also claims that gymnastics and music are beyond the abilities of the masses: commoners (the *demos*) have ruined physical education and culture at Athens (1.13). Even in the tribal events urban, well-to-do youths probably dominated. Since the Greeks themselves felt that people from the better classes were comelier and more dignified, the selection process (by tribal leaders or liturgants) may have been somewhat elitist. Gardiner romanticized fifth-century Greece as "a nation of athletes,"[129] but ancient sport — even in democratic Athens — was hardly egalitarian in practice or ideology. Despite public gymnasia and civic rewards, no revolutionary popularization of athletic competition took place at Athens.

We cannot read the minds of Panathenaic athletes, and, realistically, the motives of all competitors and spectators need not always have been singular or pure. As well as an athletic spectacle and a forum for piety and nationalism, the Panathenaia also meant a rare meat meal for many and the chance of aggrandizement for a few. A fragment from Euripides' *Autolykos* (see below) critically associates athletic festivals with eating, and Aristophanes' *Wealth* (lines 1161–63) contains a statement that the Greek god of wealth was highly sympathetic to musical

FIG. 62 Terracotta vase in the form of a kneeling athlete, ca. 540–530. Agora Museum, Athens, P 1231

and gymnastic contests. Gymnastic and equestrian competition was a visible, prestigious activity, and the patronage and administration of athletic games, facilities and rewards formed a major area of concern and expense. As fields of competition and forums for publicity and display, games necessarily had a political potential, extra-constitutional but influential, that ambitious individuals did not overlook. Victory by itself was not enough: victors publicized their achievements with statues, odes, and speeches. In Thukydides' account (6.16.2) of his campaign speech in 415 for the leadership of the ultimately disastrous Sicilian expedition, Alkibiades boasted of his Olympic chariot success: "For it is the custom that such accomplishments convey honor, and at the same time power is inferred from the achievement" (trans. S. Miller). Such self-glorification was in the tradition of Homeric aristocratic individualism in war and sport, and it was not offensive—within limits. However, Pindar shows that athletes were thought to need god-given talent and divine favor to win, and modesty in victory was encouraged in poetry and suggested in art (fig. 62).[130]

The great appeal of the Panathenaic Games, like that of the procession, was that they offered a chance for every Athenian—and many non-Athenians—to share in the experience. Participation was not as glorious as winning, of course, but participation even at the humblest spectatory level gave a sense of involvement in the communal celebration.[131]

Popular Attitudes Towards Athletics and the Panathenaia

Since the program and expense of Panathenaic athletics grew over time, we might ask how the people of Athens felt about athletics and the Panathenaia. As with most questions about the Greeks, our extant literary testimonia tend to reflect the views of the intellectuals and the elite. When no longer a matter of private aristocratic display, but organized and financed by city-states, athletics faced some vocal critics. However, we should be cautious not to ascribe too much significance to some famous Athenian criticisms of athletics.[132] Rather we should be alert to indications that common Athenians, "the poor and the many" in Athenian political parlance, supported and delighted in the holding of the games.

Early, non-Athenian critics of athletics established some soon-conventional literary motifs. Tyrtaeus deprecated the value of the athlete as soldier-citizen, and Xenophanes criticized the custom of rewarding athletes rather than intellectuals. Notable Athenian criticisms appear in the last third of the fifth century in the context of the Peloponnesian War and Sophism. Earlier protests against the popular adulation of athletes now were expanded with criticisms of excessive training (especially eating habits) and overspecialization as well as assertions of the supposed decline of physical education. Ever suspicious of new trends, Aristophanes in the *Clouds* (lines 1002–23; originally produced ca. 423) has his arch conservative, the Just Logos, lament that the younger generation was no longer fit, trained or modest, that they preferred the courts and baths to the gymnasia. Singling out traditional ritualistic events that symbolize the piety and military vigor of the state, Aristophanes' characters (*Clouds* 988–89; *Frogs* 1087–88) charge that Panathenaic pyrrhic dances and torch races were performed poorly. We must remember that Aristophanes invoked the age-old theme of the "good old days" above all to incite laughter.[133] That such charges were included in comedies, which, like tragedies, abundantly used technical athletic terminology and metaphors, in fact shows that the audience was athletically knowledgeable and attentive. An exciting passage in Sophocles' *Elektra* (lines 681–

756) was obviously written for an Athenian audience that knew and enjoyed dramatic athletics. In the play a messenger falsely reports that, after victories in several events at the Pythian games, the hero Orestes perished horribly in a crash in a chariot race while trying to overtake an Athenian driver from the "city built by the gods."

A fragment of a satyr play (a burlesque piece presented after tragedies for comic relief) of ca. 420 by Euripides (Athenaeus 10.413f = *Autolykos* frag. 282) condemns athletes as overly flattered and pretty in youth but quite unprepared to be useful citizens:

> Of the thousands of evils which exist in Greece there is no greater evil than the race of athletes. In the first place, they are incapable of living, or of learning to live, properly. How can a man who is a slave to his jaws and a servant to his belly acquire more wealth than his father? Moreover, these athletes cannot bear poverty nor be of service to their own fortunes. Since they have not formed good habits, they face problems with difficulty. They glisten and gleam like statues of the city-state itself when they are in their prime, but when bitter old age comes upon them they are like tattered and threadbare old rugs. For this I blame the customs of the Greeks who assemble to watch athletes and thus honor useless pleasures in order to have an excuse for a feast. What man has ever defended the city of his fathers by winning a crown for wrestling well or running fast or throwing a *diskos* far or planting an uppercut on the jaw of an opponent? Do men drive the enemy out of their fatherland by waging war with *diskoi* in their hands or throwing punches through the line of shields? No one is so silly as to do this when he is standing before the steel of the enemy.
>
> We ought rather to crown the good man and the wise man, and the reasonable man who leads the city-state well and the man who is just, and the man who leads us by his words to avoid evil deeds and battles and civil strife. These are the things which benefit every state and all the Greeks.
>
> (trans. S. Miller)

By this time literary conventions included the athlete as a physical caricature, but writers such as Euripides could and did choose from either critical or laudatory commonplaces depending on the nature of the work being written.[134] It is noteworthy that ca. 416 Euripides accepted a commission to write a victory ode (extant in Plutarch's *Life of Alkibiades* 11) for Alkibiades' Olympic chariot victory.

As noted above, the Old Oligarch claims that the athletically inept masses were moved by greed, but he also suggests that civic athletics were expanded because of popular enthusiasm.[135] He objected not to athletics or festivals *per se* but to the liturgical system and non-aristocratic participation. Festivals were not new, but Athens, justly or not, now had more resources (i.e. tribute from subject allies) to fund even grander productions. The Old Oligarch criticized much about imperial, democratic Athens, but he conceded that the people had the power to get what they wanted, and that Athenian life was not likely to change because of oligarchic disagreement with popular tastes. In fact, such critics themselves testify to the spread and popularity of civic athletics. Social critics censured most of Athens' significant and popular institutions—its politics, courts, empire, and festivals. The critical voices have a disturbingly modern ring to them, but historically they represent at best an ineffectual minority viewpoint.

Even at Athens, actions spoke louder than words, and the people "spoke" legislatively through the assembly. Athenian religion saw a Panathenaic festival in some form as necessary for keeping Athena's divine favor for the city, but the maintenance of elaborate, expensive games—even in times of stress—indicates popular enthusiasm and not just religious conservatism. Similarly, the practice of *sitesis*—the awarding of a free daily meal in the town hall to Athenian Panhellenic victors—was renewed in Periclean Athens as a gesture of civic appreciation for an accomplishment which aided both citizen and state.[136] The citizens understood that athletic traditions, like festivals and rewards, were essential to the glorious image of Athens. Later, Plato's Sokrates (*Apology* 36d-e) compared his own worth to the city as a moral benefactor to that of Olympic equestrian victors, contending that he deserved and needed state maintenance (sitesis) more than victors. Representing popular opinion, the jury of common Athenians ultimately condemned

the exceptional Sokrates and went on honoring athletes and attending the games. Criticism of athletics in Greece had no more effect on athletic practice than it does today. Modern editorials decry high salaries and steroids in sports, but the masses have hardly rejected athletics.

Conclusion

Panathenaic athletics succeeded—and the critics failed—because of popular enthusiasm for the combination of religious rites and spectacular athletics in the Panathenaia. Just as the richness or modesty of votive dedications reflected means more than degree of sincerity, men's participation in the Panathenaia varied as their resources and talents dictated. Whether an athlete, an official, a vase-painter, or a spectator, almost everyone shared in and appreciated the thriving athletic life of Athens. Panathenaic sport was essential to the self-definition and the civic history of the Athenians, and the arrival of the Greater Panathenaia every four years brought Athenians together in larger numbers and with greater enthusiasm than on most other civic occasions.

Overall, the function of the Panathenaic Games was festive and athletic: they were to celebrate and to glorify the city and its goddess, and to satisfy the agonistic inclinations of the Athenians directly by competition and vicariously by spectatorship. Inspired more by city-state nationalism than by Panhellenism, the focus of the Panathenaia was voiced in its name. In the myth of its foundation and in the sixth-century motivation behind its success, the Panathenaia was a sacred festival of unity; whether competing in or just watching Panathenaic athletics, citizens relived the shared religious duties and civic glories of Athens. As tangible reminders, the prize Panathenaic amphoras themselves aptly symbolize Athenian civic athletics, associating the popular sporting activities with their divine patroness. Both the city and the festival benefited from the association, and, indirectly, so have all later admirers of Athenian art and culture.[137]

E. J. W. BARBER

The Peplos of Athena

In the city of Pallas
shall I yoke colts to
the beautiful Athenian chariots
in the saffron peplos,
figuring it with intricate
flower-dyed wefts, or
[weave] the race of Titans
that Zeus son of Kronos
puts down with a fiery bolt?

Thus speak the captive Trojan women in Euripides' tragedy *Hecuba* (lines 466–74), describing in their lament what they know of women's work at Athens: weaving figured dresses for the great goddess Pallas Athena.

According to ancient authors, one of the central features of the Panathenaic Festival was the presentation to Athena of a specially woven, rectangular woolen cloth called a peplos, always decorated with the fiery Battle of the Gods and the Giants. Presenting a textile seems appropriate enough, for Athena was, among other things, the goddess of weaving. But there clarity stops. Who wove it and how often? Was a new one made every year, or only every four years for the Greater Panathenaia? Just how big was it? How ornate was the weaving and what was the design? How was the cloth used? Was it simply hung up like a curtain, or was it intended to dress Athena's statue—and if so which one? Why were the Athenians doing all this and how long had they been doing it?

To get a better grasp on answers to these many questions, we need to arm ourselves with solid information about the nature of Greek weaving technology and the significance of cloth within Greek society and religion.

Bronze Age Background

The Classical Greeks had inherited a 7000-year tradition of weaving, which even before the end of the Stone Age had blossomed in Europe into an elaborate technology of pattern-weaving that had left the rest of the ancient world far behind. By the year 3000, Egyptian women were weaving fine white linens and the Mesopotamians were experimenting with simple striped cloth, but the pile-dwellers in the swampy backwaters of Switzerland were making polychrome linen brocades, using both a type of loom and a set of techniques developed even earlier along the middle Danube. By 2000, the Egyptians were weaving plain white linen of 200 threads to the inch (as fine as the most delicate handkerchief), but the Minoans were purveying to Egypt multicolored woolen cloths covered with elegant spiral patterns. By this time also, the weavers of Syria were making and trading textiles so expensive that they could only have been true tapestry.[1] Clearly, textiles flourished in the Bronze Age.

The Greeks, for their part, picked up this technology very quickly when they arrived on the Mediterranean scene early in the second millennium, as a careful analysis of the textile terms of their language demonstrates. The inherited Indo-European terms are sufficient only for weaving on a small, simple beltloom, but all the additional words needed for weaving on the large warp-weighted loom that was developed in Neolithic Europe are borrowed, a few (but not the most basic) clearly from Minoan itself.[2] This large and complex loom was used throughout Europe—by Minoans, Mycenaeans, Etruscans, Celts, classical Greeks and Romans, among others. With this loom the Greeks clearly acquired the basic pattern-weaving techniques that had been developed on

4 Lekythos with Athena battling the giant Enkelados, attributed to Douris, ca. 480

FIG. 63 Drawing of Penelope at her loom on a skyphos attributed to the Penelope Painter, ca. 440. Museo Archeologico Nazionale, Chiusi, 1831

it, namely twill and supplementary weft patterning (see p. 111).

By 1500, when the Mycenaean Greeks were constructing their citadels, the enormously increased trade around the eastern end of the Mediterranean was spreading textile products and weaving technology in all directions. Little ivory spindles made in Syria turn up at Perati in Attica in the late Mycenaean period, while demonstrably Minoan and Cypro-Mycenaean textile designs appear in Egyptian tombs throughout the era. The Mycenaeans themselves, like the Minoans before them, were involved in this textile trade in a big way. A single season's inventory from Knossos alone records close to 100,000 sheep, a large proportion of them castrated males (wethers), which are of use only for a wool industry.[3]

At least some of this Bronze Age array of textile techniques made it through the poverty and destruction that we know as the Greek Dark Age (roughly 1200–800) into Archaic and Classical Greece, as is shown by a number of textile objects, depictions, and references. Not least of these is a woven belt of about 1000 found recently at Lefkandi in Euboia, which has the same design as some textile representations from about 1450.[4] Vase-paintings suggest that the Bronze Age weaving traditions survived most strongly in Ionia, Attika, and remote parts of Crete, and the occasional literary references indicate much the same. For example, Plutarch mentions "a woman from Ionia who showed great pride in a piece of her own weaving, which was extremely valuable."[5]

Homer (or the poets that we know as "Homer") portrayed highborn ladies of centuries past working figured textiles every day. The epics describe Helen weaving battle scenes and Andromache weaving talismans (*Iliad* 3.125–27, 22.440–41), and imply similar activities for Penelope (fig. 63).[6] The *Iliad* also describes Hecuba going to the temple to lay the most gorgeous robe in her possession on the knees of Athena's statue in supplication during dark days at Troy (*Iliad* 6.269–311). Thus the Homeric poems preserve a tradition of Bronze Age roots for both the weaving of story-cloths and the habit of women offering textiles to their goddesses.

With this rich tradition in mind, we must tackle the questions surrounding the making of the sacred peplos of Athena. Fancy weaving in the fifth century was not a late and newly acquired art, for professionals only, but a household craft that had been at the very core of Aegean culture for millennia. In fact, given how old the tradition of ornate weaving was in the Aegean and how important it had been to the Bronze Age economy, it would be strange if the main religious customs surrounding weaving were not old and deeply rooted.

Textiles in Greek Society and Religion

Spinning and weaving occupied most of women's time in Classical Greece, just as it had since the Neolithic, just as it did until the Industrial Revolution, and just as it still did earlier in our century in rural Europe. Properly married Athenian women (as opposed to courtesans) spent their lives sequestered at home spinning and weaving for the family's needs, with or without serving-women to help, while they took care of the children and the food. Xenophon reports (*Oikonomikos* 7) that the fourteen-year-old bride of a wealthy friend knew nothing of the world other than how to work wool herself, and how

to allot woolwork to the maidservants. Processing raw flax or wool for sale as fiber or yarn was also one of the ways in which less privileged women—poor widows and freed slaves—might earn a living. Homer paints a touching picture of such a woman in one of his similes (*Iliad* 12.433–35):

> thus an honest woman, a handspinner, holds up the weights and the wool on either side of her balance, keeping them even, to earn a miserable wage for her children.

Of the 57 freed slavewomen in the Athenian manumission lists whose occupations are given, 44 were involved with textile work, presumably using the skills they had learned in their former households.[7] Rural women, who of necessity were less sequestered, then as today took their spinning with them as they carried on the numerous tasks of farm life, for it took many times as long to spin a pound of fiber as to weave it. Herodotus (5.12) tells a humorous tale of King Darius' amazement at seeing a woman spinning flax while walking to and from the river, balancing a water-jug on her head and leading a horse to be watered (fig. 64).

Although making cloth and clothing for the family seems from all the evidence to have occupied most of women's time inside the home, in the outside market textiles were no longer the central commodity for foreign trade that they had been in the Bronze Age. The Athenian weaving shops that made cloth for sale were small—a shop of even a dozen employees, consisting of male and/or female slaves, was large and unusual, as we learn from Xenophon's story of Sokrates and Aristarchos.[8] Apparently the trade was basically local.

Given that women devoted most of their waking hours to preparing textiles and food, it is entirely understandable that what we see Greek women making for the gods is always food and clothing. We know, for example, that Athena's peplos was traditionally woven by young women selected from upper-class Athenian families (see below). It is also particularly appropriate that the women of Athens should weave cloth for their goddess, since textiles were the special province of Athena—or, to put it the other way around, since Athena was in part the divine representative of the principle of weaving.

FIG. 64 Oinochoe with woman spinning, attributed to the Brygos Painter, ca. 490. British Museum, London, D13

Among the Olympian gods, Athena was the goddess of all crafts, but since she was herself female she was most particularly the patroness of women's work. We see this clearly in Hesiod's story of Pandora, which he tells twice among his extant poems. In one case he shows Zeus ordering Hephaistos to fashion the girl Pandora out of clay, Aphrodite "to shed grace on her head," and Athena "to teach her skills—to weave a complex warp" (*Works and Days* 60–65). In the other account (*Theogony* 573–75), Athena is made to provide her with suitable clothing:

> The owl-eyed goddess Athena dressed her in a girdle, and decorated her with shining raiment. From her head she spread with her hands a highly worked veil, a wonder to behold.

Both accounts underscore the close social connection between women, cloth, and clothing. For Athena's close connection with weaving, one can also cite the famous and thoroughly embellished story that Ovid tells of Arachne. This unfortunate mortal's hubris in challenging Athena herself to a weaving contest results in the girl's metamorphosis into the first spider, doomed to weave forever. That the basic story is far older than Ovid

FIG. 65 Drawing of an aryballos with contest of Athena and Arachne, from Corinth, ca. 600. Archaeological Museum, Corinth, CP 2038

is shown by a tiny Corinthian jug of ca. 600 (fig. 65) showing the contest.[9]

A tangible indicator of the close tie between Athena and weaving comes in a number of loomweights from the Greek colonies in Italy. On these weights Athena herself appears in the form of an owl, her sacred bird, spinning wool from a wool-basket in front of her. The owl is shown with a pair of human arms and hands (in addition to the expected wings and feet) to do the work, as on a late fifth-century weight from Tarentum (cat 12).[10]

Cloth and clothing were often dedicated in Greek temples, and such things appear frequently in the temple inventories. Moreover, on the Akropolis, Athena's "home," excavators have found a number of fragments of terracotta dedications (now in the National Museum of Athens) showing weaving scenes. Since they depict both women and weaving, they were almost certainly dedicated by women.

Athena was not the only deity in Greece to which clothing was offered on a calendrical basis, but the practice was not common. In his dissertation on the peplos of Athena, John Mansfield has gathered together the small number of known Greek rituals involving the actual weaving of a garment for a deity (as opposed to mere routine maintenance of cult objects). He notes two instances for Hera, at Argos and Olympia (Kallimachos, *Aitia* Book 3, and Pausanias 5.16.2), one for Apollo, at Amyklai (Pausanias 3.16.2), and possibly a second for Athena at Argos. On the other hand, says Mansfield, "only in the case of Athens . . . is it known that the garment was actually placed upon the statue."[11]

The textiles that both people and gods wore were important indicators of status, as they always have been.

We shall return presently to some of the elements of that social code in discussing what the peplos looked like. But first we need to know how the Athenians made cloth in general and a woolen peplos in particular.

The Greek Technology of Cloth-Making

The two main fibers were flax (producing linen) and wool. Wool was more common, because sheep were easy to keep and could be grazed anywhere in Greece, whereas flax required a relatively rich soil to grow in and lots of water (a precious commodity) for its initial processing. Wool also had the advantage over linen of coming in various colors (from black through grey and brown to tawny, beige, and white), being easy to dye, and providing greater warmth in winter. Linen, on the other hand, was softer next to the skin and much stronger. Regardless of which fiber was needed for a particular use, however, what was not grown by the family could be purchased in the market.

The first step in processing the wool was to clean it of burrs and other debris, to untangle the knots, and generally to comb it out loosely into long, fluffy, sausage-shaped rolls for easy spinning. Three women are shown performing this task on a handsome sixth-century lekythos by the Amasis painter (fig. 66a, b), a vase that depicts most of the stages of cloth-making. (Two of them are standing and one sitting, each with a wool-basket in front of her, and each holding the top end of a fluffy roll that is mostly coiled in the basket.) All our evidence indicates that in ancient times wool was invariably combed so the fibers lay parallel, to make so-called

FIG. 66 a, b Lekythos with women working wool, attributed to the Amasis Painter (obverse and reverse), ca. 560. The Metropolitan Museum of Art, New York, Fletcher Fund, 1931, 31.33.10

FIG. 67 a, b Villanovan bronze pendant, ca. 600. Museo Civico Archeologico, Bologna

"worsted" thread, rather than carded into a spongy mass of fibers lying every which way, like modern knitting yarn.[12] Worsted yarn is much stronger than yarn from carded wool, but it also has a harsher feel.

Since the wool was often weighed out at this stage in lots sufficient for individual weaving projects (a step also shown on the Amasis vase), the whole process of cleaning, combing, and spinning the wool came to be known as *talasiourgein* ("to work the allotment," from ★*tla*-"weigh," whence *talasia* "weighed allotment," and from *ergein* "to work").[13] This half of the job is nicely illustrated on one side of an Etruscan or Villanovan bronze pendant of ca. 600 (fig. 67a).[14] At the bottom, two women sit comfortably chatting while they clean and comb the wool; above them a woman spins.

The other side of the pendant (fig. 67b) shows the second half of the task—making the warp and then setting up the loom and doing the weaving, collectively known as *histourgein* ("working the loom," from *histos* "beam" or "loom"). At the bottom, one woman weaves the heading band (see below) while the other pulls out the loops of thread destined to become warp, until they are long enough to slip over the measuring pegs behind her. Above, a third woman weaves while a fourth brings her a new supply of weft yarn. It is noteworthy that in most of the ancient and prehistoric representations of weaving, two or more women are working together, helping each other. It was a communal activity, both because two women working together formed an efficient team that could produce more than two women working separately, and also because it was more congenial to have a companion.

FIG. 68 Diagram of a warp-weighted loom

The warp-weighted loom traditional to Europe is different from other looms in several ways. It is a vertical loom (like the Near Eastern tapestry loom and unlike the Egyptian groundloom), but the warp threads are merely hung from the top beam. Tension on the warp, mechanically necessary to keep the threads in one place long enough to insert the weft, is achieved by hanging weights on the bottom rather than by tying the bottom ends to a second beam. All of this can be seen, once again, on the Amasis lekythos, which provides one of the clearest ancient representations of the loom and its parts.

This unique mode of tensioning has many consequences. Archaeologically it means that we can trace the development of this loom all the way into the sixth millennium, since the sets of baked clay loomweights are less perishable than the exclusively wooden parts of other looms. Thus, for example, we can spot the advent of mechanized twill pattern-weaving in the Aegean in the third millennium, because we see a shift to much larger numbers of smaller weights, falling in more than two rows.[15]

For the weaver this method makes certain patterning techniques easy and even obvious, whereas others are ruled out. Thus, neither tapestry nor pile knotting can be done on this type of loom, because both techniques require an immobile warp under extremely high tension. The warp on a warp-weighted loom swings around and can be picked up. Twill and supplementary weft float patterns (see below) are easy, however, and all the surviving pattern-woven textiles from Europe are in these techniques. Any designs put into Athena's peplos will thus not have been true tapestry.

The design of the warp-weighted loom (fig. 68) also means that the weaver has a particularly tricky task in tying the warp and its weights onto the loom in order to begin weaving. The problem is that, unless the warp is stabilized somehow in advance, the weights will yank the warp-threads out of place as the weights are being tied on. The traditional solution, already visible in the Neolithic fabrics from Switzerland, is to weave the warp threads through a band as a separate step. This heading band (*ex-astis*) with the warp-threads hanging down is then fastened to the top of the loom, after which the warp (*asma* or *di-asma*) is divided in two (every other thread to either side of a bar, to form the primary division or "shed"), and the weights are fastened to the bottom. This process is called *attesthai* or *di-azesthai*, defined loosely by the lexicographer Hesychius as "to set the warp in the loom" or "to divide"—seemingly diverse meanings that make perfect sense once one understands the loom.[16] Because of the heading band, the cloth comes out with three closed edges, unlike textiles from other looms, which have two. The only raw edge is at the bottom where the weights are cut off after weaving. And because, for technical reasons, the warp-threads are woven into the heading band in pairs, the top edge ends up with a strongly ribbed appearance, different from the weave of the rest of the cloth. This unique ribbed edge can be seen clearly on virtually every piece of cloth sculpted on the Parthenon frieze (fig. 69): on the edge flung over the left arm of each man, and on the left edge of the folded cloth—presumably the sacred peplos—at the center of the east frieze.[17] Clearly the sculptor of this particular textile was copying a cloth woven on a warp-

FIG. 69 Parthenon frieze: apobates. Courtesy Alison Frantz

weighted loom, a deduction that is doubly strong since this is the only large loom for which the art and archaeology of ancient Greece give us any evidence.

The use of the warp-weighted loom means, however, that any piece of cloth woven on it is likely to have been no more than four to six feet in either direction. (The widest loom recorded, either archaeologically or ethnographically, is 240 cm., accommodating a textile width of at least 30 cm. less than that.) To weave a wider cloth meant obtaining a loom beam and a shed bar that were longer than usual, and correspondingly heavier. Wood was scarce in Attika, but if money were no object, one could imagine widening the loom by perhaps another foot or two, but it is hard to justify more. Making the cloth larger in the other dimension would be easier, but that too had its difficulties.

To weave a longer cloth meant fitting the loom with a roller-beam mechanism at the top (it is not entirely certain from the representations we have as to when such a device was invented), or finding some other way to keep the working part of the warp within reach of the weaver. The Etruscan pendant, for example, shows the weaver sitting on a balcony; contemporary Hallstatt weaving huts sometimes had trenches into which the extra warp hung down; and the little Corinthian aryballos depicting the weaving contest between Athena and Arachne (see fig. 65) shows the women standing on little stools or platform shoes.[18] Clearly, any attempt to lengthen the warp involved considerable adjustments: hence it may be considered possible but not very probable. Even with a roller beam, one is faced with the formidable task of retying all the weights on the warp every time the warp is rolled any sizable distance. To get a substantially larger textile, such as might be needed for a sail, one would have to weave several cloths and stitch them together.

The usual estimate for the size of an ordinary Greek woman's peplos (fig. 70), the genre of garment that interests us here, is at most five feet by six, based upon the average height of Greek women at that time and upon the way we see the dress draped on ancient representations. We can see that this matches what we know of typical cloths from the warp-weighted loom, and in fact the dress style was almost certainly at least partly a function of what the available loom made it convenient to weave. The size in turn gives us a good basis on which we can make some other interesting estimates, such as how much wool was needed for such a dress and how long it took to process the wool.

For comparison, a 5′ by 6′ handwoven woolen pile carpet in my collection weighs around seventeen pounds; it is far too heavy to wear and too stiff to drape. On the other hand, a handwoven Polish peasant cape of worsted wool (close to what I would have expected the Greeks to be making and wearing), 3′ by 6½′ in size, weighs a mere one and a half pounds; a 5′ by 6′ cloak of this material would then weigh something under two and a half pounds. These two figures can safely be taken as outer limits for the weight of the ordinary peplos worn by an Athenian woman, with the true figure clearly lying near the lower end. In both Mycenaean and medieval times, a sheep seems to have yielded an average of 1.6 pounds of wool,[19] so for the sake of round numbers let us assume that the garment required the fleece of two sheep, and ran about three pounds—a reasonable cloth both to wear and to produce on a warp-weighted loom.

A woman accustomed to using the European dropspindle has estimated that she could spin two ounces of prepared wool into the requisitely fine, two-ply worsted yarn in about three hours. To spin three pounds of wool thus amounts to twelve days of spinning for six hours a day. So let us give a generous estimate of a month for one person to clean, comb, and spin the wool for a peplos. My own experience suggests that it might take at most a week of two people helping each other to make and set up the warp. Then the weaving can begin. If the weaving is fully mechanized—that is, plain-woven with

FIG. 70 Diagram showing how a peplos is worn

or without stripes, or woven in a fairly simple twill—one could weave the necessary five to six feet in a few days, especially if two women are working the loom together, as we know they often did.

We know, however, that the peplos of Athena was elaborately figured with Athena, Zeus, giants, horses, war-chariots, etc. That sort of pattern-weaving takes a huge amount of time by any technique, because, since each figure is unique, it has to be darned in carefully by hand. We know also that the priestesses were allotted nine months in which to do the job, a time-span commensurate with intricate pattern weaving but absurdly excessive for a plain peplos. Let us see, then, what we can deduce about patterning techniques.

The most well-known method of weaving pictures into a cloth is, of course, tapestry. True tapestry involves running each color of weft across the warp only where the color is wanted for the pattern, and packing it down so hard that the warp doesn't show at all. Tight packing requires extremely high tension in the warp, and unless the packing is tight, not only will the warp show through and spoil the effect of the color fields, but the fabric will tend to fall apart when taken off the loom, partly because there is no single weft that goes all the way across the fabric to stabilize it.

We have already seen that the warp-weighted loom rules out the use of true tapestry technique because of insufficient tension. But there is another way of weaving a dense color-field of any shape in any place (which is what is required for depicting people, animals, etc., on a cloth which tells a story). This is the old European method, inherited by the Greeks, of floating a colored pattern-weft across the top of a ground-weave. That is,

one weaves a plain background cloth as usual, but between each row of ground-weft (one that goes all the way across and holds the cloth together) the weaver inserts an extra colored weft-thread, bringing it to the top as needed to form the pattern, and otherwise leaving it to ride behind. Hence the technical term, supplementary weft-float pattern. (The reader may have seen typical Colonial New England bedspreads made this way.) If the pattern thread is a bit thicker than the ground thread, it will cover the ground threads entirely, giving much the same illusion as tapestry. The same trick can be done in the warp direction with extra pattern-warps, as in the belt from Lefkandi (see p. 104), where thick colored threads of wool formed the pattern against a ground of fine white linen. Note that the basic cloth is thus used as a ready-made background for the figures being created by the pattern threads, a feature which can make a weft-float story-cloth quicker to weave than a tapestry one, and therefore less costly. (In true tapestry there is no such background, since every bit of space has to be filled in separately by the pattern-wefts.) We will return to the question of cost presently.

There are two basic ways to handle a floating supplementary weft. One is to have a pattern bobbin for each and every little area to be filled in with that color (much as in tapestry, but over the ground-weave). The other way, far more efficient when one color is being used a great deal, is to carry the pattern thread all the way across the cloth each time, bringing it to the surface where needed. This method is very efficient for small, repetitive, all-over patterns, which are what the Minoans (for example) had specialized in, and is almost certainly the variety of weft-float that the Greeks had inherited from

FIG. 71 Indonesian tampan pasisir (ship-cloth) from Sumatra, 19th century A.C. The Cleveland Museum of Art, Cleveland, Gift of The Textile Arts Club, 84.50

the Bronze Age. But when one tries to use it to tell a story, that is, to produce a non-repeating pattern, a serious problem arises. If the pattern thread in a particular row has to float very far on the back of the cloth before it is needed again on the front, long threads develop that are easily snagged once the cloth is in use. The solution that quickly becomes obvious to the weaver is to add extra little filler ornaments between the story-figures, to catch and hold the pattern threads. And because of the structure of weaving, the fillers always end up looking the same, whether they are on Austrian ribbons or Indonesian ship-cloths (fig. 71): diamonds, chevrons, "pine trees" and any other sort of simple figure based on the diagonal.[20]

We see the same sort of filler decorating the backgrounds of early Attic vases, from the Dipylon funeral vases onwards (see p. 79, fig. 52), and occurring at just the appropriate intervals. The figures of the dead and of the mourners, moreover, have also been transformed into the triangular-shouldered stick-figures typical of slightly debased versions of this weaving style, and the entire composition has been divided into thin horizontal bands (which is the way a weaver's weft builds the cloth, and which therefore is the most natural way to build a picture when weaving). There is no structural reason whatever for the vase-painter to do any of these things. He does not have to build his depiction with one horizontal thread at a time, he is not wrestling with successive rows on the diagonal from each other, and he has no floats to catch. He can copy anything he sees — and it is now clear what he has been looking at: weft-float textiles showing people and other non-repetitive figures.

But if the Geometric vase-painters were copying weft-float story-cloths, that means, once again, that the use of weaving by Greek women for telling stories predates the beginning of Geometric Greek art. In fact, so many motifs in early Greek art can be shown to have come down from the Bronze Age, once we understand the channel of transmission,[21] that we can conclude that the tradition of making story-cloths such as the peplos of Athena must have come down from that era too.

The Panathenaic Peplos

Armed with this information about Greek weaving, let us turn now to the Panathenaic peplos in particular. What do we know about it from written sources?

We know that the peplos was a rectangular woolen cloth described as showing the figures of Athena and Zeus leading the Olympian gods to victory in the epic Battle of the Gods and the Giants (see, for example, the lines from *Hecuba* quoted on p. 103). That is, it was a cloth that told or represented a story in the weaving. Such woolen story-cloths were clearly a regular part of Greek culture, and we have already seen the technology behind them. In both *Iphigeneia in Tauris* and *Ion*, Euripides shows his heroines discussing the myths they wove into their cloths as young maidens, and in the latter play Euripides has Ion (a temple servant at Delphi) fetch a large number of story-cloths from the temple storerooms in order to set up a huge outdoor pavilion for a feast.[22] The cloths had been left as dedications, we are told, either made for the purpose or as part of the spoils of war. (None of this is unexpected. Temples and temple treasuries functioned as the cultural repositories or "museums" of their day, just as cathedrals did in the Middle Ages, and fancy cloth pavilions were widely used already in the Bronze Age.)

The sacred peplos was also made specifically by townswomen, according to Euripides, who shows the homesick Iphigeneia mourning that she will never weave Athena and the Titans like the other women (*Iphigenia in Tauris* 222–24). In addition we also have the clear state-

FIG. 72 Parthenon frieze: peplos ceremony. Courtesy Alison Frantz

ments of the lexicographer Hesychius. Under the term *diazesthai*, which we discussed above as the verb for hanging the already-made warp onto the warp-weighted loom, dividing it, and attaching the weights, he mentions that this is what the *ergastinai* do at the Chalkeia festival, nine months before the Panathenaia, in order to begin the weaving of the sacred peplos. He explains ergastinai as the girls who weave the peplos. Another ancient author says much the same, explaining that the Chalkeia is "the same day on which the priestesses together with the *arrephoroi* also warp the peplos."[23] The youthfulness of the arrephoroi, the four girls of perhaps seven to eleven years old who were chosen from aristocratic Athenian families to live on the Akropolis and serve Athena for a year, is no argument against their being able to weave ornate textiles. Young girls do a great deal of the weaving of patterned pile carpets in the Near East even now: in fact, they are preferred because their fingers are small and nimble, and they still have good eyesight.

Many other women were apparently involved in the process too. These included the "priestesses" mentioned above, and other women who helped comb and spin the wool prior to the beginning of the weaving. Thus Mansfield reports that "groups of young women, over one hundred in number, [were] honored in a series of decrees from the end of the second century for 'having worked wool for Athena for the peplos.'"[24]

A few ancient authors, however, refer to a peplos for Athena that was made by professional weavers. According to the *Constitution of Athens* (49.3, 60.1), the weavers were commissioned to produce this peplos as the result of competition. (The original committee that awarded the commission was accused of favoritism, we are told, and had to be changed.) Zenobios and Athenaios even name a few of these male professionals (see below).

A solution to the puzzle of who wove the peplos, women or men, has been worked out painstakingly by John Mansfield. His argument is complex but, in a nutshell, he concludes that there were *two* peploi given to Athena—one made every year in the age-old traditional way by women, and the other made once every four years by professional men. Mansfield noticed that the details concerning the women's peplos never overlap with those concerning the men's. The two peploi differ not only in who made them, but in periodicity, size, purpose, and means of display.

Every year, as we have seen, beginning at the Chalkeia, select Athenian girls began weaving a peplos figured with the gigantomachy. This garment, woven on a warp-weighted loom, would have been roughly 5' by 6', give or take a foot. We know from a number of ancient sources that this peplos was destined to clothe the roughly life-sized cult statue of Athena Polias on the Akropolis, for which purpose it was handed over, at the next Panathenaia, to the Praxiergidai, an Athenian clan that held the hereditary right and duty to maintain the statue's clothes.[25] This moment of handing over the peplos, folded and with its ribbed edge clearly shown, appears to be depicted on the east frieze of the Parthenon (fig. 72; see n. 17).

On the other hand, at the Greater Panathenaia, a peplos was apparently displayed like a sail on the mast of a ship placed on wheels and drawn through the city like a float. The most circumstantial description of this event occurs in Plutarch's *Life of Demetrios* (10.5, 12.3). It seems that the Athenians had voted to honor a certain Demetrios (for saving Athens from its enemies) by having his portrait woven into the next peplos along with Zeus and Athena. But as the Panathenaic ship-float passed through the Kerameikos during the procession, a tremendous squall hit and the sacred cloth was ripped up the middle. (This implies that the ship's peplos was rather large in proportion to its thickness, more so than what we have deduced about the normal peplos.) We get more details from other authors. In his comedy *The Macedonians*, written ca. 400, the poet Strattis refers to "countless men" hauling on the ropes to raise the peplos to the top of the mast, and others refer to the considerable expense of the ropes and tackle needed to do this job.[26]

Thus the sail-peplos was indeed very large. We know that, to dress the cult statue, the peplos needed to be roughly 5′ by 6′. We must allow something for comic exaggeration, of course, but a 5′ by 6′ cloth flexible enough to serve as a dress and thin enough to be ripped by the wind could have weighed no more than three or four pounds at the outside, probably rather less—not enough to strain the muscles of a single girl, let alone countless men. Furthermore, a sail that size would look silly hung on a "ship" bigger than a rowboat (see below). We need to imagine a cloth far bigger than the peplos for Athena's statue as the "sail" of the ship-float, in order to accommodate all our facts.

The use of a ship in the Panathenaic procession possibly began shortly after the Persian Wars, using one of the boats from the battle of Salamis to celebrate and recall the saving of the city.[27] So presumably this second form of peplos-offering began then too. Similarly, the first professional weavers said to have made a peplos, Akesas (or Akeseus) and Helikon, seem to have flourished about that time.[28] Thus, because the "sail" was too big to be suitable as a dress for the statue, and because the dress itself was traditionally the Athenian women's special offering to their goddess (whereas the "sail" was made by men, and for pay), and because of the consistent difference in reported frequency of the two offerings, Mansfield makes a strong case for there having been not one but two peploi woven for the Greater Panathenaia (from the 470s on), and only one—the traditional dress—in the years in between.

There is also linguistic evidence in this argument's favor. Mansfield discusses a scholiast who explains that "by special usage among the Athenians, peplos means the sail of the Panathenaic ship, which the Athenians fit out for the Goddess every four years. . . ." Mansfield points out that the scholiast is not saying that the dress of Athena is used for the sail (then there would be nothing extraordinary in the use of the word), but that the Athenians have transferred the use of the word "peplos" from the dress to another cloth that isn't a dress.[29] Semantic re-evaluation of this sort is a well-known linguistic phenomenon and requires a pivotal situation in which both uses of the word are equally appropriate. If the dress was not used as a sail and the sail not used as a dress, then the only point of connection can be that they were two manifestations of the same religious offering of a textile, and hence that they were both pieces of cloth bearing the same sacred scene, the Battle of the Gods and the Giants.

Apparently the quadrennial sail-peplos was so magnificent that even a Roman like Plautus could make jokes about citizens taking special trips into Athens once every four years to see it.[30] It was also far too costly to use or display for only a single day. Thus Mansfield's suggestion that it was hung up in the temple somewhere for the next four years, perhaps as a backdrop to one of the statues, is a reasonable one.[31] Ritual textile backdrops were well within the Greek tradition (a point we saw briefly above), as they are in many cultures including our own.

Now we can turn to the question of how the design on the peploi—the Battle of the Gods and the Giants—may have been treated. For the large sail-peplos made by professionals we have no information. We do not even know for sure what kind of loom the men used, since the tapestry loom was well known elsewhere in the Mediterranean and could have been imported at any time by specialists. In fact, if Athenaios (*Deipnosophistai* 2.48b) is correct in his assertion that Akesas and Helikon were Cypriot, they may very well have been using tapestry

FIG. 73 Detail showing Demeter on a skyphos by Makron, ca. 480. British Museum, London, E 140

FIG. 74 Marble sculpture of Athena, 1st century. Staatliche Kunstsammlungen, Dresden, 26

looms and true tapestry technique. They may also have been employing the layout of textile designs in stacked friezes that was begun there in the Late Bronze Age. It is the best guess we can make, given that the much later story-cloths of large dimension that have survived from areas of strong Hellenic influence were designed that way.[32] Nowhere have we any evidence in the ancient world for the weaving of a single large scene on a cloth, like the huge and incredibly expensive Gobelin tapestries of France.

We can say more about the traditional cloth made by the women, however, because we know for certain that it was made on a warp-weighted loom, which, as we have seen, entails certain limitations; and further, because we can deduce from Archaic Greek art something about the traditional textile forms. What we see are two forms: successive scenes in a series of horizontal friezes going the entire width of the cloth, and square panels in a ladder-like arrangement going down the front of the garment.[33] These, then, are our chief candidates for the design of Athena's peplos.

Representations of women wearing clothing covered with story-friezes of people and animals are numerous. From the Akropolis itself we can mention some small terracotta statuettes in the National Museum in Athens (e.g., Akr. 15148, ca. 590), and the Euthydikos Kore (Akr. 686, ca. 490), on whose shoulder is to be discerned a frieze with a chariot race.[34] Other early representations include the François Vase (ca. 570) and various vases by Sophilos (such as the magnificent dinos in the British Museum), also early sixth-century, all of which show many an elegant princess and goddess wearing garments friezed in this fashion. From a century later we have the vase from Chiusi showing Penelope weaving such a frieze at her loom, and a vase by Makron (fig. 73, ca. 480) showing Demeter wearing a splendid cloak friezed with leaping dolphins, racing chariots, and winged runners.

Representations of women wearing the ladder-like panels are rather fewer. A Tyrrhenian amphora by the Timiades Painter, dated to the second quarter of the sixth century and now in the Boston Museum, shows Herakles fighting an Amazon named Andromache who is wearing just such a dress. In a marble statue now in Dresden (fig. 74), Athena is shown wearing aegis, gorgon's head, and a ladder of a dozen small picture-boxes

down the front of her dress. The metope-like boxes contain scenes of dueling that are commensurate with the Greek conventions for representing that battle. The statue is in fact Roman, of a mixed Archaistic and Classical style, so it is not clear how accurate a representation it might be of sacred peploi of, say, the fifth century. But it was clearly intended to put the beholder in mind of Athena and her famous peplos with the gigantomachy.[35]

Both horizontal friezes and square panels seem likely candidates for the design of Athena's peplos. Friezed clothing is widely attested and is represented among artifacts found on the Akropolis itself; ladder-panels are also attested for clothing, and at least once are shown on a statue of Athena herself.

Rather than trying to decide which design was used, we may perhaps say that sometimes one style was used, sometimes the other. It is worth noting that the relative costs of these two forms are very different, a factor which could well have had an influence on the design chosen from one year or decade to the next. The stacked friezes, which run the width of the cloth and therefore cover the whole textile, would be very time-consuming and hence very expensive. Much less costly would be the ladder of figured panels up the front of the dress, because the rest of the cloth is plain and could be woven quickly and mechanically—even if it were made suitably magnificent by using colored yarns and/or a mechanized twill pattern. One could imagine that the cheaper method might have been used in years when Athens was hard pressed for financial resources or for the necessary peace and quiet to complete a more ambitious cloth. But the weaving technique for both the ladder-panels and the long friezes would be much the same, and we have considerable evidence (some of it cited above) that heirloom textiles were stored in the temples for long periods of time, sufficient to stimulate the weavers' imaginations when they had more resources to apply to so central a ritual object as the dress of their patron deity.

We get a final interesting insight into the tradition of the peplos, and its great antiquity, when we consider the colors used for Athena's dress. In his play *Hecuba*, quoted above, Euripides called it a "saffron peplos" worked with "flower-hued wefts." A scholium on the passage claims that Strattis, too, "makes clear that the peplos was saffron and hyacinth-colored." The most expensive and sought-after dye was of course murex purple (Homer portrays Helen of Troy sitting at home in Sparta spinning sea-purple wool: *Odyssey* 4.135), and it may well have been used as the chief contrasting color in making the pattern.[36] An outstanding virtue of sea-purple, aside from its intrinsic beauty, was that it was colorfast (as was saffron) to both water and prolonged exposure to light, unlike most natural dyes. The peplos would be exposed to light daily for an entire year. But the dominant color—presumably the color of the ground-weave—was saffron-yellow.

Saffron-yellow was the color associated throughout Greek myth and ritual with women: early authors Homer and Hesiod regularly use epithets like "saffron-robed" for female deities and heroines, from obvious ones like Eos (Dawn) to miscellaneous giantesses, nymphs, and muses. The clearest proof that saffron-yellow was specifically and exclusively a woman's color, however, comes from Aristophanes, who invariably bedecks in saffron clothing the men he portrays as effeminate and those who are masquerading as women. The text of *Thesmophoriazousai* ("the women celebrating the Thesmophoria festival," lines 939–42) are chock full of yellow gowns, and when Mnesilochos' disguise is discovered and he is tied up, he begs the official to strip him first, "so that I, a full-grown man, don't have to be ridiculed in saffron robes and girdles...."

Recent excavations of the Bronze Age town at Akrotiri on Thera have shed new light on the early association of saffron with women. The house called Xesti 3 is decorated with a great fresco showing girls and young women of various ages collecting saffron-stamens in pails and depositing them at the feet of a goddess or priestess at the center of the painting. The fresco as a whole has been quite plausibly interpreted as a puberty ceremony, and we are informed that in the Aegean Islands saffron is still considered a medicine against menstrual ills.[37]

In this light, the depiction of saffron crocuses on both of the faience dresses found in the Temple Repositories at Knossos[38] begins to make new sense. In fact, these offerings give us proof that the Minoans of 1500 were already presenting dresses (if only in effigy) as well as saffron to a central female deity, however dif-

ferently the dress itself may have been structured to accord with fashion. The offering of saffron-colored robes to Athena in the next millennium is most simply viewed as a local continuation of such a custom for a not entirely dissimilar goddess. The Minoan deity and Athena are both associated, for example, with sacred snakes, symbols, even today throughout Central Europe, of household prosperity.[39]

The women involved in the saffron ritual of the Xesti 3 fresco are clearly of different ages as shown by hair style, clothing, and bodily development. Similarly, the accounts of the making of Athena's peplos tell us that the combing, spinning, and weaving of the wool involved young girls, older girls, and married women. The several parallels suggest that the ritual of making the peplos for Athena may (originally?) have had rather more to do with women's rites of passage than is immediately apparent.

Conclusions

To sum up, it now looks as though two sets of people wove peploi for the goddess, and at different intervals. Select women of Athens wove a normal-sized robe destined to dress the cult statue every year, whereas professional male weavers seem to have woven a cloth every fourth year for pay—a sail-peplos that was much larger, fancier, and newer in tradition than the women's, and not intended for the statue. Both textiles, however, seem to have displayed in their threads Athena's part in the Battle of the Gods and the Giants, as a renewed thank-offering to the patroness of Athens for saving the city from destruction. The women's cloth, at least, woven on the warp-weighted loom, must have shown these scenes in the traditional European weaving technique of supplementary weft-float, developed in the Neolithic and Bronze Ages. The saffron color of the peplos, too, may be part of a very old Aegean tradition intimately connected with women and their special goddess. All this evidence strongly suggests that the entire ritual of presenting Athena with an ornate new dress was a local relic of the Bronze Age.

And well it might be. We must remember that the Greeks came into the Balkans unable to weave anything bigger than belts, as the linguistic evidence demonstrates. The indigenous Aegean weavers, then, the "inventors" of Athena herself (a pre-Hellenic deity), are the most likely originators of all these customs. Furthermore, there is a well-attested principle in the mythologies of the world that the more important the domain of a deity is to a society, the more important the deity.[40]

It was during the Bronze Age, not the Iron Age, that textiles were at the heart of the Aegean economy. That is when women's cloth-rituals should have been at their peak, when both cloth and its female producers had far more economic importance than they did in Classical times.[41] The wall-paintings of Thera (both the saffron gatherers and the dressing ladies) as well as the faience dresses from the Temple Repositories at Knossos confirm that such rituals were already present in some form.

Regardless of the origins of the custom of presenting a robe every year to Athena, and regardless of the obscurity of some of the details of the event, the ritual clearly held an integral place in the lives of the Athenian citizens, most particularly of the women. She was their particular patron goddess, and to her they rendered the most appropriate gift they could make, a saffron robe: a splendid piece of weaving celebrating Athena and thanking her for one of her most famous deeds, the destruction of the world-threatening giants.

BRUNILDE SISMONDO RIDGWAY

Images of Athena on the Akropolis

Olympian gods, like humans, are subject to iconographic stereotyping. We visualize Zeus as long-haired and massive, Aphrodite as beautiful and scantily dressed, Hermes as the perennial traveller. Of all of them, Athena is perhaps the easiest to visualize: formidable, mature, and fully armed with helmet, aegis and shield, as she sprang from the head of Zeus at her birth, the prototypical wise female warrior. Although this image is essentially consistent with the texts, many variations on the theme are possible and were in fact used in depicting the goddess in antiquity, each period and location preferring a slightly different iconography for religious or symbolic reasons.

In terms of location, Athens and Athena seem inextricably bound by their names, although it is uncertain which came first, the deity or the city. To be sure, both of them go back to prehistoric times, the goddess' name being now attested in tablets written in an early form of Greek, the so-called Linear B script, although found at Knossos, in Crete, away from Athens.[1] Athena was worshipped throughout the Greek world, and even at Troy, according to Homer (*Iliad* 6.303), but Athens is thought to have been under her direct patronage, and the Athenian Akropolis was her special seat, focus of many rituals and beliefs. Several of them centered around venerable images of the goddess, and many private dedications stood within the sanctuary, their epithets highlighting different aspects of Athena. This essay attempts to trace her sculptural iconography through time, but primarily in the main period of the Akropolis' greatness, from ca. 700 to ca. 400.[2]

Even in as literate a place as Athens, however, it is difficult to find clear evidence for the forms cult images and festivals took through the centuries. It should first be stressed that religion held such a major place in the Athenians' daily lives that no need was felt for elaborate accounts and explanations: everybody knew what it was all about. Our reconstructions are complicated by the fact that many of the ancient testimonies were written considerably later, some almost a millennium after the time under review, and almost all of them addressed concerns different from our own.

The more nearly contemporary texts are building accounts, inventories of temple treasures, historical narratives, dramatic plays, rhetorical speeches; later in time, there are learned commentaries on previous literature, and religious treatises tinted by Christian bias. They offer snatches of information that cannot always be trusted. The best among such sources is the account of the traveller Pausanias, who around the mid-second century after Christ visited Greece and wrote a detailed description of the ancient monuments he saw. His pages on the Athenian Akropolis are of primary importance (without them, we might not even have known the subjects of the Parthenon pediments!), but they reveal his difficulty in accounting for all the many features of an unusually rich sanctuary, and have not even come down to us in their entirety, betraying some gaps at crucial points.

The material remains may seem far more useful and plentiful: actual statues, inscribed statue bases, temples which housed images and were decorated with related architectural sculpture, and representations of Athena on Attic black-figure and red-figure vases. But Archaic statues, deprived of their ornaments, attributes, and often their original color, are difficult to identify. Statue bases tell us little about the appearance of the figures they once supported. Temples retain only faint traces, at best, of the cult images they sheltered, and their architectural decoration is badly damaged and fragmentary. Finally, vase-paintings do not always distinguish between the

61 Marble relief, 1st century

goddess as a presence (epiphany) and as an actual monument, nor can they be expected to be reliable in all details, even when a statue is clearly indicated.

In addition, various marble sculptures in classical style were carved during times of Roman supremacy, as reproductions of famous images of Athena (cats. 56, 59, 60). Although these so-called Roman copies can in some instances be identified with certainty as replicas (for example, of the Pheidian Parthenos), they differ in detail from the originals, most often because of their considerably reduced scale. In other cases, we cannot be sure that they copy statues from the Athenian Akropolis, and in still others, whether they are indeed more or less faithful imitations of classical prototypes or outright creations in retrospective style. Indispensable as the Roman copies are for our knowledge of the Greek monuments, they should be treated with caution.

Various theories, some of them contradictory, have been advanced about the Akropolis Athenas on the strength of these various forms of evidence. We shall here endeavor to clarify the complexity of the issue, focusing on sculpture by types, and in roughly chronological order, but discussing also locations and rituals, since these are often inextricably involved with our understanding of the imagery.

The early Akropolis is shrouded in relative darkness. Continuity of occupation from the Mycenaean period onward seems assured, but remains are few and uncertain. Homer tells us that Athena lived within the palace of King Erechtheus (*Odyssey* 7.80–81; see also *Iliad* 2.547–549, where Erechtheus is said to share her temple), but whether the concept is prompted by the presence of an actual image we cannot tell. Votive offerings are scarce, especially in sculptural form. Remarkable among these is a bronze statuette of a nude female, dated as early as the eighth century.[3] Naked goddesses are at home in the ancient Near East, not in Greece, and on the Akropolis this occurrence remains unique. It is well to remember that Athena was not the only female deity worshiped there, and this unusual offering might have been made to Aphrodite or Artemis, traditional fertility symbols; the former's cult is in fact attested on the slopes, the latter's on the citadel itself. On the other hand, attributes and identities might not have been firmly established at this early a date, and what was considered an appropriate gift for one deity might have served as well for another.

The Wooden Athena Polias

A temple of Geometric date seems to have existed on the Akropolis, on the evidence of two column bases, but these were not found *in situ* and tell us little about the total structure.[4] Moreover, the existence of a temple does not always correlate with the presence of a cult image, since empty shrines are known even from later times, and the focus of worship was traditionally the external altar. Yet in Athens a highly revered statue of olive wood was said to have fallen from the sky (Pausanias 1.26.6), and formed the center of devotion on the citadel. The tradition of its heavenly origin may suggest that no maker for the image was known, and it certainly added to the cult's venerability. The epithet for this wooden Athena was *Polias* ("of the city") and may also have been *Archegetis* ("the Founder");[5] these honors were shared with Zeus, who as *Polieus* also had a cult on the Akropolis. The wooden image looked so obviously ancient that tradition supported its remote past by associating it with mythological figures like Erichthonios and Kekrops, legendary kings of Athens; its vesture ceremony and the washing of its clothing were connected with Aglauros, one of Kekrops' daughters. It formed the focus of the Panathenaic festival, which was said to have been instituted by Theseus or alternatively by Erichthonios.[6]

There has been considerable discussion about this ancient statue and its appearance. On the one hand, we cannot even determine exactly where it was housed during the Archaic period, and whether it was standing or seated. On the other hand, its presence is so "tangible" that inventories of the fourth century give us the listing of its ornaments and clothing: gold diadem, earrings, neckband with attachments, several gold necklaces and a bracelet, a gold aegis and gorgoneion, a gold owl, and a gold phiale; the garments included the Panathenaic peplos, a himation, a Theran robe (*theraion*), perhaps hair veils (*trichapta*).[7] The phiale was held in the right hand,

5 Terracotta seated goddess, ca. 500–470

6 Terracotta seated goddess,
ca. 500–470

as if to receive libations; the gold owl may have been on her left hand, as it appears on third-century bronze coins of Athens that may show this statue. A helmet on her head may have been added later, since it is not included in the fourth-century inventories but is rendered on the above-mentioned coins; or, less probably, only gold, not bronze, items required listing, and thus the helmet went unacknowledged. Whether the Athena on the coinage truly reflects the wooden Polias is, however, still a matter of debate.[8]

Evidence for the statue's pose is at best inconclusive. That it was seated was inferred from various terracotta statuettes of Archaic date found on the Akropolis,[9] (cats. 5, 6), which could, however, represent a conventional type without direct reference to a specific image; yet their arms are muffled under their clothing, as if a real garment had been added to a statue that did not allow proper draping. Ancient mentions of other early idols refer to them as seated, including an Athena Polias made in wood by Endoios for Erythrai, in Asia Minor (Pausanias 7.5.4), but epithets could recur independently of iconography, especially at such geographical distance. That the Akropolis Athena was standing has been argued on the evidence of the above-mentioned bronze coins, which could, however, show a different statue; in fact, special pleading (a "modernization" of the wooden forms by Endoios) was needed to explain its apparent shapeliness, incompatible with the extant sources. The Panathenaic robe could have been more easily added to a standing figure, but its unfitted rectangular shape may have been suitable also for a seated image; at any rate, the ritual was established around the statue, rather than vice versa, and therefore the type of image could not have been determined by sartorial convenience.

In size, the Athena was probably relatively small, capable of being lifted and carried. This assumption is made not only on the basis of what little is known about early wooden sculpture, but also on some circumstantial evidence. First, there is the likelihood that the statue was removed from the Akropolis in 480, at the time of the Persian invasion, and taken to safety with the fleet. This transfer is never explicitly mentioned by the ancient historians, and it has recently been argued that the story of Themistokles' search for the missing gorgoneion in the baggage of the evacuees implies that the image had remained behind.[10] On the other hand, the same episode has usually been read to demonstrate the opposite, that the image was removed and its apparel (*kosmos*) perhaps rescued piecemeal. From the ancient silence about any damage to the statue by the Persian fire we may infer absence from the Akropolis, rather than special reverence on the part of the enemy. Herodotus (8.55) mentions a sacrifice on the Akropolis by the Athenian exiles right after the sack, but for this ritual only the altar seems necessary, not the image itself.

Another indication of relative smallness is that the Athena was clothed in actual garments. The ritual of this robing has traditionally been understood in a straightforward fashion, by assuming that all ancient sources on the Panathenaic peplos refer to the same item of clothing. John Mansfield has, however, recently argued that a distinction should be made between the peplos/robe—woven by privileged women and given to the goddess annually at the Lesser Panathenaia—and the peplos/tapestry, made by professional weavers selected by competition, and carried in procession as the sail of the Panathenaic Ship every four years as part of the Greater Panathenaia.

That a peplos of normal size could serve as the sail of a regular ship had already been considered incongru-

ous, and the difficulty had been circumvented by assuming that the cloth was much larger and served to dress the colossal Athena Parthenos by Pheidias in Classical times. This explanation is, however, unlikely: real garments were probably used in antiquity only for those images that presented no artistic embellishment of their own, whereas the gold-and-ivory Parthenos was especially impressive because of its materials; the splendid gold, fully modelled, would hardly have been covered by a cloth, no matter how luxurious.[11]

Conversely, the ship itself could conceivably have been only a small cart, but this theory should be discarded on epigraphical evidence listing tackle and mast and other appurtenances of a true boat.[12] If allusion to Athens' maritime power was indeed implied by the use of the conveyance, a regular ship, perhaps a trireme captured from the enemy and pulled on wheels, as suggested by Mansfield, would have been more effective than a ship-cart. Mansfield's interpretation of the sources reconciles the small dimensions of the annual peplos/robe with the sail-like size of the quadrennial ship tapestry.

One more argument on the Polias' size, based on the depiction of a cloth being folded on the east frieze of the Periclean Parthenon (see p. 113, fig. 72), carries little weight, to my mind, at least until the scene in question has been convincingly interpreted. Not only is it difficult to calculate exactly what dimensions are implied by the cloth represented,[13] but there is no assurance that the object is the peplos/robe given to the wooden Athena. The meaning of the Parthenon frieze will be discussed below, but we can anticipate the comment that its subject matter is still controversial. In addition, the current work of restoration on the Akropolis, by revealing the possible presence of a carved frieze above the great east doorway, has opened up new vistas for further interpretations.

Of greater iconographic importance is Mansfield's theory that only the peplos/tapestry was decorated with the gigantomachy, whereas the peplos/robe was plain. Elaborate weavings and hangings were certainly available in antiquity, as is known through various ancient references, primary among which is Euripides' *Ion*, lines 1141–1158, describing figured awnings also called *peploi*.[14] But that the annual robe for the wooden image was simply colored purple seems to me unnecessary infer-

ence. In fact, some allusions to gigantomachy weavings by Euripides suggest that the peplos/robe is meant. In *Hecuba* (lines 466–474), the Trojan women lament that, as captives in Athens, they shall be made to "yoke horses to the beautiful Athenian chariots in the saffron peplos, figuring it with crafted flower-dyed wefts, or [weave] the race of Titans which Zeus son of Kronos put down with a fiery bolt." In *Iphigeneia in Tauris* (lines 222–224), the protagonist laments that she will never weave Athena and the Titans like other ladies.[15] If the distinction between professional weavers and ladies of good birth advocated by Mansfield applies, Iphigeneia can only be ranked with the latter, and therefore should refer to the making of the annual robe, not of the tapestry.

Additional support is provided by an Archaistic marble statue of a striding Athena in Dresden (see p. 115, fig. 74), known also from at least two bronze replicas at small scale (one from Athens); the life-sized image wears a peplos whose central stripe, the *paryphe*, is decorated by eleven figured squares, each containing a duel between a god and a giant, as in a metopal frieze. Although the date of the sculpture cannot be earlier than the Late Hellenistic period, the iconography obviously refers to the Athenian ritual, thus suggesting that a decorated costume was actually worn by the image.[16] Since definite evidence exists that the sail/peplos illustrated the gigantomachy, it is perhaps simpler to assume that both robe and tapestry carried the same decoration, in different degrees of elaboration.

There is nothing inherently impossible in this assumption. Barber points out that Greek clothing was normally plain in the fifth century, except when worn by deities and foreigners. Athena, and in consequence her statue, fall into the first category. Plato (*Republic* 2.378c) states that one should neither tell nor weave gigantomachies, yet he must have been aware of the state ritual; is he advocating religious monopoly on the subject? Barber assumes that elaborate tapestries may have survived as heirlooms from Mycenaean times, and that the prehistoric origin of the Panathenaic festival is in fact confirmed by the detail of the peplos. The garment would have been an Athenian gift to the goddess who had saved her people from the giants by helping bury them under volcanoes and mountains. She sees fire ele-

ments in the Panathenaia and takes the Hesiodic description of the gigantomachy as a veiled metaphor for a volcanic eruption, perhaps a reminiscence of the Theran explosion.[17]

We shall return to the gigantomachy and its significance in discussing other types of Athena on the Akropolis. At present, we should outline the rituals involving the wooden image of Athena Polias. Two months before the Panathenaia (on 20–23 Thargelion), a special festival, the Kallynteria, was held for the adornment of the statue—a practice said to have started with Aglauros when she was made priestess of Athena. On her death, the sacred garments of the image were not washed for one year, whereupon the festival of the Plynteria was established to clean them (25 Thargelion): the statue was disrobed, probably sponged off (although not bathed at sea near Phaleron, as often stated), and then wrapped in a shroud, as a sign of mourning for Aglauros. During that period, the sanctuaries were closed and no sacrifices were offered. On the following day (26 Thargelion), the statue was unveiled and dressed again with the cleaned garments. This elaborate sequence of events, with its mourning element, is unparalleled elsewhere, although individual aspects of the ritual recur in connection with other ancient statues.[18] It is tempting to speculate whether the Panathenaic peplos/tapestry could possibly have served as the veil that covered the image when unclothed, in a clear allusion to the funeral for a corpse, since Barber points out that ancient shrouds could be very elaborate. Not only does the Homeric Penelope weave a funerary cloth for Laertes' last rites, but actual textiles have been found in the so-called Kurgan of the Seven Brothers and, in smaller size, in the Macedonian royal burial at Vergina.[19]

If we now summarize the information obtained from ritual and iconography, it would seem as if a relatively neutral wooden image—or at least one provided only with religious symbols of phiale (= libation) and owl (= wisdom) appropriate for the "Polias"—was gradually transformed by the Athenians through the addition of attributes into a more "typical" Athena with war-like connotations: aegis, gorgoneion, perhaps helmet, and probably peplos alluding to the goddess' role in the gigantomachy. Since the gorgoneion may have

FIG. 75 Akropolis sites with statues of Athena

1. Erechtheion: Athena Polias
2. Old Athena Temple: Athena Polias
3. Parthenon: Athena Parthenos
4. Athena Ergane
5. Athena Promachos of Pheidias
6. Athena Hygieia
7. Temple of Athena Nike: Athena Nike

existed by ca. 480, so would the aegis, implying that the transformation had already taken place within the sixth century. The reorganization of the Panathenaic festival, in ca. 566, may provide a suitable date for these additions to the statue. Other embellishments, such as various items of jewelry and extra garments, probably carried only messages of veneration and wealth.

The original location of the Athena Polias is one of the puzzles in the complex religious topography of the Archaic Akropolis (fig. 75). Around 510, the idol was most probably kept in the Old Athena Temple, the "Archaios Neos" mentioned by the inscriptions, which stood on the so-called Dörpfeld Foundations, just south of the "Erechtheion." One of the temple pediments was even decorated with a spirited gigantomachy in the round, thus creating a thematic link with the Panathenaic peplos. That structure used to be dated around 525, therefore before the advent of democracy but after the death of Peisistratos; it was consequently attributed to his sons and styled "the Peisistratid Temple." Revisions

in our assessment of architectural and sculptural developments have recently led to a lower chronology, which is gaining wider acceptance.[20] Much more controversial is the issue of its predecessor and, to some extent, of its successor.

The existence of an earlier structure on the Dörpfeld Foundations has often been advocated on the evidence of numerous architectural members surviving from the first half of the sixth century. Given the traditional date for the reorganization of the Panathenaic Festival, ca. 566, it is logical to assume that this grandiose building was erected in this connection. Yet the extant architectural remains correspond to a temple larger than what the Dörpfeld Foundations could accommodate, and which is therefore to be sought elsewhere.[21] The term Hekatompedon (the "Hundred-footer") mentioned by inscriptions as independent from the "Archaios Neos" had been taken to refer to just such a temple, but recent discussion has supported a different interpretation: the term would apply not to a building but to a sacred area.[22] Although this reading is generally convincing, a suitable location should still be found for the architectural elements mentioned above, and the area of the present Parthenon seems to offer the only, albeit undemonstrable, alternative.

Recent restoration work on the Akropolis has provided a piece of additional evidence for cult activity in that location. Within the north *pteron* of the Parthenon, that is, between the cella wall and the outer colonnade, a rectangular opening on the paving has been noted, which was once surrounded by a *naiskos* (fig. 76); additional traces on the floor reveal the former presence of an altar facing the small shrine. Although this unidentified cult could have been added later to the Periclean building, "strong circumstantial evidence" points to the shrine having existed at the spot before the Parthenon, and possibly influencing the latter's position, off the axis of the Akropolis.[23] The naiskos probably housed an early image, most likely of Athena. But was it the same as the olive-wood Polias or was it another early idol?

Some years ago, an influential monograph by C. J. Herington advocated that Athena was worshiped on the Akropolis under two main guises: as Parthenos ("Maiden") and as Polias; the former would have emphasized

FIG. 76 Reconstruction of the naiskos or small shrine in the north pteron of the Parthenon

the war-like character of the goddess, the latter her civic aspect. The epithets and cults would have corresponded to specific locations on the citadel, the Parthenos occupying the area marked by the Parthenon and its predecessors, the Polias claiming the sacred territory to the north with its many "tokens," and marked successively by the presumed Geometric temple (ca. 700 [?] to ca. 515), the Old Athena Temple (ca. 510 to ca. 480), and eventually the so-called Erechtheion (ca. 431–405 to the Christian era). This theory has lost favor in recent years, as epigraphical arguments have defended a northern location for the early sixth-century architecture; but if dimensions represent, as it seems, an insurmountable difficulty, we should perhaps reconsider the division both of temple locations and of cults. The newly noted shrine left uncovered within the later Parthenon may then mark the spot of the early "Parthenos" image, different from the Polias, even if not as venerable. During the sixth century, the iconographic distinction of the images might have been blurred, as mentioned above, but the tradition of separate cult aspects might have persisted.

Certainly, the sacred area of the tokens was considered worthy of a new temple even when the Periclean Parthenon stood in its recently completed glory. The Old Athena Temple, damaged by Persian fire, was thought by Dörpfeld and others to have survived as a charred ruin at its west end, since inventories of the Treasurers of Athena and the Other Gods mention an

enigmatic "Opisthodomos" as part of the Akropolis structures in 434/3 and later, and as apparently distinct from both the "Hekatompedos Neos" and the Parthenon. The wooden Athena Polias would have been housed in a temporary shrine in the area of the later east cella of the "Erechtheion" or in the "Opisthodomos" until the replacement temple was completed. W. B. Dinsmoor, Sr., even dated the removal of the "Opisthodomos" to 353, thus accepting that until so late a date a makeshift structure had blocked the view of the elaborate caryatid porch and conflicted with the optimal vista of the "Erechtheion" from the Propylaia.[24]

This sequence of events has, however, been challenged by the suggestion that the "Opisthodomos" of the inscriptions refers instead to the west room of the Periclean Parthenon, accessible only through the rear porch. That vast and impressive room, its ceiling probably supported by four tall Ionic columns, would have housed the treasure of Athena, and in fact its door, wider than the east one, was especially reinforced with iron bars attested by traces scraped on the marble floor by their sagging, while the intercolumniations of the prostyle porch were closed by grilles from which sills and tenon marks remain. This interpretation does away with the need for the hypothetical ruined west end of the Old Athena temple, for which no material evidence exists, and carries important consequences for the styling of the Parthenon itself, to be discussed below.[25] Barring this survival, therefore, we could return to the idea of a temporary shrine for the wooden Polias in the area to the north, for which vague traces may remain.

As part of the refurbishing program of the Akropolis, the so-called Erechtheion was finally built. Traditional dating used to place that temple in the 420s, with an interruption in the works attested by accounts of resumed activity in 409 until completion in 405. The current restoration work on the citadel has revealed that some unfluted column drums from the inner order of the earlier Propylon were reused in the foundations of both the Propylaia and the north wall of the temple, thus prompting the suggestion that the latter was begun before 431. Corresponding dimensions in the columns of these two buildings have also been taken to indicate that Mnesikles was the architect responsible for both.[26]

There is general agreement that the Ionic structure with the caryatid porch was the Temple of Athena Polias, often called by the ancient sources the Archaios Neos because it continued the tradition of the earlier buildings near the area, or because it housed the ancient image. But was it also the Erechtheion of Pausanias' account? This identification, presuming a double cult of Athena and Erechtheus, goes back to the early studies of the Akropolis in the seventeenth century, but is primarily based on Pausanias' account and on the restoration of a crucial inscription. Recent restudy of the epigraphic evidence has considerably lessened its import, and Pausanias's text (1.26.6–27.3) is certainly confusing at this point. The traditional reading would have him enter the west (rear) part of the temple first, devoted to Erechtheus, then describe the east (front) cella of Athena, and then again move westward to discuss the olive tree, which certainly grew within the Pandroseion to the west of the building. So difficult is this reading that J. Travlos some years ago attempted to reverse the traditional interpretation, suggesting that the west, not the east, section of the temple was the cella of Athena.[27]

Although Travlos' suggestion has met with opposition, there is a growing sense that the Erechtheion mentioned by Pausanias should be an independent building unconnected with the "Archaios Neos." Jeppesen tentatively located it to the west of the "Erechtheion," in the imperfectly known structure along the north Akropolis wall supposed to be the house of the Arrephoroi. Mansfield, emphasizing that Pausanias discusses the Erechtheion *before* describing the Temple of the Polias, suggested the area presently attributed to the cult of Zeus Polieus.[28] This is not the place to enter into the relative merits of each proposal, but one point should be stressed in relation to the cult image. The statue of Athena (by which *the* Athena image, the most sacred one, must be meant), according to Cassius Dio (54.7.3) faced east, but at one point, as a sign of ill omen, "turned around so that it faced west and spat blood."

Perhaps little credence can be given to this "miracle," but Mansfield is probably correct in interpreting it as one of the many portents (also related by the same ancient source) that in 31 warned the Athenians against supporting Antony in his fight with Octavian, and should thus

contain an element of truth.[29] If, however, the Polias faced east, only the eastern part of the "Erechtheion" enters into consideration, thus indirectly confirming the nature of the main cult within the temple.[30]

At present, I am inclined to accept the "Erechtheion" as solely the temple of Athena Polias, the Archaios Neos in which the ancient image stood, through various damages and enemy fires, at least until the second century after Christ. How much later that statue survived is now impossible to judge. To establish where the cult of Erechtheus (the true Erechtheion) was located is beyond the scope of this inquiry.

The War-Like Athena (So-Called Promachos Type)

If the cult of Athena Polias occupied the north side of the Akropolis, and that of Athena Parthenos the south, was there a counterpart image to the wooden idol, and can we recover its appearance? Some scholars believe we can, but this issue as well is highly controversial.

From their very beginning, the Panathenaic prize amphoras given to the winners at the games showed on one side an Athena armed with shield, spear, and helmet in vigorous stride to the left. The image has usually been considered the depiction of an actual statue existing on the Akropolis, although identification has ranged from the Polias to an Archaic (otherwise unattested) Promachos, perhaps a cult image housed within the predecessors of the Parthenon, to even the idol of Athena Nike, to be discussed later. Suffice it here to say that the last possibility is negated by the ancient sources describing the statue on the bastion as holding a pomegranate and a helmet in her hands. The Polias, as we have seen, whether standing or seated, did not carry a shield and spear, and a striding pose has been judged unlikely for an Archaic monument, even of bronze, as early as the 560s. The threatening implications of the action and the oblique direction of the composition would also be inappropriate for a cult image, which should be facing the worshiper in a neutral, if not necessarily welcoming, attitude.

Yet, if any statue at all had a right to be on the Panathenaic vases, the Polias should have been shown, since it was the focus of the festival and the recipient of the offerings. Perhaps its appearance was considered too plain (or too sacrosant?) for the prize amphoras. Probably a more significant imagery was found. A recent and compelling argument by G. Ferrari Pinney has explained the Athena on the vases not as the echo of an actual monument, but as a representation of the dancing goddess.[31] More specifically, Athena would be performing the Pyrrhic, a war-like dance that ancient sources connect with her on at least two occasions: when she was born from the head of Zeus, and when she celebrated the destruction of the giants.

Although the dancing theme would therefore be appropriate to depict either occurrence—the birth or the victory—Pinney is, I believe, correct also in seeing the entire Panathenaic Festival as a celebration of victory in the gigantomachy. The traditional assumption—that the event commemorated the birth of Athena—is modern speculation based on the ancient statement (Kallisthenes, *FGrHist* 124 F 52) that the Panathenaic procession took place on 28 Hekatombaion, the goddess' birthday. But the *motivation* for the festival is explicitly stated by Aristotle and other ancient writers,[32] and is indirectly confirmed by the fact that the cult of Athena Nike ("Victory") on the Akropolis seems to coincide with the reorganization of the Panathenaia in the 560s. The theme of military prowess is predominant in the iconography, and we shall return to it later. Here we need only recall the importance of the gigantomachy as the sole decorative theme for the Panathenaic peplos. H. A. Shapiro[33] has also pointed out that the earliest gigantomachies on vases are all datable around 560 or slightly later, and all come from the Akropolis, in an unparalleled correlation between locale and subject.

That the Athena on the amphoras can be removed from consideration as reflection of an actual statue is supported also by variations in her apparel according to time and painter: not only do her shield devices change, but also the shape of her helmet, her costume, and even pose. A true statue would have been copied more or less faithfully, or at least recognizably, through the centuries. Yet eleven bronze statuettes of an armed Athena from the

FIG. 77 Bronze statuette of Athena from the Akropolis, ca. 510. National Museum, Athens, 6457

FIG. 78 Bronze statuette of Athena from the Akropolis, ca. 570–550. National Museum, Athens, 6450

Akropolis have also been grouped together despite internal dissimilarities, and continue, by convention, to be styled "Promachos" as a type, although the only statue with that epithet attested from antiquity—the Pheidian bronze colossus on the Akropolis—seems to have stood quietly with spear upright, and is so named by a *single* ancient source.[34]

An initial classification of the Akropolis "Promachos" bronzes suggested a chronological span ca. 530–470 and attributed the creation of the type to Athens. A revision of this position would lower the earliest Akropolis statuette (N.M. 6457, fig. 77) to the last decade of the sixth century—and this aegis-less Athena, standing quietly in chiton and himation albeit with raised spear, is much closer to a typical kore than to the well-characterized striding goddess. In addition, a bronze statuette in Basel, in distinctive Ionic style and costume, has been dated ca. 535, therefore approximately a quarter century earlier than the examples from the Akropolis, and is considered proof of East Greek iconographic inspiration for all further renderings. The sequence has been arranged to show, on stylistic grounds, that the type began with a stance comparable to that of the kouroi, one leg slightly in advance of the other, eventually progressing to the full stride of the developed type, by 480–470. If this reconstruction is chronologically correct, another argument can be added against a statuary prototype for the Panathenaic Athena, depicted in strong motion over half a century earlier.[35]

The armed Athena is iconographically so widely diffused within the Greek world that it is pointless, here, to trace lines of influence and presumed origins.[36] It is therefore more fruitful to concentrate on the evidence from Athens and from the Akropolis.

I would accept that the striding bronze statuettes were inspired not only by the "narrative" rendering of the Panathenaic amphoras, but also by the very influential gigantomachy pediment on the Old Athena Temple: their late date would suggest it, as well as the directional pose, in movement to the right, rather than frontal. No other monumental prototype need be advocated for them.[37] Yet another very ancient image of the armed Athena (the "Pallas") existed in Athens, although not on the Akropolis. The Athenians believed that this was the Palladion taken from Troy by some Argives, who in turn were robbed and killed on their way home by the Athenian king Demophon. Pausanias (1.28.9) tells the story in a somewhat garbled fashion, because his primary interest is in the law-court named after the Palladion where cases of involuntary homicide were tried. But the ritual connected with the statue is known through various ancient sources,[38] and it involved conveyance of the idol to Phaleron, under escort by the ephebes, to be washed or purified at sea; it apparently took place in the fall or early winter, and is therefore to be distinguished from the Plynteria, which took place in the summer and involved the Polias.

The Trojan Palladion in Attic vase-painting is shown in a variety of forms and costumes (see p. 36, cat. 3), and we cannot be sure that a single ancient statue was reflected in all. But a bronze statuette from the Akropolis (Athens N.M. 6450, fig. 78) seems considerably earlier than the

2 Bronze statuette of Athena the Warrior, ca. 580–560

FIG. 79 Marble Athena dedicated by Angelitos, ca. 470. Akropolis Museum, Athens, 140

FIG. 80 Oinochoe with statue of Athena, attributed to Group of Berlin 2415, ca. 460. The Metropolitan Museum of Art, New York, 08.258.25

FIG. 81 Peplos kore from the Akropolis, ca. 530. Akropolis Museum, Athens, 679

"Promachos" series and closer to the pillar-like shape associated with venerable images. Niemeyer has accepted it as reflecting the cult statue for the earliest temple in the area of the Parthenon,[39] but it could imitate the Pallas in the city. The goddess is shown in a richly decorated peplos, with high-crested helmet and (probably) spear in her raised right hand. The angle of the arm suggests however that the weapon was not brandished but held upright. Should this reconstruction be correct, we would gain an important insight into Athenian iconography.

Around 470, a certain Angelitos dedicated on the Akropolis a marble Athena, under life-sized, made by the sculptor Euenor (fig. 79). The statue is now headless, but traces of a crest on her back indicate that she wore a helmet. Her restful pose, with left hand on hip and one leg slightly flexed, confirms that the raised right hand held a spear vertically, rather than horizontally (fig. 80); her doughy peplos and leathery aegis make the figure one of the early renderings of the goddess in clear Severe style. Since late Archaic bronzes showed Athena increasingly active in a war-like stance, it has been suggested that the shift to a less aggressive iconography reflected a different political emphasis, from the still combative early democracy to an Athens sure of itself after the victories over the Persians.[40] Yet Angelitos' Athena can also be seen as a link in a tradition that goes from the Akropolis bronze "Palladion" statuette, perhaps through the Peplos Kore (fig. 81), down to the colossal Pheidian Athena "Promachos" in a similar pose.[41] I would prefer to see this type as independent of the Parthenos cult.

The colossal bronze "Promachos" (to give it the modern misnomer) was one of the three famous Athenas by Pheidias on the Akropolis, yet it cannot be recaptured through Roman copies, although a few identifications have been suggested. Even remains of its inscribed base are debated, and some pieces may be Roman replacements, but a date around 460–450 seems assured by the fact that it was a dedication for Marathon and should precede the Parthenos. Pausanias (1.28.2) mentions only its shield engraved with a Centauromachy (an allusion to Theseus' help against the Persians?), and that spear-tip and helmet-crest were visible to sailors coming in from Cape Sounion. Athenian coins show a statue holding a Nike on the right hand, and if correctly identified, this would be the first Athena Nikephoros.[42] In the *Lysistrata* (line 755), Aristophanes has a woman planning to climb into Athena's helmet to give birth, "just as the pigeons do." The allusion may be to the helmet of the colossal bronze, and could imply a Corinthian type, tilted back, whose empty eye cavities would provide excellent refuge for the birds. The imagery of this Pheidian statue must have suggested vigilant repose: shield perhaps still

FIG. 82 Lioness and bull pediment from the Akropolis, ca. 570–560. Akropolis Museum, Athens, 4

FIG. 83 Kore signed by Antenor, ca. 530–520. Akropolis Museum, Athens, 681

strapped on the left arm, but spear upright and helmet clearing the face. I believe the Parthenos (and its predecessors?) may have conveyed a different message.

The Athena Parthenos

If the early Archaic architecture connotes a very large temple (Hekatompedon) on the south side of the Akropolis, and if the "Panathenaic" Athena of the amphoras was not its cult image, can we assume that one existed nonetheless, and can we visualize it? The shrine on the north colonnade of the Parthenon might confirm its existence, but the following comments are purely speculative.

Since the temple was probably the first built on the spot, and only one ancient image is ever mentioned within the Akropolis walls, any statue for the building erected around 566 would have had to be made for the occasion. The pedimental sculpture associated with the structure gives us no iconographic clue: the power of the goddess is expressed through the timeless struggle of lions versus bulls (fig. 82), but the enormous animals, although awesome to behold, seem to belong to a primordial sphere of religious belief and imagery, apotropaic and symbolic rather than anthropomorphic. The victim-predator group represents a virtual badge of Athena, not only in the many examples from Archaic Athens, but also from later places and periods; yet the scarcity of Attic depictions of the goddess in human form before 566 has been correctly noted.[43] I believe, however, that some dedications on the citadel reproduce a cultic image of Athena, which have gone unnoticed so far because they have lost their attributes and have been mistaken as generic korai.

Of the many Archaic marble statues of young women from the Akropolis, at least two—Akr. 681 (the so-called Antenor's Kore (fig. 83) and Akr. 669—wear helmets whose crests were added in metal and are now lost. The diadem-like visor around the calotte was also once embellished by metal ornaments, which, on Antenor's Kore, may have taken the form of flower buds, since a few survive. This type of helmet is virtually nonfunctional, an attribute rather than a piece of armor, yet it recurs on several vases and is occasionally adorned with projecting foreparts (*protomai*) of griffins or other animals. I have suggested elsewhere that such elaborate headdresses go back to early idols and may connote antiquity and venerability. In the above-mentioned Akropolis korai, the head covering is combined with a surprising stiffness of the hair tresses, and a certain early stylistic flavor that contrasts with more advanced details of costume and modelling. I believe that these marble dedications imitate an earlier image, perhaps in wood with hair added in metal and inserted eyes (as shown in Antenor's

FIG. 84 Marble replica of Athena Parthenos (Varvakeion statuette), early 2nd century A.C. National Museum, Athens, 129

56 Miniature replica of the Athena Parthenos of 447–438, ca. 150 A.D.

Kore), which may have been the cult statue for the Parthenon: Athena the virgin, as a young girl, albeit imposing and already victorious.[44]

Circumstantial evidence for my assumption can be found in the appearance of the Pheidian Athena, as known through later replicas (fig. 84; cat. 56). This is the only Akropolis monument that can be known with confidence, together with its original setting, although the precious image does not survive. The colossal statue in gold and ivory was made between 447 (the inception of the Parthenon) and 438, as inferred from building accounts. It can now be best visualized through the splendid recreation sculptured to scale (and completed in 1990) for the Parthenon in Nashville, Tennessee, by Alan LeQuire, who took into consideration all available ancient testimonia. But he omitted the one feature that, to my mind, was meant to connect the Pheidian statue with remote antiquity: the series of pegasos protomai springing from her visor, as attested through Athenian coins and other reproductions, and which combine with the pegasos- and sphinx-crest holders to make Athena's helmet one of the most elaborate creations of the fifth century (cat. 58).[45]

On the one hand, the Pheidian Athena recalled earlier idols; on the other, it was a new conception attuned to contemporary beliefs and political events. The statue and its temple have usually been taken as outspoken com-

58 Terracotta medallion with head of Athena, late 5th or 4th century

memoration of the Athenians' victory over the Persians, but this meaning to me seems secondary, or at least subsumed, to the primary level of symbolism: victory in the gigantomachy, as celebrated in the Panathenaic festival. A fifth-century Athenian would have probably "read" the imagery as follows:

Athena has defeated her giant: the pitched battle is shown in the east metopes of the Parthenon, where the

57 Stater of Aphrodisias with Athena Parthenos (reverse), ca. 375

FIG. 85 Drawing showing position of the frieze on the Parthenon facade

FIG. 86 Parthenon east frieze: Athena and Hephaistos. Courtesy Alison Frantz

goddess is being crowned by Nike as she fights. The other metopal compositions around the temple emphasize similar battles: against the Amazons, the Centaurs, (perhaps) the Trojans. On the frieze, the procession of the festival unrolls; it is unclear whether it represents the Greater or the Lesser Panathenaia, and it should be admitted that not everything about it is explicable. Perhaps the culmination of the event would have appeared in that lost portion of the frieze that only now has been suspected, past the porch columns, above the cella door (fig. 85).[46] But we can at least acknowledge the presence of all the gods, among whom only Zeus is singled out by his throne, whereas Athena is just one of the Olympians, sitting on a stool (fig. 86), with minimal characterization. Had the festival celebrated Athena's birth, her relatively inconspicuous position as well as the full attendance of the other gods would have seemed surprising; in celebration of the gigantomachy, the rendering is comprehensible and obvious, since all took part in the battle.[47]

But Athena alone is glorified in the pediments and the cult image. The east gable depicts her birth from Zeus; the west, the contest with Poseidon for the patronage of Attika, for which the sacred tokens exist on the very Akropolis. In the interior of the cella, against the background of the enframing colonnade, the enormous chryselephantine image fills almost all space, its gold garment and attributes a glittering expanse of riveting impact, highlighted by the reflecting pool in front and by the two windows newly recognized in the east door-wall.[48] Athena is still armed, and wears her voluminous peplos belted over the overfold, to insure freedom of movement. But she is no longer fighting; her shield is at her side, barely supported by her lowered left hand, and her snake—the "guardian of the Akropolis" (Herodotus 8.41)—coils within it to emphasize its permanence; the Attic helmet is worn with cheekpieces raised; and the long spear rests against one shoulder. The goddess stretches out her right hand, and Nike alights on it like a homing bird, to crown her winner. The allusion to the east metope is clear, but the moment is later, in the aftermath of the battle. There will be no more war. It is perhaps significant that, after the Parthenos, other images of Athena show her in increasingly peaceful attires, sometimes even encumbered by a mantle, with helmet and aegis remaining as fossilized tokens of identification.[49]

Why was this specific Athena called the Parthenos? The sources do not tell us, and we cannot assume that the temple gave its name to the goddess rather than vice versa. The Periclean building is consistently called the "Hekatompedos Neos," by Lykourgos, Plutarch, and,

according to Harpokration, even by Mnesikles and Kallikrates, the two major architects active on the Periclean program. It had been assumed that "Parthenon" was the name of the west room, extended to the entire temple in later times, and a specious etymology had been provided by assuming that in that room the *ergastinai* (who were virgins) wove the Panathenaic peplos. But Roux has convincingly shown that this is solely a modern assumption, and that any weaving was unlikely in a window-less strongbox filled with treasure; the west room, as stated above, is probably the "Opisthodomos" of the inscriptions. The "Hekatompedos Neos" becomes the Parthenon because it houses the Parthenos, in the east cella.[50] Perhaps, as in folktale mythology, it was the virginal aspect of Athena that was required for victory over the giants, rather than her fighting prowess alone. To be sure, the static Palladion, the active warrior of the narrative contexts, the alert Athena "Promachos" of the Marathon dedication, even the aegis-clad Polias, are all manifestations of the same goddess with greater or lesser emphasis placed on some of her aspects; but virginity may be the one intangible attribute that could only be conveyed through its result—victory.

Two additional points deserve discussion. Since the Pheidian Athena was a fifth-century creation, it is often assumed that its contemporaries considered it a work of art (a non-ancient concept?), a victory monument, a repository of Athenian gold, but, in brief, not a cult image worthy of worship. Mansfield[51] has, however, pointed out that an offering table within the cella is mentioned by the fourth-century inventories, and that thus the Parthenos was the object of cult like the Polias.

Second point: It has been stated that a major fire damaged the Parthenon in A.D. 138 and consumed the chryselephantine image. If this is the case, which Parthenos did Pausanias see in the late fifties of the second century? Do the Roman copies of Imperial date reproduce a replacement or the original statue by Pheidias? Once again, certainty is impossible. No specific evidence has been adduced for the precise date. During the Antonine period, to be sure, a series of close replicas of Akropolis monuments seems to have been produced, thus suggesting repair work to the citadel temples and their sculptures; but whether these repairs amounted to virtual reconstruction is unknown and seems unlikely. Travlos has postulated a major fire only at the time of the Herulian invasion, in A.D. 267. W. B. Dinsmoor, Jr., has opted for decay of the timbers and extensive damage in the second half of the fourth century after Christ. The current restoration work on the Akropolis has now recognized spoils from over 40 buildings which, at various times, were incorporated into the structure of the Parthenon, and these include the columns of a Hellenistic stoa used to replace the inner colonnade of the cella after a fire.[52] Only this recent work is likely to provide a firmer date for the vicissitudes of the Parthenon, and our questions must await an answer.

Athena Nike

If, as suggested, the Panathenaia celebrated not Athena's birth but her victory in the gigantomachy, then many cults of the Akropolis appear thematically interconnected. The firmest association is perhaps with Athena Nike.

That the deity worshiped on the bastion is Athena and not Nike is clearly explained by L. Beschi, who cites the pertinent ancient sources. Victory at the site is wingless (*apteros*), not because it should not leave the city, as Pausanias (3.15.7) assumes, but because it is the goddess rather than the personification of the concept. This latter is traditionally shown winged—for instance, on the very Nike Balustrade surrounding the bastion. If the cult assumed monumental form around 566, as suggested by the remains of an inscribed altar and other evidence, the connection with an Athena victorious in the gigantomachy becomes obvious.[53]

Ancient authors describe a wooden image holding a pomegranate in her right hand, a helmet in the left, but do not state whether it was standing or seated, or when it was made. I. Mark, who interprets as part of a statue base the rectangular cavity previously considered to be an *eschara* for an offering deposit, postulates a seated image approximately 1 m. high and datable ca. 600–550. One wonders whether a tenon for a wooden statue would have required so massive a cutting, but we have minimal evidence for the fastening of sculptures other

FIG. 87 Votive relief from the Akropolis, ca. 420. Akropolis Museum, Athens

FIG. 88 Votive relief with Charites, 4th century. Akropolis Museum, Athens, 1556

than in stone or bronze.[54] Beschi must believe in a standing image, because he sees it reflected in a late fifth-century votive relief from the Akropolis of unusual format.

The fragmentary slab (fig. 87) shows an Athena seated with her back against a taller structure that projects from the top edge of the relief, suggesting a small shrine. Within its frame stands a female figure in chiton and himation; both her lower arms, outstretched, are now damaged, so that the attributes they once held are uncertain; her head, with long locks falling on the chest, is crowned by a *polos*. The figure is visible only from the knees upward, perhaps because a table appears in front of it. Beschi assumes that Athena, as true presence, sits against a naiskos containing her own statue, and in this he is undoubtedly correct; but why the idol should depict Athena Nike is to me unclear, since all identifying elements are missing. The shrine could even be the newly found one on the Parthenon colonnade, and the "live" Athena on the relief, sitting on a boulder, may be depicted in the open-air area near it.[55]

Another type of image has been connected with the Nike bastion, because it appears on a votive relief including the three Graces (Charites) (fig. 88). It is a peplos-wearing Athena with polos and aegis, holding a pome-granate and a phiale, depicted only from the waist upward. She is framed by large phialai in relief while to the right, in the background, three smaller half-figures in the same attire clearly represent the Graces. Beschi and, more recently, Palagia, have argued for a cult of the Charites on the Nike bastion, in front of the Mycenaean wall, but the latter sees the Athena as an independent statue, not as the cult image of the Nike temple.[56] The question whether either votive relief, both, or none, can help us visualize the wooden image must remain open, but one more monument, closer in date to the inception of the cult, may tentatively be considered.

Since the pomegranate attribute is rarely preserved in extant statues, we might recall here the peculiar Kore Akr. 593 (fig. 89). This headless figure is considered among the earliest from the Akropolis because of its plank-like and stiff appearance. Yet her attire, albeit smooth and concealing, shows the folds of a thin chiton buttoned along the arms below the heavier upper garments, as well as some advanced modelling, and her surface retains the first-known traces of the tooth chisel. If my assumption is correct—that the Akropolis korai serve largely the same function as votive terracottas at other sanctuaries, and therefore reproduce various di-

FIG. 89 "Pomegranate" kore, ca. 560–550. Akropolis Museum, Athens, 593

vinities—perhaps this monument, with pomegranate and wreath, was erected in honor of Athena Nike, in imitation of the ancient wooden idol.[57]

When the extant Temple of Athena Nike was built, perhaps as third at the site, around 425, the Temple of Athena Polias (the so-called Erechtheion of our textbooks) was under construction. A recent study of an architectural block from the Nike Temple in the British Museum has pointed out that the anthemion rendered plastically on the Polias building recurs in paint on the Nike Temple, and that other architectural elements correspond.[58] When both Ionic structures were newly completed, the visitor would have been immediately aware of the decorative similarities between the two and would have mentally linked the recipient of the Panathenaic peplos with the victorious goddess commemorated on the bastion. It is also significant, in terms of interconnections, that the pediments of the Nike Temple probably depicted a gigantomachy and an amazonomachy, that a central akroterion in gilded bronze showed Bellerophon victorious over the Chimaera—the hero riding the winged horse Pegasos which Athena had helped him harness—and that the temple friezes as well as the balustrade emphasized themes of war, worship, and victory.[59]

Athena Hygieia; Athena Ergane; Akr. 625; The "Mourning Athena"

In his tour of the Akropolis, Pausanias mentions two more places of worship for Athena, under two different aspects: as goddess of Health (Hygieia) and as "the Worker" (Ergane). Although actual statues of the deity in these two functions existed, they are now lost, and their iconography cannot be recovered with any certainty. The antiquity of both cults is moreover lesser, or at least less well attested, than for the others on the Akropolis.

Athena Hygieia had an altar and a base for a statue near the east façade of the Propylaia. The manner in which the pedestal was made to fit against the southernmost column of the gateway shows clearly that the monument was erected after the building had been completed, therefore after 432, and the letter forms of the inscription are in keeping with a date in the early 420s. The Athenian sculptor, Pyrrhos, who signed the pedestal, is virtually unknown except for this work, ambiguously listed by Pliny (*Natural History* 34.80: "Hygiam et Minervam"). The cuttings on the base suggest that it supported a bronze Athena with right foot forward, the left touching the ground only with its toes, a spear held in the left hand and anchored to a hole on the marble surface. The goddess was therefore shown armed, as customary. The epithet "Hygieia" is included in the dedicatory inscription, and it may have sufficed to clarify the nature of the cult; the presence of a snake, standard in representations of the personification of Health as the daughter of Asklepios, could have had ambivalent meaning in this instance, since the animal was also a common attribute of Athena.[60]

According to a story in Plutarch (*Life of Perikles* 13.12), Perikles established the dedication to Athena Hygieia after she appeared to him in a dream; the goddess is supposed to have told him how to cure a slave who was injured while building the Propylaia. The same anecdote is repeated by Pliny (*Natural History* 22.44), and would seem supported by the general chronology and location of the extant base. But the dedication is made in the name of "the Athenians," and probably postdates Perikles' death in 429, during the plague—one more in-

FIG. 90 Drawing of relief with Athena Ergane from Scornavacche, ca. 425–400. Museo Nazionale, Syracuse

FIG. 91 The "Endoios" Athena, ca. 530–520. Akropolis Museum, Athens, 625

stance of how ancient sources may preserve distorted versions of the truth. The cult itself seems to go back to the sixth century. That a sacrifice was made to Athena Hygieia at the Lesser (annual) Panathenaia is stated in a Lykourgan decree of ca. 335 which reorganizes various Attic festivals and ceremonies. It is interesting to note, therefore, that Athena could be celebrated under various aspects even during festivals that addressed one of her functions in particular.[61]

Athena Ergane is mentioned by Pausanias (1.24.3) as he moves along the north side of the Parthenon, but the text is corrupt at that point, although it cites the Athenians as the first to honor the goddess with that epithet. Given that Athena is associated with Hephaistos in promoting arts and crafts, that she weaves in competition with Arachne, and that she is shown on Attic vases as presiding over the workshops of vase-painters and potters, making a clay horse, and otherwise engaging in similar activities, the title seems appropriate. Yet it has been argued that the cult as such finds no mention in Athenian sources until the end of the fifth century, to be instead prominently attested during the fourth.[62]

The suggestion that Athena as Ergane was brought to the fore during the Periclean period has been made on the basis of a fragmentary terracotta from Scornavacche, Sicily, showing the upper part of a seated female wearing an Attic helmet with raised cheekpieces and holding a distaff in the left hand (fig. 90). The figure has been visualized with a spindle in the right, therefore as a spinning Athena—eminently suitable iconography for the Worker. Its style, and the presence of the distinctive helmet, as well as possible traces in the rock cuttings on the northwest side of the Parthenon platform, have been taken to support the theory of a Pheidian prototype. Such a monument would have marked a splintering, as it were, of a new aspect of Athena from the ancient Polias cult, probably promoted by Perikles. No Archaic predecessor for either cult or iconography was therefore considered possible.[63]

A sixth-century precedent has, however, been advocated by restoring as a spinner a well-known Athena statue, Akr. 625 (fig. 91). Traditionally, this seated image has been equated with a dedication by Kallias mentioned by Pausanias (1.26.5) during his visit to the Athenian citadel and attributed to the Archaic sculptor Endoios. Since this is the only pre-Persian monument listed by the traveller on the Akropolis, since Akr. 625 was found on the north slope rather than within the trenches containing the Persian debris, and since both chronology and style present no evidence to the contrary, it had been surmised that the heavily weathered piece could have been still standing at the time of Pausanias' visit, thus justifying the equation. Yet further investigation has now suggested that Akr. 625 must have rolled down the slope when the upper retaining wall containing the debris gave way under pressure, spilling the fill. The statue was therefore damaged during the Persian attack and removed with other monuments during the post-invasion

FIG. 92 Terracotta relief plaque with Athena Ergane, ca. 500. Akropolis Museum, Athens, 13055

FIG. 93 Terracotta relief plaque with Athena wearing polos, ca. 500. Akropolis Museum, Athens, 13057

clearing operations; its connection with Kallias' dedication is thus considerably weakened.[64] Moreover, Pausanias refers to the latter at some remove from his mention of Athena Ergane.

To be sure, this last fact would not preclude restoring the missing attributes of Akr. 625 as spindle and distaff, or even as a distaff in each hand, as Pausanias (7.5.4) describes the Polias at Erythrai. Certainly the stool on which the Akropolis Athena sits would be better suited for spinning than a throne with armrests. In addition, comparison has been made with some terracotta plaques from the citadel, showing a spinner in virtually the same pose as the marble figure, with one leg retracted. Although this position may simply be dictated by the desire to indicate both legs in a relief medium, nonetheless the similarity remains. Of the plaques, some exhibit a female wearing a snood (*sakkos*) (fig. 92), and thus probably human, but others show her wearing a polos (fig. 93), suggesting a divine identification, in the typical Archaic practice of using the same iconography for worshiper and worshiped with only minor modification of attributes.[65]

On consideration of these sixth-century representations, I would accept a cult of Athena Ergane as early as the Archaic period, especially since the advocated Periclean promotion seems to rely heavily on the stylistic assessment of a single terracotta example from a colonial area. I am less sure about Akr. 625, since different attributes are easily conceivable. The goddess wears a fine chiton covered by an ample aegis with central gorgoneion and once fringed by metal snakes; she is thus in war-like attire and could easily be completed with shield, spear and a helmeted head. Other late Archaic marble statues of Athena are extant from the Akropolis, but they are all fragmentary and usually recognizable only through the headdress or the presence of the aegis. It seems therefore as if the bellicose or protecting aspect of the goddess was emphasized toward the end of the pre-Persian phase, although some pieces, especially the standing figures, might have belonged to narrative contexts, such as the Athena restored between two squatting males (Achilles and Ajax?) presumably playing a game of chance. Others might have been combined with statues of heroes, in Athena's distinctive role as helper of brave deeds.[66] With a sweeping generalization, it could however be suggested that the post-480 representations of Athena from the Akropolis show her less heavily armed or at least characterized by fewer threatening attributes. Even divine iconography seems to respond to the political climate.

One peculiar feature should, however, be noted as an addition to the goddess' traditional paraphernalia: the eastern cap that she wears under her helmet in several representations, both in sculpture and vase-painting. Usually taken to be just a soft leather lining for a metal head cover, the Persian "tiara" has now been convincingly identified and related to the Athenian victories over the eastern enemy. Among the best known of such depic-

FIG. 94 Marble relief with so-called "Mourning" Athena from the Akropolis, ca. 470. Akropolis Museum, Athens, 695

60 Marble statue of Athena (Ince type), Roman copy after a 5th-century Greek original

tions is a small votive relief from the Akropolis, the so-called Mourning Athena (fig. 94).[67] Its interpretation is still debated, but for our purposes, it suffices to note the simple, heavy peplos worn by the goddess, the lack of aegis, the overall similarity with Angelitos' Athena, the resting pose, and, most importantly, the symbol of supremacy implied by the subordination of the eastern cap to the Corinthian helmet. Athens' protectress has completed her task, and she can now relax in relative ease, having discarded some of her armor but retaining at least one of the spoils from her victory.

After 450, the goddess changes costume once again. The simple belted peplos frequently gives way to the more elaborate combination of chiton and himation, as in the late sixth century; but in the Classical period the latter garment is more voluminous and worn in a looser draping—it may thus suggest lessened freedom of movement. The reduced size of Athena's aegis may also allude to diminished military preparedness, and the remaining pieces of armor are simply identifying tokens: Athena is becoming more feminine, or at least less openly active, in keeping with the reduced military supremacy of her city. Yet most monuments from this period are known only through the possibly modified versions of the Roman copyists (cat. 60), and we cannot be sure which, if any, of their prototypes stood on the Akropolis.

The Athena Lemnia

One last image of Athena from the citadel needs to be considered because of its relative fame in antiquity and its even greater reputation in modern times: the Lemnia by Pheidias. The very name of its maker would have insured scholarly attention, but Pausanias (1.28.2) adds that it was the most worth seeing among Pheidian works. He sees it himself on his way out of the Akropolis, probably next to a statue of Perikles. Both monuments are dedications, the Athena receiving its name from the dedicants. Two other ancient sources refer to the sculpture by its nickname (not an epithet of cult, and therefore not quite in the same rank as other images previously considered); of the two, Lucian (*Imagines* 4), writing in the second century after Christ, praises the

Lemnia for the contour of her face, cheeks and nose. This passage has had a crucial influence on the scholarship about the piece, because it has been taken to mean that the Athena was represented bareheaded, probably holding her helmet in one hand, with an iconography attested by several Attic vases (cat. 15). Even more influential has been Furtwängler's identification of the work in an Athena type he recomposed through Roman copies, by joining a head in Bologna with a torso in Dresden; the resulting statue has since entered our handbooks as "the Lemnia by Pheidias" and only recently have some doubts been raised about both reconstruction and identification.[68]

Since the original monument is irrevocably lost, any attempt at recovering its appearance is bound to remain speculative; even its medium is unstated by the primary sources, so that many scholars believe it was bronze, some think of marble, and Harrison, who favors the Athena Medici type (cat. 59), would accept an akrolithic technique.[69] It is important, however, to note that no solid evidence exists for the assumption that the Pheidian statue was helmetless, and even Lucian's passage can be reconciled with an Athena wearing a Corinthian helmet, which in fifth-century iconography is usually tilted back to reveal the face up to the hairline. In brief, through the ancient sources it is impossible to state whether the Lemnia was fully or partially armed, or even weaponless, and whether standing or seated. We are only told that she was beautiful—hardly a criterion for identification, but important as indication of femininity, in contrast to the gigantic Promachos and Parthenos, whose impact stemmed from their impressive size.

The reason for the statue's nickname is also a matter of slight debate. It has been taken to mean that the dedicants were not true Lemnians but Athenian cleruchs sent to the island, yet the date of the cleruchy is uncertain and based on other indirect evidence.[70] To some extent, the style of the Dresden Athena has also subconsciously served to place the historical event around the mid-fifth century, with a somewhat circular argument. The Bologna head is definitely too late for this chronology, and even the Medici Athena type may not fit it entirely. Given the fact that neither can be proven to replicate the Lemnia, they should be left out of the argument. Perhaps

15 Nolan amphora with Athena holding helmet (obverse), attributed to the Berlin Painter, ca. 480

59 Marble head of Athena (Medici type), Roman copy after a 5th-century Greek original

only the events in Pheidias' life, which suggest that he left Athens for Olympia after the Parthenos was completed, in 438, provide a *terminus ante quem*; but it is hard to believe that he had time for additional commissions during the eight years in which he worked at the chryselephantine colossus, or after having completed the Promachos, presumably by 448. For our purposes, the true significance of the monument may lie in the fact that a private dedication, or one with only faint political overtones, could command the services of an "official" sculptor like Pheidias, and that the work was popularly admired in the third quarter of the second century after Christ (the date of all three "safe" sources), as Harrison has pointed out.

Except for some votive reliefs and a few fragmentary sculptures of Roman date, no other major representation of Athena can be assuredly connected with the Athenian Akropolis after the end of the fifth century. The great vitality of the Periclean program, carried out to 405 with the completion of the Polias Temple, was followed by virtual building inactivity until the time of Lykourgos, during the second half of the fourth century—and most of *those* constructions carried little sculptural decoration and stood outside the Akropolis. Yet the citadel continued to be filled with private and public dedications, which, however, as suggested by treasurers' accounts, were periodically removed or melted down. It is impossible for us today safely to trace the evolution of Athena's iconography on the Akropolis beyond ca. 400. Perhaps, as its development responded to the various historical stimuli during the late Archaic period and in the aftermath of the Persian wars, so was the imagery of later phases stifled by Athens' dwindling political importance, or staled through repetition and imitation. Certainly, nonetheless, the *cult* of the goddess continued unabated through the many splendid festivals, the rich sacrifices, and the athletic competitions. Not even Dea Roma was able to supplant Athena, but joined her on the Akropolis in subtle allusion, by imitating the architectural forms of the Temple of the Polias in a modest round building. Eventually, only Christianity could defeat the goddess when the Parthenon was transformed into a church, but the names of Hagia Sophia ("Holy Wisdom") and of the Virgin Mary suggest that as late as the sixth century after Christ something of the original Parthenos, goddess of Wisdom, still lingered on Athena's citadel.[71]

Catalogue

All dates are B.C. and all vases are Attic earthenware with slip decoration unless otherwise noted. For abbreviations, see pp. 192–93. The entry for cat. 62 was written by Wolf Rudolph.

Dimensions are given in centimeters, with the equivalent measure in inches in parentheses. In the case of three-dimensional objects, either the height (H.), width (W.), and depth (D.) are given (if available) or the height and diameter (Diam.). In the case of a fragment, the thickness (Th.) is noted.

The venues at which an object will be shown are indicated by the following abbreviations. If none are indicated the object will be exhibited at all four venues.

DC Hood Museum of Art, Dartmouth College
 Hanover, New Hampshire

TA Tampa Museum of Art
 Tampa, Florida

VA Virginia Museum of Fine Arts
 Richmond, Virginia

PR The Art Museum, Princeton University
 Princeton, New Jersey

Athena and Athens

1 **Black-Figure Amphora with Birth of Athena**
Obverse: **Birth of Athena**
Reverse: **Herakles and the Nemean Lion**

The goddess Athena was the daughter of Zeus and Metis (Wisdom), his first wife. Having been warned that his children by Metis would supercede him, Zeus swallowed his pregnant wife and in due course Athena was born, springing fully armed from his head. This myth is etiological, serving to explain the goddess' innate wisdom, military prowess, and masculine character (having been born from a man).

On Athenian black-figure vases of the mid-sixth century, the birth of the goddess Athena from the head of Zeus is a popular subject; there are over a dozen extant examples. The Richmond vase, however, is unique in this group in showing Zeus frontally (the only other instance occurs on a red-figure pelike dated ca. 470–460 in the British Museum [E 410], the name-vase of the Birth of Athena Painter). Grasping his thunderbolt and scepter, Zeus sits on an elaborate throne, his sandaled feet resting on a footstool. Interestingly, his left toes are delineated by incision, his right by reserve. Emerging like armrests from the throne are the foreparts of two rearing horses. These also are unique, and can be taken as a reference to the goddess as Athena Hippia, an epithet that demonstrates her special relationship to horses (see p. 22).

Zeus is flanked by two women gesturing toward the newborn Athena. On the basis of comparable examples we would call these women Eileithyiai, or birth attendants. However, the one on the right wears a crown and a more elaborate peplos, and gestures with her right hand only. She is likely to be Hera expressing indignation at a birth in which she was not involved (Hesiod, *Theogony*, lines 924–28), since her presence is attested by inscription on contemporary vases. Behind her stands her son Ares, heavily armed with a spear, helmet, greaves, and large shield emblazoned with a tripod. The fifth member of this balanced composition is Hermes, holding his *kerykeion* as if heralding the miraculous birth, at the far left.

The diminutive Athena atop the mask-like head of Zeus is nearly lost, as the crest of her helmet blends into a palmette of the lotus-palmette chain above. In her right hand she holds vertically an extraordinarily long spear, and a shield rests on her left shoulder. The entwined snakes of her aegis emerge from her back, and on her chest a rectangular gorgoneion (head of Medusa) stares forth. According to myth, she received the gorgoneion from Perseus after he beheaded the monster, and so its appearance at her birth is anachronistic. Perhaps the artist was influenced by a similar gorgoneion, as seen on cat. 18.

Athena appears on the reverse of the vase as well, but in a less aggressive pose. She stands calmly, spear in hand, witnessing Herakles plunge his sword into the mouth of the Nemean lion. She is balanced on the right by the figure of Iolaus, Herakles' nephew and henchman. A nearly identical composition appears on a Group E amphora in Oxford (1965.135).

Attributed to Group E [Bothmer]
ca. 540
H. 42.5 cm. (16¾ in.) Diam. 28.5 cm. (11¼ in.)
Virginia Museum of Fine Arts, Richmond
The Glasgow Fund, 1960
60.23

PUBLISHED: *Paralipomena* 56, no. 48*ter*; *Addenda* 36 (with bibl.); F. Brommer, "Die Geburt der Athena," *Jahrbuch des Römisch-Germanischen Zentralmuseums, Mainz* 8 (1961) 69 and 83, no. 13, pl. 37; *Ancient Art in the Virginia Museum* (Richmond 1973) 72–73, no. 88 (with bibl.); K. Schefold, *Götter- und Heldensagen der Griechen in der spätarchaischen Kunst* (Munich 1978) fig. 5; *LIMC* II, pl. 744 Athena 351; Y. Korshak, *Frontal Faces in Attic Vase Painting of the Archaic Period* (Chicago 1987) 33 and 66, no. 221, illus. 84; T. H. Carpenter, *Art and Myth in Ancient Greece* (London 1991) fig. 100.

On the birth of Athena, see Brommer (above) 66–83; E. H. Loeb, *Die Geburt der Götter in der griechischen Kunst der klassischen Zeit* (Jerusalem 1979) 14–27; S. Pingiatoglou, *Eileithyia* (Würzburg 1981) 14–19; Schefold, (see above) 12–20; *LIMC* II, 985–90, Athena 334–78; K. W. Arafat, *Classical Zeus* (Oxford 1990) 32–39. On the Birth of Athena Painter's pelike, ARV^2 494, 1. On the Group E amphora in Oxford, *ABV* 137, 59; Boardman, *ABFV* fig. 94.

2 **Athena the Warrior** (see illus. p. 128)

Athena is depicted in early Greek sculptural art brandishing her weapons, just as she did at her birth, when she emerged from the head of Zeus. Sometimes termed the "Promachos," this early Athena type is known primarily from bronze statuettes, many of which have been found on the Athenian Akropolis. The goddess is normally shown frontally with high-crested helmet, shield strapped to her left arm and held in front of her body, and spear in her raised right hand directed at the viewer. This exceptional bronze is one of the earliest known representations in Greek art of Athena with the aegis. It is worn like a cape over her back (as on the Burgon amphora, fig. 19) and is fringed with eight snakes (two are now lost) rearing upwards. Its mode of attachment seems to have been the two thick rope-like thongs lying alongside her braids on either side of her chest.

Although made in Sicily by Greek colonists, the style of this bronze shows strong Laconian influence. It can be compared to a bronze female figure from Olympia (B 3400), dated to the end of the seventh century, which has been identified as Athena. Similarities include their stocky proportions, the rendering of the feet protruding from the drapery, and the linear patterning of their peploi.

The parts of this bronze which were cast separately, the crest of the helmet, the shield, and the spear, are now lost. Their existence is assured, however, by the tail of the helmet crest on Athena's back, the round hole in her left hand for the attachment of the shield, and the opening in her right hand. In antiquity the statue was once repaired in a unique way. The right hand, broken at the wrist, was reattached by joining it to the adjacent snake-head with a ball-and-socket joint.

> Sicilian (in Laconian style), ca. 580–560
> Solid cast bronze with coldwork incision
> H. 13.9 cm. (5½ in.)
> George Ortiz Collection, Switzerland
> Provenance: Selinunte
> Ex-coll. Marquis de Sarzana; Charles Gillet
> Venues: DC

PUBLISHED: J. Dörig, *Art antique, collections privées de Suisse romande* (Geneva 1975) no. 167; *Hommes et Dieux de la Gréce antique* (Brussels 1982) no. 2; C. Rolley, *Greek Bronzes* (1986) 133–34, fig. 112; *LIMC* II, pl. 719 Athena 138.

On bronze statuettes of Athena, see H. Niemeyer, *Promachos* (Waldsassen 1960). On the Olympia bronze, see *Bericht über die Ausgrabungen in Olympia* 7 (1961) 166, ill. 98, pl. 69; *100 Jahre deutsche Ausgrabung in Olympia* (Munich 1972) 93, no. 38 (B. Fellmann).

This entry is based entirely on the one written by George Ortiz for an exhibition, *The George Ortiz Collection*, to open at the Hermitage Museum, St. Petersburg, 2 February – 11 April 1993, cat. 126, and any differences are the responsibility of this writer.

3 Red-Figure Plate with Statue of Athena

Interior: **The Rape of Kassandra** (see illus. p. 36)

The diminutive, nude Trojan princess Kassandra clings with her right arm to an imposing statue of Athena while the Greek warrior Ajax, son of Oileus, attempts to pull her away. This episode from the *Ilioupersis* ("Fall of Troy") was popular in Greek art from the early sixth century on, no doubt because it was one of the few scenes of Greek myth in which Archaic artists could depict a nude female. Visually the conflict appears to be between the helmeted Athena and Ajax, at whom she seems to be pointing her spear. This reading is even more apparent in earlier black-figure versions where Athena is striding forward. Here she stands still, feet together, in the first attempt to show her as a statue, a key element in the story. For it was not the fact that Ajax violated the young Kassandra that so outraged his fellow Greeks, but the fact that he did so in the sanctuary of the goddess. Throughout the war Athena had been steadfastly anti-Trojan, but this nefarious deed against her young priestess incurred her wrath, which brought about the Greeks' arduous homeward journeys.

Paseas, a pioneer in the then new technique of red-figure, seems also to have specialized in white-ground votive plaques with black-figure images of Athena, all of which have been found on the Akropolis. One of these, Akr. 2589, preserves part of Athena advancing left with spear raised, like the goddess of the Panathenaic prize amphoras. Curiously, this plaque is inscribed "one of the paintings of Paseas" in obvious imitation of the official inscription of the prize vases. Since no Panathenaics attributed to him are extant, it has been suggested that Paseas was perhaps a disappointed bidder for the lucrative festival contract. However, the contracts were more than likely given to potters rather than painters, and since artists' names are found on an unusually high proportion of the vases dedicated on the Akropolis, Paseas is probably just taking advantage of the public context to advertise his wares.

Attributed to Paseas [Beazley]
ca. 520–510
H. 2.7 cm (1 1/16 in.) Diam. 18.7 cm. (7 3/8 in.)
Yale University Art Gallery, New Haven
Gift of Rebecca Darlington Stoddard
1913.169
Venues: DC, VA, PR

PUBLISHED: *ARV*² 163, no. 4; *Addenda* 182 (with bibl.); *New England* 70, no. 31; S. M. Burke and J. J. Pollitt, *Greek Vases at Yale* (New Haven 1975) 47–49, no. 43 (with bibl.); *LIMC* I, pl. 260, Aias II 51; S. B. Matheson, *Greek Vases, A Guide to the Yale Collection* (New Haven 1988) 14–15.

On the rape of Kassandra, see J. Davreux, *La Légende de la prophétesse Cassandre* (Liège 1942). On the Akropolis plaques, see J. Boardman, "A Name for the Cerberus Painter?" *JHS* 75 (1955) 154–55, and *idem*, *ABFV* 106.

4 Red-Figure Lekythos with Gigantomachy

Athena battling the giant Enkelados (see illus. p. 102)

Although Athena is often depicted as if going into battle, she is only actually shown fighting in the gigantomachy, where her traditional opponent is the giant Enkelados (Euripides *Ion*, lines 209–10; see also Apollodorus I.6.1–2), as here. The multi-figured theme of gods battling giants is popular in Athenian art, and the earliest extant examples in vase-painting from ca. 560, were all dedicated, presumably to Athena, on the Akropolis. Later, duels of god versus giant were excerpted as taste changed in favor of more monumental compositions on vases. For Athenians at the end of the sixth century, the most prominent image of Athena fighting a giant would have been the over-lifesize marble version (Akr. 631) in the pediment of the Old Temple of Athena of ca. 510.

A much closer parallel for this vase, however, is a metope from Temple E at Selinus in Sicily. Here, instead of the extended aegis that one sees on the pediment and most subsequent Attic vase-paintings, a round shield is strapped to Athena's left arm. Also the helmeted and greaved giant is still on his feet, collapsing to the right. The artist of this lekythos has added some interesting details to enliven the scene: the gorgoneion in profile (which also can be seen on the relief Akr. 13058, and a krater by the Niobid Painter, Louvre G 341), the giant's broken spear in the background, the nearly frontal face of the dying Enkelados (which compares closely to the face of Ajax on a cup by Douris in Paris, Cab. Méd. 537), the blood oozing from his wounds, and the centaur on his shield which could be a post-Marathonian reference to the Persians.

Attributed to Douris
ca. 480
Restored H. 38 cm. (15 in.) Diam. 14.1 cm. (5 1/2 in.)
The Cleveland Museum of Art, Cleveland
Purchase from the J. H. Wade Fund
78.59
Venues: VA, PR

PUBLISHED: W. G. Moon and L. Berge, eds., *Greek Vase-Painting in Midwestern Collections* (Chicago 1979) 186–87, no. 105, and color pl. 6 (A.P. Kozloff); J. Neils, ed., *The World of Ceramics, Masterpieces from the Cleveland Museum of Art* (Cleveland 1982) 15, no. 17 (J. Neils); Y. Korshak, *Frontal Faces in Attic Vase Painting of the Archaic Period* (Chicago 1987) 38–39, illus. 95; D. C. Kurtz, "Two Athenian White-ground Lekythoi," in *Greek Vases in the J. Paul Getty Museum* 4 (1989) 120, figs. 2a-b.

On the gigantomachy, see F. Vian, *La Guerre des Géants* (Paris 1952); *LIMC* II, 990–91; 1023–24; Shapiro, 38–40. On the Selinus metope, see *Lo Stile severo in Sicilia* (Palermo 1990) 194–95, no. 28. For gorgoneia in profile, see J. Floren, *Studien zur Typologie des Gorgoneion*, *Orbis Antiquus* 29 (Münster 1977) pl. 8,1 and 11,6. For shoulder figures on lekythoi, see D. C. Kurtz, *Athenian White Lekythoi* (Oxford 1975) 126–27 and pl. 8, 2b (Bologna lekythos).

5 **Seated Goddess** (see illus. p. 121)

6 **Seated Goddess** (see illus. p. 122)

These two terracotta statuettes of a draped woman seated on a winged-back throne, her hands on her knees and her feet on a footstool, are of a type found most frequently in Attika. Since they were excavated in the hundreds from trenches filled with debris from the Persian sack of the Akropolis, they have been interpreted as the goddess Athena. This identification is confirmed by one which preserves a painted aegis. Otherwise the goddess has no attributes, and in fact her chiton and the symmetrical mantle which veils her stephane actually conceal her figure. In her rigid frontality and unarticulated body, she suggests an older, more primitive cult statue, possibly the olive-wood Athena Polias (see Ridgway, pp. 120–27).

The beaded locks of the Houston statuette are more Archaic, and hence earlier than the wavy locks of the Harvard example. Both were made solid in a single mould, and have a flat back; after moulding, the lower part was hollowed out in order to decrease the weight and save clay. After firing, a white slip was applied as a base for added color, in this case, red.

5 Attic, ca. 500–470
 Moulded terracotta with red and white overpaint
 H. 17.8 cm. (7 in.) W. 11.3 cm. (4½ in.) D. 7.9 cm. (3⅛ in.)
 Arthur M. Sackler Museum, Harvard University Art Museums, Cambridge
 Gift of William C. Kohler in memory of Professor and Mrs. George M.A. Hanfmann
 1990.70
 Ex-coll. Erlenmeyer

PUBLISHED: Sotheby's, London sale cat. 9 July 1990, no. 55.

6 Attic, ca. 500–470
 Moulded terracotta with red and white overpaint
 H. 18.7 cm. (7⅜ in.) W. 11.8 cm. (4⅝ in.) D. 9.2 cm. (3⅝ in.)
 The Museum of Fine Arts, Houston
 Gift of Miss Annette Finnigan
 37.16

PUBLISHED: H. Hoffmann, *Ten Centuries That Shaped the West* (Houston 1971) 254–55, no. 116.

On the type, see R. A. Higgins, *Greek Terracottas* (London 1967) 72, pl. 29; *LIMC* II, 959–60, Athena 15–25. For a thorough discussion of a seated versus standing cult statue of Athena Polias in relation to terracotta votives, see B. Alroth, *Greek Gods and Figurines*, Boreas 18 (Uppsala 1989) 48–54.

7 **White-Ground Lekythos with Seated Athena**

There are extant at least three white-ground lekythoi by the Athena Painter which show Athena seated in a sanctuary surrounded by owls. On all three, the goddess sits on a folding stool in profile to the right, but looking back over her shoulder. While it may seem odd to think of a goddess sitting on a camp stool, the fifth-century inventories for the temple of Athena Polias list a large number of folding stools. Behind Athena rests her shield, and in front a volute altar, both topped by owls. Framing the scene are a pair of Doric columns which indicate a building, most likely a temple. Palmettes on long, curving tendrils fill the background and decorate the shoulder of the vase. Athena wears a high-crested Attic helmet and a voluminous snake-edged aegis over her chiton. In her left hand she holds an upright spear, and in her right a phiale, except on this example where her hand is empty. This vase is also unique in the addition of a third owl, perched on the ground behind Athena.

Why so many owls, and what is their significance? In Athenian vase-painting, owls serve both as a sign of Athens and as an attribute of Athena. Here they probably serve to indicate that the goddess being worshiped is Athena of Athens, and more specifically the Akropolis, for we know that a species of small owl (*glaux*) dwelled in the rocky bluffs of ancient Greek *akropoleis*. In Homer, Athena is frequently referred to as "owl-eyed" (*glaukopis*) but whether she was ever worshiped in bird form is uncertain. Since this artist decorated similar lekythoi with enormous heads of Athena flanked by owls, it may simply have been Athenian coinage (see cat. 10) that suggested the juxtaposition.

 Attributed to the Athena Painter [Beazley]
 Late 6th century
 H. 23.5 cm. (9¼ in.) Diam. 8.3 cm. (3¼ in.)
 The Nelson-Atkins Museum of Art, Kansas City, Missouri
 Nelson Fund
 34.289
 Formerly Athens market

PUBLISHED: Haspels, *ABL* 257, no. 74; *Paralipomena* 260, no. 74; Shapiro 31, n. 102, pl. 11 a–b.

The other two examples are Athens 1138 (Haspels, *ABL* pl. 47, 2) and Münster, Arch. Mus. 24 (*Griechische Vasen aus westfälischen Sammlungen* [Münster 1984] 173–74, no. 64). See also C. Bron, "Chouettes," *Etudes des Lettres* 4 (1983) 39–53. On the folding stool, see O. Wanscher, *Sella Curulis* (Copenhagen 1980) 86–88.

8 Statuette of Athena with an Owl (see illus p. 12)

The owl as the attribute *par excellence* of Athena also appears in small-scale bronze statuary, which may imitate monumental prototypes. Here Athena stands in a classical contrapposto pose, her weight on her right leg, her left bent. She wears a sleeved peplos pinned at the shoulders and an Attic helmet crowned by a sphinx. Her outstretched right hand serves as a perch for her owl, while her left once held a vertical spear, now lost. Her head is bent downward; either she is gazing at her owl or at worshipers, since many Classical cult statues show deities looking at their devotees. A crouching sphinx is perched atop her helmet which bears a prominent visor. At the back one sees the curving tail of the sphinx echoed in Athena's ponytail, a hairstyle characteristic of her in the fifth century.

In her simple, unbelted Doric dress, this Athena resembles the many *peplophoroi* in marble and bronze, especially those serving as mirror supports, popular in the fifth century. This statuette is a forerunner of the well-known Elgin Athena in The Metropolitan Museum of Art (50.11.1), although the latter wears a Corinthian helmet and her pose is slightly different.

While the Walters Athena is probably not a direct copy of any one monumental image of the goddess, it may represent a combination of elements. The sphinx on the helmet recalls the Athena Parthenos of Pheidias (see cat. 58), while the owl on her hand can be seen in statues on Athenian bronze coins minted in the Roman period.

Greek, mid-5th century
Bronze, hollow cast
H. 14.4 cm. (5⅝ in.) W. 7.9 cm. (3⅛ in.)
The Walters Art Gallery, Baltimore
54.766
Ex-coll. Brummer, 1929

PUBLISHED: D. G. Mitten and S. F. Doeringer, *Master Bronzes from the Classical World* (Cambridge, Mass. 1967) 96, no. 92 (with bibl.); G. K. Sams, ed., *Small Sculptures in Bronze from the Classical World* (Chapel Hill 1976) no. 23; R. Tölle-Kastenbein, *Frühklassische Peplosfiguren Originale* (Mainz 1980) 48–49, no. 8b, pl. 35.

On Athena with owl in hand, see M. H. Groothand, "The Owl on Athena's Hand," *BABesch* 43 (1968) 35–51; *LIMC* II, 976, Athena 200–209. On *peplophoroi*, see also L.O.K. Congdon, *Caryatid Mirrors of Ancient Greece* (Mainz 1981); J. Boardman, *Greek Sculpture, The Classical Period* (London 1985) 27. For the Elgin Athena, see Tölle-Kastenbein (above) 49–50 no. 8c, pl. 36; J. R. Mertens, *Greek Bronzes in The Metropolitan Museum of Art* (New York 1985) 40–41, no. 24. For coins with related statues of Athena, see J. N. Svoronos, *Les Monnaies d'Athènes* (Munich 1924) pls. 83 and 84.

9 Owl

In ancient Greece, birds were believed to be agents of divine will, and their appearance was often heralded as an omen. The owl, as we have seen, was particularly associated with Athena, and was considered a sign of good luck by Athenians. Before the battle of Salamis, for instance, an owl is said to have flown from the east to the Athenian fleet and perched on the mast of Themistokles' ship (Plutarch, *Life of Themistokles* 12).

This bronze owl may have been a freestanding sculpture, but it is also possible that it once sat on the open palm of a bronze statue of Athena (see cat. 8). Since most of its claws are missing, it is now impossible to ascertain the bird's original mount. The angle of its head suggests that it might be turned around to stare at the goddess.

On the basis of its proportions, this owl can be identified either as a little grey owl or a barn owl. Especially noteworthy are the infinite hatchings on the wings which indicate the owl's barred and speckled plumage. Although difficult to date, the attitude, stance and plumage suggest the early Classical period.

> East Greek, first half of 5th century
> Solid cast bronze with coldwork incision
> H. 7.58 cm. (3 in.) L. 8.23 cm. (3¼ in.)
> George Ortiz Collection, Switzerland
> Provenance: allegedly from the peninsula of Knidos
> Venues: DC

PUBLISHED: J. Dörig, *Art antique, collections privées de Suisse romande* (Geneva 1975) no. 234.

This entry is based entirely on the one written by George Ortiz for an exhibition, *The George Ortiz Collection*, to open at the Hermitage Museum 2 February – 11 April 1993, cat. 130, and any differences are the responsibility of this author.

10 Athenian Tetradrachm

Obverse: **Head of Athena**
Reverse: **Owl and olive sprig**

When Aristophanes jokes about "bringing owls to Athens" (*Birds*, line 301), the humor is that of double-entendre. Athens was not only a habitat for the birds, but its coinage, known as "owls," bore the image of the bird on the reverse. Since this coin type endured nearly unchanged for centuries and was widely circulated throughout the Mediterranean, owls became virtually synonymous with Athens. In addition to the owl, the coinage bears other elements which refer to the city: the head of Athena on the obverse, the olive branch, and more directly the inscription ATHE on the reverse.

Given this lack of change, the dating of Athenian coinage is problematic (see also cats. 67 and 68). Coins such as this on which the helmet of Athena is decorated with upright olive leaves can be dated after the victory over the Persians in 480. Likewise the crescent moon beside the owl is a fifth-century addition, perhaps an allusion to the battle of Salamis fought in the moon's last quarter, but more likely a symbol of the nocturnal bird. Most telling is the Classical style of the Athena head; with its profile eye, fleshy lips, and the spikey palmette on the helmet, it can be dated to the fourth century.

> 4th century
> Silver
> Diam. 2.5 cm. (1 in.) Wt. 17.2 g. (.6 oz.)
> Hood Museum of Art, Dartmouth College, Hanover
> Gift of Glenn Babbitt
> 174.30.23

Unpublished.

On Athenian coinage, see C.M. Kraay, *Archaic and Classical Greek Coins* (Berkeley 1976) 63–77, pl. 11.

11 **Red-Figure Owl Skyphos**

This distinctively shaped cup, known as a Type B skyphos, has one vertical and one horizontal handle. It is also known as a *glaux*, the Greek word for owl, because of its inevitable decoration, an owl on each side. The owl is posed in profile to the right with frontal head and is flanked by sprigs of olive. This combination of owl and olive naturally derives from the famous Athenian coinage (cat. 10). However, since these skyphoi vary in size, they cannot be considered a kind of official measure, but merely a popular form during the fifth century. When the pottery industry declined in Athens at the end of the century, these vessels continued to be produced in Apulia. Beazley once suggested that the vase shape was intended to suggest an owl, the vertical handle being the beak, and the horizontal the tail.

This skyphos can be assigned to Johnson's Group II, of which a primary characteristic is the row of dotted lines paralleling the eyebrows. It is of the standard type which was produced in quantity and has been found throughout Greece and Italy. Two unique variations on this type are the glaux in Oxford (1927.4331) which shows a frontal owl with spread wings, and one in the Louvre (CA 2192) on which the owl is armed with shield and spear and wears a crest. This latter owl is certainly a humorous reference to Athena "Promachos."

> Owl Skyphoi Group II
> ca. 450
> H. 7.1 cm. (2¾ in.) Diam. 9.5 cm. (3¾ in.)
> Private collection, Cincinnati
> Formerly London market, 1952

Unpublished.

On owl skyphoi, see *ARV*² 982–84 (with bibl.); F. P. Johnson, "An Owl Skyphos," *Studies Presented to David Moore Robinson*, vol. 2 (St. Louis 1953) 96–105; *idem*, "A Note on Owl Skyphoi," *AJA* 59 (1955) 119–24, pls. 35–38; Boardman, *ARFV* 2, 39.

12 **Loomweight with Spinning Owl**
(see illus. p. 107)

In pose this relief owl resembles those on Athenian coinage (cat. 10) and the painted examples on red-figure skyphoi (cat. 11). However, this bird is distinctive in having human arms. In its hands is a distaff with which it spins wool from a basket below. The spinning owl is certainly a reference to a more peaceful manifestation of Athena, that of Ergane, the goddess of crafts.

The motif of the spinning owl does not appear in other media, but is particularly appropriate for this object. The size, horseshoe shape, and the two holes at the top indicate that this terracotta was a weight used to give tension to the warp of a warp-weighted loom (see p. 109, fig. 68).

> Greek, ca. 300
> Terracotta
> H. 5.6 cm. (2³⁄₁₆ in.) Th. 2.5–2.6 cm. (1 in.)
> Ella Riegel Memorial Museum, Bryn Mawr College
> Gift of C. C. Vermeule, 1962
> T-182
> Provenance: Tarentum

PUBLISHED: *Echoes from Olympus: Reflections of Divinity in Small-scale Classical Art*, suppl. (Berkeley 1974) 54–55, no. 73; G. F. Pinney and B. S. Ridgway, eds., *Aspects of Ancient Greece* (Allentown 1979) 291, no. 148.

On owl loomweights, see P. Wuilleumier, *Tarente, des origines à la conquete romaine* (Paris 1939) 439; H. Herdejürgen, *Die Tarentinischen Terrakotten des 6. bis 4. Jhrs. im Antikenmuseum Basel* (Basel 1971) 73–74.

13 Red-Figure Amphora (Panathenaic Shape) with Athena at Altar

Obverse: **Athena at altar**
Reverse: **Athena holding helmet at altar** (see illus p. 47)

The Nikoxenos Painter, a bilingual vase-painter whose name derives from this vase, clearly favored the theme of Athena standing between columns in his red-figure work. He has painted it twice on this vase and on one in Boston (95.19), and once on vases in Berlin (2161) and Munich (8728). Although these are Panathenaic-shaped amphoras, the decorative format varies considerably from the norm. For instance, the columns are of the Ionic order, a band of lotus-bud chain encircles the vase below the ground line, and the panels are framed by vertical zones of net pattern. In terms of figural decoration, only the fragmentary amphora in Munich bears Panathenaic iconography (i.e. obverse, Athena striding to left; reverse, jumper), and even here the columns are surmounted by palmettes instead of cocks and an altar is inserted below her shield. Clearly this artist, who is not known to have painted prize Panathenaics (although his pupil, the Eucharides Painter did), enjoyed creating variations on the festival theme.

A common motif in his red-figure work is Athena at her altar, streaked with the blood of previous sacrifices, as we see here. On the obverse she simply stands statuesquely near it, fully garbed in chiton, himation, sandals and helmet. On the other side she has shed her mantle and helmet, the latter held in her right hand, and stares down at the now flaming altar. Is the artist perhaps suggesting a temporal sequence, before and during sacrifice?

The dog as a shield device is unusual for Athena (see below), but it does appear in other Panathenaic contexts, where it gnaws a bone. The device might allude to the animal sacrifice which would undoubtedly attract scavenging dogs to the sanctuary.

Graffito: kappa on underside of foot.

Name-vase of the Nikoxenos Painter [Beazley]
ca. 500
H. 43 cm. (17 in.) Diam. 27.9 cm. (11 in.)
The University Museums, The University of Mississippi
1977.3.115
Provenance: Capua
Ex-coll. Count Stroganoff, St. Petersburg and Rome

PUBLISHED: ARV^2 221, 6 (with bibl.); J. D. Beazley, "The Master of the Stroganoff Nikoxenos Vase," *BSA* 19 (1912–13) 229–47, figs. 3–4; *LIMC* II, 1010–11 Athena 582.

Athena appears on both sides of a number of black-figure Panathenaic-shaped amphoras: Naples, private coll. (Brandt pl. 13c–d), London market (Christie's sale cat. 28 April 1964, no. 62), Louvre F 275 (*CVA* Louvre 5, pl. 2, 1&3), Louvre F 284*bis* (*CVA* Louvre 5, pl. 4, 6, 9). Another instance of a dog as Athena's shield device can be found on the pseudo-Panathenaic amphora, British Museum B 140 (*CVA* London 1 pl. 4, 2a–b). For the dog gnawing the bone, see Shapiro, pl. 8d (Munich 1727) and pl. 22b (Dunedin E48.226).

14 **Red-Figure Amphora (Panathenaic Shape) Fragment**

Obverse: **Head and shoulders of Athena**

In the earlier part of his long career the Berlin Painter decorated a number of Panathenaic-shaped amphoras in the red-figure technique, and only later won contracts for the prize vases (see cats. 24 and 39). His usual scheme of decoration was one figure per side. With Athena on the one preserved side, a likely candidate for the other is either Herakles or Hermes (see cat. 15). Since Athena is wearing her high-crested Attic helmet, her outstretched left hand may have held an oinochoe. Her spear, a portion of which is preserved at the left, was presumably clutched in her right hand. One supposes that she is moving to the right, but looking back over her shoulder. The voluminous aegis lacks a gorgoneion, as is often the case with this painter, but is bordered with a fringe of snakes; those at the shoulders are rearing up, as on prize Panathenaics.

As this mere fragment demonstrates, the Berlin Painter was a master at portraying the dignity and majesty of his city's patron deity.

> Attributed to the Berlin Painter [Beazley]
> ca. 490
> W. 10 cm. (4 in.) Th. .5–.6 cm. (¼ in.)
> Ella Riegel Memorial Museum, Bryn Mawr College
> P-188
> Provenance: Italy
> Ex-coll. E. P. Warren, Lewes House (R 1087); J. C. Hoppin.

PUBLISHED: *ARV*² 198, 16; *CVA* 1 (USA 13) 43–4 (with bibl.), pl. 30, 1; *Three Thousand Years of Classical Art* (Sydney 1970) no. 60; *Echoes from Olympus: Reflections of Divinity in Small-scale Classical Art* (Berkeley 1974) 36–37, no. 50.

15 **Red-Figure Nolan Amphora with Athena and Hermes**

Obverse: **Athena holding helmet** (see illus. p. 141)
Reverse: **Hermes**

The Yale vase shows a later and more complete version of the Berlin Painter's Athena. Perhaps because of the space constraints of the Nolan amphora, Athena has doffed her high-crested helmet and holds it forth in her right hand. Her spear rests at the diagonal along her left arm. Here the aegis has a more modest snake fringe, and her long hair is tied neatly back. The figure on the reverse is the god Hermes, who faces the opposite direction and so confronts the Athena on the obverse. These Olympians are paired on two other amphoras by the Berlin Painter, one of Panathenaic shape in the Vatican, and the other a neck- amphora with twisted handles in London (E 268).

> Attributed to the Berlin Painter [Beazley]
> ca. 480
> H. 33.2 cm. (13 in.) Diam. 19.5 cm. (7⅝ in.)
> Yale University Art Gallery, New Haven
> Gift of Rebecca Darlington Stoddard
> 1913.133
> Ex-coll. P. Arndt, Munich
> Venues: DC, VA, PR

PUBLISHED: *ARV*² 201, 71; *New England*, 82–83, no. 39; S. M. Burke and J. J. Pollitt, *Greek Vases at Yale* (New Haven 1975) 52–54, no. 46 (with bibl.); S. M. Matheson, *Greek Vases, A Guide to the Yale Collection* (New Haven 1988) 22–23.

On Athena and Hermes, see *LIMC* II, 1001 Athena 493–95; P. Zanker, *Wandel der Hermesgestalt in der attischen Vasenmalerei* (1965) 65–70.

16 **Red-Figure Lekythos with Athena**

Athena holding her helmet

An artist related to the Berlin Painter, the Tithonos Painter decorated small amphoras and lekythoi. This simple red-figure lekythos without shoulder decoration (see cat. 4) shows again the helmet-holding Athena. Like the Berlin Painter's Athena (cat. 15), she holds her spear on the diagonal, but tip downwards, and wears a diadem with upright leaves. Her helmet is more elaborate, with engraved curls below the visor, and a small gorgoneion stares forth from her aegis. She is also dressed differently, wearing a sleeved peplos with a fancy hem, a specialty of this artist.

Classically calm, these late Archaic helmet-holding Athenas herald a new age in art. Secure after their stunning victories over the Persians, the Athenians no longer needed an aggressive goddess to protect their interests, but looked to one who stands disarmed but nonetheless confident in her more peaceful attitude.

> Attributed to the Tithonos Painter [Beazley]
> ca. 480
> H. 34.9 cm. (13¾ in.) Diam. 11.8 cm. (4⅝ in.)
> The Metropolitan Museum of Art, New York
> Fletcher Fund, 1927
> 27.122.6

PUBLISHED: *ARV*² 310, 15 (with bibl.); *LIMC* II, pl. 727 Athena 195.

On the helmet-holding Athena, see N. Kunisch, "Das helmhaltenden Athena," *AM* 89 (1974) 85–104; *LIMC* II, 975–76 Athena 194–99.

154

Musical Contests

17 Black-Figure Amphora (Panathenaic Shape) with Aulete

Obverse: **Panathenaic Athena**
Reverse: **Recital of double pipes** (see illus. p. 64)

Athena with her owls recurs on the obverse of this small black-figure amphora. She is the striding Athena of the Panathenaic prize vases shown between two Doric columns, but in this instance they are surmounted by owls, rather than the traditional cocks (see pp. 33–34). The palmette-lotus chain decorating the neck of the vase is also nontraditional. In terms of shape and composition, this vase resembles the Panathenaic prize vases, and so we can interpret the scene on the reverse as a festival contest.

Here a small and presumably quite young aulete stands atop a three-stepped podium, or *bema*. His double pipes are barely visible, but the *phorbeia* or leather strap across his lips is very much in evidence. He also wears a sleeveless chiton, the standard dress of musicians. Two older men seated on folding stools and enveloped in their himations comprise his audience; they may be either listeners or more likely judges.

> Unattributed
> ca. 540
> H. 27.5 cm. (10⅞ in.) Diam. 17.2 cm. (6¾ in.)
> Archer M. Huntington Art Gallery, The University of Texas at Austin
> The James R. Dougherty, Jr., Foundation and Archer M. Huntington Museum Fund, 1980
> 1980.32
> Provenance: Caere
> Ex-coll. Castle Ashby, the Marquess of Northampton
> Venues: DC

PUBLISHED: *CVA* Castle Ashby (Great Britain 15), no. 11 (with bibl.) pl. 15, 5–6; Christie's sale cat. (2 July 1980) 142–43, no. 89; H. A. Shapiro, *Art, Myth, and Culture: Greek Vases in Southern Collections* (New Orleans 1981) 104–105, no. 40; Shapiro 33, pl. 13 c–d.

18 Black-Figure Amphora (Panathenaic Shape) with Aulode

Obverse: **Panathenaic Athena** (see illus. p. 43)
Reverse: **Aulodic contest** (see illus. p. 63)

The second musical contest involving double pipes was that of the aulode, an accompanied singer. On the reverse of this Panathenaic-shaped vase, two draped youths stand on a wooden table rather than the traditional podium as seen in cat. 17; the one on the right plays the pipes while the singer facing him holds a branch. As on the Austin vase (cat. 17) the audience consists of two men seated on camp stools. Here, however, they hold objects (the man at left, an apple, the one on the right, a flower), and so look less like judges.

The identification of the concert as a Panathenaic agon is suggested not only by the shape of the vase, but by the Panathenaic Athena on the obverse, flanked by cock columns. This image deviates somewhat from the standard iconography. For instance, the cocks are posed looking back away from the goddess, an owl is perched on her shield, and the gorgoneion of her aegis is depicted even though we are looking at the back of the figure. The Princeton Painter to whom this vase is attributed depicted Athena many times and seems to have enjoyed variety in her pose, dress and accoutrements. On this vase her shield is particularly elaborate; rather than a single motif in added white, we have here a circular band filled with a pair of lions separated by lotus buds.

Graffito: gamma-omicron retrograde, between the handle and the border of the panel on the reverse.

> Attributed to the Princeton Painter [Bothmer]
> ca. 540
> H. 38.9 cm. (15⅜ in.) Diam. 27 cm. (10 in.)
> The Metropolitan Museum of Art, New York
> Gift of Norbert Schimmel, 1989
> 1989.281.89

PUBLISHED: *Antike Kunst* 30 (1987) 64–65, pl. 8.3, 9.1–2. [The height as given in n. 39 and on p. 65 is incorrect.]

For a similarly elaborate shield of Athena (Akr. 923), see Graef-Langlotz, pl. 59.

19 **Black-Figure Neck-Pelike with Musical Contests**

Obverse: **Kithara-player** (see illus. p. 71)
Reverse: **Aulodic contest** (see illus. p. 52)

The contest on the reverse of this vase is similar to that of cat. 18 except that the instrumentalist is bearded, and hence older than the singer. Further, the musicians are mounted on a rectangular block which serves to identify them indisputably as competitors. The young singer is particularly animated as he throws his head back in song, a pose that is more common in red-figure.

This vase is unusual in pairing two musical contests (see Shapiro pp. 70–71). The obverse shows another musician on a podium, in this instance a kitharist, or possibly a kitharode although there is no evidence that he is going to sing. He daintily lifts the corner of his long, white chiton, the traditional garb of musicians. His left arm cradles the kithara via a straphold behind the strings. Since he already wears a wreath, he may be represented as a victor taking a bow (note his raised right heel).

The artist has given more prominence to this musician, who is larger in scale and more elaborately dressed, than to those of the reverse, perhaps because the kithara was a more difficult instrument to master and hence the domain of the professional musician.

This neck-pelike is unique in its shape, and seems to mark a transition from a neck-amphora (see cat. 30) to a standard pelike (see cat. 51) which does not have an offset neck. It may be interesting to note that the triple-palmette decoration on the neck is also found on a group of small pseudo-Panathenaics associated with the Painter of Oxford 218 B.

Unattributed
ca. 500
H. 26.7 cm. (10½ in.) Diam. 14.5 cm. (5¾ in.)
The Metropolitan Museum of Art, New York
Rogers Fund, 1907
07.286.72

PUBLISHED: G. Pinney and B. S. Ridgway, eds., *Aspects of Ancient Greece*, (Allentown 1979) 60–61, no. 27 (with bibl.); Yalouris, *Olympics* 71, fig. 29.

On the shape, see D. von Bothmer, "Attic Black-figured Pelikai," *JHS* 71 (1951) 40–47; R. M. Becker, *Formen attischer Peliken* (Bollingen 1977) 86–92. On the pseudo-Panathenaics associated with the Painter of Oxford 218 B, see *Paralipomena* 150–51.

20 **Black-Figure Amphora with Lyre-Player**

Obverse: **Herakles and the Nemean Lion**
Reverse: **Lyre-player** (see illus. p. 65)

The similar settings for the figures on either side of this panel amphora (Type B) indicate that we are dealing with contests. The wrestling contest of Herakles and the Nemean lion is flanked by columns surmounted by sphinxes, and the musical performer on the reverse is framed by the more traditional cock columns. Although he is not standing on a podium, his festal garb, a long sleeveless chiton under a himation, and the confronted cocks suggest a contest. The capitals of the columns, however, are Ionic, and the instrument is a lyre rather than a kithara, so this is probably not a Panathenaic contest. The figure might even be the divine musician Apollo, for whom the Ionic columns would be appropriate.

Herakles' struggle with the Nemean lion is here depicted in the mode of a stand-up wrestling match, although the hero is thrusting his sword into the animal's maw. This iconography and the amphora shape are both characteristic of Group E (see cat. 1), named for the workshop in which the painter Exekias learned his craft. This first labor of the hero is by far the most popular in Attic vase-painting, and it has been suggested that its appearance may have been inspired by the establishment of the Nemean Games as a Panhellenic festival in 573.

Attributed to Group E [Kilinski]
ca. 550–540
H. 35.4 cm. (14⅛ in.) Diam. of rim 15.1 cm. (6 in.)
San Antonio Museum of Art
Gift of Mr. Gilbert M. Denman, Jr.
86.134.40

PUBLISHED: K. Kilinski II, *Classical Myth in Western Art: Ancient Through Modern* (Dallas 1985) 48, no. 11.

21 **Red-Figure Nolan Amphora with Kithara-Player**

Obverse: **Nike with kithara** (see illus p. 68)
Reverse: **Kithara-player**

As we move from the Archaic period to the early Classical, a new character enters the repertoire of Athenian vase-painters in scenes dealing with music. She is Nike, the winged goddess of victory, and since she carries a kithara, she is more specifically the deity who brings victory in this musical contest. This innovation can be credited to the Berlin Painter to whom this vase is attributed. It shows Nike in mid-flight to the right with her drapery billowing out behind, and on the reverse the victorious musician in his straight long chiton awaiting her. The Berlin Painter decorated three other small amphoras in a similar manner, as did many of his followers.

The Nolan is a type of small red-figure neck-amphora whose *floruit* was ca. 490–430, and which is found almost exclusively in Italy. This example can be dated to 460 because of its ridged handles and because it represents the latest stage of the Berlin Painter's career. Regarding the Nolan, Greek vase-painting connoisseur Beazley has stated, ". . . if it was not invented for or by the Berlin Painter, which is quite possible, he paid special attention to it, and more Nolan amphoras came from his workshop than from any other."

Graffito: 4–bar sigma-iota retrograde ligature on the base.

Attributed to the Berlin Painter [Beazley]
ca. 460
H. 35.9 cm. (14⅛ in.) Diam. 18.7 cm. (7⅜ in.)
The Saint Louis Art Museum, St. Louis
Museum Purchase
57.1955
Ex-coll. Ludwig Pollak
Venues: DC, VA, PR

PUBLISHED: ARV^2 203, no. 104 (with bibl.); *Bulletin of the City Art Museum, St Louis* 44 (1960) 11–13 [grafitto read as beta]; Beck, *Album*, pl. 46, 244a–b; The Saint Louis Art Museum, *Handbook of the Collections* (St. Louis, 1975) 34.

On the development of the Nolan, see H. Euwe, "The Shape of a Nolan Amphora in Otterlo," *Enthousiasmos*, Allard Pierson Museum Series 6 (Amsterdam 1986) 141–42. On the Berlin Painter's Nolans, J. D. Beazley, *The Berlin Painter* (Mainz 1974) 3–4. The three other amphoras with similar imagery are listed in ARV^2 202–203, nos. 74, 75 and 100. On the graffito, A. W. Johnston, *Trademarks on Greek Vases* (Warminster 1979) 120, no. 26, type 7D.

Athletic Contests

22 Red-Figure Lekythos with Nike

Nike with kithara (see illus p. 59)

The ultimate reduction of the musical contest occurs on this red-figure lekythos where only Nike herself alludes to the competition. She floats to the left with a phiale in her outstretched right hand, the kithara held in her left by its strap. An elaborate patterned scarf hangs from her left arm (see the less able rendering of this scarf on cat. 21 where it is not differentiated from Nike's mantle). Her wings are also highly detailed, and it is clear that the painter has expended his greatest talent on this painting.

The Oionokles Painter was a follower of the Providence Painter, who in turn was a pupil of the Berlin Painter (cats. 14, 15, 21). All three painters executed images of kithara-bearing Nikai on their smaller vases, so it was something of a workshop specialty. Such vases may have been commissioned by victorious musicians to commemorate their success at the Panathenaia.

Attributed to the Oionokles Painter
ca. 470
H. 36.5 cm. (14⅜ in.) Diam. 14 cm. (5½ in.)
Archer M. Huntington Art Gallery, The University of Texas at Austin
The James R. Dougherty, Jr., Foundation and Archer M. Huntington Museum Fund, 1980
1980.63
Venues: DC

PUBLISHED: H. A. Shapiro, *Art, Myth, and Culture: Greek Vases in Southern Collections* (New Orleans 1981) 32–33, no. 9; E. D. Serbeti, "The Oionokles Painter," *Boreas* 12 (1989) fig. 1.

On kithara-bearing Nikai, see D. Shafter, "Musical Victories in Early Classical Vase Painting," abstract of AIA paper, *AJA* 95 (1991) 333–34. On the Oionokles Painter, *ARV*² 646–49 and Serbeti (see above).

23 Black-Figure Amphora (Panathenaic Shape) with Runners

Obverse: **Footrace** (see illus p. 83)
Reverse: **Footrace**

The footrace was the first event established at the Olympic Games in 776 and was the only contest until the pentathlon was introduced in 708. Of the three distances, the *stadion* (sprint), *diaulos* (double-stade), and *dolichos* (long-distance), the shortest race is represented on this vase. With wide-spread arms, high front legs, and straight rear legs propelling the figures forward, three equally spaced runners on each side dash to the right. At first glance the runners seem to be duplicates of one another, but on careful examination one sees that one is beardless, and another wears a red fillet across his chest. Although in the middle position, he may represent the soon-to-be winner.

The artist to whom this vase is attributed belongs to the circle of Lydos, a painter of early prize Panathenaics with runners. These early sprinters are drawn in an Archaic convention: frontal torso combined with profile legs, and non-diagonal position in which the forward arm and leg are on the same side of the body. This unnatural pose is corrected at the end of the Archaic period (cat. 24), although it recurs in the fourth century (cat. 25).

This vase is unusual among pseudo-Panathenaics (see pp. 42–44) in pairing two versions of the same contest, rather than devoting one panel to the Panathenaic Athena. The palmette-lotus cross on the neck, although not traditional for prize vases, is not uncommon on sixth-century Panathenaic amphoras (see cat. 41).

Graffito: lambda-upsilon retrograde.

Attributed to the Painter of Louvre F 6
ca. 540
H. 30.5 cm. (12 in.)
Shelby White and Leon Levy

PUBLISHED: Sotheby's, *Art at Auction* (1984–85) 335; Sotheby's sale cat. (17–18 July 1985) no. 313; D. von Bothmer, ed., *Glories of the Past: Ancient Art from the Shelby White and Leon Levy Collection* (New York 1990) 135–36, no. 104.

On the Painter of Louvre F 6, see *ABV* 123–29. For a belly amphora with paired scenes of runners, see *Griechische Vasen aus westfälischen Sammlungen* (Münster 1984) 93–95, no. 28.

24 Panathenaic Prize Amphora with Runners

Obverse: **Panathenaic Athena**
Reverse: **Footrace** (see illus p. 84)

The Berlin Painter (see also cats. 14, 15, 21) was one of the first artists to correctly observe the proper position of runners' arms and legs. Consummate draftsman that he was, he raised the depiction of the footrace to a new level of artistry. Note the variety in the poses: the surge of the front runner with head bent into the race; the second in three-quarter back view landing on his forward foot; the third with torso turned to the front in an easy lope; and the fourth, older and slighter in build, straining to catch up. With their varied physiques and hairdos, these athletes are individuals for the first and perhaps only time. They are unevenly spaced and the *terma* is added at the far left to indicate that they are about to make one of the many turns necessitated in the long-distance race (*dolichos*). Most unusual of all is their direction; they dash like hoplites to the left.

Of the seven extant prize Panathenaic vases attributed to the Berlin Painter (see also cat. 39), four depict runners, but this is the earliest and the only long-distance race. The amphora in Berlin (F 1832) has four men sprinting to the left, but it lacks the variety and individuality of the Castle Ashby vase. It has been suggested, even by Beazley himself, that these vase-paintings may not be from the master's hand, but could be workshop pieces. Given the number of prize vases needed for the stadion alone (approx. 228), it would not be surprising to find workshop apprentices imitating the master in order to complete the large order. However, the earlier date and quality of this vase indicate the Berlin Painter's hand.

The insignia of his workshop is the gorgoneion as shield device for the Panathenaic Athena on the obverse. Also distinctive are the red-dotted shield rim, the scaly aegis, the stepped neck-piece of the helmet, the clustered folds of the chiton emerging from a foldless overgarment, groups of four white dots on the drapery, and the incised swastika as a decorative motif on the drapery and shoulder flap (see cat. 39).

It is not certain whether the accompanying lid, which has a knob in the form of a fruit and a band of ivy leaf along the rim, is original to this vase.

Attributed to the Berlin Painter [Beazley]
ca. 480–470
H. 62.2 cm. (24 1/2 in.) Diam. 41.9 cm. (16 1/2 in.)
Private collection, New York
Provenance: Vulci
Ex-coll. Lucien Bonaparte Prince of Canino; Bassegio; Castle Ashby, Marquess of Northampton
Venues: DC, VA, PR

PUBLISHED: *ABV* 408, 1; *Addenda* 106 (with bibl.); *CVA* Castle Ashby, 9–10 (with bibl.) pls. 17, 18.1,2,61; Yalouris, *Olympics* 167, fig. 74; Christie's sale cat., 2 July 1980, 136–39, no. 87.

On the issue of master vs. workshop, see D. Kurtz, *The Berlin Painter* (Oxford 1983) 113, no. 82.

25 **Panathenaic Prize Amphora with Sprinters**

Obverse: **Panathenaic Athena** (see illus. pp. 32 and 33)
Reverse: **Footrace** (see illus. p. 83)

On this, the latest prize amphora in the exhibition, the depiction of the footrace has reverted to the archaic scheme of non-diagonal running. Four evenly-spaced sprinters, arms flung wide, fly to the right, their feet well off the ground. Given the advanced articulation of their abdominal muscles, it is curious that they are posed so awkwardly. Perhaps the artist was deliberately archaizing in order to conform with the archaic image of Athena on the obverse.

The Athena, although grown taller along with the vase itself, is in the standard Panathenaic pose. Her shield device, now nearly lost, is a small quatrefoil surrounded by a floral wreath. Just as the musculature of the runners is in contrast with their retardataire stride, so the curving drapery folds of Athena's dress contrast with her stiff pose. However, it is not these anomalies that serve to date the vase, but rather the new element crowning the columns.

Instead of the traditional cocks, there are figures of the god Ploutos (wealth) holding a large cornucopia. At the beginning of the fourth-century, statue types such as this are substituted for the cocks, and since the name of the eponymous archon is usually inscribed at the right, most fourth-century Panathenaics are datable. Although this particular amphora does not bear the archon's name, Ploutos appears on another Panathenaic (Berlin 3980) made during the archonship of Philokles (392/1).

> Attributed to the Asteios Group [Beazley]
> 392/1 (Archonship of Philokles)
> H. (without lid) 70.5 cm. (27¾ in.) (with lid) 84.6 cm. (33⅜ in.) Diam. 37.5 cm. (14¾ in.)
> The Detroit Institute of Arts
> Founders Society Purchase, General Membership Fund
> 50.193a, b
> Provenance: near Benghazi, Libya
> Ex-coll. Richard Norton and Charles Morley

PUBLISHED: *ABV* 412, 3; W. G. Moon and L. Berge, *Greek Vase-Painting in Midwestern Collections* (Chicago 1979) 222–23, no. 125 (with bibl.); N. Eschbach, *Statuen auf panathenäischen Preisamphoren des 4. Jhrs. v. Chr.* (Mainz 1986) 18–26, figs. 9–10, pl. 5, 1–2, no. 10.

26 **Black-Figure Lekythos with Athletes**

Athletes practising (see illus. p. 85)

Athletics were a regular part of daily life for Athenian men, young and old. This lekythos, or oil flask, shows four youths and one bearded man working out at the *gymnasion*, or athletic grounds. The youth in the center is preparing to hurl the discus; on each side of him are an acontist (javelin-thrower) and a jumper, weights in hand. The older man hurling the javelin is the most vigorous athlete, and the vase-painter has carefully indicated the first and middle fingers of his right hand, which are inserted in the leather strap wrapped around the pole. His left hand is pressing the blunt end of the javelin back in order to tighten the thong.

The Michigan Painter's workshop specialized in athletes, and produced a number of prize Panathenaic amphoras. One of them (Vatican 374) depicts the pentathlon, which is the contest for which these men are clearly preparing, since three of the five events are depicted. Only running and wrestling, which do not involve athletic equipment, are excluded.

> Attributed to the Michigan Painter [Philippaki]
> Late 6th century
> H. 23.7 cm. (9⁵⁄₁₆ in.) Diam. 11.8 cm. (4⅝ in.)
> The Metropolitan Museum of Art, New York
> Rogers Fund, 1906
> 06.1021.60
> Ex-coll. Canessa

PUBLISHED: *ABV* 345, 1 (with bibl.); *Paralipomena* 157–58 ("The Hague Class"); Metropolitan Museum of Art, *5,000 Years of Art*, (New York 1981), no. 16.

On the Michigan Painter's Panathenaics, see Brandt 7–8, nos. 63–70.

27 Red-Figure Kylix with Boxer

Interior: **Youth wrapping hand with boxing thong**
(see illus. p. 76)

After running and the pentathlon, the next event introduced at the Olympics was boxing. In Greek art, however, it was depicted as early as the Minoan and Mycenaean periods, and so must have been a popular sport in the Bronze Age. Boxers could be bare-fisted, but more often they wrapped their hands with light rawhide thongs. These long supple laces protected their fingers from fracture and their wrists from sprain, but did not inflict injury on their opponents, unlike the Roman *caestus*, a boxing glove equipped with lumps of metal and spikes.

On the tondo of this delicate cup a young athlete sits on the ground amidst his athletic equipment, a large discus, a pair of black jumping weights, and a pick to loosen the ground for wrestling. In the background tied into a cluster with red strings are the objects for his personal hygiene: a sponge, an aryballos or oil flask, and a thin metal strigil seen in profile. Thus the setting is the *gymnasion*. He is in the process of binding his left wrist and palm with a long thong, and is pulling the end with his right hand to tighten it. So in addition to being a pentathlete, he is also a boxer.

The words *Epidromos kalos* are added in red encircling the boxer's head. This inscription ("Epidromos is handsome") appears in the tondo of a dozen other cups by the same artist, whom Beazley naturally named the Epidromos Painter. Here the artist is attempting bold foreshortening of the legs and a three-quarter view of the torso. The large, reserved exergue is unusual in his work and that of contemporary cup-painters; perhaps it is meant to indicate the ground of the palaestra.

> Attributed to the Epidromos Painter [Cahn]
> ca. 520–500
> H. 9.5 cm. (3¾ in.) Diam. 19.6 cm. (7¾ in.)
> Hood Museum of Art, Dartmouth College, Hanover
> Gift of Mr. and Mrs. Ray Winfield Smith, Class of 1918
> C.1970.35

PUBLISHED: *ARV²* 117, 6; Münzen und Medaillen, *Auktion XVIII* (Basel 1958) pl. 32, no. 111; *New England* 78–79, no. 36; D. Buchanan, *Greek Athletics* (Harlow 1976) 42.

On boxing equipment, see Poliakoff 68–79. On the Epidromos Painter, see *ARV²* 117–18; Boardman, *ARFV* I, 62. For a large area of reserve representing the sea, cf. a cup by the Ambrosios Painter (Boston 01.8024; Boardman, *ARFV* I, fig. 119).

28 Red-Figure Kylix with Victorious Athlete

Interior: **Man and young athlete** (see illus. p. 98)
Obverse: **Komos**
Reverse: **Komos**

Attributed to the Kiss Painter [Beazley]
ca. 500
H. 11 cm. (4⅜ in.) Diam. 30.7 cm. (12 in.)
The Johns Hopkins University Archaeological Collection, Baltimore
B5
Provenance: Chiusi
Ex-coll. Hartwig; Baltimore Society of the Archaeological Institute of America
Venues: DC,PR

This red-figure cup also praises the beauty of Epidromos, twice on the exterior, but the tondo bears the inscription *Leagros kalos*.

It has been taken to refer to the young boy at the right poised on a two-step base. He holds a javelin in his outstretched right hand, a sponge and aryballos in his left. Since he is crowned with an olive wreath, it is assumed that he is a victorious pentathlete. Gazing upon him is an older bearded man cloaked in a mantle and wearing an ivy wreath. This man holds a long stick in his left hand, but it is not possible to tell if it is the forked rod of a trainer or the staff of a judge, or if he is simply an admirer. In the background hangs another sponge and aryballos, which, along with the upright pick, indicate the setting as the *gymnasion*.

Two important questions arise concerning the interpretation of this cup. First, is the figure of the boy meant to be a commemorative statue, or a living individual? Second, can we equate this boy or the man with the historic person Leagros, the general who died at Drabescus in 465 (Herodotus 9.75; Pausanias 1.29.5)? The stiff, kouros-like pose of the youth and the base clearly indicate a statue. As for Leagros, he was a contemporary of Themistokles and so born ca. 525; thus if he is shown on this vase, he should be the older man (although *kalos*-names generally refer to beardless youths). This picture has been linked with an inscribed two-step statue base found in the Athenian Agora which was dedicated by Leagros, son of Glaukon, to the Twelve Gods and is dated ca. 490–480, to judge from the letter forms. Dowel holes on top of the block show that the statue stood with right foot advanced. Raubitschek has made the ingenious suggestion that this cup shows a mature Leagros gazing upon a statue of himself as a younger, victorious pentathlete.

Since most kalos-names do not refer to figures in the composition, perhaps it is best to disassociate Leagros from the scene described above, which may rather be related to the depictions of merrymaking on the exterior. Here wreathed youths and men frolic to the accompaniment of a flute-player around a large wine krater, most likely in celebration of the athletic victory commemorated on the interior. Both public banquets and private parties were held for victors on the evening following the contests. Wine flowed freely and revelers sang victory hymns. As for the victor on the base, his open mouth suggests a living person; and given the discomfort of the smaller, straining figure on the Kiss Painter's name-vase, one can see the podium as an artistic solution for the placement of a shorter figure within a tondo.

Graffito: FE on underside of foot.

PUBLISHED: *ARV*² 177, 3; *Addenda* 185 (with bibl.); E. R. Williams, *The Archaeological Collection of the Johns Hopkins University* (Baltimore 1984) 144–47, no. 104 (with earlier bibl.); J. Jüthner, *Die athletischen Leibesübungen der Griechen* I (Vienna 1965) pl. 5d; *AJA* 73 (1969) pl. 32, fig. 4; Yalouris, *Olympics* 138, fig. 57; K. J. Dover, *Greek Homosexuality* (New York 1978) fig. R305; E. D. Francis and M. Vickers, "Leagros Kalos," *Proceedings of the Cambridge Philological Society* 207 (1981) 98–99, 118–22 (incorrectly located in Oxford, Miss.), pl. 1.

On the Agora base, see *Agora* 14, 132. On A. E. Raubitschek's interpretation, see his "Leagros," *Hesperia* 8 (1939) 160–64. The redating of this cup by Francis and Vickers is summarized in Kyle, 222–23, P100. For another boy, in this case a musician, on a base in the tondo, cf. the cup by the Splanchnopt Painter (New York 26.60.79; *ARV*² 891, 1).

29 Red-Figure Column-Krater with Jumpers

Obverse: **Jumpers and trainer** (see illus. p. 81)
Reverse: **Man courting youth** (see illus. p. 81)

One of the five events constituting the pentathlon, the jump was a running broad jump with weights called *halteres*. On this column-krater two young athletes are practising with their weights in the presence of their portly trainer. The youth at the left is swinging the weights downwards just before taking off. The second youth at the right is shown at an earlier stage, as he begins the run. In the background hangs the ubiquitous sponge and strigil, while the pillar marks the start for the take-off.

Although the Harrow Painter is not considered one of the better artists of the late Archaic period, he does demonstrate an eye for detail, and possibly humor. For instance, the cleaver-like *halteres* have a distinctive shape, unlike the rubbery ones of the Michigan Painter (cat. 26), and the jumpers are infibulated, a common practice among Greek athletes for protecting the genitals. On the reverse an older man is courting a young boy. His outstretched hand is reaching for the youth's genitals, but they are covered by the boy's mantle. Since the gymnasium was well known as a viewing ground where older men went to observe naked boys, the artist may in jest be denying his male audience that pleasure.

Attributed to the Harrow Painter [Beazley]
Early 5th century
H. 33.5 cm. (13¼ in.) Diam. 30.2 cm. (11⅞ in.)
Mead Art Museum, Amherst College, Amherst
Museum Purchase
1957.66

PUBLISHED: *ARV*² 274, 43; *Paralipomena* 353, 43; *Hesperia Art Bulletin* 2 (19) no. 68; *Archaeology* 20 (1967) 8; *The Classical Collection at Amherst College*, Mead Museum Monographs 1 (1979) 8, no. 6.

On infibulation, see W. E. Sweet, "Protection of the Genitals in Greek Athletics," *Ancient World* 11 (1985) 43–52. On sexual encounters at the gymnasium, see K.J. Dover, *Greek Homosexuality* (New York 1978) 54–55, 124–25.

30 Black-Figure Neck-Amphora with Diskoboloi

Obverse: **Two discus-throwers, trainer, and acontist** (see illus. p. 85)
Reverse: **Discus-thrower, runner, and trainer**

This vigorous painting of robust pentathletes is typically late black-figure. The composition is crowded, there is much overlapping and a vine decorates the background. The obverse and the reverse repeat almost verbatim the figures of the trainer looking back and the *diskobolos* heaving a large discus with both hands. Variation is provided by the second discus-thrower and the kneeling acontist (javelin-thrower) on one side, and the runner on the other. The large discus filling the void between his legs is white, as is the second discus on the obverse.

The one oddity in this scene is the man with the javelins: why is he kneeling on the ground? A similar figure appears on other vases of the Leagros Group (e.g. Würzburg 215), but it is not a pose that one associates with javelin-throwers. Possibly the artist likes the pose in order to give variety to the composition, or perhaps the squatting man is planting poles in the ground to serve as starting gates (see cat. 34) for the discus-throwers or to measure the distance of the throw.

Attributed to the Acheloos Painter [Cahn]
ca. 510
H. 41.8 cm. (16½ in.)
National Museum of American History, Smithsonian Institution, Washington D.C.
Gift of *Sports Illustrated*
1979.696.01
Ex-coll. Clare Booth Luce
Venues: DC, VA

PUBLISHED: *ABV* 386, 7; *Paralipomena* 169, 8 *bis*; Münzen und Medaillen, *Auktion XIV* (Basel 1954) pl. 15, 63.

For the Würzburg neck-amphora which not only repeats the kneeling figure but also the trainer, diskobolos, and runner, see *ABV* 375, 213. On the Acheloos Painter, see E. Moignard, "The Acheloos Painter and Relations," *BSA* 77 (1982) 201–11, pls. 7–14.

31 **Black-Figure Amphora (Panathenaic Shape) with Diskobolos**

Obverse: **Panathenaic Athena**
Reverse: **Trainer, discus-thrower, and athlete**

To judge from the number of extant prize amphoras and pseudo-Panathenaics depicting the pentathlon, this contest was not nearly as popular as the footrace. During the sixth century the scene normally consists of four athletes (two acontists, a *diskobolos*, and a jumper), but is reduced to three and loses some of its former vigor in the fifth century. Here only the diskobolos represents the pentathlon; he is shown at the beginning of the swing with the discus in profile in his right hand. Flanking him are a trainer or judge at the left, and at the right a fellow athlete who moves away but looks back over his shoulder. From the position of his hands it looks as if he was originally meant to be holding a javelin which the artist has forgotten to include.

The Panathenaic Athena on the obverse bears a shield with the fore-part of a boar as the blazon; this device appears also on the shield of a Panathenaic Athena on a neck-amphora in the Louvre (F 284 *bis*).

Resembles the Group of Vatican G 23
ca. 500–485
H. 38 cm. (15 in.) Diam. 24.1 cm. (9½ in.)
The Walters Art Gallery, Baltimore
48.2109
Provenance: Rhodes
Ex-coll. Sir Herman Weber; William Randolph Hearst (San Simeon 9937)

PUBLISHED: *ABV* 406; *Paralipomena* 176; Sotheby's sale cat., 22–23 May 1919, pl. 3; *AJA* 63 (1959) 182, no. 3, pl. 48, figs. 5–6.

On early Panathenaics with the pentathlon, see *Agora 23*, 131–32, no. 228. For Louvre F 284 *bis*, see *CVA* Louvre 5, pl. 4 (360) 6,9.

32 **Stater of Kos**

Obverse: **Diskobolos and tripod** (see illus. p. 85)
Reverse: **Crab**

One of the finest representations of a discus-thrower in Greek art appears on the fifth-century coinage of Kos, an island in the eastern Aegean. In dramatic frontal view the athlete stands with all his weight on his right leg, his left crossing behind, and tilts his upper torso as he lifts the discus overhead. His left hand, also raised, has just released its grip. Despite the small scale, the anatomical modeling is highly detailed, especially in the abdomen.

To the left of the athlete is a tripod on a stand. Herodotus (I, 44) states that a tripod was awarded to victors in the games of Apollo celebrated at Triopion, near Knidos, Kos' closest neighbor. Victors were compelled to dedicate their prizes in the temple of Apollo, and since this tripod stands on a base, it is presumed to be a dedication.

The reverse of this coin shows a crab which was the badge of Kos just as the owl was of Athens. It appears within an incuse square with a dotted border. The minting of these coins ceased ca. 450 in obedience to an Athenian decree of 448 which forbade its allies, the cities of the Delian League, to issue their own silver coinage.

ca. 480–450
Silver
Diam. 2.2 cm. (7/8 in.) Wt. 16.12 grams
The American Numismatic Society, New York
1947.84.8

PUBLISHED: J. P. Barron, "The Fifth-Century Diskoboloi of Kos," in *Essays in Greek Coinage presented to Stanley Robinson* (Oxford 1968) 80, pl. 9, 16a.

33 **Discus**

Inscribed: **Simos m'epoieise ("Simos made me")**

The Greek word *diskos* originally referred to anything that could be thrown or cast. The throwing of *diskoi* was a common pastime of Homeric heroes. Between battles, the Greek warriors at Troy entertained themselves by casting spears and throwing the discus (*Iliad* 2.774), as did the suitors of Penelope on Ithaka (*Odyssey* 4.626, 17.168). Odysseus impressed the Phaiakians by hurling a large, heavy stone well beyond their own lighter diskoi (*Odyssey* 8.186–190). At the funeral games for Patroklos (*Iliad* 23.826, 839) the weight thrown was a mass of pig iron, which also served as the prize.

In classical Greece the discus was shaped into a circular disk, usually thicker in the center than at the edge. It could be made of stone, iron or lead, but most of the surviving examples are bronze. These vary considerably in size (16.5–34 cm. in diameter) and weight (1.25–6.6 kg.), depending on whether the athlete was a boy or man. Many were made for dedication, but the rough surface of this example, which would give the athlete a better grip, suggests that it was actually used.

Frequently a discus is inscribed either with a dedicatory inscription or with an announcement of its origins, such as "from the games" on a marble example formerly in the E. P. Warren collection. This discus is unique in having what appears to be an artisan's signature, such as one finds more frequently on vases. Perhaps a bronze smith/athlete signed this discus of his own making, and then dedicated it as a way of self-promotion.

Boiotian (on basis of script)
ca. 500
Solid cast bronze with coldwork incision
Diam. 18.6–18.9 cm. (7¼ – 7⅜ in.) Wt. 3.57 kg (7.85 lb.)
George Ortiz Collection, Switzerland
Venues: DC

PUBLISHED: *Le Sport dans la Grèce antique* (exhib. cat. 1992).

On the discus, see Gardiner *AAW* 154–56; P. Jacobstahl, "Diskoi," 93 Berlin Winckelmannsprogramm (1933).

This entry is based entirely on one written by George Ortiz for an exhibition, *The George Ortiz Collection*, to open at the Hermitage Museum, St. Petersburg, 2 February – 11 April 1993, cat. 128, and any differences are the responsibility of this writer.

34 Red-Figure Kylix with Boxers and Acontists

Interior: **Young boxer and trainer** (see illus. p. 87)
Obverse: **Boxers** (see illus. p. 87)
Reverse: **Javelin-throwers**

Javelin-throwing was also a Homeric activity (see cat. 33), as one might expect among warriors. At the Panathenaia it was part of the pentathlon, as well as an equestrian event. The former contest was a long-distance throw, while in the latter the javelin was aimed at a target. On the exterior of this cup four youths are shown testing their javelins in the presence of a young trainer. Although the trainer is not distinguishable from the athletes in terms of age, unlike them he is clothed and wreathed, and holds a forked stick in addition to his staff. The athlete next to the trainer is shown in an earlier stage than the others, i.e. he is still wrapping the throwing-thong around his pole. The other three already have their first finger in the thong. Five additional javelins stand planted in the ground; they may have served as starting markers.

The other side of the cup and the tondo are devoted to youths' boxing. Here there is greater need for trainers, and three are present, two older and one still a youth. Again the first athlete is in a preparatory stage, stretching out his leather thong, while his companion and the youth in the tondo are already binding their hands. The temporal progression continues to the right where a bout is in full swing. Vase-paintings such as this indicate that Greek boxing consisted primarily of blows to the head rather than the body. As a result, one often sees blood pouring forth from facial wounds, as here. The Greeks considered boxing to be the most injurious of all their sports, and so it appears on this vase.

Early in his career the Triptolemos Painter decorated many drinking cups with athletic scenes. In addition he painted one amphora of Panathenaic shape on which he depicted Athena holding a writing tablet and stylus (Munich 2314; see p. 22, fig. 8); the other side shows an acontist at rest. It may be that she is keeping score for the pentathlon at the Panathenaia.

Graffito: chi under foot.

Attributed to the Triptolemos Painter [Beazley]
ca. 490
H. 13.3 cm. (5¼ in.) Diam. 32.3 cm. (12¾ in.)
The Toledo Museum of Art, Toledo
Purchased with funds from the Libbey Endowment,
Gift of Edward Drummond Libbey
61.26

PUBLISHED: *ARV*² 1648 and 1705, 36*bis*; *Addenda* 223 (with bibl.); *CVA* Toledo 1 (17) 32–34 (with bibl.), pls. 51–52; W. B. Moon and L. Berge, *Greek Vase-Painting in Midwestern Collections* (Chicago 1979) 182–83, no. 103; Poliakoff 83, fig. 87.

35 Black-Figure Oinochoe with Sparring Boxers

Boxers and two spectators

Two hefty young boxers confront each other on this small wine jug. The one at the right wears thongs on both hands, while only his opponent's right hand is protected. His bare left hand is held up in an open gesture to block the blows of his opponent. The pair is flanked by two draped men: at the right a standing figure with white hair and beard, and at the left a seated youth, possibly a judge.

This vase belongs to a class of oinochoai characterized by a trefoil mouth, black neck, low handle, and echinus foot. The name piece, London B 524, was decorated by the Amasis Painter, and it is possible that the potter Amasis devised the special shape.

> Class of London B 524 [Beazley]
> ca. 550–540
> H. 20 cm. (7⅞ in.) Diam. 12.1 cm. (4¾ in.)
> The Cleveland Museum of Art
> Gift of Amedio Canessa, 1916
> 16.1062

PUBLISHED: *Paralipomena* 179, 6; *CVA* Cleveland 1 (15), pl. 17, 1–2; Poliakoff 72, fig. 72.

On the Class of London B 524 and Amasis, see D. von Bothmer, *The Amasis Painter and His World* (Malibu 1985) 163.

36 Black-Figure Amphora (Panathenaic Shape) with Wrestlers

Obverse: **Panathenaic Athena**
Reverse: **Wrestlers and dinos** (see illus. p. 86)

According to mythological tradition, scientific wrestling was invented by the Athenian hero Theseus. It emphasized skill and strategy rather than brute strength. In the Panathenaic program it appeared twice, as the final event of the pentathlon, and as a separate competition. When it is shown on Panathenaic amphoras, we assume that the latter is being depicted.

This imitation of a prize amphora shows two youthful wrestlers butting heads and grasping each other's arms at the beginning of the bout. The aim of this upright wrestling was to throw one's opponent to the ground three times, the victor thus becoming a *triakter* or "trebler." The wrestlers are flanked by two draped men, possibly the older judge at left with his hand raised, and a young trainer at the right with a forked stick. The most prominent feature of this composition is the large dinos between the wrestlers. This bowl is certainly meant to be the prize, but it is surprising to find it in a Panathenaic context. A pseudo-Panathenaic in Basel by the same painter shows a pair of boxers cuffing each other, more appropriately over a neck-amphora.

The obverse has the traditional Panathenaic Athena, although the folds of her skirt are more elaborate than usual. Her shield device is another prize vessel, a tripod.

Attributed to the Swing Painter [Bothmer]
ca. 540–530
Pres. H. 41.05 cm. (16⅛ in.) Diam. 30.1 cm. (11⅞ in.)
Collection of The J. Paul Getty Museum, Malibu
86.AE.71
Ex-coll. Walter Bareiss (no. 367)

PUBLISHED: *CVA* Malibu 1 (23) 20–21 (with bibl.), pl. 21.

The Swing Painter's amphora in Basel is published by E. Böhr, *Der Schaukelmaler* (Mainz 1982) pl. 89.

37 Stater of Aspendos

Obverse: **Wrestlers**
Reverse: **Youth aiming slingshot**

Although this coin was minted two hundred years after the Swing Painter's vase, the poses of the wrestlers are nearly identical. The composition of two wrestlers bent over and grasping each other's arms is ideally suited to the circular format of a coin. They are framed by a dotted circle and stand on a raised groundline. The letters KF inscribed in the space between their legs refer to magistrates.

On the reverse is another athlete, a slinger, striding vigorously to the right. The fine folds of his short chiton seem to billow in the wind, and his musculature, like that of the wrestlers, is carefully modeled. The magistrates' letters reappear here, and the local name for Aspendos is inscribed vertically at the left edge. The triskeles, seen in front of the slinger, had been the reverse type for the city's coinage in the previous century. The slinger may also be a punning reference to Aspendos, since the word for sling (*sphendone*) resembles the name of the town.

ca. 370–333
Silver
Diam. 2.3 cm. (7/8 in.) Wt. 10.7 g. (.4 oz.)
Hood Museum of Art, Dartmouth College, Hanover
Gift of the Class of 1962
990.24.27095

Unpublished.

On the coinage of Aspendos, see O. Morkholm, *Numismatic Chronicle* (1971) 21 and 28.

38 Panathenaic Prize Amphora with Fighters

Obverse: **Panathenaic Athena**
Reverse: **Wrestlers or pancratists with judge**

The shield device of the winged horse pegasos indicates the workshop of the Kleophrades Painter; he and the Berlin Painter were the finest pot-painters of the late Archaic period. This Athena, compared to that of the Swing Painter (cat. 36), is tall and high-waisted; the folds of her chiton now sway in relation to her movement; her helmet has sprouted a visor, and the formerly realistic snakes along the aegis have become a decorative fringe. In short, she is archaizing, rather than truly Archaic.

The athletes and their referee on the reverse, however, are *au courant* with early fifth-century figurative style, even though the Kleophrades Painter, a red-figure artist, rendered them in the now old-fashioned but religiously sanctioned technique of black-figure. Two bearded men step gingerly forward, extending their left arms for protection while preparing to take hold with their right. The position of the judge or referee in the center is unique, but is in keeping with this artist's desire to vary the familiar imagery. The composition is balanced, but not strictly symmetrical. The extension of the judge's right elbow to the left is offset by his draped left hand protruding to the right. His glance over his shoulder to the left suggests that this athlete will be victorious.

The only ambiguous aspect of this scene is the contest. Is it wrestling or the pankration, an all-out fight which barred only biting and gouging? Since the fighters are not yet engaged it is difficult to determine. The extended left leg of the right-hand athlete could suggest a leg trip, common in wrestling (see cat. 39), or kicking as part of the pankration. The open hands indicate preparation for a wrestling hold, whereas pancratists tend to punch with their fists like boxers. Whatever the contest, the Kleophrades Painter has heightened the tension by depicting the moment just before these two powerful men engage in what is sure to be a fearsome match.

> Attributed to the Manner of the Kleophrades Painter [Beazley]
> ca. 490
> H. 63.5 cm. (25 in.) Diam. 41 cm. (16⅛ in.)
> The Toledo Museum of Art, Toledo
> Purchased with funds from the Libbey Endowment,
> Gift of Edward Drummond Libbey
> 61.24

PUBLISHED: *ARV*² 1632 and 1705; *Paralipomena* 175, 5*bis*; *CVA* Toledo 1 (17) 7–8 (with bibl.), pl. 13.

On Panathenaics by the Kleophrades Painter, see S. B. Matheson, "Panathenaic Amphorae by the Kleophrades Painter," *Greek Vases in the J. Paul Getty Museum* vol. 4 (1989) 95–112.

39 Panathenaic Prize Amphora with Wrestlers

Obverse: **Panathenaic Athena** (see illus. p. 28)
Reverse: **Wrestlers with judge** (see illus. p. 30)

Similar ambiguity is evident in the painting on the reverse of the Panathenaic vase by the Berlin Painter, whose workshop succeeded that of the Kleophrades Painter in the production of prize amphoras. Here two athletes are also grappling with each other in the presence of a judge, who stands at the left. The athlete at the right has gained an advantage since he holds his opponent at both his right shoulder and his left elbow. If he is twisting his opponent's arm, as the incised lines above the elbow might indicate, then the contest may well be the more violent pankration, which often began with finger and arm twisting known as *akrocheirismos*. His victim seems to be running away to the left, but his upper body is wrenched back toward his aggressive pursuer in an ambitious three-quarter view. In the next moment he will undoubtedly be tripped by the right foot of his opponent which is raised to the level of his knee. Tripping was allowed in wrestling bouts as well as in the pankration, so the action is not definitive in determining the contest. Since the trainer or referee usually stands at the left in wrestling scenes, whereas his counterpart in the pankration is generally at the right, this bit of evidence may tip the scale in favor of wrestling.

In comparison with the Kleophrades Painter's robust figures, the Berlin Painter's athletes are lighter, quicker, more agile; or as Beazley so succinctly articulated the contrast: "the painter of power" versus "the painter of grace."

Attributed to the Berlin Painter [Bothmer]
ca. 480–470
H. 62.2 cm. (24½ in.) Diam. 40.6 cm. (16 in.)
Hood Museum of Art, Dartmouth College, Hanover
Gift of Mr. and Mrs. Ray Winfield Smith, Class of 1918
C.959.53

PUBLISHED: *ARV*[2] 214; *Paralipomena* 177, *2ter*; D. von Bothmer, "A Panathenaic Prize Amphora," *Dartmouth College Alumni Magazine* (June 1959) 24–26; *New England* 62–63, no. 26; *Treasures of the Hood Museum of Art, Dartmouth College* (Hanover 1985) 38, no. 5 (color); Poliakoff 39, fig. 29.

40 Panathenaic Prize Amphora with Boy Wrestlers

Obverse: **Panathenaic Athena** (not extant)
Reverse: **Boy wrestlers and judge** (see illus. p. 86)

Depictions of boys' events in the Panathenaia become more frequent in the later fifth century. They represent the youngest of the three classes of athletes, and are distinguishable from youths by their smaller size. They are often shown standing at ease before or after the event, or just about to engage, as here, rather than actively competing.

This vase was reputedly found in the same tomb with three other prize amphoras, two from the same group (Baltimore Museum of Art 1960.55.3, Mississippi 1977.3.59) and one by the Achilles Painter (Harvard 60.309). The first of these also represents boy wrestlers, and so two of the six prize vases awarded at one Panathenaia in the late fifth century may be extant. It is interesting to note that the athletic scenes are not identical, i.e. the position of the trainer/judge is reversed. The conclusion to be drawn here is that a given workshop was not bound to produce identical copies.

Attributed to the Robinson Group [Beazley]
ca. 430
Restored H. 53.4 cm. (21 in.) Diam. 32.4 cm. (12¾ in.)
Arthur M. Sackler Museum, Harvard University Art Museums, Cambridge
Bequest of David M. Robinson
1959.128
Provenance: Attika
Ex-coll. David M. Robinson, Baltimore; Mrs. Leonard Russell, London

PUBLISHED: *ABV* 410, 3; *Addenda* 107 (with bibl.); *CVA* Robinson 1 (4) pl. 31, 2 and 33, 5; Beck, *Album* pl. 37, 197b; Poliakoff 35, fig. 19.

Equestrian Contests

41 Black-Figure Amphora (Panathenaic Shape) with Horse Race

Obverse: **Panathenaic Athena**
Reverse: **Horse race** (see illus. p. 91)

Horse racing was certainly an aristocratic event and, as today, the prize was awarded to the owner of the horse, rather than the jockey. The earliest extant prize Panathenaic celebrating the horse race (Nauplion 1) in fact shows the winning horse and jockey being led in by the trainer and greeted by what appears to be the owner. Thereafter, the usual scheme is to show two overlapping jockeys galloping at full speed to the right, as here.

The small size and lack of columns and inscription on the obverse indicate that this is not a prize vase. A date in the third quarter of the sixth century is suggested by the lotus-palmette cross on the neck and the cap-like helmet of Athena. Although not common for Athena, the tripod which appears on her shield also occurs on a fragmentary Panathenaic from the Akropolis (Akr. 914). Since the tripod was frequently a prize in *agones*, its presence here is especially appropriate.

Unattributed
ca. 540
H. 34.3 cm. (13 1/2 in.) Diam. 22 cm. (8⅝ in.)
Tampa Museum of Art
Joseph Veach Noble Collection
86.24

PUBLISHED: Ars Antiqua, Luzern, *Auction V*, 7 November 1964, no. 123, pl. 30; J. V. Noble, "Greek Vases and Some Mistakes by Their Potters and Painters," *American Ceramic Circle Bulletin* 2 (1980) 114, fig. 1; Tampa Museum of Art, *The Joseph Veach Noble Collection* (Tampa 1985) 20, 40, no. 19.

For the Nauplion amphora, see *ABV* 260, 27; Brandt no. 28; *Mind and Body* 308–10, no. 197. On Akr. 914, see *ABV* 666 (Echekles). A pseudo-Panathenaic by the Swing Painter (British Museum 1949.11–22.1) shows the acclamation of the winning horse, which is followed by a youth bearing a tripod; see *ABV* 307, 59; *Mind and Body* 310–11, no. 198.

42 Black-Figure Amphora (Panathenaic Shape) with Horse Race

Obverse: **Panathenaic Athena**
Reverse: **Horse race** (see illus. p. 91)

The scheme for the horse race here is similar to the Tampa vase (cat. 41), except that these jockeys are nude and the race is more animated. The riders have bounced high off their mounts, and the front runner has turned around to observe the competition. His horse has all four hooves well off the ground, a most unusual pose for this date, being more common at the end of the fifth century (see cat. 51).

The Athena of the obverse is flanked by the canonical cock columns. The later date of this vase is indicated by the drapery folds which contrast with the still skirt of the Tampa Athena, and the fuller helmet. Oddly, the textile pattern of her skirt, red dots next to clusters of small white dots, has migrated to her aegis. The curving snake is a popular shield device, especially among the prize Panathenaics by the Eucharides Painter, who also favored the theme of the horse race.

Unattributed
ca. 500
H. 36.6 cm. (14 ⅜ in.) Diam. 25.5 cm. (10 in.)
Hearst Castle, California Department of Parks and Recreation, San Simeon
529.9.5449
Ex-coll. William Randolph Hearst

PUBLISHED: E. E. Bell, *The Attic Black-Figured Vases at the Hearst Monument, San Simeon* (Ph.D. diss., University of California, Berkeley 1977) 31, 269–70, no. 19, pls. 53–55.

On the Eucharides Painter's Panathenaics, see *ABV* 385, 1–3. A pseudo-Panathenaic in Baltimore (Walters 48.2105), which was also in the W. R. Hearst collection, is closely related; see *Paralipomena* 176.

43 Lekanis Lid with Chariot Race

(see illus. p. 93)

Athenian black-figure vase-painters favored lids for the depiction of the chariot race. The circular format lends itself to the continuous coursing of quadrigas or four-horse chariots around the periphery. Although at first glance these black horses and white-robed charioteers look to be copies of one another, they are in fact quite varied. Note in particular the position of the drivers' arms, and the incised markings on the light carts and wheels. One pair of contestants is overlapping.

A lekanis was a large lidded bowl with strap handles. The lid has a prominent knob with central hollow, here encircled with lotus bud decoration. The flanged rim is ornamented with ivy leaf, and rays emerge from the base of the knob. The pairs of drilled holes indicate an ancient repair.

Unattributed
ca. 520–510
H. 12.69 cm. (5 in.) Diam. 40.64 cm. (16 in.)
Shelby White and Leon Levy

PUBLISHED: D. von Bothmer, *Glories of the Past, Ancient Art from the Shelby White and Leon Levy Collection* (New York 1990) 147–48, no. 111.

For a close parallel, a fragmentary lid from Lentini, see G. Rizza, *BdA* 48 (1963) 342–44, fig. 5.

44 Panathenaic Amphora with Chariot Race

Obverse: **Panathenaic Athena** (see illus. p. 46)
Reverse: **Quadriga** (see illus. p. 92)

Chariot racing was the most prestigious event at the Greater Panathenaia, and the most lucrative. The first prize was 140 amphoras of olive oil, which is equivalent to over 1400 gallons of oil. On prize vessels the contest is almost always shown as a single chariot racing to the right, with the horses rearing and their front hooves grazing the edge of the panel. The driver carries a long goad or *kentron* and grasps the reins in both hands. Here the wind blows his hair back and part of his long robe, revealing his chest.

Although this vase is regulation size, it lacks the prize inscription on the obverse. Perhaps it was fabricated for the Panathenaia, but was then rejected by the inspectors because the columns have Ionic capitals. Another unusual feature is the aegis: the fringe of snakes continues along the front at Athena's waist, whereas in all other examples it is seen only at the side. The white of the goddess' flesh has disappeared, as has that of the shield device, a gorgoneion. Her dress seems to consist of a diaper-patterned peplos over a chiton, of which the softer folds can be seen below.

> Possibly by the Painter of Würzburg 173 [Bothmer]
> ca. 500
> H. 62.4 cm. (24 ½ in.) Diam. 41.1 cm. (16 ¼ in.)
> The Art Museum, Princeton University
> Bequest of Mrs. Allan Marquand
> 1950.10
> Ex-coll. Allan Marquand

PUBLISHED: H.R.W. Smith, *Art and Archaeology* 20 (1925) 120–21; F. F. Jones and R. Goldberg, *Ancient Art* (Princeton 1960) 34–35; *Art Journal* 26 (1967) 172, fig. 5; *Athens Comes of Age, From Solon to Salamis* (Princeton 1978) front and back covers; J.-M. Moret, *Oedipe, La Sphinx et les Thébains* (Geneva 1984) pl. 60, 1.

For the attribution, see D. von Bothmer in *Antike Kunst* 30 (1987) 64, n. 40. A similar full-size Panathenaic without inscription, which has Ionic capitals on the obverse and a quadriga on the reverse, is British Museum B 135; see *CVA* London 1 (1) pl. 3 (27) 2a-b.

45 Panathenaic Prize Amphora with Chariot Race

Obverse: **Panathenaic Athena**
Reverse: **Quadriga**

The Kleophrades Painter (see also cats. 38 and 46) has the largest number of extant prize amphoras of any Athenian vase-painter. The vases from his workshop are immediately recognizable by the conspicuous shield device, a flying pegasos. The shape of his amphoras is distinctive: they are slimmer and have a lower center of gravity than, for instance, the Berlin Painter's (see cat. 39). His Athena-type is also distinctive with her thick lips, prominent nose, fully rounded chin, and clusters of curls framing her face. She traditionally wears a red fillet on her helmet, scaly aegis, red belt, and sleeveless dress decorated predominantly with incised motifs. The Yale Athena appears to be wearing an *ependytes*, with an all-over decoration of incised squares and stars, over her chiton, the folds of which emerge from the lower border of this garment.

Of the twenty prize Panathenaics that have been assigned to the Kleophrades Painter's workshop, nearly half depict the chariot race. Compared to the Princeton quadriga (cat. 44) this team is larger, its rear legs and red tails overlapping the chariot. The added red for the driver's beard can be found consistently on other athletes by this artist.

> Attributed to the Kleophrades Painter [Beazley]
> ca. 490
> Restored H. 65.5 cm. (25 ¾ in.) Diam. 40.2 cm. (15 ¾ in.)
> Yale University Art Gallery, New Haven
> Gift of Frederic W. Stevens, B.A. 1858
> 1909.13

PUBLISHED: *ABV* 404, 5; S. M. Burke and J. J. Pollitt, *Greek Vases at Yale* (New Haven 1975) 41–43, no. 40; S. B. Matheson, *Greek Vases, A Guide to the Yale Collection* (New Haven 1988) 20–21; S. B. Matheson, "Panathenaic Amphorae by the Kleophrades Painter," *Greek Vases in the J. Paul Getty Museum* 4 (1989) 99, fig. 3, 107, fig. 10.

On the Kleophrades Painter, see J. D. Beazley, *The Kleophrades Painter* (Mainz 1974).

Tribal and Other Contests

46 Panathenaic Prize Amphora with Hoplitodromos

Obverse: **Panathenaic Athena**
Reverse: **Judge, hoplite, and attendant** (see illus. p. 36)

This unique prize amphora has been given three different interpretations since it was first exhibited in 1983. The scene on the obverse has been said to represent the *pyrrhike* or armed dance (Bothmer), the *euandria* or contest in manly excellence (Reed), and the *hoplitodromos*, or armed footrace (Tiverios). The last is the most likely since it is the only contest for which olive oil was the documented prize. There are six extant Panathenaics with a hoplite race on the obverse, although none shows a man holding two shields, as this contestant does. It would appear that the Kleophrades Painter has simply chosen to depict a preparatory moment rather than the race itself. Tiverios suggests that the central figure might be comparing the weight of the two shields, while an attendant (identified by the himation wrapped around his waist) holds a third. A contest official or judge looks on at the left to ensure fairness. This identification is corroborated by the shield device, a hoplite, which is common in scenes of the hoplite race.

> Attributed to the Kleophrades Painter
> ca. 490
> H. 65.8 cm. (26 in.) Diam. 40.4 cm. (16 in.)
> Nicholas S. Zoullas
> Ex-coll. Nelson Bunker Hunt, Fort Worth
> Venues: VA, PR

PUBLISHED: Sotheby's sale cat., 13 December 1982, 64–65, no. 221; *Wealth of the Ancient World* (Fort Worth 1983) 66–67, no. 9; N. B. Reed, "The *Euandria* Competition at the Panathenaia Reconsidered," *Ancient World* 15 (1987) 61, 64, figs. 5–6; M. Tiverios, "Panathenaike Eikonographia," *Thrakike Epethrida* 7 (1987–90) 288–91, 295, fig. 3; Sotheby's sale cat., 19 June 1990, no. 9.

Panathenaics with the hoplitodromos are: Akr. 921 (*ABV* 300, 16); Milan market (Brandt no. 47); Compiègne 986 (Brandt no. 65); London B 143; Bologna PU 198; Naples 81293. On the hoplitodromos, see J. D. Beazley, "A Hoplitodromos Cup," *BSA* 46 (1951) 7–15, pls. 5–7.

47 Red-Figure Skyphos with Acrobat and Aulete

Obverse: **Acrobat with two shields** (see illus. p. 96)
Reverse: **Aulete at potter's wheel**

While the Kleophrades Painter's two shields are part of the preparations for the hoplite race (cat. 46), there apparently were performances involving two shields in ancient Athens, as exemplified by this vase and others. In all examples the helmeted shield-bearer uses an inclined plank propped up by a post during his performance. The plank, presumably, was a spring board: the Noble skyphos shows him on the board preparing to execute a backwards flip. A black-figure cup in Würzburg (428) shows the acrobat upside-down and in mid-air, and on a pseudo-Panathenaic in Paris (Cab. Méd. 243; see fig. 23), he appears to have landed upright on a horse. A black-figure lekythos in Bonn (inv. 340) shows a hoplite with spear and shield running towards such a contraption, under which rests a helmet. An acrobat is shown upside-down with his feet planted on the upper border of the frieze on a band-cup in Boston (67.861), as also in a lost Etruscan tomb painting from Chiusi (Tomba di Poggio al Moro), where, however, the jumper is not armed.

That this acrobatic performance was accompanied by music is indicated by the tomb painting as well as the vases in Paris and Bonn. The Noble skyphos also includes an aulete, albeit on the other side. Holding a pipe in each hand, he has the typical accoutrements of a double-pipes player: a *phorbeia* (a sort of leather halter with two holes into which the two mouthpieces were inserted) strapped to his head, and a short tunic over his long, sleeveless chiton. His leopard-skin flute case hangs behind. More enigmatic is the potter's wheel in front. It, like the springboard and possibly the rock behind the acrobat, might be another prop in his performance, since the two sides of the vase are related.

We have no indication that acrobatics were part of the Panathenaia, other than the vase in the Cabinet des Médailles which is pseudo-Panathenaic and which, like many of its genre, might allude to the festival. Beazley refers to this scene as a "sideshow," rather than one of the official events of the games. However, it seems ironic that this sideshow should be the only event accorded a grandstand full of spectators, one of whom shouts "bravo" to the jumper.

Unattributed
ca. 470
H. 11.4 cm. (4 7/16 in.) Diam. 21.1 cm. (8¼ in.)
Tampa Museum of Art
Joseph Veach Noble Collection
86.93

PUBLISHED: D. von Bothmer, *Ancient Art from New York Private Collections* (New York 1959) 63–64, no. 248, pls. 82, 90; D. Paquette, *L'Instrument de musique dans la céramique de la Gréce antique* (Paris 1984) 56–57, no. A51; Tampa Museum of Art, *The Joseph Veach Noble Collection* (Tampa 1985) 47 no. 87.

On acrobats with two shields, see J. D. Beazley, "Two Swords: Two Shields," *BABesch* 14 (1939) 4–14, fig. 8 (Würzburg 428). For the Bonn lekythos, see *AA* (1935) 466–67, no. 34, 472–73, figs. 48, 50. For the Boston cup, see CVA Boston 2 (19) pl. 106, 2–3. For the Tomba di Poggio al Moro, see J. Jüthner, *Die athletischen Leibesübungen der Griechen* 1 (Vienna 1965) pl. 19. For performers on the potter's wheel: Paestan skyphos, Oxford 1945.54 (M. Vickers, *Greek Vases* [Oxford 1978] no. 73); Paestan oinochoe, Luzern market (see Galerie Fischer, 21 May 1941, 7 and pl. 6, no. 68); Attic red-figure chous, London E 387 (ARV^2 1134, 10). The acrobat's shield device is a dog relieving itself; dogs, similarly posed, can be seen under the handles of the Amasis Painter's kylix in Boston (10.651).

49

48 Black-Figure Pelike with Pyrrhic Dancers

Obverse: **Pyrrhic dancer and aulete** (see illus. p. 56)
Reverse: **Pyrrhic dancer and aulete with goat**
(see illus. p. 95)

The pyrrhic dance was a contest held at both the Lesser and the Greater Panathenaia. It was limited to Athenian citizens who represented their particular *phyle* or tribe. Like theatrical competitions at the festival of Dionysos, the *pyrrhike* was financed by a *choregos* or sponsor who helped defray the expenses. The orator Lysias (21.4–5) has recorded the costs of such sponsorship: 800 drachmas for the Greater Panathenaia of 410/409, and seven minae for boy pyrrhicists at the Lesser Panathenaia of 404/403.

Since the prize was a bull and 100 drachmas, the event is not depicted on Panathenaic amphoras. It was, however, a popular subject on other vases and is easily identifiable, since the hoplite is always accompanied by a musician. Here the pyrrhicists are practising at the gymnasium, indicated by the stools holding their cloaks, and their short chitons (contestants are shown nude). Each is equipped with a plumed helmet, shield, spear, and greaves. They are shown in two different poses, presumably different positions prescribed by the contest.

Attributed to the Theseus Painter [Beazley]
ca. 500
H. 33.4 cm. (13 ⅛ in.) Diam. 25.9 cm. (10 ¼ in.)
San Antonio Museum of Art
Gift of Mr. Gilbert M. Denman, Jr.
86.134.157

PUBLISHED: *Paralipomena* 257; Sotheby's sale cat., 11 April 1960, no. 156; Sotheby's sale cat., 8–9 February 1985, no. 66.

On the pyrrhic dance, see J.-C. Poursat, "Les répresentations de danse armée dans la céramique attique," *BCH* 92 (1968) 550–615.

49 Red-Figure Pelike with Torch Race

Obverse: **Two torch racers** (see illus. p. 96)
Reverse: **Draped youth holding aryballos and strigilus**

"In the Academy is an altar to Prometheus, and from it they run to the city carrying burning torches. The contest is while running to keep the torch still alight; if the torch of the first runner goes out, he has no longer any claim to victory, but the second runner has. If his torch also goes out, then the third man is victor. If all the torches go out, no one wins." Thus Pausanias (I.30.2) describes how fire was transferred from the altar in the grove of Akademos, site of Plato's Academy, outside the city's walls to the altar of Athena on the Akropolis, a distance of over two miles.

The torch race (*lampadedromia* or *lampadephoros*) was part of a number of Attic festivals besides the Panathenaia. There were also torch races at the Hephaisteia in honor of the smith-god Hephaistos who used fire at his forge, the Prometheia in honor of Prometheus who stole fire from heaven, and after 490, a festival in honor of Pan who had come to the aid of the Athenians at the battle of Marathon (Herodotus 6.105). We learn from the opening of Plato's *Republic* (1.328a) that a torch race on horseback was held at the Peiraeus in honor of the Thracian goddess Bendis.

While the race on this vase is clearly not in honor of Bendis, it is not possible to identify it precisely. That it is a relay race is indicated by the fact that a hand-off is about to take place. The runner in front reaches back with his right hand to receive the torch from the youth behind him. The prominent hand-shield is characteristic of the torch race, as depicted on a number of vase-paintings.

Attributed to the Painter of Louvre G 539 [Bothmer]
ca. 420–400
H. 20.3 cm. (8 in.) Diam. 16.5 cm. (6 ½ in.)
World Heritage Museum, University of Illinois,
Urbana-Champaign
77.1.1684
Ex-coll. Avery Brundage

PUBLISHED: *CVA* 1 (24) 18–19, pl. 24, 1–2.

On torch races, see G. A. Giglioli, "La corsa della fiaccola ad Atene," *Rendiconti dell'Accademia dei Lincei* 31 (1922) 315–35; Kyle 190–93. For another pelike with a torch race by this painter, see *Griechische Vasen aus westfälischen Sammlungen* (Münster 1984) 98, no. 31. For a similar pelike, see *Mind and Body* 205–206, no. 97.

50 Red-Figure Bell-Krater with Torch Race

Obverse: **Two torch-racers and priest at altar**
Reverse: **Three draped youths**

This torch race can be definitively identified as that held at the Panathenaia. Here two torch-racers approach an as yet unlit altar before which rests a bronze hydria or kalpis. We know from the fourth-century inscription (see p. 16) that the prize for the winning torch-bearer was a hydria and thirty drachmas, while the tribe received a bull and 100 drachmas. These two runners are differentiated by their headgear; one wears a spiked crown, the other a band with an upright tang bearing the picture of a runner. These perhaps align them with specific Athenian tribes. At the altar stands the *archon basileus* recognizable by his priestly garb, an *ependytes* or decorated sleeveless garment worn over a long chiton. At the far right is a tree, undoubtedly the sacred olive tree next to the Temple of Athena Polias on the Akropolis.

The reverse features three youths in conversation. They are draped in their himations, and one holds a staff, another a strigil.

Attributed to the Manner of the Peleus Painter [Beazley]
ca. 430–420
H. 36.1 cm. (14 ¼ in.) W. 39.6 cm. (15 ⅝ in.)
Arthur M. Sackler Museum, Harvard University Art Museums, Cambridge
Bequest of David M. Robinson
1960.344
Provenance: Gela
Ex-coll. Hirsch, Geneva

PUBLISHED: *ARV²* 1041, 10; *CVA* Robinson 2 (6) pl. 48, 1 and pl. 47, 2; *Archaeologia classica* 3 (1951) pl. 36, 2; *JHS* 57 (1937) 267; Fogg Art Museum, *The David Moore Robinson Bequest of Classical Art and Antiquities* (Cambridge 1961) 18, no. 103; A. Greifenhagen, *Ein Satyrspiel des Aischylos?*, 118 Winckelmannsprogram (Berlin 1963) 16–17, pl. 12, 14–15, n. 50; E. Simon, "Ein nordattischer Pan," *AntK* 19 (1976) pl. 5, 6; Simon, pl. 22, 2; *The World of Athens* (Cambridge 1984) 120, fig. 2.20; M. I. Finley and H. W. Pleket, *The Olympic Games* (New York 1976) pl. 1b; M. C. Miller, "The *Ependytes* in Classical Athens," *Hesperia* 58 (1989) pl. 54a.

On the hydria, see E. Diehl, *Die Hydria* (Mainz 1964) 195. For another vase depicting a hydria at the altar and a torch race, see G. van Hoorn, *Choes and Anthesteria* (Leiden 1951) fig. 118. On late Classical representations of the torch race, see P. E. Corbett, "Attic Pottery of the Later Fifth Century," *Hesperia* 18 (1949) 346–51. A miniature Panathenaic in New York (41.162.52) shows a victorious torch-racer seated on a hydria; see *CVA* New York 2 (12) pl. 48, 3–4. Two dilute lines suggest the presence of an animal's tail on the altar; for other examples, see F. van Straten, "The God's Portion in Greek Sacrificial Representations: Is the Tail Doing Nicely?" *Early Greek Cult Practice*, *ActaAth* 38 (Stockholm 1988) 51–68.

Procession and Sacrifice

51 Red-Figure Pelike with Rider and Torch-Bearer

Obverse: **Knight on horseback** (see illus. p. 27)
Reverse: **Woman with torch**

The draped woman holding a torch on this pelike is clearly not a racer, but may be a reveler at the *pannychis*, the nocturnal festival which took place on the night before the Panathenaic procession. This identification is suggested by the young horseman on the other side who closely resembles the bareback riders of the Parthenon frieze. Perhaps the two images taken together indicate the early morning of the 28th of Hekatombaion when the pannychis has ended and the procession to the Akropolis is about to begin. The Athenian army's cavalry corps, consisting of rich young aristocrats, played a prominent role in the contests and procession of the Panathenaia, as well as other religious festivals.

This handsome Athenian knight looks remarkably like the rider (figure no. 48) who overlaps slabs XIX and XX on the south side of the Parthenon frieze. They both wear a chlamys pinned on the right shoulder and hold their clenched right hands at waist level. Even the pose of the horse, rearing to the right, is similar. The head of the sculpted rider is missing, but he may have worn a broad-brimmed sun hat or *petasos* as the Tampa rider does.

The painter of this vase was a member of the Achilles Painter's workshop, and the two collaborated on at least one vase. Its potter produced a series of pelikai for the Achilles Painter and many of his numerous followers. One by the Achilles Painter, currently on loan to the Ashmolean, shows a very similar composition, although the knight's petasos is slung over his back.

The red streak on the front of this vase was no doubt caused by a draft in the kiln during firing.

Attributed to the Westreenen Painter
ca. 430
H. 24.7 cm. (9 ¾ in.) Diam. 16.7 cm. (6 ⅝ in.)
Tampa Museum of Art, Tampa
Joseph Veach Noble Collection
86.64
Provenance: Italy

PUBLISHED: *ARV*² 1006, 2; *Paralipomena* 439; *Addenda* 439; D. von Bothmer, *Ancient Art from New York Private Collections* (New York, 1961) 58, pl. 92, no. 228; J. V. Noble, *The Techniques of Painted Attic Pottery* (New York 1965) 79, fig. 242; Tampa Museum of Art, *The Joseph Veach Noble Collection* (Tampa 1985) 44, no. 59.

On the Class of the Achilles Painter's Pelikai, see *ARV*² 1676; J. H. Oakley, *The Phiale Painter* (Mainz 1990) 49. For the pelike in Oxford, see *JHS* 111 (1991) pl. 1a.

52 Red-Figure Oinochoe with Procession to Sacrifice

Two draped youths leading a bull

Another vase which has close parallels to the Parthenon frieze is this wine jug or *chous*. It shows two youths leading a bull to sacrifice, as indicated by the *stemma* or garland draped over its horns. These two cattle-drivers, draped in their himations and posed one on either side of the animal, match those on the south (XXXVIII–XLIV) and north (I–III) slabs of the Parthenon frieze. In particular one might cite figures 117 and 118 on south slab XLI, where the sacrificial beast is especially docile. The only significant difference lies in the gender of the animal, and vase-painters were not always accurate in this regard.

The striking similarity of scenes depicted on this vase and the previous one (cat. 51) to those on the Parthenon frieze raises the question of how visible the low-relief sculpture would have been to vase-painters who wished to adapt its composition to vases. Situated nearly forty-feet up inside a roofed colonnade, the frieze would have been practically invisible, even with paint and reflected light giving added definition. Since the frieze was almost certainly executed *in situ*, the carved blocks would never have been viewed at close range. Hence, we must assume that there were preliminary drawings used by the large corps of sculptors assigned to the frieze which were also available to vase-painters.

Attributed to the Dinos Painter [Robinson]
ca. 420
H. 23.5 cm. (9 ⅛ in.) Diam. 18.5 cm. (7 ¼ in.)
Arthur M. Sackler Museum, Harvard University Art Museums, Cambridge
Bequest of David M. Robinson
1959.129
Provenance: Vari

PUBLISHED: D. M. Robinson, "A Red-Figured Vase Influenced by the Parthenon Frieze," *AJA* 38 (1934) 45–48, fig. 1, pl. 5; *CVA* Robinson 3 (7) pl. 9; Fogg Art Museum, *Ancient Art in American Private Collections* (Cambridge 1954) 36, no. 290.

For the viewing of the Parthenon frieze, see R. G. Osborne, "The Viewing and Obscuring of the Parthenon Frieze," *JHS* 107 (1987) 98–105.

53 Black-Figure Skyphos with Religious Procession

Obverse: **Men carrying amphora and youth leading bull** (see illus. p. 40)
Reverse: **Three males, one dragging boar and two with baskets**

A more elaborate procession to sacrifice, involving six men and two animals, is depicted on this skyphos by the Theseus Painter. A late black-figure painter who specialized in small vases such as lekythoi and skyphoi, the Theseus Painter's style is recognizable by the vines in the background and the white herons placed under the handles. He seems to have had a special interest in religious processions, which often cover two sides of the same vase, as here.

The procession is led by a youth and a man, both nude, who share the burden of an amphora, lashed by the handles to a long stick resting on their shoulders. The amphora is, presumably, full, since we know from another vase-painting (Agora P 1275) that one person could carry empties two at a time. Whether it is filled with olive oil as a prize or wine for libations is not entirely clear. In scenes of revelry the Theseus Painter will show a youth shouldering a (surely wine-filled) amphora in the same manner as the basket-carriers on the other side of this vase. The special means of carrying a full amphora, lashed to a stick, which is depicted on other vase shapes including an oil flask, indicates that it is heavier and so may contain oil, rather than wine. If that is the case, then one can conclude that the procession is part of the Greater Panathenaia.

Behind the amphora-carriers depicted on this vase is a youth leading a bull to sacrifice. He is followed on the other side by three men: the first carries a block-like object, the second drags a boar by the hind legs, and the third carries a basket (*skaphos*) of cakes. Since the man in the center holds a long knife, we can conclude that the boar will soon be sacrificed as well. A very similar vase by this artist in Stuttgart (KAS 74) shows the same number of participants and the same sacrificial beasts, but replaces the second basket-bearer with a flute-player.

An ancient repair is visible on the obverse.

Attributed to the Theseus Painter [Bothmer]
ca. 490
H. 16.5 cm. (6 ½ in.)
Tampa Museum of Art, Tampa
Joseph Veach Noble Collection
86.52

PUBLISHED: *ABV* 704, 27ter; *Paralipomena* 256; *Addenda* 129; D. von Bothmer, *Ancient Art from New York Private Collections* (New York 1961) 56, pl. 76, no. 221; Tampa Museum of Art, *The Joseph Veach Noble Collection* (Tampa 1985) 25, no. 44.

For similar amphora transport, see Boardman, *ARFV* I, fig. 215 (Richmond 62.1.5), and *Griechische Vasen aus westfälischen Sammlungen* (Münster 1984) 42 and 44, no. 2. For the skyphos in Stuttgart, see *CVA* Stuttgart 1, pl. 19.

54 Red-Figure Column-Krater with Sacrifice

Obverse: **Youth with kanoun at altar** (see illus. p. 25)
Reverse: **Youth with spits**

Scenes of sacrifice are rare in Greek art, and scenes of the actual killing of the sacrificial beast even rarer. Rather, the Greeks preferred to depict the moment before, when the animals are led to the altar (cats. 52 and 53), or the moment after, when the flesh is being roasted, as here. Perhaps there was a religious prohibition against depiction of the slaughter.

On this krater the setting is the sanctuary. All the essential elements of an outdoor shrine are present: the block-like altar festooned with a garland; a *pinax*, or votive plaque, hanging above; and a three-legged table with claw feet holding the sacrificial meat. The servant, who wears his cloak wrapped around his waist (see cat. 46), stands to the right of the altar and reaches for barley corn to sprinkle on the altar from a tray-like basket, known as a *kanoun*, cradled in his left arm. The scene is completed by the figure on the other side of the vase. He is the *splanchnopt*, the servant who will roast the *splanchna*, or inner organs, part of which were given to the gods and the rest consumed on the spot by the sacrificers. He holds one spit, already laced with meat, horizontally in his right hand, and a second, empty spit vertically in his left. Shared sacrifice, in which both the god and his or her devotees took part, was said to bring about a kind of communion between the divine and the human.

Follower of the Pan Painter [Cahn]
ca. 460
H. 30 cm. (11 ¾ in.) Diam. 28 cm. (11 in.)
Duke University Museum of Art, Durham
Duke Classical Collection
72.1

PUBLISHED: Münzen und Medaillen, *Attische rotfigurige Vasen, Sonderliste N* (Basel 1971) 10–11, no. 8; H. A. Shapiro, *Art, Myth, and Culture: Greek Vases from Southern Collections* (New Orleans 1981) 102–103, no. 39 (J. Neils).

On the roasting of meat, see G. Rizza, "Una nuova pelike a figure rosse e lo 'splanchnoptes' di Styppax," *Annuario della Scuola Archeologica di Atene* 37–38 (1959–60) 321–45. On the kanoun, see J. Schelp, *Das Kanoun, Der griechische Opferkorb* (Würzburg 1975).

The Athena Parthenos

55 White-Ground Lekythos with Hieropoioi

Panathenaic Athena flanked by cocks and two officials
(see illus. p. 18)

The appearance of the Panathenaic Athena with a pair of cocks is highly unusual on a lekythos. This vase is also unique in depicting the officials of the Panathenaic festival, the *hieropoioi*; this is the only instance in Greek art in which they are labeled. They are shown with red fillets and branches (olive?) tied around their heads and holding forked sticks, which are more often seen in the hands of athletic trainers. The one in front of Athena raises his left hand, as if addressing the goddess, while his partner holds forth a branch. The cocks are poised on the ground at her feet, and a snake decorates her shield.

These *hieropoioi* ("doers of sacred things") seem to have been in charge of the Panathenaia before it was turned over to the *athlothetai* in the mid-fifth century (see p. 17). If three early sixth-century inscriptions from the Akropolis have been properly restored, we know that the hieropoioi were a board of eight who were in charge of the sacred ceremonies and the contests.

>Attributed to the Athena Painter [Beazley]
>ca. 500–480
>H. 29.7 cm. (11 ¾ in.) Diam. 10.5 cm. (4 ⅛ in.)
>Albright-Knox Art Gallery, Buffalo
>Charles W. Goodyear Fund, 1933
>33.135
>Provenance: Gela
>Ex-coll. Jacob Hirsch, New York

PUBLISHED: *ABV* 522, 34 (with bibl.); M. Bieber, "Two Attic Black-figured Lekythoi in Buffalo," *AJA* 48 (1944) 121–29, fig. 2a-b; S. A. Nash, *Painting and Sculpture from Antiquity to 1942* (Buffalo 1979) 60–61.

On the Akropolis inscriptions, see Raubitschek, nos. 326–38.
On the Athena Painter, see also cat. 7.

56 Miniature Replica of the Athena Parthenos
(see illus. p. 133)

We are fortunate in having extant many small-scale replicas of the colossal chryselephantine statue of Athena fabricated by Pheidias for the Parthenon, and this is surely the smallest. Broken off at the arms and waist, it nonetheless preserves some of the most distinctive features of the famous statue: the goddess' elaborate triple-crested helmet, long locks of curly hair falling over her shoulders, sailor-collar aegis with gorgoneion, and classically calm, majestic visage. Given the small size of this copy, some elements are simplified, such as the belt which is usually shown tied in front with a snaky knot.

>ca. A.D. 150, after the Athena Parthenos (447–438)
>Marble (Pentelic?)
>H. 11.8 cm. (4 ⅝ in.) W. 6 cm. (2 ⅜ in.)
>The Art Museum, Princeton University
>Gift of William F. Magie, 1923
>y18
>Provenance: Athens

PUBLISHED: T. L. Shear, "A Marble Copy of Athena Parthenos in Princeton," *AJA* 28 (1924) 117–19, pls. 2–4; G.M.A. Richter, *The Sculpture and Sculptors of the Greeks*, 4th ed. (New Haven 1970) 170, fig. 643; N. Leipen, *Athena Parthenos. A Reconstruction* (Toronto 1971) 4, no. 5, fig. 6; *Selections from the Art Museum, Princeton University* (Princeton 1986) 27; P. Karanastassis, "Untersuchungen zur kaiserzeitlichen Plastik in Griechenland. II: Kopien, Varienten und Umbildungen nach Athena-Typen des 5.Jhrs.v.Chr.," *AM* 102 (1987) 406–407, no. B19, pl. 40,3.

57 Stater of Aphrodisias

Obverse: **Seated Aphrodite**
Reverse: **Athena Parthenos** (see illus. p. 132)

A particularly fine representation of the Athena Parthenos is preserved on the silver coinage of Aphrodisias in Cilicia. Its details such as the triple-crested helmet, the snakes rearing from her shoulders, and the Nike in the palm of her hand are extremely clear. Her right hand is supported by a tree trunk, rather than the column often seen in sculptural reproductions. The tree is bare except for one leafy branch, which might well represent the "fresh shoot, as much as a cubit in length" which had sprung from the stump of Athena's olive tree on the Akropolis in 480, the day after it was burned by the Persians (Herodotus 8.55). This coin, issued approximately 100 years later, may commemorate that miraculous event.

The depiction of Aphrodite on the obverse clearly refers to the name of the city, Aphrodisias. She is seated on a throne flanked by sphinxes, and holds a large flower to her nose. Her tight-fitting diaphanous gown contrasts with the weighty peplos of Athena on the other side.

> Asia Minor, ca. 375
> Silver
> Diam. 2.4 cm. (1 in.) Wt. 9.98 g. (.35 oz.)
> The American Numismatic Society, New York
> 1967.1524.86

On the coinage of Aphrodisias, see C. M. Kraay, *Archaic and Classical Greek Coins* (Berkeley 1976) 280, 283, pl. 58, no. 1015. On numismatic reproductions of the Parthenos, see L. Lacroix, *Des Reproductions de statues sur les monnaies grecques. La Statuaire archaïque et classique*, Bibliothèque de la Faculté de Philosophie et Lettres de l'Université de Liège, fasc. 116 (1949).

58 Medallion with Head of Athena

(see illus. p. 133)

The attention which the sculptor Pheidias lavished on the face and helmet of the Athena Parthenos can be seen particularly well on clay and metal medallions which feature her head. The most famous are the two gold medallions found in 1830 in a mid-fourth century tomb in the Koul-Oba tumulus near Kerch in Southern Russia. Clearly in a cheaper medium but no less detailed is this terracotta roundel which was originally gilded in imitation of the metal examples (although the face had only a white slip suggesting the ivory of Pheidias' original). Although smaller, it resembles the Koul-Oba medallions in its three-quarter view, the full and heavy face, the animal *protomai* protruding above the browband of the helmet, and the owl perched on the edge of the upturned right cheekpiece. This last element was not part of the original statue, but was no doubt added as a space-filler in the tondo design. The goddess' jewelry is also very much in evidence: disc-and-pendant earrings, and a triple necklace consisting of two rows of round beads above a row of bud-like pendants. In addition, below each ear is a winged figure holding a fillet, perhaps an allusion to the Nike in the Parthenos' right hand. Raised dots are a favorite motif here, with rows of them bordering the medallion, the crests of the helmet and the cheekpieces, and a singleton for the pupil of each eye.

> Late 5th or early 4th century
> Terracotta with gilding
> Diam. 4.2 cm. (1 ⅝ in.) Th. .5 cm. (⅛ in.)
> On loan from the Royal Ontario Museum, Toronto
> Gift of Frank H. Crane
> 962.263

PUBLISHED: N. Leipen, *Athena Parthenos. A Reconstruction* (Toronto 1971) 13, no. 58, fig. 55.

For the Koul-Oba medallions, see Leipen 10–11, no. 38, fig. 42.

59 Head of Athena—Medici Type

(see illus. p. 141)

This majestic head of Athena is a Roman copy of a fifth-century type known as the Medici Athena, after a statue in the Louvre (3070). The two distinctive characteristics of this type are its drapery and the akrolithic technique. The Athena Medici wears a belted peplos over a crinkly chiton, clearly visible on her advanced right leg which emerges completely from the opening in the peplos, and a mantle bunched over her left shoulder and back. In its rich elaboration of the drapery folds, the style of this work is particularly close to the pediments of the Parthenon. A number of full-size replicas of this type indicate that it was akrolithic, i.e. white marble for the flesh and chiton parts, and gilded wood for the rest. This marble head indicates the use of other materials, in this case inlaid eyes framed by bronze eyelashes (now lost). The series of small dowel holes above the headband indicate that the helmet may have been of bronze as well. That the cheekpieces of this helmet were also doweled into place is indicated by the larger hole above each ear.

Most scholars have associated this Athena type with Pheidias, and recently it has been argued on iconographic grounds that she may in fact be his famous Athena Lemnia, dedicated on the Akropolis by the Athenians who colonized the island of Lemnos between 451 and 447 (Pausanias 1.28.2). With her shield cushioned by the drapery on her left shoulder, and with a phiale in her right hand, she resembles a departing warrior, and so would be an appropriate image for those moving to a new homeland. The Greek rhetorician Lucian (*Imagines* 4 and 6), writing at the time this copy was made, admired the Lemnia Athena for the contour of her face, the softness of her cheeks, and the fine proportions of her nose, all of which are evident in the Oberlin head.

> Roman (Antonine) copy after a 5th-century Greek original
> White marble (Anatolian)
> H. 28.9 cm. (11 ⅜ in.) W. 18.4 cm. (7 ¼ in.) D. 21.9 cm. (8 ⅝ in.)
> Allen Memorial Art Museum, Oberlin College
> Gift of Edward Capps, Sr., 1939
> 39.139
> Provenance: Thessaloniki

PUBLISHED: E. Capps, Jr., "A Marble Head of Athena from Salonika," *Allen Memorial Art Museum Bulletin* 10 (1952) 76–89, figs. 1–8; G. Despinis, *Akrolitha* (*Deltion* suppl. 21, 1975) 46, n. 51; P. Karanastassis," Untersuchungen zur kaiserzeitlichen Plastik in Griechenland. II: Kopien, Varienten und Umbildungen nach Athena-Typen des 5.Jhrs.v.Chr.," *AM* 102 (1987) 415, BII6, pl. 46, 1–3.

For the Medici Athena type, see A. Linfert, "Athenen des Phidias," *AM* 97 (1982) 76–77; *LIMC* II, Athena 172, Minerva 144. For the suggestion that it represents the Athena Lemnia, see E. B. Harrison, "Lemnia and Lemnos: Sidelights on a Pheidian Athena," *KANON, Festschrift Ernst Berger, AntK* Beiheft (Basel 1988) 101–107. For further discussion of the Lemnia, see Ridgway, *supra* pp. 140–42.

60 Statue of Athena—Ince Type

(see illus. p. 140)

As one of the most famous statues of the ancient world, the Athena Parthenos was frequently copied and adapted by later generations of sculptors. The Ince Hall type is a case in point. She is posed like the Parthenos, with her left leg bent and set to the side. The overfall of the peplos is belted, creating deep overhanging pouches at her sides, and the zig-zag folds created by the open edge of the peplos can be seen along her right leg. One major difference, visible on this replica, is the aegis which has snakes along the lower edge, and has shrunk to a mere collar encircling the neck. We also know from better preserved copies that the Ince Athena was one of many that wore a Corinthian helmet pushed back on her head, unlike the Parthenos which wore an Attic helmet (cat. 56). As for her other attributes, we surmise that there was a spear in her lowered left hand, but it is still uncertain at what she was gazing in her outstretched right hand. It may have been an owl (see cats. 8 and 61).

The right shoulder is a modern restoration.

Roman copy after late 5th-century Greek original
Marble (Pentelic?)
H. 131 cm. (51 ½ in.) W. 44.5 cm. (17 ½ in.) D. 30.5 cm. (12 in.)
Santa Barbara Museum of Art
Gift of Wright S. Ludington
1978.4.3

PUBLISHED: M. A. del Chiaro, "Greek and Roman Sculpture in Santa Barbara," *The Classical Journal* 60 (1964) 115–16, S.4, fig. 5; idem, *Classical Art: Sculpture* (Santa Barbara n.d.) 21–23, no. 4.

On the Ince Hall Athena, see B. Ashmole, *A Catalogue of the Ancient Marbles at Ince Blundell Hall* (Oxford 1929) 6–7, no. 8, pls. 10–11; G. Waywell, "Athena Mattei," *BSA* 66 (1971) 376–77, 381; *LIMC* II, Minerva 145.

61 Lanckoronski Relief

(see illus. p. 118)

Although once considered a Greek original, the Lanckoronski relief is certainly an eclectic adaptation of early fifth-century prototypes produced in Roman times. It depicts a standing Athena facing left and letting her owl fly from her outstretched right hand (see cat. 8). She wears a Corinthian helmet and a heavy peplos whose inconsistent folds are a telltale sign that this is "severizing" rather than truly Early Classical in date. Her shield carries a large gorgoneion and her right forearm rests on the head of a herm. The hairstyle of the herm is Early Classical, rolled up like that of the Kritios Boy, rather than the more common archaistic snail-curl variety found on other herms. It has been suggested that it represents the Hermes Propylaios seen by Pausanias (I.22.8) at the entrance to the Akropolis. This interpretation might help account for the unusual pose of the goddess, facing left; she and the herm would then both be looking out from the entrance to the Akropolis.

The herm, which is not otherwise found in association with Athena, might also be explained as a reference to the god Hermes. They are frequently shown together in sixth- and early fifth-century Attic vase-painting, either providing guidance to heroes or simply standing together in what appears to be a non-narrative context (see cat. 15). Both are divinities of great intelligence, and, as one scholar has put it, gods of "nearness," ever present to guide mortals and heroes.

Neo-Attic, 1st century
Marble
H. 74 cm. (29 ½ in.) W. 48 cm. (19 in.) D. 8 cm. (3 ⅛ in.)
Virginia Museum of Fine Arts, Richmond
The Williams Fund, 1960
60.5
Ex-coll. Count Antoine Lanckoronski, Vienna

PUBLISHED: *Ancient Art in the Virginia Museum* (Richmond 1963) 122, no. 138 (with bibl.); E. B. Harrison, *Archaic and Archaistic Sculpture*, Agora 11 (Princeton 1965) 135, pl. 65 c-d; B. S. Ridgway, *The Severe Style in Greek Sculpture* (Princeton 1970) 110–11, pl. 143; *LIMC* II, 976 Athena 207.

On Neo-attic reliefs, see W. Fuchs, *Die Vorbilder der neuattischen Reliefs, JdI Erganzungsheft 20* (Berlin 1959). On herms, see *LIMC* V, 295–306.

62 Statuette of Athena

This Athena seems to be gliding rather than running, enveloped in her widely billowing garment, as she moves down and forward. At first impression she seems a swiftly moving mass of drapery which swirls dramatically in sharp, broken folds. The sphinx on her helmet (see cat. 8) betrays her derivation from the Athena Parthenos, but her more immediate typological ancestry is rooted in Pergamene baroque. The Athena fighting a giant on the east side of the great Altar of Pergamon seems a likely source of inspiration in pose, garb, and overall dramatic breathlessness. Upon closer examination, however, there is a significant difference in body mass; the bronze Athena has no true corporeality, and in fact she has no feet, but tangs instead. Her garment is thus a facade, and in its artificiality expresses the same Hellenistic eclecticism that is a hallmark of Archaism. Here, too, one might note the somewhat precious disorder of the aegis, the placement of the gorgoneion over the right arm, and the ornamental border of the snakes' heads.

Athena's calm, unmoved face over the melee of folds confirms her temporal distance from the great altar's sculpture, and places her firmly in the late second or first centuries, possibly even later. Although this Athena derives from the Hellenistic baroque style of the early second century, her creator, perhaps located in southwestern Anatolia, combined a selection of different stylistic features. The combination of baroque and classicism, transforms the Athena Parthenos (see cat. 56) into a figure that speaks to its own time, while still relying on a type whose religious and political substance once spoke powerfully to fifth-century Athenians. The Berry Athena heralds the eclecticism which will become so popular in the bronze workshops of the emerging Roman empire.

Missing are the shield, once strapped to the left arm, and the spear held horizontally in the right hand. It is still uncertain whether a bronze shield and snake allegedly found with the statuette actually belong to it.

<div style="text-align: right;">Wolf Rudolph</div>

Asia Minor, late 2nd or 1st century
Bronze, hollow cast
H. 15.6 cm. (6 in.) W. 8 cm. (3 1/8 in.) D. 6 cm. (2 3/8 in.)
Indiana University Art Museum, Bloomington
Burton Y. Berry Collection
62.117.116
Provenance: Alleged to be from Anatolia (Mersin)

PUBLISHED: W. Rudolph, *Highlights of the Burton Y. Berry Collection* (Bloomington, Ind. 1979) 28–29.

On the Pergamon Altar, see J. J. Pollitt, *Art in the Hellenistic Age* (Cambridge 1986) 98, fig. 100. The theatrical pose recalls the Nike of Samothrace; see Pollitt, 115, fig. 117. For a similar face, see the mounted Amazon on the frieze of the Temple of Artemis at Magnesia; A. Davesne, *La Frise du Temple d'Artemis à Magnesie du Meandre. Catalogue du fragments du Louvre* (1982) 84, fig. 57, no. 21. For round, heavy chins as characteristic of Archaistic art, see Pollitt, 184, figs. 193–94.

The Panathenaic Shape

63 Black-Bodied Amphora of Panathenaic Shape

(see illus. p. 38)

Even without its traditional decoration, the Panathenaic-shaped amphora is immediately recognizable. With its narrow neck, thick rounded handles, bulging body, echinus-shaped mouth and foot, it is a distinctive form. The subsidiary decoration is precisely what one would find on prize amphoras: double lotus-and-palmette chain on the neck, tongues on the shoulder, and rays at the base. The vase even has the moulded ring, highlighted with red, encircling the neck just below the handle roots.

Only a few other black-bodied Panathenaics are known, although black-bodied neck-amphoras were common. An early sixth-century example in Athens (N.M. 16198) is similar in shape to the Burgon amphora (figs. 19 and 59) and has a simple lotus-and-palmette cross on the neck. Similar in size to prize vases, it served as the burial urn of a child. The later Cleveland example and its twins in Oslo and Ferrara are smaller, and were probably used as oil containers. The Ferrara vase, found in Tomb 485 at Spina, was accompanied by its lid, decorated with concentric circles around a pomegranate-shaped knob. There is a single belly-amphora with a black body and more elaborate neck decoration in Oxford.

ca. 525–500
H. 41 cm. (16 in.) Diam. 26 cm. (10 ¼ in.)
The Cleveland Museum of Art
Gift of J. H. Wade
23.644

PUBLISHED: *Cleveland Museum of Art Bulletin* 10 (1923) 180 and 191; *CVA* Cleveland 1 (15) pl. 9, 3; G. F. Pinney and B. S. Ridgway, *Aspects of Ancient Greece* (Allentown 1979) 46–47, no. 20.

For Athens N. M. 16198, see *AJA* 42 (1938) 503, fig. 9. For Oslo University Mus. 36281, see *CVA* Norway 1, pl. 12, 1. For the Ferrara vase, see S. Aurigemma, *La necropoli di Spina in Valle Trebbe* 1.2 (Rome 1965) 138–39, pl. 167. For the vase in Oxford (1927.2115), see *CVA* Oxford 2, pl. 4,4. For fourth-century black amphoras of Panathenaic shape, see *AM* 79 (1964) 40–41 and 72.

64/65 Miniature Panathenaic Amphoras

(see illus. pp. 44–45)

Obverse: **Panathenaic Athena**
Reverse: **Athlete**

Toward the end of the fifth century, a miniature version of the prize Panathenaic was created. A scholar suggested as long ago as 1876 that it served as a perfume container for the scented oil which Pliny the Elder said was called *panathenaikon* (*Natural History* 13,6). Over forty of these are preserved, ranging in height from seven to ten centimeters. As can be seen from these two examples, they mimic the prize vase with the Panathenaic Athena on one side, striding to the left, and an athlete on the other. Given the vases' small size, the cock columns are usually omitted and the reverse shows only a single athlete. The one most frequently depicted is the torch-racer; second in popularity is a seated athlete (cat. 64), either holding or wearing a white fillet — presumably the victor. The *hoplitodromos* of cat. 65 is thus far unique, as is a miniature in the Louvre which shows a boxer.

Nearly all miniature Panathenaics are assigned to the so-called Bulas Group. Its style is characterized by the near absence of incision and a generous use of white, here for tongues on the shoulder, the outer edge of Athena's shield, and the rock upon which the athlete sits. Subsidiary ornament is minimal. Clearly these vases were mass produced, and the fact that most were found in Greece suggests that they were produced primarily as inexpensive grave goods.

64 Bulas Group [Beazley]
ca. 400
H. 8.2 cm. (3 ¼ in.) Diam. 3.8 cm. (1 ½ in.)
Tampa Museum of Art
Joseph Veach Noble Collection
86.33

PUBLISHED: *Paralipomena* 316; Tampa Museum of Art, *The Joseph Veach Noble Collection* (Tampa 1985) no. 26.

65 Bulas Group [Beazley]
ca. 400
H. 8.6 cm. (3 ⅜ in.) Diam. 4.1 cm. (1 ⅝ in.)
Tampa Museum of Art
Joseph Veach Noble Collection
86.32

PUBLISHED: *Paralipomena* 317; J. V. Noble, *The Techniques of Painted Attic Pottery* (New York 1965) 134, figs. 90–91.

On miniature Panathenaics, see J. D. Beazley, "Miniature Panathenaics," *BSA* 41 (1940–45) 10–21, pls. 3–5. For the Louvre miniature (MNB 2862), see *CVA* Louvre 5, pl. 5, 2, and 4. For the Bulas Group, see *ABV* 661–62, and *Paralipomena* 316–17.

66 Miniature Red-Figure Panathenaic Amphora

Obverse: **Athena and Poseidon** (see illus. p. 45)
Reverse: **Hermes and olive tree**

A truly unique Panathenaic amphora is this miniature executed in red-figure which portrays three Olympians: Athena and Poseidon on one side and Hermes on the other. Below each handle is a tree with luxuriant foliage, most certainly olive. Poseidon resembles a famous fourth-century sculptural type in his pose: he leans forward with left leg raised and left elbow resting on his knee, and is given support by the vertical trident, the shaft of which is clasped in his right hand. On an Athenian coin of Roman Imperial date, he is shown confronting Athena in this same attitude, with an olive tree between them. This grouping has been taken to be either a monument seen by Pausanias (I.24.3) near the north flank of the Parthenon, or a joint cult image in the Temple of Poseidon at Sounion. The presence of the olive on both coin and vase supports the first hypothesis, since it must be the sacred tree on the Akropolis. The red-figure Athena also resembles a Classical sculpture; with her Attic helmet, shield on her left shoulder, left leg set to the side, and the prominent opening of her peplos, she recalls the Medici type (cat. 59). On the reverse, with his left arm propped against a pillar, Hermes also might be derived from a statue, although no specific type survives.

While large Panathenaic-shaped amphoras were decorated in the red-figure technique in the first half of the fifth century by such artists as the Kleophrades, Berlin, and Nikoxenos Painters (cat. 13), they are quite rare at the end of the century. Therefore this vase, unlike the black-figure miniature Panathenaics (cats. 64 and 65), does not seem to be aping a larger prototype, and well may have been made as a child's toy, as suggested by Hill.

ca. 400
H. 8.7 cm. (3 ⅜ in.) Diam. 4.6 cm. (1 ⅞ in.)
The Walters Art Gallery, Baltimore
48.59
Ex-coll. Massarenti, Rome

PUBLISHED: M. Massarenti, *Catalogue Musée Accoramboni* (Rome 1897) part 2, 30, no. 153; D. K. Hill, "Playing Panathenaia," *Bulletin of the Walters Art Gallery* 5 (1953) 1–2; *ABV* 662.

For the sculptural type of Poseidon and the Roman coin, see A. S. Delivorrias, ed., *Greece and the Sea* (Amsterdam 1987) 202–203, no. 103 (with bibl.). For a gem showing Hermes resting on a pillar, see *LIMC* V s.v. Hermes 805. Examples of late fifth-century red-figure Panathenaics are: Louvre CA 2584 (*CVA* Louvre 8, pl. 38, 6–8); Agora P 10554 (*Hesperia* 18 [1949] pl. 73).

67 **Didrachm (Electrotype)**

Obverse: **Amphora** (see illus. p. 51)
Reverse: **Incuse square**

The so-called *Wappenmünzen* ("heraldic coins") represent the earliest coinage of Athens, but their exact date is still a matter of controversy. The *Constitution of Athens* (10) attributes to Solon (ca. 594) the introduction of a regularized system of weights and coinage (presumably the owl tetradrachm, see cat. 10). If this statement is accepted, the Wappenmünzen would have to be dated before Solon. Most scholars, however, reject this evidence and believe instead that these didrachms were minted during the Peisistratid tyranny, with the famous owl tetradrachm series beginning sometime in the last quarter of the sixth century. What is of interest here is the relationship of this early coinage to the Panathenaia, since many of the devices can be seen to refer to the festival.

The amphora on this coin is the most obvious example. While it was once seen as an aristocratic family badge, its bulging body and small foot recall early Panathenaic vases. Other devices, e.g. the fore or rear part of a horse and the wheel, can be linked to equestrian contests. The *triskeles* (triple leg) suggests speed in the footrace, while the *astragalos* (knucklebone) could stand for luck in any competition. The owl and the gorgoneion obviously relate to Athena, and the frontal ox head may refer to the sacrifice in her honor. It seems more reasonable to interpret these devices as references to the cult of the city's patron deity than as private insignia, since the later coinage with its Athena head, owl, and olive so clearly celebrates her.

Athens, ca. 560–545
Silver
Diam. 1.8 cm. Wt. 7.47 g.
The American Numismatic Society, New York
1930.144.2

On the dating of the Wappenmünzen, see C. M. Kraay, *Archaic and Classical Greek Coins* (Berkeley 1976) 56–60, and 331, Appendix II; J. H. Kroll, "From *Wappenmünzen* to Gorgoneia to Owls," *American Numismatic Society Museum Notes* 26 (1981) 1–32, pls. 1–2. For the theory of family crests, see C. Seltman, *Athens, Its History and Coinage* (Cambridge 1924). On the relationship to the Panathenaia, see N. Yalouris, "Athena als Herrin der Pferde," *Museum Helveticum* 7 (1950) 52–54.

68/69 **New Style Tetradrachms**

Obverse: **Head of Athena**
Reverse: **Owl with amphora** (see illus. p. 51)

The Athenian "owls" (see cat. 10), one of the most long-lasting and widely circulated coinages of antiquity, were restyled early in the second century. Still bearing the owl, olive, and profile head of Athena, they nonetheless look completely different from their predecessors. The head of Athena is remodeled after that of the Parthenos (cat. 58). Although the flan could not accommodate a high crest, the goddess' helmet is otherwise quite close to Pheidias' with its griffin and raised cheekpieces. The reverse shows the owl facing right, but now perched on a Panathenaic amphora lying along the base. This elongated amphora with its pointed lid is a Hellenistic type, far removed from the rotund vase of the earliest Athenian coinage (cat. 67). The background is inscribed with letters denoting magistrates' names, dates, and ATHE for Athens. The whole is encircled with an olive wreath, which gave rise to the name *stephanophoroi* ("wreath-bearers") for these coins in contemporary inscriptions.

68 Athens, 184/3
Silver
Diam. 3.2 cm. (1 ¼ in.) Wt. 16.45 g. (.58 oz.)
The American Numismatic Society, New York
1963.31.238

On the coin type, see Thompson (see below).

69 Athens, 187/6
Silver
Diam. 3.1 cm. (1 ¼ in.) Wt. 16.97 g. (.59 oz.)
The American Numismatic Society, New York
1944.100.29576

PUBLISHED: Thompson (see below) no. 51a.

On Athenian New Style coinage, see M. Thompson, *The New Style Silver Coinage of Athens* (New York 1961) esp. nos. 51a and 83d.

70 Weight

(see illus. p. 51)

The *Constitution of Athens* (51.2) provides for a board of ten men (*metronomoi*) to be "responsible for all weights and measures, to ensure that the salesmen use honest standards." Examples of these lead and bronze weights have been found in the Agora in the vicinity of the Tholos, the building where one of the official sets of weights and measures was kept. They are roughly square in shape and carry two legends: the official state guarantee DEMOSION ("of the Demos"), and the weight. For those too busy or unable to read, the weight also bore a symbol in relief on the top. On this weight both the symbol, an amphora, and the legend TRI, incised on the top, indicate that it represents one-third of a stater, or approximately 320 grams. The state inscription, abbreviated to DE, appears in dotted letters on two sides with a small stamped owl between the letters. The owl also appears to the right of the amphora on the upper surface of the weight. It would seem to be a countermark, indicating official inspection and certification of the weight, but is not of a type previously known.

In shape the amphora resembles a neck-amphora more than a Panathenaic, but, like some of the other weight symbols (e.g. wheel, astragal, and bucranium) it surely derives from the early coinage of Athens, the *Wappenmünzen* (see cat. 67).

Attic, 4th century
Bronze with lead interior
H. 5.3 cm. (2 in.) W. 5.2 cm. (2 in.) D. 1.5 cm. (⅝ in.) Wt. 277 g. (9.7 oz.)
Collection of Mr. and Mrs. Lawrence Fleischman

Unpublished.
On Athenian metal weights, see M. Lang and M. Crosby, *Weights, Measures and Tokens*, Agora 10 (Princeton 1964) 2–33. Among the Agora weights the closest parallel in size, weight, legend, and shape of amphora is LW 20; see p. 28 and pl. 5.

71 Relief with Athletic Trophies

(see illus. p. 14)

According to inscriptional evidence (*IG* II² 3818) the Panathenaic Games continued to be held until A.D. 410. Therefore it is not surprising to find trophies from the Roman period commemorating athletic victors of the Panathenaia. This fragmentary marble block celebrates four victories (and probably a fifth) of an athlete whose name is missing, but whom we know to have been the son of Alexandros of the Attic deme of Rhamnous, from the inscription along the bottom. The other inscriptions on the relief symbols of prizes specify the contests: "Panathenaia" on the amphora; "Isthmia" inside the pine wreath; "Shield from Argos" on the round shield; and "Nemea" inside the wild celery wreath. It has been suggested that the olive wreath of Olympia would have appeared on the section of stone missing at the left. The amphora has the elongated shape of Hellenistic and Roman times, as also seen on the New Style coinage (cats. 68 and 69).

This relief has been known since the early eighteenth century, when it was observed in Greece by Fourmont.

Attic, 2nd century A.C.
Marble
H. 32.3 cm. (12 ¾ in.) L. 67.3 cm. (26 ⅜ in.)
The Metropolitan Museum of Art, New York
Rogers Fund, 1959
59.11.19
Provenance: Greece
Ex-coll. Lord Hatherton

PUBLISHED: *IG* II² 3145; O. Broneer, "The Isthmian Victory Crown," *AJA* 66 (1962) 261, n. 22 (with bibl.) pl. 67, 2; J. Frel, *Panathenaic Prize Amphoras* (Athens 1973) fig. 34; Harris, *GAA*, pl. 22c; P. Amandry, "Le Bouclier d'Argos," *BCH* 107 (1983) 628–29, no. 1 and n. 7 (with bibl.), fig. 1; B. F. Cook, *Greek Inscriptions* (London 1987) 20, fig. 10.

Abbreviations

AA
Archäologischer Anzeiger

ABV
J. D. Beazley, *Attic Black-Figure Vase Painters* (Oxford 1956)

Addenda
L. Burn and R. Glynn, *Beazley Addenda. Additional References to ABV, ARV² and Paralipomena* (Oxford 1982)

Agora
The Athenian Agora. Results of Excavations Conducted by the American School of Classical Studies at Athens

AJA
American Journal of Archaeology. The Journal of the Archaeological Institute of America

AM
Mitteilungen des Deutschen Archäologischen Instituts. Athenische Abteilung

AntK
Antike Kunst

ARV2
J. D. Beazley, *Attic Red-figure Vase-painters*, 2nd ed. (Oxford 1963)

BABesch
Bulletin antieke beschaving. Annual Papers on Classical Archaeology

Barber
E.J.W. Barber, *Prehistoric Textiles. The Development of Cloth in the Neolithic and Bronze Ages* (Princeton 1991)

BCH
Bulletin de correspondance hellénique

Beck, *Album*
F. A. Beck, *Album of Greek Education* (Sydney 1975)

BdA
Bollettino d'arte

Boardman, *ABFV*
J. Boardman, *Athenian Black Figure Vases* (New York 1974)

Boardman, *ARFV* I
J. Boardman, *Athenian Red Figure Vases. The Archaic Period* (London 1975)

Boardman, *ARFV* II
J. Boardman, *Athenian Red Figure Vases. The Classical Period* (London 1989)

Brandt
J. R. Brandt, "Archeologia Panathenaica" *Acta ad archeologiam et artium historiam pertinentia* 8 (1978) 1–23

Brouskari
M. S. Brouskari, *The Acropolis Museum* (Athens 1974)

BSA
Annual of the British School at Athens

Buitron, *New England*
D. Buitron, *Attic Vase Painting in New England Collections* (Cambridge, Mass. 1972)

CVA
Corpus Vasorum Antiquorum

Davison
J. A. Davison, "Notes on the Panathenaia," *Journal of Hellenic Studies* 78 (1958) 26–29

FGrHist
F. Jacoby, *Fragmente der griechischen Historiker* (Berlin 1923)

Graef-Langlotz
B. Graef and E. Langlotz, *Die antiken Vasen von der Akropolis zu Athen* 3 vols. (Berlin 1925–33)

Gardiner, *AAW*
E. N. Gardiner, *Athletics of the Ancient World* (London 1930)

Gardiner, *GAS*
E. N. Gardiner, *Greek Athletic Sports and Festivals* (London 1910)

Harris, *GAA*
H. A. Harris, *Greek Athletes and Athletics*, 2nd ed. (Bloomington 1966)

IG
Inscriptiones graecae

JdI
Jahrbuch des Deutschen Archäologischen Instituts

JHS
Journal of Hellenic Studies

Kyle
D. G. Kyle, *Athletics in Ancient Athens* (Leiden 1987)

LIMC
Lexicon Iconographicum Mythologiae Classicae

Mansfield
J. M. Mansfield, *The Robe of Athena and the Panathenaic Peplos* (Ph.D. diss., University of California at Berkeley 1985)

Mind and Body
O. Tzachou-Alexandri, *Mind and Body: Athletic Contests in Ancient Greece* (Athens 1989)

Paralipomena
J. D. Beazley, *Paralipomena* (Oxford 1971)

Parke
H. W. Parke, *Festivals of the Athenians* (London 1977)

Poliakoff
M. B. Poliakoff, *Combat Sports in the Ancient World* (New Haven 1987)

Raubitschek
A. E. Raubitschek, *Dedications from the Athenian Acropolis* (Cambridge, Mass. 1949)

Shapiro
H. A. Shapiro, *Art and Cult Under the Tyrants in Athens* (Mainz 1989)

Simon
E. Simon, *Festivals of Attica, An Archaeological Commentary* (Madison 1983)

Travlos
J. Travlos, *Pictorial Dictionary of Ancient Athens* (Tübingen 1971)

Vos
M. F. Vos, "Aulodic and Auletic Contests," *Enthousiasmos* (Amsterdam 1986) 122–130

Yalouris
N. Yalouris, ed., *The Eternal Olympics: The Art and History of Sport* (New Rochelle, New York 1979)

Notes to the Essays

The Panathenaia: An Introduction

1. The literature on the Panathenaia is extensive. The major sources in chronological order are: A. Mommsen, *Feste der Stadt Athen*, 2nd ed. (Leipzig 1898) 41–159; L. Deubner, *Attische Feste* (Berlin 1932) 22–35; L. Ziehen, "Panathenaia," *RE* 18.2 (1949) 457–489; J. A. Davison, "Notes on the Panathenaea," *JHS* 78 (1958) 23–41, and "Addenda to 'Notes on the Panathenaea'," *JHS* 82 (1962) 141–42; S. Piblis, *Panathenaea* (Athens 1970); H. W. Parke, *Festivals of the Athenians* (Ithaca 1977) 33–50; E. Simon, *Festivals of Attica* (Madison 1983) 55–72; H. A. Shapiro, *Art and Cult under the Tyrants in Athens* (Mainz 1989) 18–47.
2. Raubitschek, no. 164.
3. *IG* I³ 131.
4. Proklos, *In Platonis Timaeum commentarii* 9B; scholiast on Plato, *Republic* 327A.
5. See J. D. Mikalson, *The Sacred and Civil Calendar of the Athenian Year* (Princeton 1975) 16. Harpokration states that the third was Athena's birthday, but Photios, Suda, and the scholiast to *Iliad* 8.39 indicate the 28th.
6. See *Iliad* 4.515 and 8.39; *Odyssey* 3.378; Hesiod, *Theogony* 895, 924.
7. Scholiast to Aelius Aristides *Panathenaicus* 147; scholiast to Euripides, *Hecuba* 469.
8. Mikalson (supra n. 5) 34, 199.
9. C. A. Forbes, *Neoi: A Contribution to a Study of Greek Associations* (Middletown, Conn. 1933) 2.
10. S. V. Tracey and C. Habicht, "New and Old Panathenaic Victor Lists," *Hesperia* 60 (1991) 187–236.
11. Tracy and Habicht (supra n. 10) 203. A bell-krater of ca. 420 (New York 25.78.66) attributed to Polion (ARV² 1172, 8) shows three old satyrs carrying kitharas in procession toward a young flute-player. They are labeled OIDOI PANATHENAIA ("Singers at the Panathenaia"). There have been various explanations of this scene; see most recently F. Lissarrague, "Why Satyrs Are Good to Represent," in *Nothing to Do With Dionysos?*, eds. J. J. Winkler, and F. I. Zeitlin (Princeton 1990) 230, pl. 8, ns. 11–12.
12. See P. Valavanis, "La Proclamation des vainqueurs aux Panathénées," *BCH* 114 (1990) 325–59.
13. P. J. Rhodes, *A Commentary on the Aristotelian Athenaion Politeia* (Oxford 1981) 668–76; Davison 29–33; B. Nagy, "The Athenian Athlothetai," *Greek, Roman and Byzantine Studies* 19 (1978) 307–13, pl. 2.
14. Rhodes (supra n. 13) 606.
15. Raubitschek 350–58, nos. 326–328.
16. Davison 33.
17. New York 31.11.10 (*ABV* 154, 57). S. Karouzou, in *The Amasis Painter* (Oxford 1956) 44, states that the artist may have been thinking of the peplos, and that the dance on the shoulder is "possibly a religious dance to celebrate the weaving of the peplos." See also D. von Bothmer, *The Amasis Painter and His World* (Malibu 1985) 185–87.
18. Mansfield 366–79; I. B. Romano, Early Greek Cult Images and Cult Practices," in R. Hagg et al., eds., *Early Greek Cult Practice* (Stockholm 1988) 127–33.
19. For the two fourth-century testimonia on the Panathenaic Way, see *Agora* 3, 224. See also Travlos, 422–28.
20. Travlos, 477–81; W. Hoepfner, *Das Pompeion* (Athens 1971).
21. *Agora* 14, 192–94, pl. 99.
22. T. L. Shear Jr., "The Athenian Agora: Excavations of 1973–1974," *Hesperia* 44 (1975) 362–65; Kyle 60–62. Both Corinth and Argos had *dromoi* in their agoras.
23. Kyle 92–95. For the suggestion that the Lykurgan stadium was located on the Pnyx, see D. G. Romano, "The Panathenaic Stadium and the Theater of Lykourgos: A Re-examination of the Facilities on the Pnyx Hill," *AJA* 89 (1985) 441–54.
24. *Agora* 14, 126–29.
25. *Agora* 3, 97 no. 276.
26. Travlos, 389–91; A. L. H. Robkin, "The Odeion of Perikles: The Date of Its Construction and the Periklean Building Program," *Ancient World* 2 (1979) 3–12.
27. Kyle 95–97. For an attempt to locate the hippodrome at Kolonos Hippios northwest of Athens, see S. Benton, "Echelos' Hippodrome," *BSA* 67 (1972) 13–19.
28. Contra *Agora* 14, 121, and Kyle 63–64. See also *Mind and Body* 299, no. 187.
29. *IG* II² 2316 and 2317; see *Agora* 3, 80, no. 216. See also N. Reed, "A Chariot Race for Athens' Finest: The *Apobates* Contest Re-examined," *Journal of Sport History* 17 (1990) 306–17.
30. H. A. Thompson, "The Panathenaic Festival," *AA* 1961, 227–31.
31. Eusebius *Chronica*, on Olympiad 53.3–4 (i.e. 566/5): "Agon gymnicus, quem Panathenaeon vocant, actus." Marcellinus, *Vita Thukydides* 2–4, citing Pherekydes, states that during the archonship of Hippokleides the Panathenaia was established.
32. Scholiast on Aelius Aristides *Panathenaicus* 13.189.4–5. See Shapiro 19–20.
33. Harpokration, s.v. *Panathenaia*, citing Hellanicus *FGrHist* 323a F 2 and Androtion *FGrHist* 324 F 2; Apollodorus, *Library* 3 [190] 14.6.6. See N. Robertson, "The Origin of the Panathenaea," *Rheinisches Museum für Philologie* 128 (1985) 231–95.

34 The source for this story (Hyginus, *Astronomica* 2.13) is late, i.e. 1st century A.C.

35 "Divine child": J. D. Mikalson, "Erechtheus and the Panathenaia," *American Journal of Philology* 97 (1976) 141–53. Harvest festival: A. Mommsen, *Feste der Stadt Athen* (Leipzig 1898) 41–159. New Year's festival: W. Burkert, *Homo Necans* (Berkeley 1983) 154–61. These theories of origin are reviewed by Robertson (supra n. 33) 232–41, who believes the festival celebrates the bringing of new fire.

36 Athens, N. M. 559; S. Papaspyridi-Karouzou, "A Proto-Panathenaic Amphora in the National Museum at Athens," *AJA* 42 (1938) 495–505; *Mind and Body* 145–46, no. 35.

37 Munich 2314 (*ARV²* 362, 14), attributed to the Triptolemos Painter (Boardman, *ARFV* I fig. 307.1–2). A neck-amphora attributed to the Oionokles Painter, Cabinet des Médailles 369, (*ARV²* 648, 31; *Hesperia* 41 [1972] pl. 115a) depicts a similar scene.

38 See N. Yalouris, "Athena als Herrin der Pferde," *Museum Helveticum* 7 (1950) 19–101.

39 Kyle 186–87. See also G. R. Bugh, *The Horsemen of Athens* (Princeton 1988).

40 N. J. Norman, "The Panathenaic Ship," *Archaeological News* 12 (1983) 41–46. Others believe that the ship-cart was introduced after the victory over the Persians at Salamis; see Mansfield 68–78.

41 Supra n. 32.

42 Pseudo-Platonic *Hipparchos* 228B. See Shapiro 43–47.

43 Kyle 102–23.

44 For the sexual nature of this insult, see B. M. Lavelle, "The Nature of Hipparchos' Insult to Harmodios," *American Journal of Philology* 107 (1986) 318–31.

45 Martin von Wagner Museum L 515 (*ARV²* 256, 5) attributed to the Copenhagen Painter.

46 For the regulation of the Lesser Panathenaia, see F. Sokolowski, *Lois sacrées des cités grecques* (Paris 1969) 33; *IG* II/III² 334; *Hesperia* 28 (1959) B 32–34. The German excavators of the Kerameikos believe that the meat was distributed in the area of the Pompeion at the Dipylon Gate, and that the dining rooms built here ca. 400 were for the use of the officials of the Panathenaia; see W. Hoepfner, *Kerameikos* X (Berlin 1976) 20–22, 127ff. I thank Homer Thompson for this reference.

47 New York, The Metropolitan Museum of Art 53.11.1 (*ABV* 298, 5). See Shapiro pls. 9 and 10.

48 The best illustrations can still be found in M. Robertson and A. Frantz, *The Parthenon Frieze* (New York 1975). Recent bibliography is listed in *Parthenon-Kongress, Basel* (Mainz 1984).

49 On these figures as the eponymous heroes, see U. Kron, *Die zehn attische Phylenheroen* (*AM* Beiheft 5, 1976) 202–14; eadem, "Die Phylenheroen am Parthenonfries," *Parthenon-Kongress, Basel* (Mainz 1984) 235–44, 418–20, pls. 17–19. As the athlothetai, see B. Nagy, "Athenian Officials on the Parthenon Frieze," *AJA* 96 (1992) 55–69.

50 There is ongoing debate about the gender of this young attendant; see J. Boardman, "The Parthenon Frieze," *Parthenon-Kongress, Basel* (Mainz 1984) 214.

51 J. Boardman, "The Parthenon Frieze—Another View," *Festschrift für Frank Brommer* (Mainz 1977) 39–49.

52 For a discussion of the various theories regarding the origins of the Classical style, see C. H. Hallett, "The Origins of the Classical Style in Sculpture," *JHS* 106 (1986) 71–84.

Panathenaic Amphoras: Their Meanings, Makers, and Markets

1 For the Late Geometric oinochoe (Athens N. M. 192), see L. B. Lawler, "A Dancer's Trophy," *Classical Weekly* 41 (1947) 50–52; L. H. Jeffery, *The Local Scripts of Archaic Greece* (Oxford 1961) 76 no. 1, pl. 1; *Mind and Body* 306, no. 194. Another vase which may have served as a prize in a dance contest is the Middle Corinthian aryballos found on Temple Hill in Corinth, C–54–1; see M. C. and C. A. Roebuck, "A Prize Aryballos," *Hesperia* 24 (1955) 158–63, pl. 63. An Attic black-figure kylix in The Metropolitan Museum of Art (New York 44.11.1) is inscribed as a prize to a woman named Melosa who won the girls' wool-carding contest; see M. J. Milne, "A Prize for Wool-Working," *AJA* 49 (1945) 528–33. On such inscriptions on Greek vases, see H. Immerwahr, *Attic Script: A Survey* (Oxford 1990); M. L. Lang, "The Alphabetic Impact on Archaic Greece," *New Perspectives in Greek Art*, ed. D. Buitron-Oliver (Washington, D.C. 1991) 65–79.

2 London B 130; *ABV* 98, 1. For the circumstances of its discovery, see P. O. Brönsted, "On Panathenaic Vases, etc.," *Transactions of the Royal Society of Literature of the United Kingdom* (London 1832) ii, 102–135; P. E. Corbett, "The Burgon and Blacas Tombs," *JHS* 80 (1960) 52–58, pls. 1–3.

3 The scholarly literature on Panathenaics is extensive. The most comprehensive studies are: G. von Brauchitsch, *Die Panathenäischen Preisamphoren* (Leipzig and Berlin 1910); N. Gardiner, "Panathenaic Amphorae," *JHS* 32 (1912) 179–212; A. Smets, "Groupes chronologiques des amphores panathénaiques inscrites," *L'Antiquité classique* 5 (1936) 87–104; K. Peters, *Studien zu den panathenäischen Preisamphoren* (Berlin 1942); J. D. Beazley, "Panathenaica," *AJA* 47 (1943), 441–65; idem, *The Development of Attic Black-figure* (Berkeley and Los Angeles 1951; rev. ed. 1986) chapt. 8; G. R. Edwards, "Panathenaics of Hellenistic and Roman Times," *Hesperia* 26 (1957) 320–49, pls. 76–88; J. Frel, *Panathenaic Prize Amphoras* (German Archaeological Institute Athens, Kerameikos Book No. 2, 1973); J. Boardman, *Athenian Black Figure Vases* (New York 1974) 167–77; J. R. Brandt, "Archaeologica Panathenaica I," *Acta ad archaeologiam et artium historiam pertinentia* 8 (1978) 1–23; N. Eschbach, *Statuen auf panathenäischen Preisamphoren des 4. Jhrs. v. Chr.* (Mainz 1986); R. Hamilton, *Choes and Anthesteria, Athenian Iconography and Ritual* (Ann Arbor 1992) 127–34 and Appendix 7.

4 Karlsruhe 65.45; *Paralipomena* 61, 8bis.

5 Florence 97779 (*ABV* 110, 33).

6 The palmette-lotus cross appears frequently on the necks of imitation, smaller-scale amphoras of Panathenaic shape. Examples include: Taranto 13829 (*ABV* 139, 11) with sigmas on either side reminiscent of the SOS amphora; Tampa 86.24 (cat. 41); London market (Sotheby's sale cat., 21 May 1984, no. 402). Cf. also the amphora of Panathenaic shape in a private collection in Naples with a Panathenaic Athena on each side (Brandt p. 12, d, pl. 13 c-d) and the Group E amphora of Panathenaic shape with runners on both sides (cat. 23). It is a Corinthianizing ornament that appears first in the work of black-figure artists like the Gorgon Painter and Sophilos; cf. Boardman, *ARFV* I, figs. 14, 27 where it is placed on the body of the vessel, comparable to the ripe Corinthian aryballos.

7 On a few earlier non-prize Panathenaics, Athena is posed facing right: London B 139 (*ABV* 139, 12); Munich J.488; California market, near the Princeton Painter (E. Böhr, *Der Schaukelmaler* [Mainz 1982] pl.

173). She may be posed thus on the London vase in order to face the kitharode on the other side. Note also the Panathenaic Athena facing right on a red-figure amphora of Panathenaic shape by the Pythokles Painter (*ARV* 36, 1).

8 Marseilles, Musée Borely 3067 (*De Gyptis à Jules Cesar, Marseille cité grecque* [Marseille 1977] 55, no. 65). This vase is peculiar in other ways; for instance the prize inscription lacks the TO, and it has a Nike on the reverse with two boxers.

9 These can be found in parentheses in Brandt's lists. For further lists of shield devices, see G. H. Chase, *The Shield Devices of the Greeks in Art and Literature* (Cambridge, Mass. 1902, repr. Chicago 1979).

10 Brandt nos. 35, 38, 47 (Euphilteos Painter), and nos. 63–70 (Painter of the Havanna Owl).

11 *ABV* 411, 4, and 412, 1–2 middle. See also S. Brunnsaker, *The Tyrant-Slayers of Kritios and Nesiotes* (Lund 1971).

12 All three are illustrated in Beazley, *Development* (supra n. 3) pl. 99, 2–4.

13 Cf. the olive wreath on the helmets of Exekias (Brandt nos. 23–24).

14 Beazley, *Development* (supra n. 3) 92, pl. 104, 2.

15 In addition to the Burgon and Nikias amphoras, one finds the paryphe on Brandt nos. 10, 35–40, 47, 55. The most elaborate example is Akr. 920 (Brandt no. 13) which has metopal panels decorated with confronted animals.

16 Cf. the prize Panathenaics by the Painter of the Havanna Owl (Brandt nos. 63, 64); by the Eucharides Painter (*ABV* 395, 1–3); by the Berlin Painter (*ABV* 408, 1–4).

17 Cf. New York 16.71 by the Kleophrades Painter (*ABV* 404, 8). For the ependytes in Classical art, see M. Miller, "The *Ependytes* in Classical Athens," *Hesperia* 58 (1959) 312–29, pls. 51–55.

18 Scaled peplos: Agora P 24781 (*Agora* 23, no. 234, pl. 27). The scaled peplos is particularly characteristic of the Princeton Painter (see *ABV* 298, 5) and the Swing Painter (*ABV* 307, 58–59; and Böhr, [supra n. 7] pl. 89a-b).

19 Ionic capitals: Brandt nos. 83, 84. An amphora in London (B 135) which has appropriate Panathenaic decoration and is over 60 cm. tall but lacks the prize inscription also has Ionic capitals; see *CVA* London 1, pl. 3 (27) 2a-b. Acanthus capitals: Eschbach (supra n. 3) 42–44, 170; Frel (supra n. 3) 21, fig. 21.

20 Eschbach (supra n. 3), *passim*; P. D. Valavanis, "Säulen, Hahne, Niken und Archonten auf panathenäischen Preisamphoren," *AA* 102 (1987) 467–80.

21 Brandt nos. 22, 47, 65. Their shield devices include tripod, vase, dolphin, three pellets, lion and tri-lobed leaf. The hoplitodromos on the reverse of Bologna PU 198 (ABV 322, 5; Brandt no. 41) does not belong to this vase, but possibly to a later prize Panathenaic. See A. Stenico, "Un' Anfora panatenaica del pittore di Euphiletos," *Studies in Honour of A. D. Trendall* (Sydney 1979) 177–80, pls. 44–45.

22 Runners to left: Kerameikos PA 443 (Frel, [supra n. 3] fig. 7); cat. 24 (*ABV* 408, 1); Berlin 1832 (*ABV* 408, no. 4); Benghazi (Smets 66). Baskets: Munich 1454 (Brandt 64); Norwich 26.49 (*ABV* 404, 16); Isthmia IP 1172 (*Hesperia* 27 [1958] 30–31, pls. 14–15). The reverse of Bologna PU 198 (which is later in date and does not belong with the obverse) shows a basket in a scene of hoplite runners; see Stenico supra n. 21.

23 On turning posts, see S. G. Miller "Turns and Lanes in the Ancient Stadium," *AJA* 84 (1980) 159–66.

24 London B131 and B132 (*ABV* 405, 4 and 5). At Olympia the *synoris* was not introduced until 408, while the *apene* (mule-cart race) was begun in 500 but dropped in 444. Neither event is listed in *IG* II² 2311, but a synoris was held at the Greater Panathenaia in the first half of the fourth century according to inscriptional evidence; see Kyle 187–88.

25 *ABV* 369, 112–113 = Brandt nos. 72–73. The vase from Sparta, which is only 53 cm. in height, shows the chariot moving to the left just before the turning post.

26 Nauplion I: *ABV* 260, 27; Brandt no. 28. A similar scene is shown on a non-prize Panathenaic, London B 144 which Beazley attributed to the Swing Painter (*ABV* 307, 59). Böhr (supra n. 7) no. P4, puts it in the vicinity of the Princeton Painter.

27 Leningrad 1510 B: *Paralipomena* 127, Brandt no. 60.

28 Brandt nos. 58 and 71.

29 Eucharides Painter: *ABV* 395, 1–3 and *Paralipomena* 174. Near the Painter of Berlin 1833: *ABV* 407, 1–2 middle.

30 Turning post: New York 07.286.80 (*ABV* 369, 114). Trainer: Leiden PC 7 (*ABV* 407, 1).

31 Warsaw 142346 (*ABV* 408, 2). In the fourth century the potter Bakchios produced a prize Panathenaic with a horse-race: *ABV* 413, 1.

32 London 1903.2–17.1: *ABV* 411, 1. On javelin-throwing on horseback, Kyle 186–87.

33 Getty 79.AE.147, dated 340/339. See also Heidelberg 242: *CVA* Heidelberg 1, pl. 38, 4. On the apobates, Kyle 188–89.

34 Michigan Painter's pentathlons: London B 136 (Brandt no. 61); Vatican 374 (*ABV* 344; Brandt no. 63). Kleophrades Painter: Tolmeia (*Libya Antiqua* 8 [1971] 74–75, pls. 27–28); Taranto 115474 (Lo Porto [infra n. 118] pls. 33–34).

35 New York 16.71 (*ABV* 404, 8) and Leiden PC 6 (*ABV* 404, 9). See also Poliakoff, 23–63.

36 The certain pankration scenes are those mentioned above (supra n. 35) of the Kleophrades Painter and the vase in Naples where the obverse scene is labeled "pankration" (see n. 69). This "system" is borne out by other Archaic and Classical vase-paintings in addition to the Panathenaics cited here, but may not operate in the fourth century; for numerous illustrations, see Poliakoff, *passim*. Difficulties arise when the referee is in the center as on the Panathenaic in Toledo (cat. 38).

37 Ny Carlsberg 3606; *Meddelelser fra Ny Carlsberg Glyptotek* 37 (1981) 30–33, figs. 1–4. J. Christiansen identifies the scene as wrestling. See also J. Christansen, "Did the Kleophon Painter Make Panathenaics?" *Ancient Greek and Related Pottery*, ed. H.A.G. Brijder (Amsterdam 1984) 144–48.

38 Leningrad 17794; *ABV* 410, 2.

39 Pyrrhic: D. von Bothmer in *Wealth of the Ancient World* (Ft. Worth 1983) 66–67 no. 9. Euandria: N. B. Reed, "The *Euandria* Competition at the Panathenaia Reconsidered," *Ancient World* 15 (1987) 59–64.

40 Examples include the cup by the Antiphon Painter (Berlin 2307; *ARV*² 341, 77) and the skyphos in the Hearst collection near the Pan Painter (*ARV*² 561, 11).

41 M. Tiverios has reached a similar conclusion regarding this vase; see his "Panathenaika Eikonographia," *Thrakiki Epethrida* 70 (Komitini 1987–90) 285–92, pls. 1–3.

42 Frag. 4. 1ff. Bergk. Parke (p. 187) has written: "In a world in which peace was an infrequent and exceptional condition, Athena with her

helmet and breast-plate, spear and shield need not suggest militaristic aggression so much as the guidance and protection of the state."

43 A well-argued and intriguing suggestion has recently been made by G. Ferrari Pinney that the Panathenaic Athena is dancing the pyrrhic in celebration of the gods' victory over the giants, and as such is emblematic of victory at the games; see her "Pallas and Panathenaea," in *Proceedings of the 3rd Symposium on Ancient Greek and Related Pottery* (Copenhagen 1988) 467–77. I do not believe that most Athenians would view her as being in the pose of a pyrrhic dancer since she does not hold the spear as close to her side as pyrrhicists do, nor is there any musical accompaniment. See J.-Cl. Poursat, "Les représentations de danse armée dans la céramique attique," *BCH* 92 (1968) 550–615. Just as Zeus with his thunderbolt and Poseidon with his trident raised overhead do not refer to any specific narrative as far as we know, so Athena with her spear need not be fighting giants or performing a dance.

44 Worshipers: Bonn 43 (Shapiro pl. 13a-b); ex-Basel market (Böhr [supra n. 7] pl. 89) Victors: Cab. Méd. 243 (see cat. 47); Florence 97779 (*ABV* 110, 33).

45 Akr. 2298 and 1220 (Shapiro, pl. 10 a-b); Berlin 1686 (Shapiro pl. 9c); London, priv. coll. (Shapiro pl. 9 a-b); New York 53.11.1 (Shapiro pl. 14b).

46 See also Heidelberg 73/7; Shapiro pl. 11e.

47 Munich 1727; *ABV* 397, 33; Shapiro pl. 8d.

48 Supra n. 7.

49 The best known example is Theseus shown in the poses of the Tyrannicides, as for instance on the red-figure cup, London E 84 (*ARV*[2] 1269 4; J. Neils, *The Youthful Deeds of Theseus* [Rome 1987] 129–32, no. 111).

50 Beazley, *Development* (supra n. 3) 84; Boardman, *ABFV* 167. On cocks in general: Ph. Bruneau, "Le motif des coqs confrontés dans l'image antique," *BCH* 89 (1965) 90–121; H. Hoffmann, "Hähnenkampf in Athen," *Revue archéologique* 1974, 195–220.

51 As mentioned earlier, pairs of cock columns frame figures on other black-figure vases, namely neck-amphoras, but these are clearly derived from Panathenaics. A single cock column flanked by two youths appears on a red-figure pelike (Syracuse 21968) by the Leningrad Painter (*ARV*[2] 570, 65). A cock stands on what is taken to be a grave stele on a lekythos by the Athena Painter (Dresden 2V 1700); see G. Weicker, "Hähne auf Grabstelen," *AM* 30 (1905) 207–12.

52 One is reminded of the statues of Zeus at Olympia (Zeus Horkios), where the athletes and judges swore oaths of fidelity to the rules of the games (Pausanias 5.24.9), and of the Zanes, bronze statues funded by fines imposed for bribery.

53 On a Faliscan kylix in Boston (01.8114) Zeus is seated in front of an altar on top of which stands a cock; see J. D. Beazley, *Etruscan Vase-Painting* (Oxford 1947) 111, pl. 26.

54 *RE* suppl. XV (1978) 1415, s.v. Zeus. The bird normally associated with Zeus is the eagle, which appears on his outstretched hand in representations of the gigantomachy, or on the top of his scepter; see K.W. Arafat, *Classical Zeus* (Oxford 1990) pls. 1a, 2a, 3a, 5b, 30b.

55 Akr. 923 (*ABV* 667; Graef-Langlotz I, pl. 59).

56 E. Simon, *Die Götter der Griechen* (Munich 1969/1980) 182.

57 For the SOS amphora, see A. W. Johnston and R. E. Jones, "The 'SOS' Amphora," *BSA* 73 (1978) 103–41. That it was also used for wine is indicated by the François vase where Dionysos is carrying an SOS amphora to the wedding feast of Pelias and Thetis; see R. F. Docter, "Athena vs. Dionysos: Reconsidering the contents of SOS amphorae," *BABesch* 66 (1991) 45–49.

58 For Munich 1447, a panel neck-amphora near the Painter of Acropolis 606 (*ABV* 81, 1), see now D. von Bothmer, *The Amasis Painter and His World* (Malibu 1985)' 121, fig. 73. Like the earliest Panathenaic amphoras, this vase has black-figure decoration on the reserved neck and within a reserved panel on the slipped body, as well as rays at the base.

59 Such vases have been erroneously called "pseudo-panathenaics"; they should properly be called "amphoras of Panathenaic shape." Early (i.e. pre-540) examples include: New York 1989.281.89 (cat. 18); Tampa 86.24 (cat. 41); Austin 1980.32 (cat. 17).

60 For measurements of Panathenaic prize amphoras, see M. L. Lang in *Agora* 10, 58–59; M.F. Vos, "Some Notes on Panathenaic Amphorae," *Oudheidkunige mededeelingen Leyden Rijksmuseum van Oudheden* 62 (1981) 38–39. The metretes unit of 38.88 is attained by multiplying the kotyle measure of 270 cc. by 144. The average capacity of the amphoras listed by Vos, if filled to the brim, is 38.82 liters.

61 The other prize inscriptions with "emi" occur on fragments from the Akropolis, Akr. 1086 and 1087; see Graef-Langlotz I, pl. 63. See also Immerwahr (supra n. 1) 183–85.

62 Outside left column: Boulogne 441 (*ABV* 290, 1; Brandt 54) and Tocra 2128 (J. Boardman and J. Hayes, *Excavations at Tocra 1963–1965. The Archaic Deposits II and Later Deposits*, BSA Suppl. 10 [1973] 42, 44, pl. 23; Brandt 93). Behind Athena: Karlsruhe (65/45), attributed to Exekias (*Paralipomena* 61, 8 bis; Boardman, *ABV*, fig. 106; Brandt no. 23). Reverse: Florence 97779 (*ABV* 110, 33; Brandt 23).

63 Madrid 10901; *CVA* Madrid 1, pl. 27, 2a-b; Yalouris, *Olympics* 244, fig. 142.

64 Raubitschek, 3–49.

65 *ABV* 39, 16. Note also that on both dinoi by Sophilos depicting the wedding of Peleus and Thetis (Akr. 587 and British Museum GR 1971.11–1.1) the painter's signature is inscribed vertically and retrograde next to the column of the couple's house (*ABV* 39, 15, and *Paralipomena* 19, 16bis).

66 An exception is the amphora in New York 1978.11.13 dated ca. 560–555, which has its prize inscription orthograde; see The Metropolitan Museum of Art, *Greece and Rome* (New York 1987) 37–39, no. 23; see figs. 27a, b.

67 Berlin 3980; Beazley, *Development* (supra n. 3) 89; Peters (supra n. 3) 105–07.

68 Akr. 921 (*ABV* 300, 16 and 314; Brandt no. 22). Beazley was not certain of this vase being Panathenaic in shape nor that this MNES— is the same person who signed a vase in Cairo as potter and who dedicated a bronze statue on the Akropolis along with the potter Andokides; see Raubitschek, 213–16. Given that all of the inscriptions are close in date, ca. 540–530, and that a potter who received a lucrative contract for Panathenaics might well later dedicate a thank-offering to Athena on the Akropolis, it seems likely that they all refer to the same Mnesiades.

69 Naples 81294; *CVA* Naples 1, pl. 1, 1 & 3.

70 Halle 560; *ABV* 120; Brandt no. 2.

71 Supra n. 68. That the hoplite race was a diaulos or two stades in length is suggested by a passage in Aristophanes' *Birds* (lines 291–92). The

other vase that cites the diaulos is the fragment Athens 2468 (*ABV* 69, 1; Brandt no. 5; *Mind and Body* 247, no. 139).

72 "Stadion Andron Nike" Munich 1451 (Brandt no. 26, pls. 2B, 3, A & B). On a non-prize Panathenaic-shaped amphora by the Swing Painter (British Museum B 144; *ABV* 307, 59), a herald preceding a horseman and youth carrying tripod and wreath announces that Dysneikytos' horse is the winner. In spite of the vase's shape and the Panathenaic Athena on the obverse, this vase probably does not commemorate a Panathenaic victory since tripods were not offered as prizes. See Kyle 200–01, A21.

73 Kerameikos PA 443 and Agora P10204; Brandt nos. 3 and 4. The Agora fr. is now published in *Agora* 23, no. 226, pl. 26. Note also a third fragment from the Akropolis; *ibid*., p. 131.

74 Another vase, possibly a prize amphora, is signed with the potter's name Kallikles; it is in a Swiss private collection. See *Agora* 23, p. 14, nn. 11 and 13.

75 Naples 112848; *ABV* 403, 1; Brandt no. 75.

76 *ABV* 413; Beazley 1943 (supra n. 3), 455–457; Beazley, *Development* (supra n. 3) 89–90; Frel (supra n. 3) 21–22. Beazley (1943, p. 455) notes that the Panathenaic signed by Kittos (London B 604; *ABV* 413) and a contemporary Panathenaic made during the archonship of Polyzelos, 367/6 (Brussels A 1703; *ABV* 413, 2) are the only Panathenaics (with the exception of the Burgon amphora) in which the inscriptions are punctuated; the prize inscription in the first, the archon inscription in the second.

77 British Museum B 134; *ABV* 322, 1; Brandt no. 35; *CVA* London 1, pl. 2, 2a-b.

78 Akr. 914; *ABV* 666; Brandt no. 7; Graef-Langlotz I, pl. 60.

79 For recent discussion of this group, see Brandt, 11–12; Shapiro 32–36. I have not included in this discussion a group of even smaller (H. 25–35 cm.) amphoras of Panathenaic shape of which the neck decoration is not canonical, i.e. consisting of three alternating palmettes. See *ABV* 339, and *Paralipomena* 150–51 (Painter of Oxford 218B) and *ABV* 397, 3 (near the Eucharides Painter).

80 For the reversed Athena see supra n. 7. Owls on columns: Austin 1980.32 (cat. 17); Kerameikos PA 1 (Frel, [supra n. 3] fig. 11); Agora P 24661 (*Agora* 23, no. 319, pl. 32); Liverpool 56.19.23 (Brandt p. 12, f); London B 138 (*CVA* London 1, pl. 4, 3a-b). Dinoi on columns: Cab. Méd. 243 (see p. 37, fig. 23). Pithoi on columns: Norwich 2 (*ABV* 300, 17). Panthers on columns: Liverpool 56.19.18 (Shapiro pl. 15b).

81 No columns: London B 144 (*ABV* 307, 59); Swiss market (Böhr [supra n. 7] pl. 89); Tampa 86.24 (cat. 41); Bonn 43 (Shapiro pl. 13a-b); Heidelberg 73.3 (Shapiro pl. 11e); London B 141 (*CVA* London 1, pl. 6, 1a-b).

82 Kithara-players: London B 139 (*ABV* 139, 12); Walters 48.2107; Louvre E 84 (*CVA* Louvre 5, pl. 4, 3 & 5); Louvre F 282 (*CVA* Louvre 5, pl. 2, 4–5).

Pipers: Austin 1980.32 (cat. 17); Bonn 43 (Shapiro pl. 13a-b); London B 141 (supra n. 81)

Rhapsodes: Liverpool 56.19.18 (Brandt p. 12, e); Oldenburg 8250.2 (Shapiro pl. 22a).

Hoplomachia: Madrid 10901 (*CVA* Madrid 1, pl. 27, 2a-b).

Acrobats: Cab. Méd. 243 (see cat. 47 and fig. 36).

83 Celebratory: T. B. L. Webster, *Potter and Patron in Classical Athens* (London 1972) 159–60. Commemorative: Shapiro 33.

84 *Ath. Pol.* 60.2.

85 According to the scholiast on Pindar, *Nemean Ode* 10.36. See also Vos (supra n. 60) 41 and n. 49.

86 J. D. Beazley, "Miniature Panathenaics," *BSA* 41 (1945) 10–21; *ABV* 661–62: The Bulas Group.

87 *ABV* 662, 26.

88 Pentathletes: London B 602 (*CVA* London 1 pl. 5, 5a-b). This vase is also distinctive in size, being 15 cm. tall. Boxer: Louvre MNB 2862 (*ABV* 662, 24).

89 The pose of Poseidon on the left with his foot raised is actually closest to the composition on an Athenian coin of the Augustan period. Thus, the vase and the coin may reflect a common sculptural prototype. See cat. 66 for further discussion.

90 These include: Boston 01.8127 (*ABV* 260, 28); Toronto 915.24 (*CVA* Toronto 1, pl. 22); London B 135 (*CVA* London 1, pl. 3, 2a-b); Princeton 50.10 (cat. 44); Louvre F 280 (*CVA* Louvre 5, pl. 2, 8 & 10); Naples (Brandt, p. 12, g); Liverpool 56.19.23 (Brandt, p. 12, f).

91 E. N. Gardiner, *JHS* 32 (1912) 188.

92 M. A. Tiverios, "Panathenaika," *Archaiologikon Deltion* 19 (1974) 142–53.

93 M. Moore in *Agora* 23, 13, n. 4.

94 These have been collected and discussed by Vos (supra n. 60) 40. His no. 1 (Geneva MF 150) is listed in error; the unrestored height is 47.4 cm., and is otherwise full-size. Likewise his no. 6 (Munich 1455) has a published height of 65 cm. Moore (*Agora* 23, p. 13, n. 4) adds: London B 144 (*ABV* 307, 59) which lacks the prize inscription, and, as we have discussed above n. 26, is commemorative in nature; and Madrid 10901, which is anomalous both in having the inscription painted in red on the column (supra n. 63), and in depicting a non-Panathenaic event, a hoplite duel, on the reverse. To Vos' list should be added London 1903.2-17.1, a prize amphora of the Kuban Group (*ABV* 411, 1) which is only 57 cm. tall.

95 Sparta (Vos [supra n. 60], 40 no. 2).

96 Leningrad 17295 (Vos [supra n. 60] 40, no. 14), and London 1903.2-17.1 (supra n. 32).

97 Athens, N. M. 452 (CC 757) (Vos [supra n. 60] 40, no. 10).

98 See A. W. Johnston, "*IG* II[2] 2311 and the Number of Panathenaic Amphorae," *BSA* 82 (1987) 125–29.

99 See D. A. Amyx, "The Attic Stelai. Part III," *Hesperia* 27 (1958) 178–86.

100 On vase prices, see A. W. Johnston, *Trademarks on Greek Vases* (Warminster 1979) 33–35.

101 These calculations are based on a conservative equivalent of U.S. $80 per drachma. See D. Young, *The Olympic Myth of Greek Amateur Athletics* (Chicago 1984) 125.

102 *ABV* 322, and *Paralipomena* 142.

103 Munich 1453 (*ABV* 322, 4); New York 14.130.12 (*ABV* 322, 6); Amsterdam 1897 (*ABV* 322, 8). These details include the central meander strip on the skirt, the red stripes and star patterns of the radiating folds, the wavy lines on the interior of the chiton seen beyond the ankles, the scaly interior of the aegis seen beyond the right arm, the red helmet visor, the palmette just above the ear and the striations on the crest. I would suggest that the amphora in Bologna PU 198 (*ABV* 322, 5) belongs to the same series; since its reverse, which shows the hoplitodromos, belongs to a later vase, the original reverse may also have depicted the sprint.

104 Boston 99.520; *ABV* 322, 7; J. M. Padgett, *The Painted Past* (Utah Museum of Fine Arts 1988) 20–21, no. 8.

105 London B 134 (*ABV* 322, 1); Leiden PC 8 (*ABV* 322, 2).

106 *ABV* 33–44; Brandt, 7–8, nos. 63–70.

107 *Paralipomena* 156, 7 *bis* and *ter*. J. Frel, "Arx Atheniensium: Panathenaica," *Athens Annals of Archaeology* 2 (1969) 385.

108 *ABV* 369, 112–113.

109 A fragment attributed to Euphronios found on the Akropolis (Akr. 931) preserves only part of the head and shield of Athena: *ABV* 403; *Euphronios der Maler* (Milan 1991) 228, no. 54.

110 *ARV*2 220–21, 5–10. Frel (supra n. 107, p. 382) has suggested that a black-figure fragment from the Akropolis (Akr. 1008), which preserves a cock on an Ionic column, recalls the Nikoxenos Painter.

111 *ABV* 395, 1–3; *Paralipomena* 174, 3*bis;* Frel (supra n. 107).

112 S. B. Matheson, "Panathenaic Amphorae by the Kleophrades Painter," *Greek Vases in the J. Paul Getty Museum* 4 (1989) 95–112.

113 Boardman, *ABFV* 168. For the attribution of a Panathenaic to the Kleophon Painter, see supra n. 37.

114 Presumably those found in Etruscan tombs were not the prizes for the occupants, but part of the second-hand market. See, for instance, G. Riccioni and M. T. Falconi Amorelli, *La Tomba della Panatenaica di Vulci* (Rome 1968) no. 20.

115 For Panathenaics from private houses and discussion of repairs, see D. M. Robinson, *Excavations at Olynthus*, vol. 13 (Baltimore 1950) 59–64.

116 British Museum B 607; *ABV* 415.4; Eschbach (supra n. 3) 109–10, no. 63.

117 M. Vickers and A. Bazama, "A Fifth Century B.C. Tomb in Cyrenaica," *Libya Antiqua* 8 (1971) 69–84. For discussion of the Panathenaic vase see also Matheson (supra n. 112) 111–12.

118 F. G. Lo Porto, "Tombe di atleti tarentini," *Atti e memorie della Società Magna Grecia* 8 (1967) 31–98, pls. 1–43.

119 Naples 112848; *ABV* 403, 1; Brandt no. 75.

120 On Lo Porto's attribution, see Matheson (supra n. 112) 111–12.

121 Lo Porto (supra n. 118) 84.

122 Corinth I P 1172: O. Broneer, "Excavations at Isthmia," *Hesperia* 27 (1958) 30–31. Broneer attributed the vase to the Leagros Group. It has since been reattributed to the Kleophrades Painter by Bothmer; see M. B. Moore, in D. White, ed., *The Extramural Sanctuary of Demeter and Persephone at Cyrene, Libya. Final Reports*, vol. 3, part 2: *Attic Black Figure and Black Glazed Pottery* (Philadelphia 1987) 17, no. 71. Cyrene: Moore, *loc. cit.*, pp. 4, 16–17, no. 71. Matheson (supra n. 112, p. 111) considers both vases Kleophradean. The fourth-century fragments found in the Sanctuary of Demeter and Kore at Corinth: E. Pemberton, *Corinth* vol. 18, *The Sanctuary of Demeter and Kore, The Greek Pottery* (Princeton 1989) 139, nos. 305–307.

123 Amyx (supra n. 99) 178–86.

124 Thukydides 6.16; Plutarch, *Life of Alkibiades*, 11.

125 Note the recent find of two late fifth-century Panathenaics in tombs in the Caucasus: *I Tesori Kurgani del Caucaso settentrionale* (Locarno 1990) 49, nos. 101–102.

126 Black-figure amphora of Leagros Group; Akropolis 842 *ABV* 369, 119. Red-figure amphora by the Painter of Palermo 1101: Munich 2315; *ARV*2 299, 2; *CVA* Munich 4, pl. 191, and 190, 4–5. Red-figure amphora near the Talos Painter: Agora P10554; *Hesperia* 18 (1949) 306–308, pls. 73–74.

127 Munich 2220; *CVA* Munich 11 pl. 31, 1–4. Basel market; Böhr, (supra n. 7) pl. 89, no. 91. I doubt that the vase depicted on the Proto-attic olpe, Agora P8996, represents an oil container; see *Agora* 8, no. 85.

128 Agora P 10555; *Hesperia* 18 (1949) 306–307, pl. 74. Hereafter the shape is frequent in South Italian vase-painting; see D. Trendall, *Red Figure Vases of South Italy and Sicily* (London 1989) 9.

129 *Agora* 10, 5–22, pls. 5–6.

130 *Wappenmünzen:* R. J. Hopper, "Observations on the Wappenmünzen," in C. M. Kraay and G. K. Jenkins, eds., *Essays in Greek Coinage Presented to Stanley Robinson* (Oxford 1968) 16–39, pls. 2–5; J. H. Kroll, "From *Wappenmünzen* to Gorgoneia to Owls," *American Numismatic Society Museum Notes* 26 (1981) 1–32, pls. 1–2. New Style: M. Thompson, *The New Style Silver Coinage of Athens,* Numismatic Studies 10 (New York, 1961).

131 See also *Mind and Body,* no. 102.

Mousikoi Agones: Music and Poetry at the Panathenaia

1 See M. Maas and J. M. Snyder, *Stringed Instruments of Ancient Greece* (New Haven 1989) 59.

2 For the recent debate on this point, see e.g. A. Burnett, "Performing Pindar's Odes," *Classical Philology* 84 (1989) 283–92 and, most recently, M. Heath and M. R. Lefkowitz, "Epinician Performance," *Classical Philology* 96 (1991) 173–91.

3 Less is known about the education of girls in Athens, but numerous red-figure vases that show small groups of women playing and listening to musical instruments suggest that at least some women were accomplished musicians. See E. Keuls, *The Reign of the Phallus* (New York 1985) 123–24; Beck, *Album* pls. 82–83.

4 See Beck, *Album* pls. 20–21; F. A. Beck, *Greek Education* (London 1964) 126–29.

5 Vienna IV 1870; *JdI* 30 (1915) 39, fig. 2.

6 This seems to be the only instance of a singer accompanied by a kithara-player. Cf. Vos 124, n. 25.

7 On the motif of a man chastising a boy with a sandal, see J. Boardman, "A Curious Eye Cup," *AA* 1976, 286.

8 See M. Cristofani et al., *Materiali per servire alla storia del Vaso François. BdA* Ser. Spec. 1 (1982) fig. 174.

9 For Theseus holding the lyre with Ariadne, see J. Neils, "The Loves of Theseus: an Early Cup by Oltos," *AJA* 85 (1981) 177–79. I have argued elsewhere that Theseus' lyre on the François Vase is part of his romantic appeal for Ariadne: "Theseus: Aspects of the Hero in Archaic Greece," in *New Perspectives in Early Greek Art,* ed. D. M. Buitron (Washington, D.C. 1991) 126.

10 A large compendium is provided by D. Paquette, *L'instrument de musique dans la céramique de la Grèce antique* (Paris 1984).

11 R. Hampe and E. Simon, *The Birth of Greek Art* (New York 1981) pls. 55–56. On the iconography see J. P. Nauert, "The Hagia Triada Sarcophagus: an Iconographical Study," *AntK* 8 (1965) 91–98, esp. on music at the festival of Hyakinthos. See also C. R. Long, *The Ayia Triada Sarcophagus* (Göteborg 1974) 38.

12. On the musicians in the procession, see infra pp. 54–55.
13. London, private collection. See Simon, 63 and pl. 16.2 and 17.2.
14. Berlin 1686; *ABV* 296, 4.
15. Akr. 816; *ABV* 391; Graef-Langlotz I pl. 49.
16. On Exekias' name, and variants on it, see J. Boardman, "Exekias," *AJA* 82 (1978) 24.
17. Akr. 636; *ARV*² 25, 1; Graef-Langlotz pls. 50–51 (attributed by J. Neils to the Berlin Painter).
18. N VII and N VIII; F. Brommer, *Der Parthenon Fries* (Mainz 1977) pls. 60–61. Brommer (pp. 218–19) rejects earlier attempts to identify more musicians on the South Frieze as well.
19. On women flute-players, see I. Peschel, *Die Hetäre bei Symposion und Komos* (Frankfurt 1987) 31–36.
20. Boston 92.95; *ARV*² 1149, 9; L. D. Caskey and J. D. Beazley, *Attic Vase Paintings in the Museum of Fine Arts, Boston* iii (Oxford 1963) pl. 101.
21. London E 455; *ARV*² 1028, 9; *Mind and Body* no. 134.
22. See p. 96
23. E.g. a black-figure pelike, New York 49.11.1; *ABV* 384, 19; *JHS* 71 (1951) pl. 20. Two boxers, a boy and a man, are shown in balletic poses, accompanied by a flute-player. For full discussion see W. J. Raschke, "Aulos and Athlete," *Arete: The Journal of Sport Literature* 2 (1985) 177–200.
24. Taranto 115474; see Lo Porto, *Atti e Memorie della Società Magna Graecia* 8 (1967) pls. 33–34. Aslaia, Libya, see M. Vickers, *Libya antiqua* 8 (1971) pl. 28a.
25. Cabinet des Médailles 243.
26. See cat no. 46. I have elsewhere tentatively accepted the designation apobates for the jumper: Shapiro 33. See also E. Simon, "Zwei Springtänzer: DOIO KUBISTETERE," *AntK* 21 (1978) 68 and N. Reed, "The *Euandria* Competition at the Panathenaia Reconsidered," *Ancient World* 15 (1987) 59–64.
27. See infra pp. 94–95.
28. The representations are collected by J.-M. Poursat, "Les représentations de danse armée dans la céramique attique," *BCH* 92 (1968) 550–615. D. von Bothmer has interpreted the event on the Panathenaic amphora (cat. 43) formerly in the Hunt Collection as the pyrrhic: *Wealth of the Ancient World* (Fort Worth 1983) no. 9.
29. See P. Valavanis, "La proclamation des vainqueurs aux Panathénées," *BCH* 114 (1990) 350–52; on the salpinx see Paquette (supra n. 10) 74–75.
30. See infra p. 64 on musical competitions at Delphi, and J. Herington, *Poetry into Drama* (Berkeley 1985) 161–65 for a summary of all religious festivals in Greece for which musical contests are attested.
31. Plovdiv; *ARV*² 1044, 9.
32. For the games at Marathon, in honor of Herakles, see E. Vanderpool, "Three Prize Vases," *Archaiologikon Deltion* 24 A' (1969) 1–5.
33. This was located on the southeast slope of the Akropolis, next to the Theatre of Dionysos. See R. E. Wycherly, *The Stones of Athens* (Princeton 1979) 215; M. Wegner, *Das Musikleben der Griechen* (Berlin 1949) 116.
34. Davison 41. Cf. Vos 127–28, who also believes in the suspension of certain contests at certain times, particularly the aulodic contest between ca. 480 and 450. But given the accidents of preservation of Attic vases, such inferences based solely on the absence of representations in a given period are unwarranted. See also Schäfter (infra n. 92).
35. The view that Plutarch is simply incorrect was most forcefully stated by E. Preuner, "Amphiaraia und Panathenaia," *Hermes* 57 (1922) 91–95.
36. See infra, pp. 72–73.
37. See Davison 26–29.
38. See most recently A. W. Johnston, "IG II² 2311 and the Number of Panathenaic Amphorae," *BSA* 82 (1987) 125–29.
39. Johnston (supra n. 38) 125, n. 1, writes "closer to 375 than 400 or 350."
40. On the prizes, see Parke, 35. D. Young, *The Olympic Myth of Greek Amateur Athletics* (Chicago 1984) 125 attempts to calculate the modern dollar equivalents for the prizes in this inscription.
41. Preuner (supra n. 35) 92 restored these two headings at the top of the inscription.
42. E.g. stamnos, Lyons; *ARV*² 593, 46; *JHS* 71 (1951) pl. 25 below; pelike, Athens N.M. 1469; *ARV*² 1084, 17; *Archaiologike Ephemeris* 1937, p. 232, fig. 5; the pelike in Plovdiv (supra n. 31).
43. E.g. the oinochoe infra n. 45. An earlier example is on a pelike by the Pan Painter, once Basel, Münzen und Medaillen; *AntK* 20 (1977) I (advertisement).
44. E.g. stamnos, Vatican; *ARV*² 1039, 7; B. Philippaki, *The Attic Stamnos* (Oxford 1967) pl. 54, 2; the pelike in Athens (supra n. 42). Perhaps the latest bearded kithara-player is the Pan Painter's (supra n. 43).
45. Villa Giulia 5250; *ARV*² 1212, below, 1; A. Lezzi-Hafter, *Der Schuwalow Maler* (Mainz 1976) pl. 146.
46. Leningrad 17295; *ABV* 410, below, 2.
47. The awarding of prizes for musicians of gold and silver is also confirmed by Aristotle, *Ath. Pol.* 60.3.
48. See Davison 38; Vos 124.
49. Nike sitting on hydria: chous, Munich 2471; *ARV*² 1324,39; *CVA* Munich 2, pl. 88, 4. Nike bringing hydria (and amphora): pelike, Athens N. M. 1183; *ARV*² 1123, 1; *JdI* 32 (1917) 66, fig. 35.
50. Boston 96.719; *ARV*² 1107, 6; *JdI* 94 (1979) 65, fig. 17.
51. On the costume of the kithara-player, see Maas and Snyder (supra n. 1) 58–59.
52. This led Vos (128) to speculate that from the time of Perikles the aulodic contest was open *only* to small boys, but this seems unlikely and is indeed contradicted by the evidence of *IG* II² 2311. The athletic victors on Panathenaic prize amphoras of the later fifth century also look noticeably younger than in the Archaic period.
53. Pelike, London E 354; *ARV*² 1119,5; *JdI* 76 (1961) 69. The column in the background suggests an indoor setting, no doubt the Periclean Odeion.
54. Singer in front: e.g. pelike, Leiden RO II 60; *ARV*² 1084, 16; *CVA* Leiden 3, pls. 135–36; column-krater, Ferrara T. 392; *ARV*² 1104, 8; S. Aurigemma, *La necropoli di Spina in Valle Trebbe* (Rome 1960) pl. 225. Side by side: the London pelike (supra n. 53).
55. E.g. neck-amphora, Naples SA 225; *ARV*² 553, 32; *JdI* 76 (1961) 68, fig. 24; pelike, London 1910.6–15.1; *ARV*² 1123, 2; *JHS* 41 (1921) pl. 7, V 4. The Naples neck-amphora, by the Pan Painter, is pre-Periclean in date (ca. 460), while the London pelike, by a "very late mannerist" (Beazley), may be dated in the 430s.

56 See Wegner (supra n. 33) 72; Vos 126, who notes that Pollux 4.83 refers to synaulia held at the Panathenaia.

57 Agora P 27349; R. R. Holloway, "Music at the Panathenaic Festival," *Archaeology* 19 (1966) 112–19.

58 See I. Scheibler, "Bild und Gefäss," *JdI* 102 (1987) 57–118 *passim*, on the red-figure amphora of the Classical period. As Scheibler shows, most examples seem from their subject matter to have special, usually religious associations.

59 Larisa, Archaeological Museum 86/101; fully published by M. A. Tiverios, *Perikleia Panathenaia* (in Greek) (Athens 1989).

60 Tiverios (supra n. 59) 128–34 (141–42 summary in English).

61 London B 141; *CVA* British Museum 1, pl. 6, 1a-b.

62 New York 1989.281.89; *AntK* 30 (1987) pls. 8, 3 and 9, 1–2. Cf. the Princeton Painter's other amphora of Panathenaic shape with a ritual for Athena: New York 53.11.1; *ABV* 298, 5; see p. 25, fig. 14.

63 Bonn 43; *AA* 1935, 453, fig. 31.

64 E.g. the black-figure pelike Palermo 156; unpublished but mentioned by D. von Bothmer in *JHS* 71 (1951) 42, no. 3. A neck-amphora with aulodes on both sides has them once facing, once side by side, apparently just for the sake of variety: London B 188; *CVA* British Museum 3, pl. 45, 10.

65 The bema is occasionally dispensed with altogether, even in scenes that unmistakably show a Panathenaic agon, e.g. an amphora of Panathenaic shape once in the Hope Collection: E. M. W. Tillyard, *The Hope Vases* (Cambridge 1923) pl. 5, 27 (the vase is now Manchester III H52; *Paralipomena* 151, 3). The performer is an aulete who stands on the ground between two listeners.

66 Bearded: pelike, Sydney 47.07; unpublished but described by A. D. Trendall, *A Handbook to the Nicholson Museum* (Sydney 1948) 278; 282. Beardless: amphora of Panathenaic shape, Leningrad; *ABV* 396, 10; *AA* 1912, p. 340, fig. 24.

67 Louvre G 103; ARV^2 14, 2; on the scene and the inscriptions see now H. Giroux, "Trois images de l'éducation grecque," in *Mélanges d'études anciennes offerts à Maurice Lebel* (Quebec 1980) 94 and 101, fig. 5; Shapiro 42–43.

68 The most famous instance of this is the Corinthian Chigi vase of ca. 630: Villa Giulia 22679; E. Simon and M. Hirmer, *Die griechischen Vasen* (Munich 1976) pl. VII.

69 Berlin inv. 3151; *ABV* 79–80; U. Gehrig, A. Greifenhagen, and N. Kunisch, *Führer durch die Antikenabteilung* (Berlin 1968) pl. 48.

70 Braunschweig 241; *CVA* Braunschweig 1, pl. 6, 2. On the ependytes and its Eastern origins, see M. C. Miller, "The *Ependytes* in Classical Athens," *Hesperia* 58 (1989) 313–29, esp. 315 on the use of the garment by auletes. On the costume of the flute-player, see also Vos 126. She also makes the interesting observation (128) that the elaborate costume is limited to solo auletes. Flutists who accompany aulodes and are thus in a subsidiary role wear more modest outfits.

71 Athens N. M. 559; *ABV* 85, middle, 1.

72 "A Proto-panathenaic Amphora in the National Museum at Athens," *AJA* 42 (1938) 495–505.

73 E.g. M. Wegner, *Musikgeschichte in Bildern: Griechenland* (Leipzig n.d.) 70, gives a date of ca. 560, though he does take the scene to show a musical agon, for which I see no evidence. The festive dress of the musician need not refer to a contest.

74 The contests for kitharodes at Delphi were far older, if we can believe an anecdote reported by Pausanias in the same passage (10.7.2), that Hesiod was barred because he was unable to accompany himself on the kithara.

75 This is suggested by the iconographical evidence, which does not show flute-players in scenes of mourning for the dead. See my comments on this point in "The Iconography of Mourning in Athenian Art," *AJA* 95 (1991) 633–34, n. 28.

76 See E. L. Bowie, "Early Greek Elegy, Symposium and Public Festival," *JHS* 106 (1986) 27–34. He estimates that a poem of 1,000 to 2,000 lines would be the right length for performance in an agon.

77 London 1971.11.1; *Paralipomena* 19, 16*bis*; D. Williams, "Sophilos in the British Museum," in *Greek Vases in the J. Paul Getty Museum* I (1983).

78 The columns are topped by cocks on the side with the kitharode, but by sphinxes on the other side, depicting Herakles and the Lion. A full publication will appear in *Greek Vases in the San Antonio Museum of Art*, ed. H. A. Shapiro and C. A. Picon (San Antonio, in press).

79 On the occasional absence of the bema in contest scenes, see supra n. 65 and fig. 59.

80 Geneva HR 84; J. Chamay and D. von Bothmer, "Ajax et Cassandre par le peintre de Princeton," *AntK* 30 (1987) 58–68 and pl. 7.

81 Cf. the red-figure amphora (supra n. 50) where the goddess attends a Panathenaic kitharode.

82 On the tripod as victor's trophy or prize in Archaic art, see I. Scheibler, "Dreifussträger," in *Kanon* (Festschrift E. Berger, *Antk* Beiheft 15, 1988) 310–15. Like the tripod, the bronze cauldron (*lebes*) was a standard prize from the time of Homer (e.g. at funeral games), and by the sixth century can have this symbolic meaning. Thus, for example, a black-figure neck-amphora pairs a kitharode between listeners, on one side, with a striding Athena between columns, on the other: Berlin F 1873; *CVA* Berlin 5, pl. 38. The columns are topped by *lebetes*, an allusion to the victory of the musician without, however, implying that his prize actually took this form.

83 London B 260; *CVA* British Museum 4, pl. 64, 1.

84 London B 139; *ABV* 139, 12. Here Beazley included the vase with those "near Group E," but in *Paralipomena* 57 he removed it from this area. *CVA* British Museum 1, pl. 5, 3.

85 Louvre G1; ARV^2 3, 2; Wegner (supra n. 33) 67, fig. 38.

86 Basel BS 491; *JdI* 76 (1961) 50, fig. 2. For other examples of this motif in the Andokides Painter's work, see Schauenburg, *ibid*. 49–51.

87 Bologna PU 199; *ABV* 393, 14; *CVA* Bologna 2, pl. 25, 4.

88 Palinuro; *BdA* 33 (1948) 341, fig. 9 A-B.

89 Kassel T.675; *AA* 1966, 102, fig. 11.

90 E.g. column-krater, Louvre CP 11282; *CVA* Louvre 12, pl. 182, 5; neck-amphora, London 1926.6-28.7; *ABV* 375, 211; *CVA* British Museum 4, pl. 61, 4b. The reverse of the latter vase shows Athena fighting the giant Enkelados, a subject with strong Panathenaic associations, since it was woven into the peplos. One wonders if this scene was meant to reflect the subject of the kitharode's song. For other possibilities along these lines, see T. B. L. Webster, *Potter and Patron in Classical Athens* (London 1972) 161–62.

91 a. New York 56.171.38; ARV^2 197,3; *Bulletin of The Metropolitan Museum of Art* 31 (1972) fig. 17. b. New York 1985.11.5; *Metropolitan Museum of Art. Recent Acquisitions 1985–86*, p. 9. c. Montpelier 130;

*ARV*² 197, 10; *Les Vases à memoire* (Lattes 1988) no. 100. d. Leningrad 612; *ARV*² 198, 23; A. A. Peredolskaya, *Krasnofigurnye Attischeskie Vazy* (Leningrad 1967) pl. 29, 1–2. e. Formerly Hunt Collection; *Wealth of the Ancient World* (Ft. Worth 1983) no. 10.

92 D. Schafter, "Musical Victories in Early Classical Vase Paintings," (abstract of paper) *AJA* 95 (1991) 333–34.

93 P. de la Coste-Messelière, *Au Musée de Delphes* (Paris 1936) pl. 14. See, most recently, H. Knell, *Mythos und Polis: Bildprogramme griechischer Bauskulptur* (Darmstadt 1990) 18–23. On the identity of this figure, and of a third who may have been beside them, see F. Schoeller, *Darstellungen des Orpheus in der Antike* (Freiburg 1969) 12–13.

94 Black-figure oinochoe, Villa Giulia; *ABV* 432, 3; P. Mingazzini, *Vasi della collezione Castellani* (Rome 1930) pl. 82, 6.

95 Cf. supra n. 90.

96 See K. Zimmermann, "Tätowierte Thrakerinnen auf griechischen Vasenbildern," *JdI* 95 (1980) 163–96.

97 For the fifth century we are only slightly better off. We have the name of one Phrynis, who is said to have won as kitharode in the archonship of Kallimachos (446), probably the first year of contests in Perikles' Odeion (Scholiast on Aristophanes, *Clouds* 969). One Classical kitharode about whom we are well-informed is Timotheos, who came to Athens from Miletos and caused a sensation with his lyric "nomes," one of which survives. See Herington (supra n. 30); Maas and Snyder (supra n. 1) 62. The contest for kitharodes may have continued well into the Hellenistic period: see G. R. Edwards, "Panathenaics of Hellenistic and Roman Times," *Hesperia* 26 (1957) 346, no. 41 and pl. 84.

98 We may compare the career of the rhapsode Kynaithos, a native of the island of Chios, who performed in Syracuse at the end of the sixth century. See W. Burkert, "Kynaithos, Polykrates, and the Homeric Hymn to Apollo," in *Arktouros*, Festschrift Bernard Knox (Berlin 1979) 53–62.

99 On the prizes for kitharodes, see supra p. 58. One indication of the success of kitharodes is the discovery on the Akropolis of two dedications, probably made after victories at the Panathenaia, about 500, by men who identify themselves as kitharodes. See Raubitschek, nos. 84 and 86. Raubitschek speculates that the dedications, of which only parts of the inscribed bases are preserved, could have been either statues of the dedicators or bronze tripods.

100 On the dress of the kitharodes, see the pioneering study of M. Bieber, "Die Herkunft des tragischen Kostüms," *JdI* 32 (1917) 15–104.

101 On Apollo Delphinios, see Shapiro 60–61.

102 K. Schauenburg, "Herakles Musikos," *JdI* 94 (1979) 49–76. He counts 38 vases showing Herakles as musician, mostly as kitharode.

103 E.g. the black-figure neck-amphora London B 228; Schauenburg (supra n. 102) 57, fig. 11.

104 E.g. the neck-amphora Munich 1575; *ABV* 256, 16; *JHS* 95 (1975) pl. 4b.

105 The neck-amphora Worcester 1966.63; *New England* 48–49, no. 19.

106 Cf. J. Boardman, "Herakles, Peisistratos and Eleusis," *JHS* 95 (1975) 10–11, who considers the scenes of Herakles as kitharode in the light of his theory of Peisistratid influence in shaping Herakles' image in the sixth century. To explain Herakles' sudden appearance as a musician, Beazley once suggested that a poem composed for the Panathenaia would have narrated how the hero became a lover of music: *The Development of Attic Black-Figure* (Berkeley 1951) 76.

107 W. Burkert, "The Making of Homer in the Sixth Century B.C.: Rhapsodes versus Stesichoros," in *Papers on the Amasis Painter and his World* (Malibu 1987) 51.

108 On the poet and his activities as a kitharode, see M. L. West, "Stesichorus," *Classical Quarterly* 21 (1971) 302–14.

109 Pausanias 2.22.7 refers to a poem of Stesichoros on Theseus and Helen. For a survey of the poet's subjects, see P. Brize, *Die Geryoneis des Stesichoros und die frühe griechische Kunst* (Würzburg 1980).

110 Plutarch, *De Musica* 1132C. Stesichoros as solo performer: B. Gentili, *Poetry and its Public in Ancient Greece*, trans. A. T. Cole (Baltimore 1988) 122 with n. 11; West (supra n. 108) 309; with chorus: Brize (supra n. 109) 12–13; Burkert (supra n. 107) 51.

111 For Stesichoros and art, see Brize (supra n. 109) and M. Robertson, "Geryoneis: Stesichoros and the Vase-Painters," *Classical Quarterly* 19 (1969) 207–21.

112 André Emmerich Gallery, *Art of the Ancients* (New York 1968) no. 17.

113 Sydney 47.07; supra n. 66.

114 Harvard 1977.216.2397; *CVA* (Fogg Museum) pl. 21, 3.

115 [Plato] *Hipparchos* 228B. On the authenticity of the dialogue, see H. Leisegang, in *RE* (1950) s.v. Platon 2367. There seems to be an allusion to the same events in the fourth century orator Lykourgos, *Against Leokrates* 102: "Our forefathers passed a law that only Homer's epics be performed by rhapsodes at the Panathenaia."

116 I have discussed this passage and its ramifications at greater length in "Hipparchos and the Rhapsodes," in *Cultural Poetics in Archaic Greece*, ed. L. Kurke and C. Dougherty, forthcoming.

117 See Johnston (supra n. 38); Parke 35.

118 See Burkert (supra n. 107) 48; G. Tarditi, "Sull' origine e sul significato della parola rapsodo," *Maia* 20 (1968) 137–45.

119 For recent views of Homer and oral poetry, see *Classical Antiquity* 9 (1990) 311–56 (Forum on Oral Poetics, Papers in Honor of Albert B. Lord, by M. W. Edwards, R. Janko, and M. N. Nagler). On the question of how Homer performed his own poems and how others peformed them, see M. L. West, "The Singing of Homer and the Modes of Early Greek Music," *JHS* 101 (1981) 113–15.

120 On this passage, see most recently E. Cingano, "Clistene di Sicione, Erodoto e i poemi del Ciclo tebano," *Quaderni Urbinati di Cultura classica* 49 (1985) 31–40. As the title of this paper implies, the author believes that what the Sikyonian rhapsodes were performing was not the Homeric poems, but the Theban Cycle. In either case, epic diction often used "Argives" as a synonym for "Greeks."

121 A. Ford, "The Classical Definition of Rhapsodia," *Classical Philology* 83 (1988) 303.

122 The Panathenaia was probably not the only Athenian festival at which rhapsodes performed. Plato, *Timaeus* 21B, refers to rhapsodic contests at the Apatouria, a festival celebrated by the Athenian phratries in honor of several divinities, and a late source (Suda, s.v. Brauronia) mentions rhapsodes performing at Brauron, the sanctuary of Artemis in eastern Attika.

123 On the Homeridai, see Burkert (supra n. 107) 49.

124 One source (Aelian, *Varia Historia* 13.14) even says that the rhapsodes performed such episodes.

125 This general approach was pioneered by W. Zschietschmann, "Homer und die attische Bildkunst um 560," *JdI* 45 (1931) 45–60. I have

126. considered this issue at greater length in "Les rhapsodes aux Panathénées et la céramique à Athénes à l'époque archaique," in *Actes du Colloque Culture et Cité* (Brussels 1992), forthcoming.

126. See K. Friis Johansen, *The Iliad in Early Greek Art* (Copenhagen 1967) esp. 224–25; R. Kannicht, "Poetry and Art: Homer and the Monuments Afresh," *Classical Antiquity* 1 (1982) 70–86.

127. Surveys of the depiction of these subjects in the art of the sixth century can be found most readily in K. Schefold, *Götter- und Heldensagen in der griechischen Kunst der spätarchaischen Zeit* (Munich 1978).

128. See J. Griffin, "The Epic Cycle and the Uniqueness of Homer," *JHS* 97 (1977) 39–58.

129. For modern views on the composition of the Homeric poems and the place of "Homer" in oral tradition, see A. Parry, ed., *The Making of Homeric Verse* (Oxford 1971) ix–lxii; and, most recently, the papers cited in n. 119.

130. This process was by no means concluded by Hipparchos' rules. Nearly a century later, for example, there were some who claimed that the *Kypria* (telling the origins of the Trojan War) was by Homer, though Herodotus (2.117) rejected this.

131. The figure most often illustrated and discussed in the context of rhapsodes is on the Kleophrades Painter's fine neck-amphora London E 270; ARV^2 183,5; *CVA* British Museum 3, pl. 8,2; cf. Vos 122–23. There are, however, stronger arguments for his being an aulode, accompanied by the flutist on the other side of the vase, which I have presented in detail elsewhere (supra n. 116).

132. Oldenburg, Stadtmuseum; Oldenburger Stadtmuseum, *Städtische Kunstsammlungen: Griechische Vasen und Terrakotten* (Oldenburg 1978) no. 13.

133. Dunedin E 48.226; *ABV* 386,12; *CVA* New Zealand 1, pl. 17.

134. Liverpool, National Museums and Galleries on Merseyside 1956.19.18. I have illustrated this vase and discussed it at greater length elsewhere (supra nn. 116 and 125).

135. On musicians without platforms, see supra n. 65.

136. Supra, p. 62.

137. The criticism is even harsher in Xenophon's *Symposion* 3.6, where Sokrates accuses the rhapsodes of being the stupidest of men, because they don't understand the meaning of the poetry they have memorized.

138. Shapiro 125–26.

The Panathenaic Games: Sacred and Civic Athletics

1. This essay concentrates on the Greater Panathenaia in the sixth and fifth centuries; see Kyle *passim* on Athenian athletics in general.

2. Valuable bibliographies include N. B. Crowther, "Studies in Greek Athletics," Parts I & II, Special Survey Issues, *Classical World* 78.5, 79.2 (1985); and T. F. Scanlon, *Greek and Roman Athletics: A Bibliography* (Chicago 1984). Historiographic discussions include D. C. Young, *The Olympic Myth of Greek Amateur Athletics* (Chicago 1984); my "The Study of Greek Sport — A Survey," *Echos du monde classique: Classical Views* 27 n.s. 2 (1983) 46–67; and my "Directions in Ancient Sport History," *Journal of Sport History* 10 (1983) 7–34 on works from 1972–1982, updated by Crowther, "Recent Trends in the Study of Greek Athletics (1982–1989)," *L'Antiquité classique* 59 (1990) 246–55.

3. This is not to deny Gardiner's great contributions, especially in *GAS* and *AAW*, but to caution readers about his ideological subjectivity; see Young (supra n. 2), especially 76–82, and my "E. Norman Gardiner and the Myth of the Decline of Greek Sport," in D. G. Kyle and G. D. Stark ed., *Essays on Sport History and Sport Mythology* (College Station, Texas 1990) 7–44.

4. E. Segal in forward to W. E. Sweet, *Sport and Recreation in Ancient Greece. A Sourcebook with Translations* (Oxford 1987).

5. Telling signs of growth and respectability include the initiation by Yale University Press of its Sport and History Series with Poliakoff as editor; and the publication of new sourcebooks: Sweet (supra n. 4) and S. G. Miller, *Arete. Greek Sport from Ancient Sources*, second and expanded edition (Berkeley 1991). Notable also is the inclusion of three articles on Greek sport in the 1991 volume of *JHS*.

6. H. W. Pleket, "Games, Prizes and Ideology. Some Aspects of the History of Sport in the Greco-Roman World," *Stadion* 1 (1975) 49–89; Young (supra n. 2). On the ongoing debate over the sociology of Greek athletes, see below 97–98.

7. S. G. Miller ed., *Nemea* (Berkeley 1990); C. Morgan, *Athletes and Oracles. The Transformation of Olympia and Delphi in the Eighth Century B.C.* (Cambridge 1990); W. J. Raschke ed., *The Archaeology of the Olympics. The Olympics and Other Festivals in Antiquity* (Madison 1988). These three works are discussed in my "Athletes and Archaeology: Some Recent Works on the Sites and Significance of Ancient Greek Sport," *International Journal of the History of Sport* 8 (1991) 270–83.

8. Poliakoff, *passim*; also see T. F. Scanlon, "Greek Boxing Gloves: Terminology and Evolution," *Stadion* 8–9 (1982–83) 31–45. D. Sansone, *Greek Athletics and the Genesis of Sport* (Berkeley 1988) *passim*; see my review in *Journal of Sport History* 15 (1988) 356–61.

9. E.g. C. Bérard et al., *A City of Images. Iconography and Society in Ancient Greece* (Princeton 1989); W. R. Connor "Tribes, Festivals and Processions: Civic Ceremonial and Political Manipulation in Archaic Greece," *JHS* 107 (1987) 41: "These works often see ceremony as part of the symbolic expression of civic concerns and as a difficult to read but ultimately eloquent text about the nature of civic life. . . ."

10. E.g. J. J. MacAloon ed., *Rite, Drama, Festival, Spectacle. Rehearsals Toward a Theory of Cultural Performance* (Philadelphia 1984); Paul Connerton, *How Societies Remember* (Cambridge 1989).

11. E.g. W. Decker, *Sports and Games of Ancient Egypt* (New Haven 1992); J. Puhvel, "Hittite Athletics as Prefigurations of Ancient Greek Games," in Raschke (supra n. 7) 26–31.

12. Poliakoff 18–19.

13. E.g. the thirteenth-century funerary larnax from Tanagra (Thebes, Arch. Mus. 1; *Mind and Body* no. 13), with scenes of a funeral, chariot racing, and bull-leaping.

14. See A. Mallwitz, "Cult and Competition Locations at Olympia," and also cf. Hugh M. Lee, "The 'First' Olympic Games of 776 B.C.," both in Raschke (supra n. 7) 79–118. Morgan (supra n. 7) 46–48, 89–92 agrees with Mallwitz.

15. Peer-polity: C. Renfrew, "The Minoan-Mycenaean Origins of the Panhellenic Games," in Raschke (supra n. 7) 19–25. Interstate: Morgan (supra n. 7) 191–234.

16. H. A. Thompson, "The Panathenaic Festival," *AA*, 1961, 228–31; Lynn E. Roller sees civic athletic festivals (related to hero cults) superseding the old tradition of funeral games at Athens; see her "Funeral Games for Historical Persons," *Stadion* 7 (1981) 1–18. Also see Morgan (supra n. 7) 205–12.

17 Pantakles: Kyle A53 (references such as A53 or P100 are to entries in Kyle Appendix B: "Catalogues of Known and Possible Athenian Athletes"); Phrynon: Kyle A68; Kylon: Kyle A40.

18 See D. G. Kyle, "Solon and Athletics," *Ancient World* 9 (1984) 91–105.

19 See Neils supra pp. 20–21, or Kyle 24–29.

20 G. Ferrari, "Menelas," *JHS* 107 (1987) 180–82, discussing a Protoattic stand from Aegina, revives the idea of possible contests (choruses and horse races) in the pre-566 festival. See Kyle 22–24.

21 Raubitschek, nos. 326–28.

22 N. Robertson, "The Origin of the Panathenaea," *Rheinisches Museum für Philologie* 128 (1985) 295, associates the tyranny in 527–510 with the embellishment of the Academy with a wall, widening of the road to the Akropolis, and an altar of Eros at the entrance to the Academy as the start of a Lemnian-style torch race—all of these being related to changes in the Panathenaic program dating probably no later than the mid-sixth century. Shapiro (141 n. 190) properly sees Brandt's argument (from surviving datable Panathenaic prize vases) for stagnation of the Panathenaia under Peisistratos and revival under his sons as "extremely hazardous."

23 W. K. Pritchett, *The Greek State at War* Part III (Berkeley 1979) 154: "Much of the life of the ancient Greek world is lost to us if we do not understand that festivals and games with their mixture of piety, patriotism and merrymaking, holy day and holiday alike, are central facts of ancient corporate religion."

24 Robertson, (supra n. 22) 239–40, studies analogies between the mythology and rituals of the Panathenaia and other festivals (e.g. the Hellotia at Marathon and Corinth) and declares that, "Festivals of Athena were agonistic, and the games have a military flavour; there are processions under arms, contests in manliness, horse races and the like, just as in the Panathenaea. We may suppose that festivals of the warlike Athena were as uniform and long established as festivals of Demeter the corn goddess . . . of Apollo the patron of public assemblies."

25 General introductions on training include M. I. Finley and H. W. Pleket, *The Olympic Games: The First Thousand Years* (London 1976) 83–97; and O. Tzachou-Alexandri, "The Gymnasium: An Institution for Athletics and Education," in *Mind and Body* 31–40.

26 See the important discussion of this athlete in Young (supra n. 2) 95–98.

27 On these and other Athenian trainers, and on issues related to training at Athens specifically, see Kyle 137–39, 141–45.

28 E.g. Plato, *Republic* 3.404a; Aristotle, *Politics* 1335b; see below, pp. 99–101, on critics.

29 On Athenian athletic facilities, see Kyle 56–101; more generally, see S. L. Glass, "The Greek Gymnasium: Some Problems," in Raschke (supra n. 7) 155–73.

30 For a thorough discussion of the introduction and significance of Greek athletic nudity, see M. McDonnell, "The Introduction of Athletic Nudity: Thucydides, Plato and the Vases," *JHS* 111 (1991) 182–93. Also see N. B. Crowther, "Athletic Dress and Nudity in Greek Athletics," *Eranos* 80 (1982) 163–68; and L. Bonfante, "Nudity as a Costume in Classical Art," *AJA* 93 (1989) 543–70.

31 M. Golden, *Children and Childhood in Classical Athens* (Baltimore 1990) 60–61. In general, see K. J. Dover, *Greek Homosexuality* (Cambridge, Mass. 1978) 138 and *passim*.

32 For example, on Leagros as *kalos* and as an athlete, see Kyle P100 on 222–23 and n. 120 below.

33 J. Delorme, *Gymnasion* (Paris 1960) 9, 23–26, connected the rise of gymnasia and gymnastic training with the spread of hoplite warfare, but cf. Kyle 64–66. Poliakoff 94–103 sees athletics as at best an indirect preparation for warfare. Also see T. S. Brown, "Herodotus' Views on Athletics," *Ancient World* (1983) 17–29.

34 See Kyle 40–48.

35 On the program after 566, see Neils, p. 15. Herein I generally follow the sequence of athletic events as suggested by Johnston in *BSA* 82 (1987) 125–29; some differences are noted below.

36 For an essential discussion of Panathenaic vases, see Neils, supra pp. 29–31; my concern herein is with the earliest examples showing the existence of each event, and with notable or unusual vases. Excellent bibliographic surveys of Greek events are available in Crowther and Scanlon (supra n. 2). Also see appropriate sections of Gardiner *GAS* and *AAW*; Harris *GAA*; and R. Patrucco, *Lo sport nella Grecia antica* (Florence 1972). On combat sports, see Poliakoff and his *Studies in the Terminology of the Greek Combat Sports*, 2nd ed., (Beiträge zur klassischen Philologie 146, Königstein/Ts 1986). On equestrian events, see J. K. Anderson, *Ancient Greek Horsemanship* (Berkeley 1961); H. A. Harris, *Sport in Greece and Rome* (London 1972) 151–71; and J. H. Humphrey, *Roman Circuses* (Berkeley 1986) 5–12. On Panathenaic events: Kyle 178–94; Gardiner *GAS* 229–45; *Mind and Body* 41–46; A. Mommsen, *Feste der Stadt Athen im Altertum*, 2nd ed. (Leipzig 1898) 69–89; L. Ziehen, s.v. Panathenaea, in *RE* 18.3 (1949) 474–86.

37 Sansone (supra n. 8) 80–83.

38 For a chronology of the introduction of Olympic (and Pythian) events, see Miller (supra n. 5) 203. As *Mind and Body* 41 points out, Greek tradition held that the oldest events at Olympia were gymnastic but that the oldest at Athens were equestrian.

39 E.g. H. A. Harris, "Stadia and Starting Grooves," *Greece & Rome* 7 (1960) 25–35; S. G. Miller, "Lanes and Turns in the Ancient Stadium," *AJA* 84 (1980) 159–66.

40 Neils, supra pp. 41–42. E.g. Halle inv. 560 (*ABV* 120, Brandt no. 2) by a painter near Lydos of around 560 with a men's *stadion* scene (inscribed *andron*) probably is a prize but the prize inscription is not preserved; Munich 1451 (Brandt no. 26) depicts four runners and has a painted inscription labeling it for the victor in the men's *stadion*.

41 A fragment of a mid-sixth-century amphora bears an inscription declaring itself the prize for the *diaulos*, Athens N.M. 2468 (*ABV* 69, 1, *Mind and Body* no. 139). Pindar, *Olympian*, 13.38–39, may refer to the Panathenaic stadion or pentathlon. Johnston (supra n. 35) suggests a sequence from *IG* II² 2311 of dolichos, stadion, diaulos, as in later inscriptions; see S. V. Tracy and C. Habicht, "New and Old Panathenaic Victor Lists," *Hesperia* 60(1991) 196–97. Cf. Plato *Laws* 8.833a-b. The *hippios* was a middle distance race of four stades, known for Athens, Isthmia, Nemea, Argos and elsewhere (Pausanias 6.16.4; Bacchylides 9. 25); Harris *GAA* 65. It is not extant in *IG* II² 2311 but Johnston is open to its possible addition. Alkmeonides possibly won such a race at Athens around 550; see Kyle A6.

42 E.g. Bologna 11 (*ABV* 409, 1); cf. Vulci, Castello (*Paralipomena* 115, 27bis, Brandt no. 29). Some prizes (e.g. Vatican 375 [*ABV* 408, 3]; Amsterdam 1897 [*ABV* 322, 8]) appear to depict youths, but it is uncertain when separate races for boys and youths were introduced.

43 For extensive discussion, see J. Ebert, *Zum Pentathlon der Antike* (Berlin 1963). G. Wadell, "The Greek Pentathlon," *Greek Vases in the J. Paul Getty Museum* 5 (1990) 99–106, urges more use of the testimony of vase-painting. For recent theories on scoring, see Sweet (supra n. 4)

56–59 and "A New Proposal for Scoring the Greek Pentathlon," *Zeitschrift für Papyrologie und Epigraphik* 50 (1983) 287–90; my "Winning and Watching the Greek Pentathlon," *Journal of Sport History* 17 (1990) 291–305; and Donald F. Jackson, "Philostratos and the Pentathlon," *JHS* 111 (1991) 178–81. A major crux is the value of Philostratus' (On *Gymnastics* 3) story of the invention of the pentathlon by Peleus. I reject and Jackson tries to vindicate Philostratus on the pentathlon, but we both reject earlier theories involving points and lots in favor of our own modifications of Harris' system of elimination.

44 *IG* II² 2311 lines 26–28, 41–43. Olympia introduced the boys' pentathlon in 628 but immediately dropped it. Since Delphi introduced it in 586 and retained it, Delphi was probably Athens' model in this respect.

45 Agora P 2071; *Agora* 23, no. 228; Brandt no. 17. On the victory around 550: Raubitschek, no. 317.

46 On the standard composition of elements in pentathlon scenes, see Neils, supra p. 35. E.g. London B 134 (*ABV* 322, 1; *Paralipomena* 156, 7bis; Brandt no. 35, *Mind and Body* no. 168), Leiden PC 8 (*ABV* 322, 2), Vatican 374 (*ABV* 344, Brandt no. 63), London B 136 (Brandt no. 61).

47 Single acontist: London B 605 (*ABV* 411, 4). Single diskobolos: Naples RC 184 (*ABV* 409, 3), Tolmeia (*Libya Antiqua* 8 [1971] 74–75 pls. 27–28). See also Copenhagen 13812 (*CVA* Copenhagen 8 pl. 318, 1).

48 On the terminology and rules, see Poliakoff 23–53 and above n. 36.

49 The earliest prize amphora with wrestlers, from around 540 and attributed to Exekias, is Karlsruhe 65.45 (*Paralipomena* 61, 8bis), here figs. 20 and 22. Also see Naples 112848 (*ABV* 403, 1; Brandt no. 75).

50 It can be difficult to distinguish boys from youths; e.g. Athens N. M. 451 (*Mind and Body* no. 162). Boys' wrestling is shown for the sixth century by Taranto 12220 and 12217 (Brandt no. 57 a+b)—if the fragments are from the same vase.

51 *IG* II² 2311 lines 29, 44; *IG* II² 3131; see Kyle A52.

52 For these and other examples from the *Greek Anthology*, see Sweet (supra n. 4) 258–62.

53 Poliakoff 68–93.

54 Akropolis 1054 (*ABV* 403, 3), Mississippi 1977.3.S9 (*ABV* 410, 4), Leningrad 12553 (*ABV* 411, 2). Brandt no. 82 adds Erlangen I 517a.

55 E.g. Louvre F 278 (*Paralipomena* 156, 7 ter, Brandt no. 69), Berlin 1833 (*ABV* 407, 1); *IG* II² 2311 lines 32, 47.

56 See Poliakoff, 54–63. For a suggestion about the placement of judges in pankration scenes, see Neils, supra p. 35.

57 Poliakoff, ill. 29.

58 E.g. New York 16.71 (*ABV* 404, 8), Leiden PC 6 (*ABV* 404, 9); Cambridge, Corpus Christi (*ABV* 405, 2); London B 604 (*ABV* 413); London B 610 (*ABV* 417). Brandt 21 identifies no sixth-century Panathenaics with the pankration, but he feels the event probably was held. Labeled: Naples 81294; see p. 41, fig. 26.

59 In placing the hoplite race after the pankration, I follow Johnston, as well as the probable sequence at Olympia, as in J. Swaddling, *The Ancient Olympic Games* (London 1980) 37. A. Snodgrass, *Archaic Greece. The Age of Experiment* (London 1980) 152–53 suggests that the introduction of the hoplite race at Olympia in 520 (Pausanias 5.8.10) reflects changes in hoplite armor and tactics and a concern for increased mobility. On athletics and military training, see above p. 82.

60 Prize vases: Compiègne 986 (Brandt no. 65); Naples 81293, Milan market (Brandt 47); and London B143. Akr. 921 (*ABV* 300,16 & 314; Brandt no. 22) of around 540 lacks a prize inscription but Brandt accepts it as an official prize. Bologna PU 198 (*ABV* 322, 5) is erroneously restored; see Neils, p. 196, n. 21. See also cat. 46.

61 E.g. London B 608 (*ABV* 417,1); Paris, Louvre MN 704 (*ABV* 415, 12).

62 Gardiner *GAS* 285; Harris *GAA* 74–75.

63 A Panathenaic amphora of around 530, Madrid 10901 (*CVA Madrid* 1, pl. 27, 2a–2b; Yalouris, *Olympics*, fig. 142) appears to depict a *hoplomachia* or a mock fight, but Brandt 9 n. 5 and Neils, supra p. 40, feel this cannot be a prize vase despite its inscription.

64 Plato *Laches* 181e–183d; *Gorgias* 456d. See also *Laws* 8.833e and Wheeler (below n. 99).

65 In fact, Davies' study of the economic elite of Athens accepts equestrian competition as proof of a family's wealth; see J. K. Davies, *Athenian Propertied Families* (Oxford 1971) xxv–xxvi and especially n. 7 on xxv for the proverbial association of horse-raising and wealth.

66 *Clouds*, lines 21–22; Miller (supra n. 5) 51.

67 On the political use of equestrian competition, see Kyle 160–61, 166–68.

68 Alkibiades: see Kyle 163–65 and A4. Agesilaos of Sparta encouraged his sister, Kyniska, to enter a team in the Olympic chariot race (probably in 396) to show that the event required money but not skill from the owner; see Miller (supra n. 5) 100.

69 The location of the *apobates* in the program is uncertain. Johnston (supra n. 35) 127 restores it in *IG* II² 2311 between the hoplite race and the horse race. This is attractive in that the apobates would be highlighted in the center of the program and offer a transitional event between gymnastic and equestrian events. Neils, p. 15 follows Robertson (supra n. 22) 266 in placing it after the sacrifice and before the boat race (i.e. on day seven). Perhaps the apobates should have been with the other closed or tribal contests, but it is not listed before the boat race on the prize list, which breaks off after the boat race.

70 Harpokration (s.v. apobates) incorrectly says only Athens and Boiotia had this race; cf. Demosthenes 61.25. The Amphiaraia at Oropos included such an event; see the partial relief of ca. 400 in *Mind and Body* no. 186.

71 As a Mycenaean relic and military anachronism: Demosthenes 61.25; Gardiner *GAS* 237–38; Robertson (supra n. 22) 239; Parke 43. W. Burkert, *Greek Religion* (Cambridge 1985) 233 feels the ritual event recalls king Erichthonios' taking possession of his land. *Apobatai* are known from Geometric vases; see E. Simon, M. Hirmer, and A. Hirmer, *Die griechischen Vasen* (Munich 1976) 39.

72 Erichthonios: *Marmor Parium*, 17–18; Pseudo-Eratosthenes *Ktasterimoi* 13; Hyginus *Poetica Astronomica* 2.13 adds that Erichthonios himself competed in the chariot race. See Gardiner *GAS* 237–38; Thompson (supra n. 16) 228; E. Reisch, s.v. *RE* I, 2 (1894) 2814–17; Patrucco (supra n. 36) 382–84; Yalouris, *Olympics*, 246–47. For a recent survey of apobatai in sculpture and vase-painting, see N. B. Reed, "A Chariot Race for Athens' Finest: The *Apobates* Contest Re-Examined," *Journal of Sport History* 17 (1990) 305–307. Also see N. B. Crowther, "The Apobates Reconsidered (Demosthenes lxi 23–9)," *JHS* 111 (1991) 174–76, who independently reaches some of the same conclusions as Reed.

73 Robertson (supra n. 22) 266–67 also suggests that other festivals beyond Athens shared myths of Athena inventing the chariot (*Homeric*

Hymn to Aphrodite, 13) or driving her chariot in the gigantomachy (Pausanias 8.47.1).

74 Demosthenes *Erotikos* 61.24–25; trans. N. W. De Witt and N. J. De Witt (Cambridge, Mass. 1949).

75 K. Schneider, *RE* 10.2 (1919) 1760–61 s.v. *kalpes dromos*.

76 Dionysius of Halicarnassus *Antiquitates Romanae* 7.73; *Anecdota Graeca*, ed. I. Bekker vol. 1, 426.30 ff. Reed (supra n. 72) 308, 316 and Crowther (supra n. 72) make suggestions about the technique of the event from Demosthenes 61.28–29. However, I suggest caution in using this romantic, *topos*-laden piece. For example, rather than corresponding to the realities of warfare, as Demosthenes 61.29 says, as noted above, the apobates clearly was militarily anachronistic. Also see infra n. 127 on slaves.

77 Dual victories are suggested for Larisa (*IG* IX² 527 lines 8–11; see Raschke [supra n. 7] 227) and the Amphiaraia at Oropos (*IG* VII 414 line 66; B. Petrakos, *O Oropos kai tou Hieron tou Amphiaraou* [Athens 1968] no. 47 line 34); and Reed (above n. 72) 306 follows Gardiner *GAS* 238 in assuming the same for the Classical Panathenaia; but the apobates and *heniochos ekbibazon* appear on second-century Panathenaic lists as separate events; see Tracy and Habicht (supra n. 41) 198. Johnston (supra n. 35) 129 suggests a single prize of 30 and six vases (for first and second place, as in the two-horse chariot race). Demosthenes (61.25, 28) vaguely refers to "the greatest prizes" and the "crown." Charioteers and jockeys had long been used to win victories in the games (e.g. Pindar *Pythian Ode*, 5.50) for the owners of the horses without themselves being proclaimed victors.

78 Xenophon *Hipparchicus* 3.10 mentions a hippodrome, but some events probably remained in the Agora; see Kyle 95–97. Second-century inscriptions (*IG* II² 2316 line 16, 2317 line 48) refer to apobatai descending at the Eleusinion, where the topography increasingly hinders horses and chariots; see *Agora* 14, 121; and Tracy and Habicht (supra n. 41) 198.

79 See M. Robertson and A. Frantz, *The Parthenon Frieze* (New York 1975), North Frieze slabs XIII–XXII, figs. 48–66, South Frieze slabs XXV–XXXII, figs. 61–80.

80 Reed (supra n. 72) 312, 316 feels that figures in sculpture with spears are definitely not apobatai; she explains apobatai with spears in vase-paintings as "artistic license." Demosthenes (61.25–26) contends that apobatai competed nude and practised (running?) in the gymnasia.

81 Agora S399: T. L. Shear, "The Sculpture Found in 1933, Relief of an Apobates," *Hesperia* 4 (1935) 379–81; *Agora* 14, 121, pl. 66a; *Mind and Body* no. 187. The top of the base has a rectangular socket that probably held the prize, but the nature of the prize remains uncertain.

82 Malibu, J. Paul Getty Museum 79.AE.147. See Heidelberg 242 (*CVA* Heidelberg 1, pl. 38.4).

83 D. Bell, "The Horse Race (*KELES*) in Ancient Greece from the Pre-Classical to the First Century B.C.," *Stadion* 15 (1989) 167–90.

84 E.g. Nauplion I (*ABV* 260, 27, Brandt no. 28; *Mind and Body* no. 197); New York 07.286.80 (*ABV* 369, 114; Brandt no. 71), London B 133 (*ABV* 395, 1); Toronto 919.5.148(350) (*ABV* 395, 2); Berlin 1833 (*ABV* 407, 1); Warsaw 142346 (*ABV* 408, 2); Leningrad 1510 (*Paralipomena* 127, Brandt no. 60); Louvre F 274 (Brandt no. 58).

85 Herodotus 6.103; see Kyle A34, A55, 158–59.

86 Mythical funeral games appear on a fragment by Sophilos (*ABV* 39, 16, here fig. 5) and on the François vase (*ABV* 76, 1).

87 E.g. Florence 97779 (*ABV* 110,33; Brandt no. 20); New York 56.171.4 (*ABV* 291; Brandt no. 55); Taranto Inv. 4595 (*ABV* 369, 113; Brandt no. 73), Basel, Cahn (Brandt no. 70); Louvre F 273 (Brandt no. 81).

88 Raubitschek, no. 174.

89 J. D. Beazley, *The Development of Attic Black-figure* rev. ed. (Berkeley 1986) 106 n. 7. T.B.L. Webster, *Potter and Patron in Classical Athens* (London 1972) 195 and Davison 27 see the animals as horses. See Neils' discussion above, p. 34.

90 *IG* II² 2311 lines 52, 55; *IG* II² 3126 records the *synoris* for the Greater Panathenaia and possibly the Eleusinia in the fourth century.

91 London B 131 (*ABV* 405, 4) (mules), London B 132 (*ABV* 405, 5) (possibly mules). *Mind and Body* no. 184 sees horses on London B 131, but Harris (above n. 36) ill. 67 sees mules.

92 Swaddling (above n. 59) 71 suggests the introduction at Olympia may have been influenced by Sicilians.

93 Many more military horse events are known from second-century inscriptions: *IG* II² 2316, 2317; on these inscriptions and the military horse events, see M. A. Martin, *Les cavaliers athéniens* (Paris 1887) 226–33; Gardiner *GAS* 235–38; Patrucco (supra n. 36) 380–82; and now Tracy and Habicht (supra n. 41), especially 199–201.

94 Photius *Lexicon polemites hippos*.

95 Patrucco (supra n. 36) 382; E. Preuner, "Amphiaria und Panathenaia," *Hermes* 57 (1922) 90–91.

96 Fourth-century examples: *ABV* 414, 1(?), 417, 2(?). Cf. Parthenon West Frieze, slab IX; an Attic red-figure lekythion of around 400 (Athens N. M. 1631: *Mind and Body* no. 95); cf. also the fourth-century silver drachma of Larisa in Gallis in Raschke (supra n. 7) fig. 13.1. This was never a Panhellenic event but it was held at the Heraia at Argos; see B. A. Sparkes, "Quintain and the Talcott Class," *AntK* 20 (1977) 8–25.

97 Kyle 189–90; G. R. Bugh, *The Horsemen of Athens* (Princeton 1988) 59–60.

98 Cf. Gardiner *GAS* 245, who says that although the Panathenaia had "a considerable number of local events, these were of quite secondary importance in comparison with the open competitions which, if hardly Panhellenic, were certainly Pan-Ionic."

99 J.-Cl. Poursat, "Les représentations de danse armée dans la céramique attique," *BCH* 92 (1968) 550–615; "Une base signée du Musée national d'Athènes: Pyrrhichistes victorieux," *BCH* 91 (1967) 102–10; E. L. Wheeler, "Hoplomachia and Greek Dances in Arms," *Greek, Roman and Byzantine Studies* 23 (1982) 223–33. Cf. the armed dances in Xenophon *Anabasis*. 6.1.5–3.

100 G. Pinney, "Pallas and Panathenaea," *Proceedings of the 3rd Symposium on Ancient Greek and Related Pottery* (Copenhagen 1988) 468; cf. a dancer with a short chiton, helmet and shield on an Attic black-figure pelike, Athens, N. M. 455 (*Mind and Body* no. 73). Poursat (supra n. 99) 566–83 suggests pyrrhic dancers can be recognized by their nudity and their equipment (shield, spear, helmet).

101 *IG* II² 3025; Athens, Akr. 1338 (*Mind and Body* no. 101) of the 320s; see also Athens, N. M. 3854 (*Mind and Body* no. 100) discussed in Poursat (supra n. 99).

102 *IG* II² 2311 line 75; *Anecdota Graeca*, ed. I. Bekker, vol. 1, 257.13; Xenophon *Memorabilia*, 3.3.12; Suda s.v. *euandria*. On contests in beauty (*kallisteria*, e.g. the *agon kallous* at Elis) in which victors got to perform rituals or hold honorary places in processions, see N. B. Crowther, "Male Beauty Contests in Greece: The Euandria and

Euexia," *L'Antiquité classique* 54 (1985) 285–91 and Robertson (supra n. 22) 250. Crowther 286–87 clarifies that *kallisteria* were distinct from euandria and euexia "which are indeed athletic in that they required training and performance and were found at local agonistic festivals alongside the more traditional events." Also see Crowther's "Euexia, Eutaxia, Philoponia: Three Contests of the Greek Gymnasium," *Zeitschrift für Papyrologie und Epigraphik* 85 (1991) 301–04.

103 J. K. Davies, "Demosthenes on Liturgies: A Note," *JHS* 87 (1967) 36, notes that the event was tribal but that in *IG* II² 3022 a fourth-century victor presents himself as an individual winner. Showing that the event was financed liturgically, Pseudo-Andokides (4.42) refers to a man claiming victories in the euandria, torch race, and tragedies.

104 Crowther (supra n. 102) 288. Cf. Parke 36–37: "From Xenophon's allusions it is shown that large size and strength were qualities which scored points: but what tests and demonstrations the competitors had to undergo we do not know."

105 The classic expression of this attitude is Homer's depiction of the lowly but obstreperous Thersites as physically inferior and ugly in *Iliad* 2.212–19.

106 N. Reed, "The *Euandria* Competition at the Panathenaia Reconsidered," *Ancient World* 15 (1987) 59–64 makes an ingenious but unconvincing argument that the euandria "involved some demonstrations of skill with two shields and in armed combat." See cat. 46.

107 *ABV* 236; Gardiner *GAS* 243. M. R. McGettigan (*AJA* 94 [1990] 304) argues that the so-called Lambros oinochoe (Louvre CA 2509) of around 750–725 depicts a line of armed men performing a dance that includes acrobatic movements. She points out that in Homer (*Iliad* 18.593–605) on the shield of Achilles a pair of acrobats led dancers, including young men wearing golden daggers, but Homer's setting for the scene is Knossos.

108 On Athenian torch races: Parke 23, 37, 45–46, 171–73; L. Deubner, *Attische Feste* (Berlin 1932) 211–13; Simon 53–54; 63–64; G. Q. Giglioli, "La corsa della fiaccola ad Atene," *Rendiconti della Classe di Scienze morali, storiche e filologiche dell'Academia dei Lincei* 31 (1922) 315–35; and further bibliography in Crowther (above n.2) Part II, 76–77.

109 *Mind and Body* 44. Cf. Harris (above n. 36) 33 and Gardiner, *AAW* 143, who hesitate to accept the event as athletic.

110 V. Ehrenberg, *The People of Aristophanes*, 2nd ed. (Oxford 1943) 256, explains that the runners who came in last were thrashed; an old rite had become crude popular fun.

111 Scholiast (Hermias) on Plato *Phaedrus* 231e. Robertson (supra n. 22) 258–88, seeing the mythological origin as the birth and nursing of Erichthonios by Athena, suggests the rite was borrowed from Lemnos at some time in the sixth century. He postulates a transition from an early Prometheus-related processional fire-bringing (starting at the old altar of Prometheus in the Academy) to a sixth-century Hephaistos-related torch race.

112 Parke, 45–46, and Robertson, (supra n. 22) 283 suggest a possible tie to Peisistratos via the dedication of the altar of Eros by Charmos, possibly the tyrant's lover (Plutarch *Life of Solon* 1.7); but cf. Davison 29 n. 9.

113 *IG* I² 84 lines 6,33 of 346/345. Davies (above n. 103) 37 n. 55 discussing an emendation in the text of Pseudo-Xenophon *Ath. Pol.* 3.4. Simon 63–64 accepts annual torch races at the Lesser Panathenaia and suggests that the four youths with hydriai on the north frieze of the Parthenon are the annual victors carrying their prizes (metal hydriai).

114 Gardiner, *GAS* 230 puts the boat contest on the last day of the festival. If Johnston is correct in placing the apobates in the midst of the sequence of events in the fourth century, and Robertson is correct in arguing that the apobates originally and properly came last (after the sacrifice) (supra n. 69 above), then conceivably the boat race had displaced the apobates from last place on the program. This would be of social and military significance, but the question remains unanswerable.

115 Gardiner, *AAW* 241: "Of the details of the regatta we know nothing." R. J. Hopper, *The Acropolis* (New York 1971) 70 considers possible connections to the peplos-ship, Theseus, Poseidon, or Dionysus, as well as a possible association with the *thetes* to offset the *hippeis*, but "this is all purest conjecture." Early and still useful articles by P. Gardner discuss the relevant sources: "Boat-races at Athens," *JHS* 2 (1881) 315–7; "Boat-Races among the Greeks," *JHS* 2 (1881) 90–97; "A Stele Commemorating a Victory in a Boat Race," *JHS* 11 (1890) 146–50. See also Gardiner, *GAS* 221, 240–41; *AAW* 95–96. Gardiner, *GAS* 508, from much later depictions, feels that the boats used "probably were not triremes, but small boats with a single bank of oars, tender-boats . . . such as always accompanied a fleet." However, this seems inconsistent with the splendor of the Greater Panathenaia.

116 *Mind and Body* 45, following Gardiner, *AAW* 95–96. If the Old Oligarch's criticism (see p. 98) of common Athenians getting paid for "sailing" (*pleon*) refers to the boat race rather than the navy, then it was a sailing race involving many people and considerable expense.

117 Plato Comicus frag. 183 (A. Meineke, *Fragmenta Comicorum Graecorum* [1839–57] 2: 679) in Plutarch's *Life of Themistokles* 32.5; P. Wallace, "The Tomb of Themistocles in the Peiraeus," *Hesperia* 41 (1972) 451–62. Davies (above n. 103) 36 feels that Lysias 21.5 refers to the Panathenaic boat race, but the text mentions Sounion.

118 Nikoladas: J. Ebert, *Griechische Epigramme auf Sieger an gymnischen und hippischen Agonen* (Leipzig 1972) no. 26. Other non-Athenian victors at the Panathenaia: Pindar *Nemean Ode* 10.33–36; L. Moretti, *Iscrizioni agonistiche greche* (Rome 1953) 23 and *Olympionikai* (Rome 1957) no. 322; *Anthologia Palatina* 13.19. Non-Athenian victors at Athens, possibly at the Panathenaia: Pindar *Nemean Ode* 4.19, *Isthmian Odes* 2.20, 4.25, *Olympian Odes* 7.82, 9.88, 13.38–39; Moretti 12. For an argument that the discovery of prize vases in tombs in North Africa and South Italy indicates that these were burials of Panathenaic victors, see Neils, pp. 49–50.

119 In the Peloponnesian War Athens captured the famous pancratiast, Doreius of Rhodes, but released him even without a ransom (Xenophon *Hellenica* 1.5.19; Pausanias 6.7.4–5). However, earlier Athens had executed the pancratiast Timesitheus of Delphi in 508 for his involvement in Kleomenes' attempt to overthrow the new Kleisthenic democracy (Herodotus 5.72).

120 Lycurgus *Against Leocrates* 51 claims that, unlike other states, no victor statues stood in the Athenian Agora; cf. A. E. Raubitschek, "Leagros," *Hesperia* 8 (1939) 155–64 and E. D. Francis and M. Vickers, "Leagros Kalos," *Proceedings of the Cambridge Philological Society* 207 (1981) 97–136. The earliest catalogs of Greater Panathenaic victors are from the second century; see Tracy and Habicht (supra n. 41) for three new lists and a discussion of *IG* II² 2313–2317. Several dedications on the Akropolis were probably made by Panathenaic victors; e.g. a fifth-century inscribed dedication by Philaios (*Mind and Body* no. 154), possibly after a Panathenaic win. A "pseudo-Panathenaic" amphora (British Museum B144, *ABV* 307, 59, *Mind and Body* no. 198) celebrates a horse race win by Duneiketos, possibly in the Panathenaia ca.

530–525. Possible Panathenaic victors in the pentathlon include Kyle A6, A38 and P100.

121 Raubitschek no. 164; as Neils, notes (p. 14), this is the earliest extant (explicit) reference to the Greater Panathenaia. Another dedication (Raubitschek no. 21) was probably made by Kallias as a boy after a Panathenaic win ca. 480. On Kallias, see Kyle A29.

122 Raubitschek, 205–206, no. 174; Kyle A57; Davies (above n. 65) 12250=12251–12253; Bugh (above n. 97) 46.

123 See Kyle A4 and Neils, p. 50.

124 See Kyle A12. Athenaeus 5.187f refers to Xenophon's *Symposium* in which Kallias holds a party for his favorite, Autolykos. Later put to death by the Thirty Tyrants (Plutarch *Life of Lysias* 15.5), Autolykos was the son of Lykon. I. C. Storey, "The Symposium at *Wasps* 1299ff," *Phoenix* 39 (1985) 322–24 argues that this Lykon, as known from comedies, was not one of the accusers of Sokrates (cf. Plato *Apology* 24a) but was "a man of superior status and considerable prominence in the late 420s."

125 Cf. the different positions of Pleket (supra n. 6) 71–89 and "Zur Soziologie des antiken Sports," *Mededelingen van het Nederlandsch historisch Instituut te Rome* 36 (1974) 57–87; Young (supra no. 2) 147–62; and Kyle 102–23.

126 Young (supra n. 2) 115–27, 158–59; cf. my review in *Echos du Monde Classique. Classical Views* 29 n.s. 4 (1985) 134–42. Young's 1984 estimate of U.S. $67,000 (1980) is still higher than the (revised) estimate of $39,600 in Miller (supra n. 5) xi.

127 Although Olympic victories could be won only by Greek citizens, Crowther (above n. 72) 174 suggests, from Demosthenes 61.23, that slaves took part in athletic competition at Athens; see his "Slaves and Greek Athletics," forthcoming in *Quaderni urbinati di cultura classica*. Testimonia for the exclusion of slaves from gymnastic exercises (e.g. Aeschines 1.138; Aristotle *Politics* 1264a), possibly because of fear of pederastic activity, have usually been accepted; see Kyle (above n. 18) 99–101 and Golden (above n. 31) 60. The claim in Demosthenes 61.23–24 that "slaves and foreigners" competed sounds a lot like the younger Alkibiades' claim in Isokrates 16.33 that his father disdained gymnastic contests because some gymnastic athletes were "of low birth, inhabitants of petty states." Rather, Alkibiades' preference for socially exclusive chariot racing was politically opportunistic; see Kyle 136–37.

128 The tribal pyrrhic (in each of three classes), euandria and torch events all had the same prize, perhaps implying similar numbers of participants.

129 Gardiner, *GAS* 131.

130 H. M. Lee, "Athletic Arete in Pindar," *Ancient World* 7 (1983) 31–37.

131 J. Boardman, *The Parthenon and Its Sculptures* (Austin 1985) 12: "There was no real distinction between participants and viewers in the city's celebration of itself and its divine patron."

132 On critics, see Kyle 124–41.

133 See above 95–96. On the theme of athletic decline in Aristophanes, see Kyle (above n. 3) 30–32.

134 See Kyle 128–31. Euripides may have had a specific athlete in mind but, like Xenophanes, this fragment indicts general Greek, not specifically Athenian, customs.

135 He further censures the masses for expanding and enjoying athletic facilities: Pseudo-Xenophon *Ath. Pol.* 2.10.

136 *IG* I³, 131; Kyle 145–47.

137 I wish to thank Jenifer Neils for her gracious assistance with the vase-painting evidence, Elizabeth Bobrick for her thorough editing, and Nigel B. Crowther, A. E. Raubitschek and Stephen H. Hardy for their helpful suggestions.

The Peplos of Athena

1 See E. J. W. Barber, *Prehistoric Textiles: The Development of Cloth in the Neolithic and Bronze Ages* (Princeton 1991) for detailed descriptions of all these data and more.

2 Barber, 278–81. Although the Minoan scripts are undeciphered, we have deduced certain facts about the phonological and even morphological structure of the principal language, starting from such surviving vocabulary as place names. Clothmakers in the Near East were using entirely different types of looms, which required different terminology.

3 Perati: S. Iakovides, *Perati, to Nekrotapheion* (Athens 1969) 54, 56, 72–73, 76, 95–96, and pls. 15 and 23. Textile designs: Barber, 62–64, 311–57. Wool industry: J. T. Killen, "The Wool Industry of Crete in the Late Bronze Age," *BSA* 59 (1964) 1–15.

4 M. R. Popham, E. Touloupa, and L. H. Sackett, "The Hero of Lefkandi," *Antiquity* 56 (1982) 173; also Barber, 197, 348, figs. 15, 18–19 and Color Plate 3. The Lefkandi find (still not fully published) is by far the earliest patterned cloth yet to be found in Greece—the next preserved piece is fifth century, and after that Hellenistic.

5 For the evidence from vase-painting, see Barber, 365–79. The quotation from Plutarch is from *Moralia* 241d.

6 Barber, 358–59, 377–80.

7 See A. W. Gomme, *The Population of Athens in the Fifth and Fourth Centuries B.C.* (Oxford 1933) 42.

8 Xenophon, *Memorabilia*, 2.1–12. For further evidence see W. Thompson, "Weaving: A Man's Work," *Classical World* 75 (1982) 217–22.

9 G. D. Weinberg and S. S. Weinberg, "Arachne of Lydia at Corinth," *The Aegean and the Near East: Studies Presented to Hetty Goldman* (New York 1956) 262–67. Arachne's name, like that of Athena, is of pre-Hellenic (probably non-Indo-European) type—another indicator that the whole tradition associating Athena with weaving in the Aegean is Bronze Age or older, just like the technology.

10 Athena's birds may contain important clues to her history and nature as a deity associated with women's crafts. The owl appears frequently elsewhere, for instance on Athenian coins; and note her epithet "owl-eyed" in the passage quoted above from Hesiod. (It is often translated "bright-eyed" or "flashing-eyed," but has good company in Hera's zoomorphic epithet "cow-eyed.") She often appears or disappears as a bird—e.g. *Odyssey* 1.320. A bird-goddess is often represented in Neolithic European figurines all through the areas of southern Europe where the technology of the warp-weighted loom developed, and continues to this day in the peasant art and folklore of the area as the *rusalki, vily*, etc.—spirits of virgins who often appear (or disappear) as birds and who may help a woman with her spinning and increase the fertility of her farm if they like her. See e.g. J. Hubbs, *Mother Russia* (Bloomington 1988) 27–30; B. A. Rybakov, "The Rusalii and the God Simargl-Pereplut," *Soviet Anthropology and Archaeology* 6.4 (1968) 34–59.

11 Mansfield, 443. Some authors (e.g. Davison and Parke) feel that the peplos ceremony was of late invention, perhaps sixth century and perhaps copied from Hera's cult at Olympia. As will become clear below, there is a great deal of evidence from textile history suggesting that the ceremony is a remnant of the Bronze Age, in both locales.

12 Carding seems to have been invented some time after A.D. 1000, and the use of the English word "carded" in translating earlier documents is an anachronism.

13 See Barber, 260–82 for a complete semantic and etymological re-analysis of the basic Greek textile terms in light of the archaeological and ethnographic evidence.

14 C. M. Govi, "Il Tintinnabulo della 'Tomba degli ori' dell'arsenale militare di Bologna," *Archeologia Classica* 23 (1971) 211–35.

15 E.g. at Troy: Barber, 93, 110; for the shift to twill, see also E.J.W. Barber's review of J. Becker, *Pattern and Loom*, in *Archaeomaterials* 4 (1990) 210–12.

16 All these terms are from a borrowed root *as-* or *az-* referring to the warp of the warp-weighted loom. *Ex-* indicates the strange edge that "results" from the warping process, *dia-* refers to the "dividing" of the warp. In Attic Greek, *-ss-* regularly changes to *-tt-*.

17 Scholars have argued at length over what this folded cloth represents. I myself am not at all convinced by arguments that this cloth is *not* the peplos. The reason is simple and basic: there is no other cloth of signal importance involved in the festival and there is no other cloth represented. Whether it is the new peplos being handed over or the old one being taken down and put away is of course not provable, but the new one that the weavers had been working long and hard to make would seem, at this moment in the festivities, to be much more important than the old one.

18 Weinberg and Weinberg (supra n. 9); Barber, 105–06.

19 Killen (supra n. 3), 9.

20 See Barber, 374–76, for fuller discussion and illustration.

21 Barber, 365–80. See also J. L. Benson, *Horse, Bird and Man: The Origins of Greek Painting* (Amherst 1970).

22 Greek funerals, too, seem to have made use of ornate cloths at least back into Late Mycenaean times. I have laid out the case at great length elsewhere (Barber, 358–82), but one of the most interesting features was the practice of laying a story-cloth over the body during the funeral (sometimes as a coverlet, sometimes as a canopy) and eventually over the coffin. Pieces of such story-cloths have been found at the cemeteries of the Greek colonies along the Black Sea, where textiles are far more likely to be preserved than in Greece (Barber, figs. 7.11–13, 16.15). The painted scenes on the Klazomenian sarcophagi, on the Dipylon funeral vases, and perhaps on the Tanagra sarcophagi seem to be cheaper ways of accomplishing the same ritual ends.

23 Pausanias Attikistes, *Attikon Onomaton Synagoge*, quoted by Mansfield, 278, from "X 2, p. 219.24 Erbse." See Mansfield, 260–360, however, for a complete discussion of all the inscriptions and literary references to the arrephoroi (who were clearly young girls of high family, although the word itself is of unclear etymology), the ergastinai (who may or may not have been a subset of the four arrephoroi), and all the other women involved in making Athena's dress. Much of this literary material can also be found in E. Pfuhl, *De Atheniensium pompis sacris* (Berlin 1900); L. Deubner, *Attische Feste* (Berlin 1932) 9–36; and A. Michaelis, *Der Parthenon* (Leipzig 1871).

24 Mansfield, 279. His reference is to "II/III 2, 1036b [C. Hutton, *BSA* 21 (1914–16) 159], lines 5–6, and 1034, lines 7–8." The word for "young women" here is *parthenoi*.

25 Again, Mansfield (295, 366–404) has laboriously collected and interpreted all the inscriptions and references by ancient authors. See also J. P. Rhodes, *Commentary on the Aristotelian Athenaion Politeia* (Oxford 1981) 568 ff.

26 Strattis is quoted in full by Mansfield, 47: "fr. 30, I. p. 719 Kock, ca. 400 B.C., 'men uncountable haul this *peplos*, winching it with ropes, to the top of the mast, like a sail.'" He also collects all the inscriptions concerning donations of the ropes and tackle on pp. 71–74. The shape and design of the ship-float is disputed by scholars. See Pfuhl (supra n. 23), 8–11, and Deubner (supra n. 23), 29–34. In Roman times, at least, the boat was large enough to hold a number of dignitaries as it was pulled through the city.

27 This would be yet one more thank-offering to Athena for the salvation of Athens, in this case through the naval battle of Salamis. Everything in the Panathenaia appears to center around this common theme of salvation, from the cosmic gigantomachy (see Barber, 380–82, for a discussion of the Bronze Age origin of this myth) to the unfortunate Demetrios mentioned above.

28 Mansfield deals with the date of the ship-procession on 54, 68, 101, and with the weavers on 54–55, citing Zenobios (*Epitome Paroimion* 1.56) in addition to Aristotle and Athenaios (*Deipnosophistai* 2.48b—see below). He also points out that the weavers' names come respectively from words for needle (*akis*) and twisting or spinning thread (*helik-*).

29 Mansfield, 16–17, quoting from the Scholia Vetera on Aristophanes *Hippeis*, line 566.

30 Plautus, *Mercator* 66–68; also a similar fragment quoted by Servius. Cf. Mansfield, 15, 37. In his article "Athena's Robe," *Scripta Classica Israelica* 5 (1979–80) 28–29, David Lewis has proposed that the (large) peplos was presented to the Athena Parthenos in the Parthenon. Although the idea of her being dressed in it is virtually out of the question, one could easily imagine it being hung behind her as a magnificent backdrop, further saturating the temple with symbols of her antiquity and power.

31 Mansfield, 55.

32 See, for example, F. S. Greene, "The Cleaning and Mounting of a Large Wool Tapestry," *Studies in Conservation* 2 (1955) 1–16.

33 See Barber, fig. 3.26, 16.2–4, and 363–65 for lists of representations and actual surviving cloths.

34 H. Schrader et al., *Die archaischen Marmorbildwerke der Akropolis* (Frankfurt 1939) 79 and fig. 44. Note that chariot friezes like this can be traced in the artistic record back through the Geometric period and far beyond to the chariot craters of the Late Bronze Age. See also B. S. Ridgway, "The Peplos Kore, Akropolis 679," *Journal of the Walters Art Gallery* 36 (1977) 49–61, for an interesting assessment of the artistic license taken by sculptors in representing women's garments.

35 Dresden, Skulptursammlung 26; see M. D. Fullerton, *The Archaistic Style in Roman Statuary* (Leiden 1990) 50–53 for a discussion of the style.

36 The translation of the scholiast is quoted from Mansfield, 64, who cites as reference "Scholia 467, p. 47.5 Schwartz [Strattis, fr. 69, I, p. 731 Kock]." It is worth mentioning that the purple dye obtained from Mediterranean sea-snails (of the genera *Murex, Purpura, Thais* and

Nucella) varies in hue from red through lavender and purple to blue (see Barber, 228–29 for chemistry and ancient sources). Thus when Strattis describes the peplos as (saffron and) hyacinth in color, while a Latin author describes it as having designs in blood-red (Mansfield 65), we might still have the same prestigious dye-source being used.

37 N. Marinatos, *Art and Religion in Thera* (Athens 1984) 62–72.

38 A. Evans, *The Palace of Minos I* (London 1921) 506, fig. 364.

39 Athena's snake is to be seen in Pheidias' famous statue, crawling out from under her shield (which she has set down, now that the war is over and Victory is in her hand) as if to get safely back to the business of peacetime prosperity. Cf. C. J. Herington, *Athena Parthenos and Athena Polias* (Manchester 1955) 26.

40 Thus the Indo-European river god was very powerful while the Indo-Europeans lived on the steppes among huge rivers like the Volga, Don, Dniepr, and Danube, but he became so unimportant as to have been dropped entirely by the Greeks in favor of a sea god, also billed as "the earth-shaker," when they moved to a land of small rivers and ubiquitous seacoast in a major earthquake zone. Similar examples of this sort occur regularly in the mythologies of the world.

41 For Bronze Age textile economy, see Killen (supra n. 3), and Barber. For women's position in Bronze Age Aegean politics, see K. Atchity and E.J.W. Barber, "Greek Princes and Aegean Princesses," in K. Atchity, ed., *Critical Essays on Homer* (Boston 1987) 15–36. Cf. J. C. Billigmeier and J. A. Turner, "The Socio-economic roles of women in Mycenaean Greece: A brief survey from evidence of the Linear B tablets," in H. Foley, ed., *Reflections of Women in Antiquity* (New York 1981) 1–18.

Images of Athena on the Akropolis

NB: My references to Pausanias are taken from P. Levi's translation, *Pausanias, Guide to Greece* (Penguin Books 1971), and seem occasionally to be at variance with other numbering systems.

1 E. Simon, *Götter der Griechen*, (Munich 1980) 179 and n. 1 on p. 333, where she agrees with W. Burkert (*Griechische Religion der archaischen und klassischen Epoche* [Stuttgart 1977] 220) that the city's name comes first, although both derive from the same stem; on the Knossos tablets, see her p. 180 and n. 5; tablets from Pylos have *potinija* but not *atana potinija* as at Knossos. On the Mycenaean Athena, see also the discussion in *LIMC* II, s.v. Athena, p. 1016 (P. Demargne).

2 Monumental remains from the city of Athens seem to date earlier than those from the Akropolis; as a whole, the sanctuary on the citadel appears unimportant during the so-called Dark Ages, until the beginning of the Archaic period, when it becomes open to outside influences and imports. As a help to the reader, the types (and epithets) of Athena to be discussed in the course of this essay can here be listed as: Athena Polias (of the City), Promachos (Champion in Battle), Parthenos (the Maiden, or Virgin), Nike (Victory), Hygieia (Health), Ergane (the Worker). "Lemnia" is not a cultic epithet, but a reflection of the dedicants' geographical connection.

3 G. M. A. Richter, *Korai, Archaic Greek Maidens* (London 1968) figs. 23–24; R. M. Ammerman, "The Naked Standing Goddess: A Group of Archaic Terracotta Figurines from Paestum," *AJA* 95 (1991) 220 and n. 73. Other early dedications are the terracotta figurines found within the Nike Bastion, but these are now apparently lost, and their proposed date is uncertain, ranging from the Mycenaean period to the Archaic: see *LIMC* II, s.v. Athena, 958 no. 13; Travlos, 151 fig. 201.

4 C. Nylander, "Die sogennanten mykenischen Säulenbasen auf der Akropolis in Athen," *Opuscula atheniensia* 4 (1962) 31–77.

5 Aristophanes, *Lysistrata*, lines 641–642; cf. Mansfield, 145 and n. 47 on pp. 167–68 with further refs. For a discussion of the iconographic implications of this epithet, see J. H. Kroll, "The Ancient Image of Athena Polias," *Hesperia* Suppl. 20 (1982) 69–70. For sources on the ancient image, see Mansfield, 135–37 and notes 1–9 on pp. 150–53. The Greek adjective *Polias* is in its feminine form, different from the masculine form *Polieus*.

6 On the Washing festival, the Plynteria, see the entire discussion in Mansfield, 371–78, with citation of relevant sources. Wooden idol and Erichthonios: Apollodorus 3.14.6; and Kekrops: Pausanias 1.26.6. Festival instituted by Theseus: Pausanias 8.2.1, perhaps the same as Thukydides 2.15.2; by Erichthonios: Harpokration, s.v. Panathenaia.

7 Mansfield, 139, 144–49, 185–88; see 140–44 for garments. The possible dates of the inventories are 375/4; ca. 365; ca. 340/39. The *esthetes* (sacred garments) that Mansfield lists as separate from the other items could perhaps be a comprehensive term for all clothing worn by the goddess; some dedications, like the sheer robe (*xystis*) dedicated by Pharnabazos in the 380s, may have been temporary rather than a permanent part of the statue's wardrobe.

8 Mansfield, 137, accepts a standing figure, as argued by Kroll (supra n. 5); but he disagrees with Kroll's attribution of its more naturalistic features to a reworking by Endoios around 550: see Mansfield, "Supplementary Note 7," 168–74. I would also doubt such reworking, not necessarily on the same grounds as Mansfield, but because of the venerability of the image, which would have made it "untouchable." For an objection that the coins show too articulated a figure to represent a shapeless Polias with added garment, see A. A. Donohue, *Xoana and the Origins of Greek Sculpture* (Atlanta 1988) 143–44 n. 343.

9 *LIMC* II, s.v. Athena, nos. 20–21, pls. 704–05; note that the entry on the Athena Polias is *LIMC* II, Athena no. 17, included among the representations of the seated goddess, with commentary on p. 1017.

10 Mansfield, 135–36, and notes 12–15; Plutarch, *Life of Themistokles* 10.7.

11 Parke, 38–41; D. Lewis, "Athena's Robe," *Scripta Classica Israelica* 5 (1979–1980) 28–29; see the objections in Mansfield, 43–45. Parke's suggestion could be taken to mean that the peplos was just offered to, not draped on, the Athena Parthenos. Yet it was certainly read with the second meaning by G. T. W. Hooker, in his review of Parke's book, *JHS* 98 (1978) 191–92. Lewis (op.cit.) expands on this interpretation, by pointing out that the large peplos is attested before the Parthenos was stripped of its gold by Lachares, and that therefore the presumed change in size of the votive garment was not motivated by the need for clothing the despoiled image. He suggests that the ancient vesture rite was probably transferred to the new statue as soon as the Parthenon was finished.

12 Mansfield, 46–50, 68–78. If Ptolemy II Philadelphus, on suggestion by Kallias of Sphettos, could consider it appropriate for him to donate the *hopla* (ropes) for the peplos in 278/7, the royal gift should have been substantial, even if largely symbolic as stressed by T. L. Shear, Jr., *Kallias of Sphettos* (*Hesperia* Suppl. 17, 1978) 41. The large size of the Panathenaic ship, at least in Roman times, has now been confirmed by the discovery that a structure near the Athenian stadium is in fact the place mentioned by Philostratos (*Bioi Sophiston* 2.556) where the boat built by Herodes Atticus was moored after the Greater Panathenaia of A.D. 138/9. The announcement was made by Jennifer

Tobin at the Annual Meeting of the Archaeological Institute of America, December 1990, and her findings are summarized in the *Newsletter of the American School of Classical Studies at Athens* 27 (Spring 1991) 5. The structure was traditionally considered Herodes' tomb, but its dimensions, 42 x 9.50 m., make it unlikely for a grave, and compare well with the shipsheds in Peiraeus that measure 37 x 6 m.

N. J. Norman, "The Panathenaic Ship," *Archaeological News* 12 (1983) 41–46, argues that the ship became an element of the Panathenaia only during the Hellenistic period, originating perhaps with Demetrios Poliorketes, but her points are refuted by Mansfield. The apparent small size of the ship-cart on the so-called Calendar Frieze in Athens is made irrelevant by the abbreviated formulas used by the frieze, and by its Hellenistic/Roman date: Norman, 43 fig. 3; E. Simon, "Attische Monatsbilder," *JdI* 80 (1965) 105–23; Simon, pls. 1–3 for the entire frieze.

13 The 2.0–2.50 x 1.80–2.30 m. suggested by Mansfield, 137, are at best a rough estimate.

14 On ancient tapestries, see Mansfield 58–65 and 8–9; further bibliography on pp. 119–20. A thorough discussion of ancient weaving in historical times can be found in the last chapter of Barber, esp. 360–62. Although she follows the traditional version of a single peplos at the Panathenaia, see her essay in this volume pp. 103–117 for technical arguments supporting Mansfield's theory.

15 These passages are quoted from Barber, who also acknowledges (n. 5 on p. 362) that Giants and Titans, although generationally distinct, are often mentioned indiscriminately as equivalent by the ancient sources. Mansfield includes similar references, but seems more concerned with the scholiasts' comments, perhaps conflating information, than with the actual verses. See also infra n. 32.

16 Dresden Athena, with aegis and gorgoneion, but also with shield, spear, and Attic helmet with sphinx crest holder: M. D. Fullerton, *The Archaistic Style in Roman Statuary* (Mnemosyne Suppl., Lciden 1990) 50–53 and n. 37, 70, cats. 1–3, 78–79, figs. 18–20; A.-M. Zagdoun, *La sculpture archaïsante dans l'art hellénistique et dans l'art romain du Haut-Empire* (Paris 1989) 58–60, no. 172, figs. 21–24. Both authors allude to the Panathenaic gigantomachy, but consider the decorated paryphe atypical for true Archaic sculpture. Yet *painted* ornaments, including figured scenes, are known from Archaic marble korai (see, e.g. Richter, supra n. 3, *passim*) and Attic vases: see, e.g. Boardman, *ABFV*, figs. 56 and 63.2. If the decoration of the Panathenaic peplos/robe was confined to the paryphe, it would not have been impossible for a garment of regular size to be completed within a year, as was required by the annual recurrence of the Lesser Panathenaia. The much larger and more elaborate peplos/tapestry probably required the full four-year span to be prepared, even if by professionals.

That complex mythological scenes on costumes could appear as early as the Archaic period is shown also by a large Daedalic terracotta figurine of a goddess from Magna Graecia, whose dress is decorated in relief with scenes that include Ajax carrying Achilles' body: P. Zancani Montuoro, *Atti e Memorie della Società Magna Grecia* ns. 11–12 (1970–71) 67–74. The Archaic bronze statuette from the Akropolis, Athens N. M. 6450, to be discussed infra, p. 130 and note 39, also exhibits a decorated costume. A series of racing chariots was painted as the border of the chiton sleeve on Euthydikos' Kore, Akr. 686: H. Schrader, E. Langlotz, W.-H. Schuchhardt, *Die archaischen Marmorbildwerke der Akropolis* (Frankfurt am Main 1939) fig. 44 on p. 79; Richter (supra n. 3) 100 (no. 180). Cf. also Boardman, *ABFV*, fig. 53, where the female figure is not wearing a decorated paryphe, but rather a figured costume with an apron-like garment covering it partially from behind. I owe these vase-painting references to Jenifer Neils.

The two bronze replicas of the Dresden type do not show the decorated paryphe, which was probably omitted because of the greatly reduced scale (0.118 m. for the one from Athens in London).

17 Barber, 380–82, and esp. n. 14, on the fire element in the Panathenaia. Such traces of much earlier events in later stories are not impossible; in fact, all ancient mythologies seem to retain the memory of a devastating flood that virtually extinguished the human race.

18 I have derived this information primarily from Mansfield; especially useful is his distinction between the cleaning of the Polias and the procession to Phaleron of the statue "at Palladion," a sanctuary outside the walls of Athens probably near the Ilissos river: pp. 424–33, with collection of all the ancient references. This latter statue is referred to as the "Pallas" and was believed to be the Trojan Palladion; it will be mentioned infra pp. 129–30.

19 Barber, esp. 358–60 and 377–80.

20 See, e.g., most recently, A. Stewart, *Greek Sculpture: An Exploration* (New Haven 1990) 129–30. C. K. Williams, II, "Doric Architecture and Early Capitals in Corinth," *AM* 99 (1984) 67–75, esp. 71 and n. 20. The lowering trend was started by K. Stähler, "Zur Rekonstruction und Datierung des Gigantomachiegiebels von der Akropolis," *Festschrift H. E. Stier* (Münster 1972) 88–112.

Herodotus (5.72) could be referring to this temple when he mentions that Kleomenes, the Spartan king, when on the Akropolis, wanted to enter the cella to pray, but was turned away by the priestess. The episode, datable to 508/7, implies the presence of the wooden statue in the temple, or prayers could have been offered outside at the altar. See, on this passage, F. Preisshofen "Zur Topographie der Akropolis," *AA* 1977, 74–84, esp. p. 82.

21 This point has been recently reiterated by Nancy Klein, in a 1991 Ph.D. Dissertation for Bryn Mawr College on the development of the early Doric cornice. For earlier statements, see, e.g. the emphatic assertion by W.-H. Schuchhardt, quoted by H. G. Niemeyer (infra n. 39) 108 n. 14.

22 See, e.g. Preisshofen (supra n. 20).

23 H. Catling, *JHS, Archaeological Reports* 35 (1989) 8–9.

24 W. B. Dinsmoor, "The Hekatompedon on the Athenian Acropolis," *AJA* 51 (1947) 109–51, esp. p. 128 and n. 93 for his acceptance of Dörpfeld's Opisthodomos theory, and for the survival date until 353; cf. also his n. 4 for reference to traces of a temporary shrine for the image erected in 478 and "mentioned by implication in the inventories and accounts of 409/8."

25 G. Roux, "Pourquoi le Parthénon?" *Comptes rendus des séances de l'Académie des inscriptions et belles-lettres* 1984, 301–17; he summarizes previous theories and shows how unlikely Dörpfeld's supposition appeared, even when first advanced, causing unheeded rebuttals. Inscriptions mentioning the Opisthodomos are, e.g. *IG* I² 91, lines 15–18; 92, lines 52–56; 139, line 17; 324, line 20.

26 This information is given as part of the "Chronique des Fouilles," *BCH* 112 (1988) 612. The "Erechtheion" is generally thought to be by Kallikrates, on stylistic inferences: see I. M. Shear, "Kallikrates," *Hesperia* 32 (1963) 375–424, and, most recently, U. Schädler (infra n. 30).

27 Travlos, 213–27; cf. also his "The interior arrangement of the

Erechtheion," *Athens Annals of Archaeology* 4 (1971) 77–84. For the emendation of the inscription and the crucial reading "prostoion," rather than the restored "prostomiaion," see infra n. 28. Note also that the name Erechtheion occurs in only two sources: Pausanias, 1.26.5, and Plutarch, *Moralia* 843E, as cited by U. Schädler (infra n. 30).

28 K. Jeppesen, *The Theory of the Alternative Erechtheion* (Aarhus 1987), which includes reprints of his initial articles in *AJA* 83 (1979) 381–94, and *AJA* 87 (1983) 325–33, with discussion of the inscription. Mansfield, "Supplementary Note 10," 245–52, on the location of the Erechtheion; cf. also pp. 198–244, on the Temple of Athena Polias—he advocates a division of the west area into antechamber (prostoion) and main chamber by means of a north-south wall containing the two doors mentioned in the inscription, and would thus eliminate the need for an east-west crosswall in the west cella proper; he assumes that the difference in the height of the orthostats along north and south wall respectively would not affect the even level of the floor. The interior of the building is presently so damaged by the Byzantine church later housed in it that little can be observed with accuracy.

29 Mansfield, "Supplementary Note 6," 174–77. Although I do not follow him in all his theories and interpretations, I am also convinced by Mansfield's objections (236–37, n. 30) to O. Palagia's suggestion that the niche in the west chamber contained the famed Kallimachos' lamp: "A Niche for Kallimachos' Lamp?" *AJA* 88 (1984) 515–21.

30 This location of the image invalidates also a recent theory that, in defense of the traditional interpretation for the structure, focuses on patterns of anthemion decoration as elements of cultic articulation. Since five variations can be distinguished in the rendering of the floral moldings around the temple, each type is thought to isolate a specific unit, of which the north porch and wall would be one, separate from the area of the Polias which employs a different design: U. Schädler, "Ionisches und Attisches am sogenannten Erechtheion in Athen," *AA* 1990, 361–78; see esp. fig. 2 on p. 365, which gives the pattern code for the various areas, and pp. 375–76 attempting to justify Pausanias' procedure in visiting the building. The observed variations are, however, so slight that they fall easily within the range permissible in an ancient building, especially since the modern notion requiring perfect symmetry from side to side has been undermined by recent architectural studies; Greek masons seem to have changed and improved on forms as they worked along. Such an intentional exterior reminder of interior arrangements would moreover be unprecedented. More specifically, according to the published diagram, the same anthemion pattern extends from the north porch to the north anta of the east façade, thus taking up part of Athena's cella by all accounts; if any differentiation was indeed meant, it stressed wall and side, not a building unit.

31 G. Ferrari (Pinney), "Pallas and Panathenaea," in *Ancient Greek and Related Pottery* (Copenhagen 1988) 467–77.

32 Aristotle, cited in a scholion to Aristeides' *Panathenaikos* 189,4; W. Dindorf, *Aristides* 3 (1829) 323 = Aristoteles fr. 637, ed. V. Rose (Stuttgart 1967). See also a second scholion to the same work, on 197,8 (Dindorf 342–43). The link between the Panathenaia and Athena dancing over the destruction of the Titans is provided by Dionysios of Halikarnassos, 7.72.7. For the ancient confusion between the Giants and the Titans, see F. Vian, *La guerre des géants* (Paris 1952) 249–50.

33 Shapiro, 38.

34 The Pheidian statue is called "Promachos" only by the scholiast to Demosthenes, *c. Androt.* 13 = J. Overbeck, *Die antiken Schriftquellen* (1868) 642. Other ancient writers on the same monument refer to it simply as the bronze Athena; an epigram in the *Anthologia Lyrica Graeca* III (Overbeck 644) is addressed to Athena *enoplos*, suggesting that she need no longer be armed, and may be describing an actual image. Pausanias, in discussing the Pheidian statue (1.28.2), does not give it an epithet, although he mentions a Herakles Promachos in white stone at the Herakleion in Thebes (9.11.2), and a Hermes Promachos at Tanagra (9.22.2). A search through the Ibycus computer files confirms that the word can be used as a personal name (one of the Epigonoi, for instance, was "Promachos, son of Parthenopaios"; there was an athlete, "son of Dryon"), or as an adjective for heroes (often, those involved in the Trojan War), or even for Christ in Christian sources. Since the epithet means Champion, it could apply to different gods (Ares, Dionysos, and, of course Athena are attested) and statue types without implying a specific pose. It is well to realize the limits (and the dangerous implications) of modern conventions, especially since the influential *LIMC* (II, s.v. Athena, pp. 1020 and 1029–30) continues to reserve the title for the fighting image, although accepting a possible derivation from the Palladion, through animation of the static pose.

35 Initial classification by H. G. Niemeyer, *Promachos* (Waldsassen, Bayern 1960) and "Attische Bronzestatuetten der spätarchaischen und frühklassischen Zeit," *Antike Plastik* 3 (1964). The chronological revision is by H. Herdejürgen, "Bronzestatuette der Athena, *AntK* 12 (1969) 102–10: Athens N.M. 6457 is her pl. 47.4; the statuette in Basel, her pl. 45; the argument against the statuary prototype for the Panathenaic amphoras is on p. 109. For an additional statuette of the relevant type in a private collection, see C. Rolley, "Statuette d'Athéna Promachos," *Revue archéologique* 1968, 35–48. He comments on Niemeyer's classification, noting that different physical types can occur simultaneously, and that it is difficult to make close comparisons between bronze statuettes and marble statuary.

36 It should be noted, however, that goddesses brandishing spears cannot always be identified as Athena: terracotta votives in various sanctuaries, especially of Magna Graecia, show that Hera and Aphrodite would differ from Athena only in wearing a polos rather than a helmet. Hera *hoplosmia* is attested iconographically at Argos, Elis, Croton and probably at Samos; both iconographically and epigraphically at Paestum. Literary sources mention the armed Aphrodite at Sparta, Corinth, Kythera and Cyprus. Ammerman (supra n. 3), 229–30 and notes 148–49 for Hera, p. 230 and n. 151 for Aphrodite; cf. her fig. 23 on p. 230. If my perception that Athena alone wears a helmet is correct, then the Gortyn figure mentioned by Ammerman could not be Aphrodite: cf. *LIMC* II, s.v. Athena, no. 34, p. 961, pl. 707, although the presence of the helmet is queried; but see Simon, *Götter* (supra n. 1) 188 figs. 169–70, for the terracotta restored with the helmet found nearby. On the other hand, Athena need not wear a helmet at all times, but stephane and even polos seem equally appropriate for the goddess, who is then identified through other attributes.

37 Note also the equally narrative marble plaque with Athena fighting a giant, Akr. 120 (*LIMC* II, s.v. Athena, no. 124, pl. 717) as well as the many terracotta reliefs from the Akropolis (at least 45 examples in fragments) showing the goddess mounting a chariot, perhaps as an allusion to the gigantomachy: *LIMC* II, no. 176, pl. 724, and cf. the black-figure plaque with the same subject, no. 175, same plate. For a free-standing Archaic group of Athena and a giant, see Schrader (supra n. 16) 288–90, no. 413, pls. 161–62.

38 Collected by Mansfield, loc. cit. (supra n. 18).

39 H. G. Niemeyer, "Das Kultbild der Eupatriden?" in *Festschrift E. von Mercklin* (Waldsassen, Bayern, 1964) 106–11, pl. 47, dated during the second quarter of the sixth century. *LIMC* II, s.v. Athena, no. 72, lists N. M. 6450 under representations of the Palladion ("Attic?"). Shapiro, pl. 8b-c, dates it ca. 550 or earlier.

40 S. G. Miller, "A Miniature Athena Promachos," *Hesperia* Suppl. 20 (1982) 93–99.

41 Angelitos Athena, Akr. 140: Brouskari, fig. 248; *LIMC* II, s.v. Athena, no. 144 pl. 720, considered there the first "Promachos" in peplos. For good illustrations, including one of the back showing the helmet crest, see R. Tölle-Kastenbein, *Frühklassische Peplosfiguren: Originale* (Mainz 1980) 54–56 (no. 9a) pls. 42–44, esp. 43a. The text, however, suggests that Angelitos' dedication held an owl, which I find unlikely. The red-figure oinochoe in New York (= *LIMC* II, s.v. Athena, no. 590, pl. 762; here fig. 80) shows a similar Athena statue with spear upright, standing on an Ionic column.

On the Peplos Kore, Akr. 679, as a divine image, see B. S. Ridgway, "The Peplos Kore, Akropolis 679," *Journal of the Walters Art Gallery* 36 (1977) 49–61, and "The Fashion of the Elgin Kore," *Getty Museum Journal* 12 (1984) 29–58. Both articles contain additional references to similar renderings that may go back to early idols. A similar conception may be illustrated by a bronze statuette, Akr. 6454, showing Athena leaning on her spear with her left hand: *LIMC* II, s.v. Athena, no. 190, pl. 727, dated ca. 470–460 At least five bronze "palladia" are mentioned in late fourth-century inventory lists of the treasurers of Athena: D. Harris, "Bronze Statues on the Athenian Acropolis," *AJA* 95 (1991) 296; Harris mentions that the figures were in at least two poses, holding objects (some missing) in one hand or in both, but the ancient text is highly fragmentary.

42 Athena "Promachos" by Pheidias: *LIMC* II, s.v. Athena, no. 145 (the first holding a Nike, although the epithet Nikephoros is not attested in Athens and does not refer to a specific type). See also E. Mathiopoulos, *Zur Typologie der Göttin Athena im fünften Jahrhundert vor Christus* (Bonn 1968) 7–47. On the base, W. B. Dinsmoor, Sr., "Two Monuments on the Athenian Acropolis," in *Charisterion eis A. Orlandos* (Athens 1967–68) 145–55 pls. 48–49, with previous references; Travlos 55.

Shapiro, p. 36, believes that the active Athena type shown on Panathenaic amphoras and other Archaic vases reflects an actual statue that may have stood outdoors on the Akropolis, probably near an altar, and that was likely to have been destroyed or taken away by the Persians, since its depiction on non-Panathenaic vases ceases by the time of the Persian wars. He therefore suggests that the Pheidian Promachos had a double meaning: as a thank-offering for Marathon, and as replacement for the earlier monument. If the Pheidian statue has been correctly envisioned, its substitute function would have been unclear for Athenians accustomed to a different pose; and commemorating a victory achieved in 490 by replacing a monument lost to the same enemy in 480 seems hardly appropriate.

Since Marathon was exclusively an Athenian victory, without the participation of allies, the centauromachy on the Promachos' shield cannot allude to all the Greeks versus the eastern enemy or the barbarians in general, but should rather recall that Theseus helped in both the mythological and the historical battle.

43 Shapiro, 37.

44 I have developed this theory more fully in "Birds, 'Meniskoi' and Head Attributes in Archaic Greece," *AJA* 94 (1990) 583–612. For Athena looking very much like a generic kore but for the helmet, see also the late-Archaic votive relief Akr. 581, showing the goddess receiving a family of worshipers that bring her a sacrificial pig: *LIMC* II, s.v. Athena no. 587, p. 1011, pl. 762; Brouskari fig. 94.

45 Other Classical cult images with comparable headdresses are the Nemesis at Rhamnous (with deer and Nikai; Pausanias 1.33.2) and the Hera at the Argive Heraion (with Charites and Horai; Pausanias 2.17.4), but their ornaments were parts of crowns, not of helmets. See my article (supra n. 44) for further discussion of these points. Other relevant examples are cited by U. Kron, "Götterkronen und Priesterdiademe. Zu den griechischen Ursprüngen der sog. Büsterkronen," in N. Basgelen and M. Lugal, eds. *Festschrift für Jale Inan* (Istanbul 1989) 373–90.

That helmet devices carry important symbolism may be shown also by coins of Thurii, the Athenian colony in South Italy, which, around 410–360, show an Athena head whose headdress is decorated by a Skylla, in obvious allusion to the geographical location and perils overseas: *LIMC* II, s.v. Athena, no. 306, pl. 740.

46 M. Korres, "Der Pronaos und die Fenster des Parthenon," in E. Berger, ed., *Parthenon-Kongress Basel. Referate und Berichte* (Mainz 1984) 47–54, esp. 52 and fig. 5.

47 Although all the Olympians took part in the gigantomachy, they could not have won without Herakles, who was recruited by Athena. The goddess and the hero therefore play the most important role in the battle, and are given a prominent position, next to Zeus, in most representations. For ample references to all ancient sources, see Vian, supra n. 32.

48 See Korres (supra n. 46).

49 I have already expressed some of these theories, at greater length, in "The Ancient Athena," *The Nashville Athena: A Symposium* (held at the Parthenon, Nashville, Tennessee, May 21, 1990) 15–17, and in "Parthenon and Parthenos," *Festschrift Inan* (supra n. 45) 295–305. My interpretation does not, of course, exclude other possible allusions within the iconography; in particular, the coiled snake could represent the autochthony of the Athenians or even the mythical Erichthonios, but my comments refer specifically to its location within the shield.

50 Roux (supra n. 25) provides all ancient references for the nomenclature and full discussion.

51 Mansfield, 232 n. 19.

52 The date of A.D. 138 is given, without explanation, by J. Binder, "An Acroterion from the Parthenon?" *Festschrift F. Brommer* (Mainz 1977) 29–31; Travlos 444; W. B. Dinsmoor, Jr., "New Fragments of the Parthenon in the Athenian Agora," *Hesperia* 43 (1974) 132–55, esp. 147. A. Frantz, "Did Julian the Apostate Rebuild the Parthenon?" *AJA* 83 (1979) 395–401, reviews all theories on fires and damages to the Parthenon, with special reference to the Pheidian statue in n. 54 on p. 401.

For *disiecta membra* into the Parthenon, see Catling's account (supra n. 23).

Additional damage to the Parthenos may have occurred when Lachares, briefly tyrant of Athens, is said to have removed the gold from the statue to mint coins for his mercenaries, ca. 295. The problem of how this removal was possible, and of the consequent replacement (since the statue was seen undamaged by Pausanias five centuries later), is too vast to tackle here; note that a recent suggestion would interpret the passage metaphorically, for Lachares robbing the goddess

of her "treasure" rather than of her gold costume: T. Linders, "Gods, gifts, society," in T. Linders and G. Nordquist, eds., *Gifts to the Gods* (Uppsala 1987) 115–27, esp. 117 and ns. 18–20.

53 L. Beschi, "Contributi di topografia ateniese," *Annuario della Scuola archeologica di Atene* 45–46, n.s. 29–30 (1967–68) 531–36 ("Lo xoanon di Atena Nike e il culto delle Charites"); the votive relief is his fig. 16. See also *LIMC* II, s.v. Athena, no. 33, for the ancient statue. The inscribed altar: Raubitschek, no. 329.

A thorough study of the Nike bastion and its sequence of buildings, by I. Mark, is forthcoming; it will take into account the supposed Mycenaean precedents for the cult, and the issue of the cult image.

54 I. Mark, in *Perilepsis ton homilion kai ton anakoino seon. XII. Congres International d'Archeologie Classique* (Athens 1983) 126; although a brief text is included in these summaries, no expanded version appears in the later publications of the *Acts of Congress*; cf. however his "The Ancient Image and Naiskos of Athena Polias: The Ritual Setting on a Late Fifth Century Acropolis Relief," *AJA* 91 (1987) 287–88. I understand that F. A. Cooper, in a lecture delivered at the American School of Classical Studies in Athens on March 27, 1985, suggested that the so-called base is a reused block from a set of four, of which the other three were found in the Sanctuary of Aphaia on Aigina (communication by an anonymous reader). For an illustration, see Travlos, 151 fig. 201.

55 Mark 1987 (supra, n. 54) believes he can discern on the relief that the "idol" held a bird or fruit in its right hand and a phiale in the left; he suggests that the image represents the Athena Polias, because its appearance is "primitive" but its costume follows fifth-century fashions, thus indicating real clothing.

The boulder on which the relief Athena sits recalls similar renderings on the Nike Balustrade, as mentioned by Beschi (supra n. 53), but need not imply any connection beyond an open-air setting. Beschi assumes that identification would have been obvious "when the attributes held by the image were preserved."

56 O. Palagia, "A New Relief of the Graces and the Charites of Socrates," *Sacris Erudiri* 31 (1989–1990) 347–56; the relief with Athena, Akr. 1556, is her pl. 14, Beschi's fig. 17 right.

57 Akr. 593: Richter (supra n. 3) no. 43 figs. 147–50; Brouskari, fig. 75. The statue was found east of the "Erechtheion" but the findspot need not imply original setting, since the cleaning operation of the Akropolis after the Persian sack gathered together all damaged monuments into only a few trenches. The pomegranate is not, however, the exclusive attribute of Athena Nike in Athens, since it recurs in the hand of the chryselephantine Hera at the Argive Heraion: Pausanias 2.17.4.

58 H. Büsing, "Zur Bemalung des Nike-Tempels," *AA* 1990, 71–76, esp. figs. 5–6 on p. 75 after an 1838 drawing of the block by E. Schaubert, for which see ref. on p. 72 n. 7. The anta profile is the same in both buildings.

59 Nike Temple pediments: G. Despinis, "Ta glypta ton aetomaton tou naou tes Athenas Nikes," *Archaiologikon Deltion* 29 (1974, pub. 1977) 1–24, with German summary on pp. 273–75; for more recent attributions, see M. Brouskari, "Aus dem Giebelschmuck des Athena-Nike-Tempels," and W. Ehrhardt, "Der Torso Wien I 328 und der Westgiebel des Athena-Nike-Tempels auf der Akropolis in Athen,"—both in *Festschrift für N. Himmelmann* (Mainz 1989) 115–8, pl. 20, and 119–27, pls. 21–22 respectively.

Nike Temple akroterion: P. N. Boulter, "The Akroteria of the Nike Temple," *Hesperia* 38 (1969) 133–40.

Friezes and balustrade, most recently: A. Stewart, "History, Myth, and Allegory in the Program of the Temple of Athena Nike, Athens," in *Pictorial Narrative in Antiquity and the Middle Ages* (Studies in the History of Art 16, Washington, D.C. 1985) 53–73; E. Simon, "La decorazione architettonica del tempietto di Atena Nike sull'Acropoli di Atene," *Museum Patavinum* 3 (1985) 275–88; see also her "Zur Sandalenlöserin der Nikebalustrade," *Kanon* (Festschrift E. Berger, *AntK* Beiheft 15, 1988) 69–73.

60 Raubitschek, 185–88 no. 166, and, on Pyrrhos, p. 523. Travlos 124, with bibl., and fig. 170 on p. 126.

LIMC V, s.v. Hygieia, pp. 554–72 (F. Croissant); note that Athena Hygieia is discussed there, pp. 554–55, but is omitted under the entry for the goddess herself; the possibility is advanced that the cult of the personification might be a late development. In Athens, next to the statue by Pyrrhos, a statue of Hygieia is carefully mentioned by Pausanias (1.23.5) as that of Asklepios' daughter, making a clear distinction from the Athena: *LIMC* V, s.v. Hygieia, no. 28 p. 568.

61 That the cult goes back to the sixth century seems proved by two dedications (by the potter Euphronios and by a Kallis) mentioned in the *LIMC: JdI* 2 (1887) 144 = Raubitschek, 225–58, no. 225 (with a different interpretation), and *AM* 16 (1891) 154 with illustration of the inscribed sherd. Moreover, Plutarch specifically states that the altar on the Akropolis is earlier than Pyrrhos' statue. Croissant (*LIMC*, loc. cit. supra n. 60) suggests that the latter must have been erected before 420/19, date of the official introduction of Asklepios' cult into Athens. For the Lykourgan decree, see Parke, 47.

62 On Athena Ergane, and her activities as depicted in the visual arts, see *LIMC* II, s.v. Athena, 961 (with literary sources) and nos. 39–54; no. 50, pl. 709, a skyphos by the Penelope Painter, shows Athena as builder, leading a giant in constructing the walls of Athens. See R. D. Cromey, "History and Image: the Penelope Painter's Akropolis (Louvre G372 and 480/79 B.C.)," *JHS* 111 (1991) 165–74, pl. 5. Two iconographic types are defined as possible: one showing the goddess with distaff or other spinning attributes, and another placing her in a narrative context, including the competition with Arachne. The discussion (p. 1019) considers the possibility that Athena Ergane could be confused with the Polias, but would accept an early date for the origin of the cult.

A. Di Vita, "Atena Ergane in una terracotta dalla Sicilia ed il culto della dea in Atene," *Annuario della Scuola archeologica di Atene* 30–32 (1952–54) 141–54, believes instead that the cult is not attested during the Archaic period.

63 Di Vita (supra n. 62). See his n. 3 on pp. 6–7 for a listing of early works supposedly depicting Athena Ergane, but considered dubious. The Scornavacche terracotta is included in *LIMC* II, s.v. Athena, no. 54.

64 For this proposal, see S. Stucchi, "Una recente terracotta siciliana di Atena Ergane ed una proposta intorno all'Atena detta di Endoios," *Romische Mitteilungen* 63 (1956) 122–28. On Akr. 625 and the issue of its identification, see, most recently, Stewart (supra n. 20) 248, who cites Bundgaard's opinion that the statue fell onto the Akropolis slope from a breach in the wall near the Erechtheion. *LIMC* II, s.v. Athena, no. 18, pl. 704, gives Akr. 625 as possibly by Endoios but separate from the Ergane. Brouskari, figs. 134–35.

65 Comparison with the terracotta plaques: Stucchi (supra n. 64); cf. *LIMC* II, s.v. Athena, no. 43 pl. 708, for the spinner wearing a sakkos, ca. 500, and Brouskari, fig. 66, Akr. 13057, showing the same figure wearing a polos (here figs. 92 and 93).

66 Akr. 625 is traditionally compared also with the seated Zeus on the east frieze of the Siphnian Treasury at Delphi, for both chronological and compositional purposes, but there again the pose is conditioned by the relief format.

A perusal of Schrader (supra n. 16) yields approximately five recognizable (i.e., clearly helmeted) heads of Athena from the Akropolis, and at least one additional seated statue, but other fragmentary figures, both seated and standing, could be so identified were they better preserved.

Athena with Dice Players: Schrader (supra n. 16) 284–87 no. 412, pls. 159–60; cf. also D. L. Thompson, "Exekias and the Brettspieler," *Archeologica Classica* 28 (1976) 30–39, pls. 6–7. On the subject, which becomes quite popular in the late Archaic period, see S. Woodford, "Ajax and Achilles playing a game on an olpe in Oxford," *JHS* 102 (1982) 173–85, with a long list of pictorial representations.

Athena as patroness of heroes: *LIMC* II, s.v. Athena, pp. 1026–27 and 1036–37 (Section B 3).

67 For the theory, see E. Knauer, "Still more light on old walls? Eine ikonographische Nachlese," in *Studien zur Mythologie und Vasenmalerei* (Festschrift K. Schauenburg, Mainz 1986) 121–26.

Mourning Athena relief, Akr. 695: most recently, M. Meyer, "Zur 'Sinnenden' Athena," *Festschrift N. Himmelmann* (Mainz 1989) 161–68, pls. 30–31, dated ca. 460–450. Cf. *LIMC* II, s.v. Athena, no. 625 pl. 765; Brouskari fig. 237.

The rendering of an eastern cap under a Corinthian helmet recurs also on another famous type, the so-called Frankfurt Athena, known exclusively through Roman copies, that has traditionally been combined with a leaping Marsyas also extant solely in Roman versions. The total composition has been equated with a group seen by Pausanias on the Akropolis, perhaps by Myron. Since the entire construct rests on assumptions and on the modern linking of Roman replicas and ancient literary sources, the group is here omitted from full discussion; see G. Daltrop, *Il gruppo mironiano di Atena e Marsia nei Musei Vaticani* (Vatican City 1980); also, Knauer, with further bibl., and *LIMC* II, s.v. Athena no. 623a, pl. 764.

68 The third ancient source on the Lemnia is Aelius Aristeides, *Orat.* 50. All other passages in Greek and Latin authors that have been taken to refer to the same monument do not cite it by name and therefore the association is tenuous at best. The connection between the Bologna head and the Dresden body: A. Furtwängler, *Meisterwerke der griechischen Plastik* (Leipzig-Berlin 1893) 3–45; it has been challenged by K. J. Hartswick, "The Athena Lemnia Reconsidered," *AJA* 87 (1983) 335–46. It has been defended by O. Palagia, "Erythema... antì kránous. In Defense of Furtwängler's Lemnia," *AJA* 91 (1987) 81–84, but without new compelling arguments, through a chain of echoes from a presumed prototype of 450–425 that may in turn have been influenced by the Lemnia; yet admittedly there is no assurance that the type, even if it existed as early, was in fact the Pheidian creation. E. B. Harrison, "Lemnia and Lemnos: Sidelights on a Pheidian Athena," *Kanon* (supra n. 59) 101–07, would rather identify the Lemnia in the so-called Athena Medici type. Of the *LIMC* II entries, no. 197 on p. 976, s.v. Athena, mentions noncommittally Furtwängler's recomposition (Demargne); no. 141–141a, p. 1084 and pls. 794–95, s.v. Athena/Minerva, seems to accept the traditional identification (F. Canciani).

On the iconography of Athena holding her helmet, see N. Kunisch, "Zur helmhaltenden Athena," *AM* 89 (1974) 85–54, but cf. *LIMC* II, s.v. Athena, nos. 194–199 (beginning ca. 530–510), and comments on pp. 1020–21 where it is suggested that the type, deriving from the Promachos, appears in scenes diverse enough to imply simply a convenient compositional way of obtaining isocephaly.

69 On this point, see Hartswick (supra n. 68) 344–45 and n. 76; for the akrolithic technique (extremities of marble, body of cheaper material), see Harrison (supra n. 68) 106, who is, however, properly cautious in her suggestion.

70 See Hartswick (supra n. 68) 342–44, and Harrison (supra n. 68) 105 and n. 31.

71 Round Temple of Rome and Augustus: Travlos, 494–97 (s.v. Roma and Augustus). Note that the forms of the Polias Temple ("Erechtheion") were also imitated in a Roman podium Temple of Augustan date in the Agora: T. L. Shear Jr., "Recent Excavations in the Athenian Agora," *AJA* 95 (1991) 327.

On the Christian history of the Parthenon: Travlos 445 and fig. 576 on p. 456; cf. also *Enciclopedia dell'arte antica*, s.v. Atene, p. 806 (W. Johannowski).

Suggestions for Further Reading

Panathenaic Festival

Walter Burkert, *Greek Religion* (Cambridge, Mass. 1985).
A comprehensive survey of all aspects of Greek religion from its origins in the Bronze Age to the development of philosophical schools.

Martin Roberston and Alison Frantz, *The Parthenon Frieze* (New York 1975).
Documents with fine photography and drawings all 524 feet of the Parthenon frieze, which represents the only extant depiction of the Panathenaic procession.

H. A. Shapiro, *Art and Cult Under the Tyrants in Athens* (Mainz 1989).
A scholarly account of the development of various cults in Athens in the sixth century, fully illustrated with all relevant Attic vase-paintings.

Erika Simon, *Festivals of Attica. An Archaeological Commentary* (Madison 1983).
A thorough synthesis of all the literary, inscriptional, and archaeological evidence for Attic festivals.

D. E. Easterling and J. V. Muir, eds., *Greek Religion and Society* (Cambridge 1985).
A collection of essays by eminent scholars dealing with the relationship of Greek religion to such aspects of Greek civilization as poetry, architecture, art, and philosophy.

H. W. Parke, *Festivals of the Athenians* (London 1977).
An account of the chief religious festivals of Athens according to their order in the Athenian calendar.

Panathenaic Amphoras

J. D. Beazley, *The Development of Attic Black-figure* (Berkeley 1951; rev. ed. Berkeley 1986, eds. Dietrich von Bothmer and Mary B. Moore).
Chapter 8 of this essential introduction to early Athenian vase-painting deals exclusively with Panathenaic prize vases. The newest edition includes many additional illustrations.

John Boardman, *Athenian Black Figure Vases* (New York 1974).
Chapter 7 of this survey of Attic black-figure is a succinct account of the development of Panathenaic amphoras.

Jiří Frel, *Panathenaic Prize Amphoras*, Kerameikos Book no. 2 (Athens 1973).
A general survey of the history and development of Panathenaics, including previously unpublished material from the Athenian Kerameikos.

Richard Hamilton, *Choes and Anthesteria: Athenian Iconography and Ritual* (Ann Arbor 1992).
Explores the relationship of literary evidence and Attic vases in a study of Athenian cult, taking a structuralist approach. Appendix 7 provides a useful list of extant Panathenaic amphoras.

B. A. Sparkes, *Greek Pottery. An Introduction* (Manchester 1991).
A lively introduction to the subject of Greek ceramics which explains techniques, chronology, shapes, and decoration to the beginner.

Music at the Panathenaia

Walter Burkert, "The Making of Homer in the Sixth Century B.C.: Rhapsodes versus Stesichoros," in *Papers on the Amasis Painter and his World* (Malibu 1987) 43–62.
The evolution of the rhapsode from a creative bard in the time of Homer to a performer of memorized texts in the late Archaic period.

J. A. Davison, "Notes on the Panathenaea," *Journal of Hellenic Studies* 78 (1958) 23–41.
The evidence of vase-painting for the introduction of musical competitions at the Panathenaia in the sixth century.

John Herington, *Poetry into Drama* (Berkeley and Los Angeles 1985).
A study of the "song culture" of Archaic Greece, and especially of the role of performances at festivals, by musicians and rhapsodes, in shaping the genres of Archaic verse.

R. Ross Holloway, "Music at the Panathenaic Festival," *Archaeology* 19 (1966) 112–119.
Publication of an important red-figure amphora from the Agora excavations showing two musical contests, in the time of Perikles.

Martha Maas and Jane McIntosh Snyder, *Stringed Instruments of Ancient Greece* (New Haven 1989).
A thorough study of all types of stringed instruments, including the kithara, as well as the people who played these instruments, their costumes, and the occasions on which they played.

M. F. Vos, "Aulodic and Auletic Contests," in *Enthousiasmos*, Festschrift J. M. Hemelrijk (Amsterdam 1986) 122–130.
A complete catalogue, with commentary, of vases showing flute-players and singers with flute accompaniment at the Panathenaic Games.

Athenian Athletics

Norman E. Gardiner, *Athletics of the Ancient World* (Oxford 1930, repr. ed. Chicago 1978).

 Based on his *Greek Athletic Sports and Festivals* of 1910, Gardiner's work is marred by Victorian ideology but it remains in wide use as a textbook on ancient sport. In his day Gardiner was the leading English authority on sport, especially on technical matters concerning events, and his works are still consulted as collections of evidence and ideas.

Donald G. Kyle, *Athletics in Ancient Athens* (Leiden 1987).

 The first full-length study of the historical development of athletics in ancient Athens (to 322 B.C.), this work shows that the city-state's distinctive athletics contributed significantly to the civic experience and consciousness of the Athenians.

Michael B. Poliakoff, *Combat Sports in the Ancient World. Competition, Violence, and Culture* (New Haven and London 1987).

 A meticulous study of combat sports (boxing, wrestling, pankration, stick-fighting) in the ancient Near East, Greece and Rome, by the leading authority on violent Greek sports, this work clarifies matters of terminology and technique, and it delves into questions of origins and symbolism.

Wendy J. Raschke, ed., *The Archaeology of the Olympics. The Olympics and Other Festivals in Antiquity* (Madison 1988).

 In this valuable collection of fourteen papers presented at an international symposium in Los Angeles in 1984, leading scholars use archaeology and art history to discuss the historical development and cultural significance of athletics at Olympia and other sites.

Olga Tzachou-Alexandri, ed., *Mind and Body: Athletic Contests in Ancient Greece* (Athens 1989).

 A lavishly illustrated exhibition catalogue with essays on the origins of Greek athletics, and on various festivals, sites and events, this is a sometimes idealistic but generally excellent overview of the variety of archaeological evidence used to reconstruct the athletic life of the Greeks.

David C. Young, *The Olympic Myth of Greek Amateur Athletics* (Chicago 1984).

 Young demythologizes ancient Greek sport by arguing that Greek athletes were never "amateurs" in the modern sense, and that scholarship has been mislead by modern amateurism into misrepresenting the history of ancient Greek athletics as well as that of the early modern Olympics.

Panathenaic Peplos

E.J.W. Barber, *Prehistoric Textiles: The Development of Cloth in the Neolithic and Bronze Ages* (Princeton 1991).

 The first comprehensive study devoted to Bronze Age textiles in Greece.

M. Hoffmann, *The Warp-Weighted Loom: Studies in the History and Technology of an Ancient Implement*, Studia Norvegica (Oslo 1964).

 A study of Scandinavian looms which are closely related to the ancient Greek models as seen in vase-painting representations.

Eva C. Keuls, "Attic Vase-Painting and the Home Textile Industry," in *Ancient Greek Art and Iconography*, ed. W. G. Moon (Madison 1983) 209–230.

 Treats the role of women as wool-workers in Athenian society.

J. M. Mansfield, *The Robe of Athena and the Panathenaic Peplos* (Ph.D. dissertation, University of California at Berkeley 1985, available from University Microfilm, Inc., Ann Arbor, Michigan).

 A scholarly work on various aspects of the Panathenaic festival, it is perhaps the first to distinguish between the annual peplos/garment and the quadrennial peplos/tapestry given to Athena. Although embedded in a dense prose, many other insights and illuminating information on images of the goddess in Athens can be found in this text.

Sculptural Representations of Athena

A. A. Donohue, *Xoana and the Origins of Greek Sculpture* (Atlanta 1988).

 A compendium of ancient sources on early statues, with an excellent critical analysis of writers' biases that have colored our own understanding of the origins of Greek sculpture. Although a strong case is made for the relative sophistication of early wooden Greek statuary, the existence of more or less amorphous wooden idols (comparable, perhaps, to drift wood) for which no human carver could be named, and therefore held in deep veneration, should not be discounted.

C. J. Herington, *Athena Parthenos and Athena Polias* (Manchester 1955).

 A lucid account of the topographical problems related to the Athenian Akropolis and its buildings, it advances the theory that locations were connected with specific cults, and thus differentiates between two aspects of Athena and her imagery. Although new archaeological discoveries have rendered this text somewhat outdated, it is still worthy of consideration.

G. F. Pinney, "Pallas and Panathenaea," *Proceedings of the 3rd Symposium on Ancient Greek and Related Pottery* (Copenhagen 1988) 467–477.

 Presents convincing arguments that the Panathenaic festival commemorated the victory of Athena in the gigantomachy, rather than her birthday, as traditionally assumed. The Athena depicted on Panathenaic prize amphoras is thus seen as dancing a war-dance, rather than as echoing an existing statue in the so-called Promachos pose.

B. S. Ridgway, "Birds, 'Meniskoi' and Head Attributes in Archaic Greece," *American Journal of Archaeology* 94 (1990) 583–612.

 Argues that some Archaic statues given as votive offerings on the Athenian Akropolis may be reflections of cult images, specifically of Athena, and discusses head ornaments as attributes and signifiers of divinity in the sixth century B.C., as well as in Classical times.

B. Tsakirgis, ed., *The Ancient Athena: A Symposium* (held at the Parthenon, Nashville, Tennessee, May 21, 1990)—forthcoming, by the University of Tennessee Press.

 Contains various papers discussing the modern reconstruction, by Alan LeQuire, of Pheidias' chryselephantine Athena Parthenos, and the insights it offers to our understanding of such works in antiquity.

Glossary

Academy
the grove located outside the walls of Athens where Plato established a school in the early fourth century.

acontist
javelin-thrower.

aegis
breastplate worn by Athena made of goatskin fringed with snakes and bestowing magical powers of protection.

ageneios
literally, beardless; a term used to designate a category for competitors whose age fell between the category for boys and that for men.

agon (pl. agones)
assembly convened to watch the games; hence the singular *agon* is used to denote a contest in the games; the plural *agones* also is used to denote "the games."

agonothetes (pl. agonothetai)
judge of the games; or the sponsor, producer, or manager of the games.

agora
marketplace of a city which also served as a civic center.

akon
light spear or javelin.

akrolithic
sculptural technique whereby a stone head and extremities were attached to a wooden body for the making of a statue.

akroterion (pl. akroteria)
ornament or statue placed above the three angles of the pediment of a gabled building.

aletrides
women of noble birth who prepared the offering cakes for the sacrifice to Athena Polias.

amazonomachy
battle between Greeks and Amazons.

amphora
two-handled jar for wine, oil, and other liquids.

anabates (pl. anabatai)
literally, one who mounts; a rider, but used sometimes as a synonym for *apobates*.

ankyle
rawhide thong, roughly six feet in length, which was used in throwing the *akon*.

anta
thickening of the projecting end of the lateral wall of a Greek temple.

anthemion
continuous pattern of alternating palmette and lotus.

anthippasia
competition and display by tribal cavalry units.

aoidos (pl. aoidoi)
singer.

apene
wagon or cart drawn by mules.

apobates (pl. apobatai)
literally, one who dismounts; an armed warrior who jumps from a moving chariot.

apteros
wingless.

Archaic
term referring to the early period of Greek art and history, ca. 650–480.

Archegetis
the Founder; epithet of Athena.

Archon
title of the chief magistrate of Athens.

arete
virtue, valor, excellence.

arrephoroi
four girls of perhaps seven to eleven years in age who were chosen from aristocratic Athenian families to live on the Akropolis and serve Athena for a year.

aryballos (pl. aryballoi)
small vase which often contained scented oil or perfume used by athletes to lubricate their skin and cleanse it after exercise.

asma
warp of a loom.

athlon (pl. athla)
prize of a contest; contest; used in the genitive plural on the Panathenaia prize inscription.

athlothetes (pl. athlothetai)
literally one who sets out a prize; used as the title of one who organized the games with prizes, synonymous with *agonothetes*.

aulete
player of a type of flute, literally double pipes made from reeds.

aulode
singer to the double pipes.

aulos
any woodwind instrument, but usually the double pipes.

bema
podium.

Boulé
the council or senate of a city-state.

cella
main room of a temple, containing the cult statue of the deity to which the temple was dedicated.

chiton
woman's dress made of linen and consisting of a rectangular piece of cloth buttoned along the arms to make sleeves.

choregos
wealthy male citizen who met the expenses of a playwright's entry at a festival.

chrematitic
adjective applied to games in which the prizes were either money or of monetary value.

cleruchy
settlement of poorer Athenian citizens granted a piece of land in a conquered territory.

deme
township or territorial division.

demos
the people of a given city; the whole adult male citizen body.

demosion
adjective meaning "of the state."

diaulos
a footrace which was twice the *stadion* in length.

dinos
large bowl without handles which is supported by a stand.

diphrophoros (pl. diphrophoroi)
stool-bearer.

diskobolos (pl. diskoboloi)
discus-thrower.

diskos
disc-shaped weight thrown by athletes.

dolichos
long-distance footrace.

drachma
unit of money equivalent to six obols.

dromos
race course; a race.

echinus
curved molding just below the abacus of a Doric capital.

Ekklesia
generally an assembly; specifically the assembly of citizens to which the *Boulé* reported its recommendations for legislation.

ependytes
sleeveless over-garment that resembles a flat apron.

ephebos (pl. epheboi)
young man who had reached the age (eighteen) of training for, and ultimately entry to, citizenship.

epinikion (pl. epinikia)
commemorative ode often commissioned to immortalize athletic prowess.

Ergane
worker; epithet of Athena.

ergastinai
the girls who wove the peplos of Athena for the Panathenaic festival.

eschara
hearth-like altar for burnt offerings.

euandria
contest of manly excellence.

eunomia
good order.

exergue
space below the groundline in a tondo composition.

gigantomachy
the battle between the gods and giants.

gorgoneion
mask-like head of the gorgon, Medusa, which often appears on Athena's aegis.

gymnasion
literally a place where exercises in the nude take place; athletic practice grounds.

halter (pl. halteres)
small weight shaped like a dumbbell used by jumpers.

Hekatompedon
temple or precinct 100 feet in length.

heptathlos
cycle of seven deeds.

herm
pillar surmounted by a head.

hieropoios (pl. hieropoioi)
literally a doer of sacred things; overseer of temples and sacred rites.

himantes
leather thong which was wrapped around the hand and served as a boxing glove.

himation
cloak or mantle.

hippodrome
track for race horses.

histos
literally anything set upright; beam of a loom.

hoplite
heavily-armed foot soldier.

hoplitodromos (pl. hoplitodromoi)
footrace in armor which was similar to the *diaulos* in length.

hoplomachia
military exercise and a component of Athenian ephebic training but not a Panathenaic event.

hydria (pl. hydriai)
three-handled water jar.

ikria
wooden grandstands.

incuse
reverse of a coin which has a deeply impressed punch mark without design.

infibulation
method of giving athletic support to the male genitals.

kalokagathia
composite word from the Greek *kalos kai agathos*, "beautiful and good," signifying physical and moral excellence.

kalos
beautiful, handsome.

kalpe (or anabates)
race for mares; or a race which involved the rider jumping off and running alongside the horses for part of the race.

kampter (pl. kampteres)
post where the turn was made in footraces and horse races.

kanephoros (pl. kanephoroi)
girl who carried the offering basket at the head of the Panathenaic procession.

kentron
goad or riding crop.

kithara
elaborate form of lyre.

kitharist
player of the kithara.

kitharode
singer who accompanied himself on the kithara.

komos
revel.

kore (pl. korai)
literally maiden; Archaic freestanding statue of a draped female.

kouros (pl. kouroi)
literally youth; Archaic freestanding statue of a nude youth.

krater
large, deep bowl with two handles for the mixing of wine and water.

kylix (pl. kylikes)
two-handled stemmed cup for wine.

lampadephoros (lampadedromia)
torch race, usually in the form of a relay race as a part of civic and religious ceremonies.

leitourgia
system of sponsorship that required wealthy citizens to underwrite the expenses of sport teams or productions of plays at a festival.

lekythos (pl. lekythoi)
perfume or oil flask.

libation
liquid offering to a god, generally poured over an altar.

loomweight
small weight attached to warp threads on a vertical loom.

metic
resident non-citizen.

metope
rectangular space between the triglyphs of a frieze in the Doric architectural order; frequently the location of sculptural decoration.

metretes
unit of liquid measure equivalent to approximately 39 liters.

Moriai
sacred olive trees.

mousikoi agones
musical contests.

naïskos (diminutive of **naos,** temple)
shrine; or small temple generally without columns.

Nike
personification of victory.

obol
one-sixth of a drachma

odeion
music or recital hall.

oinochoe
jug or pitcher for pouring liquids.

olpe
variant of the oinochoe.

opisthodomos
porch at the rear of a temple.

pais (pl. paides)
boy, but also used as an official designation for the youngest group allowed to compete at the games or to exercise in the *gymnasion*.

palaestra
wrestling ground.

Panathenaia, Lesser and Greater
Athenian festival in honor of Athena, held on her reputed birthday on the 28th of Hekatombaion, and celebrated every fourth year with particular splendor (the Greater Panathenaia).

panathenaikon
scented oil contained in the miniature Panathenaic-shaped amphoras.

pankration
Greek athletic event, which combined boxing and wrestling with no holds barred except for biting and gouging.

pannychis
all-night revel.

paradeigmata
samples; models.

Parthenos
unwed maiden; virgin; epithet of Athena.

paryphe
decorated central vertical stripe on a garment.

pegasos
winged horse in Greek mythology.

pentathlon
five-part contest consisting of footrace, discus, long or broad jump, javelin, and wrestling.

peplophoros
a person wearing a peplos.

peplos
a woolen garment worn by Greek women consisting of fabric joined on one or both sides and fastened with pins at the shoulders.

periodonikes
victor in each of the four great Panhellenic games.

periodos
literally "going around"; a circuit of crown games.

petasos
broad-brimmed hat worn by ephebes.

phiale (pl. phialai)
a saucer-like bowl used for pouring libations to the gods.

phorbeia
mouth-band of leather used to assist *auletes*.

phyle
tribe.

pinax
painted plaque.

polemisterios
adjective meaning "of a warrior."

Polias (fem.) (Polieus, masc.)
of the city; epithet of Athena and Zeus.

polis (pl. poleis)
Greek city-state, that is, the city and its surrounding territory as a self-governing unit.

polos (pl. poloi)
age category for young (not yet fully-grown) horses; headdress worn by goddesses.

pompeia
solemn procession.

Promachos
literally "fighting in front"; epithet of Athena.

protome (pl. protomai)
front part of an animal or human being.

prytaneion
civic building comparable to a town hall, where guests of the state were invited for free meals.

psephisma
official decree passed by the popular assembly.

pteron
area between the cella wall and the outer colonnade of a temple.

pyrrhike
dance in armor.

quadriga
four-horse chariot.

rhabdos
rod or staff of office.

rhabdouchos (pl. rhabdouchoi)
literally a bearer of the rod; judge of a contest.

rhapsode
professional reciter of epic poetry at festivals.

sakkos
snood, worn by women.

salpinx
long war trumpet used to play a fanfare for the victors of athletic contests.

setesis
awarding of a free daily meal in the town hall to Athenian victors of Panhellenic games.

skaphephoros (pl. skaphephoroi)
basket-carrier.

skyphos
deep drinking cup with small handles.

splanchnopt
one who roasts sacrificial meat.

stadion
originally a unit of measurement, 600 feet in length, which gave its name to the footrace of the same distance.

stater
term used in Greek numismatics for the principal denomination of a coinage.

stele (pl. stelai)
upright stone slab, often used for a gravestone or for public inscriptions.

stemma (pl. stemmata)
wreath, garland.

stephane
crown.

stephanitic
adjective derived from the Greek word *stephanos*, and applied to the four Panhellenic games in which the only prize of victory was a crown.

strigil
instrument used for scraping the skin after a bath; used also by athletes to remove sweat, dirt, and oil from their skin.

synaulia
flute duet.

synoris
two-horse chariot.

terma
literally an end or boundary; finishing line, goal.

thallophoroi
branch-bearers.

tondo
circular center on the interior of a kylix.

trichapta
hair veils.

triskeles
motif, often seen as a shield device, consisting of three legs.

xystos (pl. xystoi)
covered practice track one *stadion* in length.

warp
arrangement of strands of yarn or thread that run vertically.

weft
the horizontal threads interlaced through the warp of a loom.

Index

Index by Nicholas Humez.
Italic page numbers denote illustrations or their captions.

Academy, Athenian, 81, 89, 96, 204n.22
Acharnians, the (Aristophanes), 97
Acheloos Painter, *85*, *164*
Achilles, 20, 53, 139
Achilles Painter, 31, 48, 171, 180
Acontists, *85*, 160, 164, 167, *167*. See also Javelin throwing
Acrobats, 56, 96, 176, 207n.107
Aegis, 33, 115, 120, 124, 134, 139, 145, 146, 148, 153, 159, 173, 183, 187
Against Leokrates (Lykourgos), 202n.115
Agariste, wooed by Hippokleides, 20
Agesilaos, king of Sparta, 205n.68
Aglauros, daughter of Kekrops, 120, 124
Agon, 17; in Homer, 20
Agonism, 78
Agonothetes, 41
Agora, Athenian, *18*, *19*, 83, 89
Aischylos, 38, 96
Aitia (Kallimachos), 106
Ajax, 139, 147
Akesas/Akeseus, 114
Akrocheirismos, 171
Akropolis, *17*, 18, 20, 26, 37, 40, 106, 119, 120, *124*, 135, 210nn.2–3
Akrotiri excavations, Thera, 116
Aletrides, 24
Alexandrides, prizewinner, 14, 191
Alkibiades, 50, 81, 89, 97, 99, 100, 208n.127
Alkmeonides, prizewinner, 204n.41
Amasis Painter, 106, *108*, 109, 168, 194n.17
Amazons, 34, 115, 134, 137
Amphoras, prize, 14, 21, 29–51, 101, 127; imitation, 3, 42–46; inscriptions, 40–42; markets for, 48–50; meaning of the imagery, 36–39; miniature, 44–45, 188, 189; obverse decoration, 30–34; reverse decoration, 34–36; shapes, 38–39, *39*; size, 39–40; as symbols, 50–51; workshops and artists, 46–48
Amyklai, 106
Anabates, 90
Anacharsis (Lucian), 82
Anakreon of Teos, 72
Andokides Painter, 66–67, *67*
Andokides, potter, 197n.68
Andromache (Amazon), 115
Andron, 42
Angelitos, donor of Athena statue, 130
Ankyle, 85

Antaios, 86
Antenor's Kore, *131*, 131–33
Anthipppasia, 94
Antimenes Painter, 35
Aoidoi, 72, 194n.11
Apene, 93, 196n.24
Aphaia, sanctuary of, at Aigina, 214n.54
Aphrodite, 34, 37, 105, 119, 120, 184, 212n.36
Apobates, 15, 20, 35, 80, 89–91, 110, 205n.69, 206n.76, 206n.77, 206n.80
Apollo, 21, 57, 65, 70, 106, 166, 204n.24
Apology (Plato), 100–101
Apparel (*kosmos*), 122. See also Clothing
Arachne, 105–106, *106*, 111, 138
Archaios Neos, 124, 125, 127, 129
Archenautes, sacrificer, 56
Archery, 20
Archon, eponymous, 34, 41
Archon Basileus, 26, 96, 179
Ares, 37, 145
Arete, 27, 29
Argos, 106; games at, 14
Arion of Lesbos, 69–70
Aristocracy, equestrian, 98, 205n.65
Aristogeiton, tyrannicide, 20, 24, *25*, 33
Aristophanes, 23, 24, 81–99 passim, 116, 130, 150
Aristotle, 13, 72, 81, 85, 98, 212n.32
Arrephoroi, 17, 23, 26, 113, 126, 209n.23
Artemis, 65, 120
Asklepios, 137, 214n.61
Asia Minor, 184, 187
Asma, 109
Assembly, Athenian, 15
Asteios Group, *32*, 33, *83*, 160
Astragalos, 190, 191
Atarbos, *choregos*, 95
Athena: Akropolis statue sites, *124*; at altar, 47, 148, *149*, 152, *152*; Anatolian, 187; Angelitos statue, *131*, *131*, *138*, 140, 213n.41; and Arachne, 105–106, *106*, 111, 138; Archaic bronzes of, 130; Archegetis, 120; assists Peisistratos, 26; birth of, *15*, *144*, 145; Dresden statue, *115*, 115–16, 123; early documentation of cult of, 13; *enoplos*, 212n.34; Ergane, 21, *21*, *138*, 138–139, *139*, 210n.2, 214n.62; helmet-holding, 47, *141*, 152, 153, *154*, 215n.68; and Hephaistos, *134*, 138; Hippia, 145; Hygieia, 137–138, 210n.2, 214n.60–61; Ince type, *140*, 186; Lanckoronski relief, *118*, 186; Lemnia, 140–42, 185, 210n.2, 215n.68; as listener, 60, 70; Medici type, *141*, *141*, 185; "Mourning",

140, *140*, 215n.66; Nike, 127, 135–37, 210n.2; Nikephoros, 34, 130, 213n.42; with owls, *12*, *148*, *149*, *150*, *190*; Pallas, 36–37, 129–30, 211n.18, 213n.41; Panathenaic, 37; Parthenos, 34, 120, 123, 125, 131–35, 141, 142, 149, 183, 209n.30, 210n.2, 213–214n.52; patroness of Athenian women, 105, 117, 208n.10; and Poseidon, 45, 134, 189; Polias, 13, 17, 21, 23, 38, 120–31, 135, 139, 210n.2, 210n.8, 215n.71; pose and proportions of, 30–31; Promachos, 127–31, 135, 141, 146, 151, 210n.2, 212n.34, 213n.42; protectress of heroes, 36, 38, 77; rears Erichthonios, 21, 207n.111; as scorekeeper, 22, 167; shield of, 155, 160; with stylus, 22, *22*; and the Trojan horse, 22, *22*; Tritogeneia, 14–15
Athena Painter, *18*, 118, *118*, 148, *149*, 183, 197n.51
Athens 894 Workshop, 79
Athenaios, 113, 114–15
Athletics: equestrian events, 13, 15, 20, 21, 22, 34–35, 93–94, 205n.65, 206n.77, 206n.92; gymnastic events, 82–89; history of, 77–78; origins and early development, 78–80; popular attitudes towards, 99–101; training and the Athenian state, 80–82; tribal events, 15, 94–97, 208n.128
Athlothetai, 17, 39, 46, 183
Attic script, 40
Auletes, 58, 60–65 passim, 71, 155, 176, 201n.70
Aulodes, 58, 60–65 pasim, 155, 156, 201n.70
Aulos, 21, 94. See also Double flute; Flute; Double Pipes
Autolykos, pankration victor, 88, 97
Autolykos (Euripides), 98

Backdrops, textile, ritual, 114, 209n.30
Bakchios, potter, 42
Battle of the Gods and the Giants, *see* Gigantomachy
Beardless youths, *see* Ephebes
Beazley, J. D., 33, 48, 93, 157, 159, 161, 171, 176
Bellerophon, 137
Beltloom, 103
Bema, 62, 65, 69, 70, 74, 155, 201n.65
Bendis, Thracian goddess, 177
Berlin Group 2145, oinochoe by, *22*, 130
Berlin Painter, 10, *28*, *29*, 30, 31, *31*, 33, *34*, 35, 39, *41*, 48, *58*, 67, *68*, 69, *84*, 88, *141*, 153–59 passim, 170, 171, 174
Birds, the (Aristophanes), 81, 88, 150
Boat race, 13, 15, 97, 207nn.114–16
Boiotian, 166

Boulé, Athenian, 15, 17, 39
Boxing, 20, 35, 44, 49, 50, *51*, 86, *87*, 88, 98, 161, 167, 168
Boys' contests, 46, 83, 86, 171, 200n.52, 204n.42
Bribery, 197n.52
Brygos Painter, *105*
Bulas Group, *44*, *45*, 188
Bull attacking lioness, 131, *131*
Burgon, Thomas, 29, 50
Burgon amphora, 29, *30*, *30*, 39, 40, *93*
Burial urn, 188

Caestus, 161
Cap, eastern, 139, 215n.67
Cassius Dio, 126
Cavalry, 22, *27*, 35, 91, 180
Celery wreath, 14
Centaur motif, 31
Centauromachy, 130, 134, 213n.42
Chalkeia festival, 17, 113
Chariot race, 15, *21*, 34–35, 48, 49, 50, 91–93, *93*, 173, 174
Charites (Graces), 136, *136*
Charmos, lover of Peisistratos, 207n.112
Chimaera, 137
Chios, poets' guild at, 72
Chiton, 33, 129, 136, 139, 140, 155, 156, 159, 170, 174, 177, 185
Chlamys, 180
Choregos, 95, 177
Chrematitic festivals, 82. *See also* Prizes
Circuit games, 14. *See also* Periodos
City Dionysia (festival), 15
Class of London B524, *168*
Close combat, 20
Clothing: as sacred offering, 106 (*see also* Peplos); women's in Greek art, 115. *See also* Chiton; Himation
Clouds, the (Aristophanes), 24, 89, 93, 95, 99
Cock, 18–37, 183
Cock columns, 30–39 passim, 45, 66, 155, 173, 197n.51, 201n.78; modified, 44, 160, 201n.78
Coinage, 51, *51*, *85*, 122, 130, *132*, 133, 148, 149, 150, 166, *169*, 184, 189, 190, *190*, 213n.45
Columns, 40; cock (*see* Cock columns); with sphinxes, 65
Constitution of Athens (pseudo-Xenophon), 17, 39, 41, 44, 46, 72, 95, 98, 113
Copenhagen Painter, 25
Council, Athenian, 15
Courtship, homosexual, 81–82, 164
Crowns, 14. *See also* Wreaths
Cyrene, 50

Dance competition, 13. *See also* Pyrrhic dance
Dances, armed. *See* Pyrrhic dance
Darius *hystapis*, king of Persia, 105
Dea Roma, 142
Deipnosophistai (Athenaios), 114–15
Delphi, 14, 20, 57, 69, 78, 79
Deluge myths, 211n.17
Demeter, 34, 50, 204n.24
Demodokos, Homeric *aiodos*, 72
Demophon, king of Athens, 129
Demosion, 40

Demosthenes, 89, 208n.127
Diasma, 109
Diaulos race, 41, 83, 88, 158, 204n.41
Diazesthai, 109, 113
Dinsmoor, W. B., 126, 135
Diomedes, 21
Dionysos, 15
Diphrophoroi, 26
Dipylon Gate, 18, 195n.46
Discus, 20, 35, 85, *85*, 86, 164, *165*, 166
Distaff, 138, 139, 151
Dog, 152
Dolichos, 41, 83, 158, 204n.41
Dolphin, 31, 69, 70
Doreios of Rhodes, pancratiast, 207n.119
Dörpfeld Foundations, 124, *125*
Double flute, 52, 54, *64*, 155
Double pipes, 21, *64*, 155. *See also* Aulos; Double flute; Flute
Douris, painter, *102*
Dove, 37
Dresden Athena statue, *115*, 115–16, 123
Dromos, 17, 18, 80, 83
Duties of a Cavalry Commander (Xenophon), 94

Eagle, 37, 197n.54
Earthquakes, 210n.40
Echekles *kalos*, 42
Egyptian weaving, 103
Eirene/Peace, 34
Ekklesia, Athenian, 15
Elegy, 64
Elektra (Sophokles), 99–100
Eleusinion, 20
Elitism, athletic, 98, 205n.65
E(i)mi, 40
Empedokrates, flutist, 64
Endoios, sculptor, 122, 138
Enkelados, 147, 201n.90
Eos, 116
Ependytes, 33, 64, 174, 179
Ephebeia, 82, 88–89
Ephebes, 15, 62, 66, 129
Ephesos, potters of, 42
Epic meter, 70
Epidromos Painter, *76*, 77, 161, *161*
Epinikion, 29
Equestrian events, 13, 15, 20, 21, 22, 34–35, 93–94, 205n.65, 206n.77, 206n.92
Erechtheion, 26, *124*, *125*, 126–127, 137, 211–112nn.26–30
Erechtheus, 13, 21, 120, 126
Ergastinai, 17, 113
Erichthonios, 21, 89, 120, 205n.71, 207n.111, 213n.49
Eros, 34
Erotic Essay (Demosthenes), 89
Erythrai, Athena statue at, 122, 139
Eschara, 135
Esthetes, 210n.7
Eteoboutadai, 23–24
Euandria, 22, 36, 95–96, 175, 206–207nn.102–104, 208n.128
Euboia, woven belt from, 104, 110
Eucharides Painter, 35, 48, 152, 173

Euenor, sculptor, 130. *See also* Athena: Angelitos statue
Eumenides (Aischylos), 38
Eunomia, 79
Euphiletos *kalos*, 42
Euphiletos Painter, 33, 46–48
Euphronios, potter, 62, 214n.61
Euripides, 82, 98, 100, 103, 112, 116, 123
Euthydikos Kore, 115
Exastis, 109
Exekestos, flutist, 55
Exekias, painter, 30, *31*, 33, 35, *35*, 55, 156

Fire, transfer of, from Academy, *see* Torch race
Flax, 105, 106. *See also* Linen
Flute, 55–62 passim, 194n.11; duets for, 60. *See also* Aulos; Double flute; Double pipes
Footrace, 15, 20, 34, 41, *42*, 46, *81*, 82–83, *83*, 158, 159, 160; armed (*see* Hoplite race)
François Vase, 53, 115
Free meals, public, 14, 16, 17, 24, 100, 195n.46
Freedwomen, Athenian, 105
Frogs, the (Aristophanes), 96, 99
Funeral cloths, 209n.22
Funeral games, 79, 166
Furtwängler, A., 141

Ganymede, 37
Gardiner, E. Norman, 45, 77, 98
Ge, 21
Gigantomachy, 94, *102*, 103, 114, 117, 123–35 passim, 147, 197n.43, 201n.90, 212n.37, 213n.47
Goat, 31
Goose, 37
Gorgoneion, 31, 33, 115, 120, 122, 124, 139, 145, 147, 183, 187, 190
Graces, Three, 136, *136*
Grave goods, 188
Greek religion, public aspects of, 13
Griffins, 131
Group of Berlin 2415, *22*, 130
Group E, *15*, *65*, 145, 156
Group of Vatican G23, *165*
Gymnasiarch, 96
Gymnasia, 81, 160, 163, 164, 177

Hades, 34
Hagia Sophia, 142
Hagia Triada sarcophagus, 54
Hallstat, weaving huts of, 110
Harmodios, tyrannicide, 20, 24, *25*, 31
Harrow Painter, *81*, 164
Havana Owl, Painter of, 31, 48
Hecatomb, 13, 24. *See also* Sacrifice
Hecuba, 104
Hecuba (Euripides), 103, 112, 116, 123
Hekatombaion (month), 14–15, 17
Hekatompedon, 125
Hekatompedos Neos, 134–35
Helen of Troy, 104, 116
Helikon, 114
Hellotia festival, 204n.24
Helmet, 33, 122, 124, 130–48 passim, 154, 159, 172, 186, 189, 213n.45, 215n.66, 215n.68

Hephaisteia festival, 177
Hephaistos, 21, 105, *134*, 138, 177
Heptathlos, 26
Hera, 106, 145, 208n.10, 209n.11, 212n.36, 213n.45
Herakles, 34, 36, 65, 70, *70*, 86, 115, 145, 152, 156, 202n.106
Herennius Dexippos, P., 41
Hermes, 45, 75, 119, 145, 152, *153*, 186, 189, *189*
Herodes Atticus, 18, 41
Herodotus, 13, 105, 122, 134, 166, 203n.130, 211n.20
Heroes, 34, 74; Athena protectress of, 36, 38, 77; cults and shrines of, 20, 89
Hesiod, 72, 105, 116, 201n.74
Hesychius, lexicographer, 109, 113
Hieropoioi, 17, *18*, 183
Himantes, 86
Himation, 120, 129, 136, 140
Hipparchicus (Xenophon), 20
Hipparchos, tyrant, 22, 24, 31, 57, 69, 72, 73, 75, 91
Hipparchos (attr. to Plato), 72
Hippias, tyrant, 60, 91
Hippios, 204n.41
Hippodrome, 20, 206n.78
Hippokleides *aphrontis*, archon, 20, 57
Histos, 108
Homer, 13, 20, 70, 104, 105, 116, 119, 120, 203nn.129–30
Homeridai, 72
Homosexuality, *81*, 81–82, 164
Hoplite race (*hoplitodromos*), 21, 34, 36, *36*, 42, 61, 83, 88–89, *89*, 175, 197n.71, 205n.59
Hoplomachia, 89
Horse race, 17, 35, 48, 91, *91*, 172, 173
Horse, 89; as motif, 31, 34–35
Hypereides, potter, 42

IG II² 2311, 15, *16*, 22, 57, 58, 83, 88, 96, 97
Ikria, 18, *19*
Iliad (Homer), 13, 20, 21, 73, 104, 105, 119, 120
Ilioupersis, 147
Iolaus, 145
Ion (Euripides), 112, 123
Ion (Plato), 74
Ion of Ephesos, rhapsode, 72, 74
Ionian alphabet, 40
Iphigeneia in Tauris (Euripides), 112, 123
Isokrates, 77, 89
Isthmia, 20, 50, 79
Isthmian games, 14, 57, 191

Javelin throwing, 35, 46, 85, 86; mounted, 82, 93, 94, *94*. *See also* Acontists
Judges, 60, *86*, 94, 155, 168–175 passim. *See also* Referees
Jumping, *81*, 85, 164
Just Logos (*Clouds*), 95, 99

Kallias, prizewinner, 14
Kallias, son of Didymias, 97
Kallias, son of Phainippos, 91
Kallikrates, architect, 135
Kallimachos, 106

Kallisteria, 206–207n.102
Kallisthenes, 127
Kallynteria festival, 124
Kalokagathia, 96
Kalos-names, 42, 81, 161, 163
Kalpe, 90
Kampteres, 83
Kanephoroi, 23, 24
Kanoun, 182
Karouzou, Semni, 64
Kassandra, 36, 65, 147
Kekatompedos Neos, 126
Kekrops, 120
Kentron, 17, 35
Kerameikos, 29
Kerkyon, 86
Kerykeion, 145
Kimon *koalemos*, 89, 91
Kiss Painter, *98*, *112*, 163
Kithara, 46, 54–60 passim, 65–69 passim, *71*, 156, 157, 158, 194n.11
Kitharodes, 58, 61, 65–71 passim, 202n.97, 202n.106
Kittos, potter, 42
Kleisthenes, reforms of, 22, 97
Kleisthenes, tyrant of Sikyon, 20, 72
Kleitias and Ergotimos, painter and potter, 53, 115
Kleomenes, king of Sparta, 211n.20
Kleomenes, would-be tyrant, 207n.119
Kleophrades Painter, 31, 34, 36, *36*, 48, 49, *88*, 170, *170*, 174, 175
Knights, 27. *See also* Cavalry
Knights (Aristophanes), 86
Knossos, 104, 116, 119
Komos, 64, 163
Korai: Antenor's, *131*, 131–33; Peplos, *130*, 213n.41; "Pomegranate" kore, *137*
Kosmos, statue's apparel, 122
Kritios Boy, 186
Kylon, runner, 79, 98
Kynaithos, rhapsode, 202n.98
Kynisia, female chariot-sponsor, 205n.68
Kynosarges, 81
Kypria (attr. to Homer), 203n.130

Ladder-panels, 115–16
Laertes, 124
Lampadephoros, 96
Lanckoronski relief, *118*, 186
Laurel wreath, 14
Laws (Plato), 94
Leaf motif, 31
Leagros, son of Glaukon, 163
Leagros Painter, 48, 69, *70*
Lebes, 201n.82
Lefkandi (Euboia), woven belt from, 104, 110
Leitourgia, 82
Lekanis, 173
Leneia (festival), 15
Leningrad Painter, 197n.51
LeQuire, Alan, 133
Life of Alkibiades (Plutarch), 100
Life of Demetrios (Plutarch), 114
Life of Perikles (Plutarch), 22, 57, 137

Life of Phokion (Plutarch), 90
Life of Themistokles (Plutarch), 53
Life of Theseus (Plutarch), 21
Linear B, 119
Linen, 106
Lioness attacking bull, *131*, *131*
Long-jump, 35
Loom, 103, 108, *108*, 109, *109*
Loomweights, 106, *107*, 109, 151
Love-gift, pederastic, 37
Lucian, 82, 140–41, 185
Lucilius, 86
Lyceum, 81, 82
Lydos, painter, 30, *41*
Lykos, flutist, 55
Lykourgos, 18, 134, 202n.115
Lyre, 53, 54, 66, 69, 156
Lysias, orator, 93, 177
Lysistrata (Aristophanes), 23, 130

Macedonians, the (Strattis), 114
Makron, painter, 115, *115*
Mansfield, John, 11, 106, 113, 114, 122, 123, 126–27, 135
Marathon, battle of, 26, 82, 213n.42
Marathon race, 83
Marsyas, 215n.66
Medusa, 145
Megakles, suitor of Agariste, 20
Melesias, trainer, 81
Melosa, prizewinner, 197n.1
Memorabilia (Xenophon), 82, 95
Menander, 81
Meno (Plato), 93–94
Mesopotamian weaving, 103
Metics, 23
Metretes, 39
Michigan Painter, 46, *85*, 160
Military dancing, *see* Pyrric dance
Military training, athletics as, 82, 89
Minoans, 103, 116–17. *See also* Knossos
Mnesiades, potter, 41, 197n.68
Mnesikles, architect, 126, 135
Moriai, 44
Mounychia harbor, 97
Mourning Athena, 140, *140*
Mule-cart race, 93, 196n.24
Munich Painter 2335, *61*
Murex purple, 116, 209–210n.36
Music, 13, 17, 20, 46, 53–56, 57–58, 61–69, 70–71
Myceneans, 104
Myron, sculptor, 85

Naiskos, 125, *125*, 136
Natural History (Pliny), 45, 137
Neleids of Pylos, 91
Nemea, 20, 78, 79
Nemean games, 14, 57, 156, 191
Nemean Odes (Pindar), 29
Nemesis, 213n.45
New Phaleron, 20
Nicomachean Ethics (Aristotle), 13
Nike, 34, 50, 51–69 passim, 134, 157, 158; temple of, on Akropolis, 136

Nike bastion, Akropolis, 135, 136, 210n.3, 214n.57
Nikias, potter, 30, 41, *42*, 83
Nikoladas of Corinth, 97
Nikoxenos Painter, *47*, 48, 152, *152*

Octavian (Augustus), 126
Ode, commemorative, 29
Odeion, 22, 57
Odeion, 20
Odysseus, 21, 77, 166
Odyssey (Homer), 73, 79, 120
Oedipus at Colonus (Sophokles), 38
Oikonomikos (Xenophon), 104
Oionokles Painter, 59, 158
Old Athena Temple, 124, 125, 127, 129
Old Oligarch, 98, 100
Olive branch, 150, 151
Olive oil, 17, 21, 29, 35, 38, 44
Olive tree, 126, 179, 184, 189
Olive wreath, 14
Olympia, 20, 78, 79, 82, 106
Olympiads, 83
Olympic games, 14, 15, 50, 57, 78–79, 83, 88, 89, 93; modern, 18
Olympos, 64
Onesimos, *89*
On Horsemanship (Xenophon), 94
Opheltes, 20
Opisthodomos, 126, 135
Orchestra of Agora, 18
Orestes, 100
Orpheus, 69
Ostraka, 97
Ovid, 105
Owl, 31, 37, 44, 51, *51*, 106, *107*, 120, 122, 124, 148–55 passim, *150*, 185–191 passim, 208n.10

Painter of Berlin 1686, *17*, 55
Painter of Louvre F6, *81*, *83*, *96*, 158
Painter of Louvre G539, *96*
Painter of Munich 2335, *61*
Painter of Palermo 1108, prize amphora by (detail), *50*
Painter of the Havana Owl, *31*, 48
Painter of Würzburg 173, *46*, 93, *174*
Palaestrae, 81
Palaimon, 20
Palladion, 129–30, 211n.18, 213n.41
Pan Painter, follower of, *25*, *182*
Panathenaia, 14, 17, 82; and Athenian art, 24–27; athletes, 97–99; as civic event, 23–24; events of, 13 (*see also* individual contests); festival calendar, 14–15; Greater, 10, 13, 14, 57, 80; Lesser, 13, 14, 138; music at, 53–70; popular attitudes towards, 99–101; prizes (*see* Prizes); program of, 15–17; topography of, 18–20
Panathenaic Way, 14, 18
Panathenaikon, 45
Pandora, 105
Pandroseion, 126
Pankration, 35, 41, 86, 88, *89*, 170, 196n.36
Pannychis, 15, 56, 180
Pantakles, runner, 79
Panther, 44; and stag, *31*

Paradeigmata, 46
Parthenon, 119, 125, 126, 135, 142, 211–12nn.27–28, 212n.30; facade, *134*
Parthenon frieze: *apobates*, *90*, 110; kitharists, *55*; peplos, *113*, *123*; procession, 23, *23*–24, 25–27, 181
Paryphe, 33, 123, 211n.16
Paseas, painter, *36*, 147
Patroklos, 20; funeral games for, 166
Pausanias, 13, 64, 82, 106, 119–40 passim, 177, 186, 201n.74, 212n.34
Peace (Aristophanes), 81
Pegasos, 49, 133, 137, 170, 174
Peiraeus, 97
Peisistratid Temple, 124
Peisistratid tyranny, 62, 72, 74, 80, 96, 190, 204n.22
Peisistratos, 20, 22, 26, 57, 91
Peleus Painter, *50*, 60, *60*
Peloponnesian War, 60, 97, 99, 207n.119
Pelops, 20
Penelope, *104*, 115, 124
Pentathlon, 49, 85–86, 160, 164, 165, 169
Peplos, 13, 17–33 passim, 110, *111*, 112–17, 120, 124, 127, 137, 140, 149, 174, 185, 186, 194n.17, 209n.17; Bronze Age antecedents, 103–104; ceremony of, 113, 209n.11; sail, 114, 122, 209nn.26–28, 209n.30
Peplos Kore, 130, *131*
Periander, tyrant of Corinth, 69
Perikles, 20, 22, 57, 77, 137, 138, 140
Periodonikes, 97
Periodos (games circuit), 14, 79
Persephone, 34, 50
Perseus, 36
Persian invasion of 480, 44, 122, 125, 133, 138, 214n.57
Petasos, 94, *180*
Phaleron, conveyance of Palladion to, 129
Pharnabazos, 210n.7
Phayllos of Croton, 97
Pheidias, 34, 129, 140, 142, 149, 183, 184, 185
Pheidippides (in *The Clouds*), 89
Phiale, 58, 120, 124, 136, 148, 158, 185
Philoclean (in *The Wasps*), 97
Philokles, archon, 41, 160
Philostratus, 205n.43
Phokion, 90
Phokos, son of Phokion, 90
Phorebeia, 176
Photius, 93
Phrynis, kitharode, 202n.97
Phrynon, pankration winner, 79, 98
Pile knotting, 109
Pinax, *182*
Pindar, 29, 81, 86, 91, 99
Pine wreath, 14
Pinney, G. Ferrari, 11, 94, 127
Plague of 429, Athenian, 137
Plato (comic dramatist), 97
Plato (philosopher), 72, 81, 82, 89, 93–94, 100–101, 123, 177, 202n.122
Plautus, T. Maccus, 114
Pleket, H. W., 78
Pliny the Elder, 45, 137, 188

Ploutos (Wealth), *33*, 34, 98, 160
Plutarch, 21, 22, 53, 57, 90, 100, 104, 114, 134, 137
Plynteria festival, 124, 129
Poetic recitation contests, 13, 15, 22, 57
Polemisteria, 93
Polemon, archon, 41
Polias, 120–27
Polos, 136
Polygnotos, workshop of, 55
Pomegranate, 135, 136, 214n.57
Pomegranate Kore, *137*
Pompeion, 18, 195n.46
Poseidon, 21, 45, 50, 189, 197n.43, 210n.40
Potters: Bakchios, 42, 196n.31; Euphronios, 62, 214.61; Hypereides, 42; Kittos, 42; Mnesiades, 41, 197n.68; Nikias, 30, 41, *42*, 83; Sikelos, 42, 49
Praxiergidai, 17, 113
Princeton Painter, *25*, 43, 62, *63*, 155, 196n.18
Prizes, 15–16, 36, 46, 58, 69, 79, 82, 93–98 passim, 177, 179, 191; vases, 29, 195n.1; winner's lists, *16*, 207–208n.120
Processions, 13, 17, 18, 23, *23*–24, 25–27, 40, 50, 54, *54*, 79, 80, 93, 114, 181
Pronapes, prosecutor of Themistokles, 97
Propylaia, 18, 126, 137
Propylon, 126
Protomai, 131, 184
Providence Painter, 158
Prytaneion, 17, 100
Psephisma, 57
Pseudo-Andonikes, 97
"Pseudo-Panathenaic" amphorae, 42–46
Ptolemy II Philadelphus, 210n.12
Pyrrhic dance, 13, 21, 36, 56, 56–57, 82, 94–95, *95*, 127, 175, 177, 197n.43, 208n.128, 212n.32
Pyrrhos, sculptor, 137
Pythian games, 57, 64
Pythodelos, archon, 30–31

Quadriga, *173*. *See also* Tethrippos

Referees, 35. *See also* Judges
Regatta, *see* Boat race
Religion, public aspects of, 13
Republic (Plato), 82, 123, 177
Revel, *see* Komos; Pannychis
Rhapsodes, 15, 22, 57, 72–75, *74*, *75*, 202n.98, 202n.115, 202n.120, 202n.122
Rhetoric (Aristotle), 98
River-gods, 210n.40
Robinson Group, *86*, 171
Roman copies, 185, 186
Running, 85. *See also* Footraces; Hoplite race

Sacrifice, 13, 24, 238, 152, 181, 182
Saffron, 116–117
Sakkos, 139
Salamis, battle of, 114, 150, 195n.40
Salpinx, 57
Sanctuaries, 20, 37, 49–50
Satyr plays, 100
Satyrs, 194n.11
Scornavacche relief of Athena Ergane, 138, *138*

Sculptors: Endoios, 122, 138; Euenor, 130; Myron, 85; Pheidias, 34, 129, 140, 142, 149, 183, 184, 185; Phrrhos, 137
Sculpture: Angelitos' Athena, 130, 213n.41; Bull attacking lioness, *131*, 131; Dresden Athena, *115*, 115–16; "Endoios" Athena, 138; Ince Athena, *140*, 186; Kritios Boy, 186; Lanckoronski relief, *118*, 186; Medici Athena, *141*, 141, 185, *185*; Relief of Atarbos, *95*; Tyrannicides, 31–32; Varvakeion Athena, *133*
Severe style, 130
Shapiro, Alan, 11
Shields: in acrobatics, 176; Athena's, 31, *31*, 33, 130, 146–160 passim, 172, 185, 188, 189, 213n.49; as prizes, 95
Ship-cloth, Sumatran, 112
Ship-cart, 22, 123, 195n.40, 210–11n.12
Shrouds, 124
Signatures, potters' and artists', 41
Sikelos, potter, 42, 49
Sikyonian Treasury, Delphi, 69
Simonides of Keos, 72
Singing, 58
Sitesis, 100. See also Free meals, public
Skaphephoroi, 23, *24*
Skaphos, 181
Slingshot, 169
Snakes, 33, 48, 116, 134–53 passim, 173, 183, 210n.39, 210n.49
Snood, 139
Sokrates, 72, 74, 81, 82, 100–101
Solon, 36, 79, 82
Sophilos, painter, *19*, 40, 65, 197n.65
Sophism, 99
Sophokles, 38, 99–100
"SOS" amphoras, 38–39
Spear, 129, 130, 146, 154, 212n.36
Spear throwing, 20. See also Acontists; Javelin throwing
Sphinx, 31, 149, 184
Spindle, 104, 110, 138, 139
Spinning, 105, *105*
Splanchnopt, 182
Sponsorship, 82, 95, 96, 177. See also Leitourgia
Sport history, methodology of, 77–78
Stadion footrace, 41, 42, 83, 158, 159, 204n.41
Stadium, 18, 194n.17
Stag and panther motif, 31, 44
Standard weights and measures, *51*, 39–40, 191
Star motif, 31
Statue and altar, as shrine, 37
Stelai, 40, 50
Stemma, 181
Stephanitic events, 14
Stesichoros of Himera, 70
Stoa of Attalos, 18
Story-cloths, 104, 111, 112, 209n.22
Strattis, poet, 114, 116, 209n.26, 210n.36
Swing Painter, 51, *86*, 169, *169*, 196n.18
Synaulia, 60
Synoris, 34, 93, 196n.24
Syrian weaving, 103

Talasia, 108
Tapestry, 103, 111

Taranto, amphoras in tomb at, 49
Temple treasuries, 112
Temples of Athena: Nike, 137; Parthenos (*see* Parthenon); Polias, 142, 215n.71 (*see also* Erechtheion)
Terma, 159
Tethrippon, 91. See also Quadriga
Textiles, *see* Spinning; Tapestry; Weaving
Thallophoroi, 23
Theban Cycle, 202n.120
Themistokles, 53, 93–94, 97, 122, 150; tomb of, 97
Theogony (Hesiod), 105
Thera, 116
Theraion, 120
Theseus, 26, 36, 53, 70, 86, 120, 169
Theseus Painter, 40, *40*, 50, 56, 95, 177, *180*, 181
Thesmophoriazousai (Aristophanes), 116
Tholos, 40
Thukydides, 24, 81, 99
Tiara, Persian, 139
Timaios, lexicographer, 20
Timestheus of Delphi, pancratiast, 207n.119
Timiades Painter, 115
Timotheos, kitharode, 202n.97
Tithonos Painter, 154
Tiverios, M., 45
Tombs, Panathenaic amphorae in, 49
Torch race, 13, 15, 56, 80, 96, 177, 179, 188, 207n.103, 207n.111, 207n.113
Trainers, 81, *81*, 85, 167, 169, 171
Treasures of the Akropolis, 39, 41, 125–26
Triakter, 169
Tribal contests, 15, 94–97, 208n.128
Trichapta, 120
Triopion, games at, 166
Tripod, 31, 37, 50, 169, 172, 201n.82
Triptolemos, 34
Triptolemos Painter, *22*, 87, 167
Triskeles, 31, 169, 190
Trojan Cycle, 73
Troy, Athena cult at, 119
Trumpet, 57
Twill weaving, 109
Tyche/Fortune motif, 34
Tyrannicides: stamnos with, 24, *25*; statues of, 31–32. See also Aristogeiton; Harmodios
Tyrtaeus, 99

Varvakeion statuette of Athena Parthenos, *133*
Vase Painters: Acheloos P., *85*, *164*; Achilles P., 31, 48, 171, 180; Amasis P., 106, *108*, 109, 168, 194n.17; Andokides P., 66–67, *67*; Antimenes P., 35; Asteios Group, *32*, 33, *83*, 160; Athena P., *18*, 148, *149*, 183, 197n.51; Athens 894 Workshop, *79*; Berlin 2415 Group, oinochoe by, 22, *130*; Berlin 1686 P., *17*, 54–55, *55*; Berlin P., 10, *28*, 30, 31, *31*, 33, *34*, 35, 39, 48, *58*, 67, 68, 69, *84*, 88, *141*, 153, *153*, 157, *157*, 158, 159, *159*, 170, 171, 174; Brygos P., *105*; Bulas Group, 44–45, 188; Copenhagen P., *25*; Dinos P., *180*, 181; Epidromos P., 76, 161, *161*; Eucharides P., 35, 48, 152, 173; Euphiletos P., 33, 46, 48; Exekias, 30, *31*, 33, 35, *35*, 55, 156; Group E, 15, 65, *65*, 144–45, 156, *157*; Harrow P., *81*, 164; Havana Owl, P., 31, 48; Kiss P., *98*, 162, 163; Kleophrades P., 31, 34, 36, *36*, 48, 49, 88, 170, *170*, 174, *174*, 175, *175*; Kleitias and Ergotimos, 53, 115; Leagros Group, 69, *70*; Leagros P., 48; Leningrad P., 197n.51; Louvre F6 P., 83, 158, *159*; Louvre G539 P., *96*, 177, *177*; Lydos, 30, *41*; Makron, 115, *115*; Michigan P., 48, *85*, 160; Munich 2335 P., *61*; Nikoxenos P., 47, 48, 152, *152*; Oionokles P., *59*, 158; Onesimos, *89*; Palermo 1108 P., *50*; Pan P., follower, *25*, *182*; Paseas, *36*, 147; Peleus P., *50*, 60, *60*; Peleus P., manner of, *178*, 179; Penelope P., *104*; Polygnotos, workshop of, 55; Princeton P., *25*, *43*, *62*, *63*, 155, 196n.18 + n.26; Robinson Group, *86*, 171; Sophilos, *19*, 40, 65, 197n.65; Swing P., 51, *86*, 169, *169*, 196n.18 + n.26; Theseus P., 40, *40*, 50, 56, 95, 177, *180*, 181; Tithonos P., 154, *154*; Triptolemos P., *22*, 87, 167; Westreenen P., *27*, *180*, 180; Wurzburg 173 P., *46*, *174*, 177
Vergina, Macedonian royal burial at, 124
Victor, crowning of, 15, 17, *17*, 57
Victory odes, 100
Virginity, 135

Wappenmünzen, 51, *51*, 190, 191, 199n.130
Warp length and breadth, 110
Wasps, the (Aristophanes), 81, 97
Wealth (Aristophanes), 98
Weaving: patterning techniques, 111; on vase by Penelope Painter, *104*; pre-Hellenic, 103; religious accounts of, 105–106; technology, 106–112
Weft-float pattern, 111–12
Weights: jumping, 85, 164; loom (*see* Loom-weights); official standard, *51*, 39–40, 191
Westreenen Painter, *27*, 180, *181*
Wolf motif, 31
Women: in Athenian manumission lists, 105; clothing of, in Greek art, 115; as musicians, 55, 199n.3; as owners of horses, 89, 205n.68; participation of, in Panathenaia, 23–24; and textile occupations, 104–106
Wool, 104, 106, *108*, 110, 151, 195n.1
Works and Days (Hesiod), 72
Worsted thread, 108
Wreaths, 14, *14*, 46, 49, 58, 156
Wrestling, 20, 25, 29, *35*, 49, 85, 86, *86*, 169, 170, 171; boys', 86

Xenophanes, 99
Xenophon, 20, 82, 94, 95, 96, 97, 104, 205n.78, 207n.104
Xystis, 210n.7

Zanes, 197n.52
Zenobios, 113
Zeus, 33, 34, 37, 105, 119, 134, 145, 197n.43, 197n.54; Polieus, 38, 120, 126

Photography Credits

Michael Agee, cat. 45
Courtesy American School of Classical Studies at Athens: Agora Excavations, figs. 3, 4, 31, 38
Courtesy Museum of Fine Arts, Boston, cat. 46
Michael Cavanaugh and Kevin Montague, cat. 62
Sheldon Collins, cats. 23, 43
Deutsches Archaologisches Institut, Athens, figs. 78, 81, 83, 86, 90, 94
Bernard Devos, fig. 36
Alison Frantz, figs. 10–12, 15–18, 56, 69, 72, 82, 84, 89
Ingrid Geske-Heiden, fig. 9
George Holmes, cats. 17, 22
Cheryl Kremer (drawing), fig. 24
Aaron Levin, cat. 28
William Martin, cat. 13
Charles Mercer, cat. 49
Jenifer Neils, fig. 7
Claire Niggle, fig. 45
Jeffrey Nintzel, cats. 10, 11, 27, 37, 39
Courtesy George Ortiz, cats. 2, 9, 33
Courtesy Sotheby's, fig. 37
Warren Swing, cat. 42
Joseph Szaszfai, cat. 15
Bruce M. White, cat. 70
D. Widmer, fig. 33
Konstantinos Yfantidis, fig. 47

fig. 5. From P. E. Arias and Max Hirmer, *A History of Greek Vase Painting* (London 1962) pl. 39.
fig. 25. From *The Annual of the British School of Athens* 73 (1978) pl. 18a.
fig. 28. From Donna C. Kurtz and John Boardman, *Greek Burial Customs* (Ithaca 1971) fig. 84.
fig. 63. From Adolf Furtwängler and Karl von Reichhold, *Griechische Vasenmalerei* vol. 3 (Munich 1932) pl. 142.
fig. 70. From Susan Woodford, *Introduction to Greek Art* (Ithaca 1986) fig. 73.
fig. 76. From *Bulletin de correspondance hellénique* 112 (1988) fig. 3.
fig. 77. From *Antike Kunst* 12, 2 (1969) fig. 4
fig. 79. From Maria Brouskari, *The Acropolis Museum* (Athens 1974) fig. 248.
fig. 85. From Giovanni Becatti, *Problemi fidaci* (Milan 1951) fig. 36.
figs. 87, 88. From Otto Walter *Beschreibung der Reliefs im Kleinen Akropolismuseum in Athen* (Vienna 1923).
fig. 91. From Maria Brouskari, *The Acropolis Museum* (Athens 1974) fig. 66.
fig. 93. From National Gallery of Art, *The Human Figure in Early Greek Art* (Washington 1988) fig. 61.